POPism

POPism
THE WARHOL SIXTIES

Andy Warhol
and Pat Hackett

A Harvest Book • Harcourt, Inc.

Orlando Austin New York San Diego Toronto London

www.HarcourtBooks.com

The Library of Congress has cataloged the previous paperback edition as follows:
Warhol, Andy, 1928–1987
POPism.
Includes index.
1. Warhol, Andy, 1928–1987. 2. Artists—United States—Biography.
3. Pop art—United States. I. Hackett, Pat, joint author. II. Title.
NX512.W37A2 1980
700'.92'4 [B] 79-1851
ISBN 0-15-672960-1 (pbk.)
ISBN-13: 978-0-15-603111-0 (pbk.) ISBN-10: 0-15-603111-6 (pbk.)

Printed in the United States of America

Text set in AGaramond
Designed by Cathy Riggs

A C E G I K J H F D B

ACKNOWLEDGMENT

Because Steven M. L. Aronson is a great friend, he continued editing this book even after he left publishing. His wit, eccentric insights, and just plain discrimination were invaluable. Line by line, thread by thread, he shaped the scenes that were the sixties.

A. W. and P. H.

FOREWORD

This is my personal view of the Pop phenomenon in New York in the 1960s. In writing it, Pat Hackett and I have reconstructed the decade, starting in '60 when I began to paint my first Pop canvases. It's a look back at what life was like then for my friends and me—at the paintings, movies, fashions, and music, at the superstars and the relationships that made up the scene at our Manhattan loft, the place known as the Factory.

—*Andy Warhol*

1960–1963

If I'd gone ahead and died ten years ago, I'd probably be a cult figure today. By 1960, when Pop Art first came out in New York, the art scene here had so much going for it that even all the stiff European types had to finally admit we were a part of world culture. Abstract Expressionism had already become an institution, and then, in the last part of the fifties, Jasper Johns and Bob Rauschenberg and others had begun to bring art back from abstraction and introspective stuff. Then Pop Art took the inside and put it outside, took the outside and put it inside.

The Pop artists did images that anybody walking down Broadway could recognize in a split second—comics, picnic tables, men's trousers, celebrities, shower curtains, refrigerators, Coke bottles—all the great modern things that the Abstract Expressionists tried so hard not to notice at all.

One of the phenomenal things about the Pop painters is that they were already painting alike when they met. My friend Henry Geldzahler, curator of twentieth-century art at the Metropolitan Museum before he was appointed official culture czar of New York, once described the beginnings of Pop this way: "It was like a science fiction movie—you Pop artists in different parts of the city, unknown to each other, rising up out of the muck and staggering forward with your paintings in front of you."

The person I got my art training from was Emile de Antonio—when I first met De, I was a commercial artist. In the sixties De

became known for his films on Nixon and McCarthy, but back in the fifties he was an artists' agent. He connected artists with everything from neighborhood movie houses to department stores and huge corporations. But he only worked with friends; if De didn't like you, he couldn't be bothered.

De was the first person I know of to see commercial art as real art and real art as commercial art, and he made the whole New York art world see it that way, too.

In the fifties John Cage lived near De in the country, up in Pomona, and they'd gotten to be good friends. De produced a concert of John's there, and that's how he first met Jasper Johns and Bob Rauschenberg. "They were both of them on their hands and knees driving nails, building the set," De told me once. "They were penniless then, living down on Pearl Street, and they'd take baths when they came out to the country because they had no shower at their place—just a little sink to take a whore's bath in."

De got Jasper and Bob work doing windows at Tiffany's for Gene Moore, and for those jobs, rather than use their real names, they both used the same pseudonym—"Matson Jones."

"Bob would have all these commercial ideas for the window displays, and some of them," De once said, "could be very bad. But a really interesting one he had was to put stuff down on blueprint paper so you'd get a transfer of image. That was around '55 when you couldn't give away one of his paintings." De laughed his hefty laugh, evidently recalling the wide range of Bob's ideas. "His displays that were crude were beautiful, but the ones that were sort of 'arty' were terrible." I remember De telling me all this so well, because right at that point he said, "I don't know why *you* don't become a painter, Andy—you've got more ideas than anybody around."

Even a few other people had told me that. I was never sure, though, what my place could be in the whole painting scene. De's support and his open attitude gave me confidence.

After I'd done my first canvases, De was the person I wanted to show them to. He could always see the value of something right off. He wouldn't hedge with "Where does it come from?" or "Who did it?" He would just look at something and tell you exactly what he thought. He'd often stop by my place for drinks late in the afternoon—he lived right in the neighborhood—and we'd usually just gab while I showed him whatever commercial drawings or illustrations I was working on. I loved to listen to De talk. He spoke beautifully, in a deep, easy voice with every comma and period falling into place. (He'd once taught philosophy at the College of William and Mary in Virginia, and literature at the City College of New York.) He made you feel somehow that if you listened to him long enough, you'd probably pick up everything you'd ever need to know in life. We'd both have a lot of whiskey out of some Limoges cups I had, my serving system at the time. De was a heavy drinker, but I had my fair share, too.

I worked at home in those days. My house was on four floors, including a living area in the basement where the kitchen was and where my mother lived with a lot of cats, all named Sam. (My mother had shown up one night at the apartment where I was living with a few suitcases and shopping bags, and she announced that she'd left Pennsylvania for good "to come live with my Andy." I told her okay, she could stay, but just until I got a burglar alarm. I loved Mom, but frankly I thought she'd get tired of the city pretty quick and miss Pennsylvania and my brothers and their families. But as it turned out, she didn't, and that's when I decided to get this house uptown.) She had the

downstairs part and I lived on the upper floors and worked on the parlor floor that was sort of schizo—half like a studio, full of drawings and art supplies, and half like a regular living room. I always kept the blinds drawn—the windows faced west and not much light came in anyway—and the walls were wood-paneled. There was a somber feeling about that room. I had some Victorian furniture mixed in with an old wooden carousel horse, a carnival punching machine, Tiffany lamps, a cigar store Indian, stuffed peacocks, and penny arcade machines.

My drawings were stacked neatly, I was very organized about that. I've always been a person who's semiorganized, constantly fighting the tendency to clutter, and there were all these little piles of things in bunches here and there that I hadn't had a chance to sort through.

At five o'clock one particular afternoon the doorbell rang and De came in and sat down. I poured Scotch for us, and then I went over to where two paintings I'd done, each about six feet high and three feet wide, were propped, facing the wall. I turned them around and placed them side by side against the wall and then I backed away to take a look at them myself. One of them was a Coke bottle with Abstract Expressionist hash marks halfway up the side. The second one was just a stark, outlined Coke bottle in black and white. I didn't say a thing to De. I didn't have to—he knew what I wanted to know.

"Well, look, Andy," he said after staring at them for a couple of minutes. "One of these is a piece of shit, simply a little bit of everything. The other is remarkable—it's our society, it's who we are, it's absolutely beautiful and naked, and you ought to destroy the first one and show the other."

That afternoon was an important one for me.

I can't even count the number of people after that day who when they saw my paintings burst out laughing. But De never thought Pop was a joke.

As he was leaving he looked down at my feet and said, "When the *hell* are you going to get yourself a new pair of shoes? You've been wearing those that way all over town for a year. They're crummy and *creepy*—your *toes* are sticking out." I enjoyed De's honesty a lot, but I didn't get new shoes—it'd taken me too long to break that pair in. I took his advice about most other things, though.

I used to go around to all the galleries in the late fifties, usually with a good friend of mine named Ted Carey. Ted and I both had wanted to have our portraits done by Fairfield Porter, and we'd thought that it would be cheaper if he painted us in tandem and then we could cut it apart and each take half. But when he'd posed us, he sat us so close together on the couch that we couldn't slice a straight line between us and I'd had to buy Ted out. Anyway, Ted and I followed the art scene together, keeping up with what was going on.

One afternoon Ted called up very excited to say he'd just seen a painting at the Leo Castelli Gallery that looked like a comic book and that I should go right over there and have a look myself because it was the same sort of thing I was doing.

I met Ted later and we walked upstairs to the gallery. Ted was buying a Jasper Johns light bulb drawing for $475, so it was easy to maneuver ourselves into the back room, and there I saw what Ted had been telling me about—a painting of a man in a rocket ship with a girl in the background. I asked the guy who was showing us the stuff, "What's that over there?" He said it was a painting by a young artist named Roy Lichtenstein. I asked

him what he thought of it and he said, "I think it's absolutely provocative, don't you?" So I told him I did paintings that were similar and asked if he'd like to come up to my studio and look at them. We made an appointment for later that afternoon. His name was Ivan Karp.

When Ivan came by, I had all my commercial art drawings stashed away out of sight. As long as he didn't know anything about me, there was no sense bringing up my advertising background. I still had the two styles I was working in—the more lyrical painting with gestures and drips, and the hard style without the gestures. I liked to show both to people to goad them into commenting on the differences, because I still wasn't sure if you could completely remove all the hand gesture from art and become noncommittal, anonymous. I knew that I definitely wanted to take away the commentary of the gestures—that's why I had this routine of painting with rock and roll blasting the same song, a 45 rpm, over and over all day long—songs like the one that was playing the day Ivan came by for the first time, "I Saw Linda Yesterday" by Dickey Lee. The music blasting cleared my head out and left me working on instinct alone. In fact, it wasn't only rock and roll that I used that way—I'd also have the radio blasting opera, and the TV picture on (but not the sound)—and if all that didn't clear enough out of my mind, I'd open a magazine, put it beside me, and half read an article while I painted. The works I was most satisfied with were the cold "no comment" paintings.

Ivan was surprised that I hadn't heard of Lichtenstein. But he wasn't as surprised as I was, finding out that someone else was working with cartoon and commercial subjects, too!

I had a very good rapport with Ivan right away. He was young, he had an "up" attitude to everything. He was sort of dancing around to the music.

For the first fifteen minutes or so, he looked through my stuff tentatively. Then he dug in and began to sort it out. "These blunt, straightforward works are the only ones of any consequence. The others are all homage to Abstract Expressionism and are not." He laughed and said, "Am I being arrogant?" We talked for a long time about this new subject matter of mine and he said he had intimations that something shocking was about to happen with it. I felt very good. Ivan had a way of making you feel good, so after he left, I sat down and wrapped the Little Nancy cartoon painting that he said was his favorite and sent it over to him at the gallery with a red bow on it.

The next day he brought by some people who had been receptive to Lichtenstein's things in the back room at Castelli's. (Castelli wasn't officially showing Lichtenstein yet—it was an informal sort of thing.)

A few months later I asked Ivan how he'd come to have those first paintings of Roy's in the gallery. He said that one day he was in the gallery lecturing to some college students on how you evaluate new artists' works (how you decide whether or not you want to show them), when a nervous-looking young guy appeared in the doorway with his paintings—he was too shy to come in when he saw all the students there. Ivan had had to look at his paintings in the hallway. The students were naturally eager to see a real-life demonstration of what Ivan had just been explaining to them, and they naturally expected Ivan to be his usual confident, unflappable self. But when he took a look at Lichtenstein's work, he got confused—they were "peculiar and aggressive," very remote from anything he'd seen before, and he told Roy that he'd like to keep two paintings in back room racks to show to Leo Castelli.

Ivan, I found out, had started working for Castelli in '59. "I was working with Martha Jackson then," he told me, "and

Michael Sonnabend came to me one day and said, 'Ivan, you're much too good for this, come have lunch with me and some friends.' I said, 'I'll do anything for lunch.' And it was the Carlyle, which I'd never been to, with very thick tablecloths and napkins, and standoffish, slightly disdainful waiters, and I'll do anything for a lunch like that, so I went to work for Leo Castelli, who was then still married to Ileana. [She later became Ileana Sonnabend.] With my first paycheck, I bought a new suit."

Leo had an art history background and a very good visual sense, but it was Ivan who got him to be adventurous, to poke around new artists' studios. Ivan was young and open to new possibilities; he wasn't locked into any strict art philosophy.

Ivan managed to be "light" without being frivolous. And he was so good with words. His whole manner was like a witty aside, and people loved it. His loose, personal style of art dealing went perfectly with the Pop Art style. Years later I figured out why he was such a successful art dealer—this may sound strange, but I believe it was because art was his second love. He seemed to love literature more, and he put the serious side of his nature into that. During the sixties he wrote *five novels*—that's a lot of writing. Some people are even better at their second love than their first, maybe because when they care too much, it freezes them, but knowing there's something they'd rather be doing gives them a certain freedom. Anyway, that's my theory about Ivan's success.

In the late post–Abstract Expressionist days, the days right before Pop, there were only a few people in the art world who knew who was good, and the people who were good knew who else was good. It was all like private information; the art public hadn't picked up on it yet. One incident especially brought home to me how low the general art world awareness was.

De had met Frank Stella when Frank was an undergraduate at Princeton, and they had stayed good friends. (De reminded me that he'd once brought Frank to my house and I'd pointed at a small painting of his that he had with him and said, "I'll take six of those." I don't remember that, but it must have happened, because I do have six of that painting.) One of Frank's black paintings hung in De's apartment on East 92nd Street. Around the corner from De lived a famous psychiatrist couple who I'll call Hildegarde and Irwin. They were what's known as straight eclectic Freudians. I tagged along with De to a few parties that they gave, and those parties were just remarkable: the guests who weren't psychiatrists were all black people from the UN or UNESCO—"all do-gooding groups," as De put it. He used to laugh and swear that over the years, at all of their parties combined, "I've met exactly *one* attractive woman; they're a terrible-looking group of people."

One afternoon I decided to stop by De's, and just as I got to the door, he was opening it and telling Hildegarde and another woman, a friend of hers who lived down the street, "Get out! I never want to see you again!" I couldn't figure out what was going on, because he and Hildegarde were very good friends, so I just walked on into the apartment as they walked on out. It was a beautiful snowy day; the windows were open and the snow was blowing in.

De explained to me that it had all started with Hildegarde pointing over at the Stella on the wall and sneering, "What's that?" De had told her, "It's a painting by a friend of mine." She and her friend had burst out laughing. "A *painting*???" Then Hildegarde had walked over and lifted it off the wall and poured a bottle of whiskey on it. Then she'd picked up some ether they sniff in the streets during Carnival in Brazil that she'd just brought

back from there for De and she sprayed it all over the painting. The Stella was wiped out. De kept saying to me, but it was really to himself, "What can you do? You can't hit a woman . . ."

As De finished telling me the story, I suddenly saw the ruined Stella lying in a corner. I didn't know what to say. I just sat there with my galoshes dripping a puddle on the floor. The phone rang and, coincidentally, it was Frank. De told him the whole story. I couldn't believe it when I heard De say that the woman with Hildegarde was actually married to a sculptor—I mean, it wasn't like some cleaning lady had seen an all-black painting and tried to scrub it clean with steel wool! De hung up the phone and said that Frank had promised to make him another one "just like it," but he wasn't consoled, he knew that it's not possible to make two paintings exactly alike.

Then the doorbell rang and it was Irwin, sheepishly holding a Motherwell. He said, "Can we give you this, and some money?" De told him to get the fuck out.

One evening De and I were having dinner at "21." I was always sort of starry-eyed, I guess, asking him about the artists he knew, and this night he was describing for me "the greatest art exhibit" he'd ever been to. In the mid-fifties, Jasper Johns had called De up and very formally invited him to dinner "a week from Wednesday." De and his wife at the time—I think it was his third—were on the kind of terms with Jasper where they'd call each other up and say what're you doing tonight? so this "week from Wednesday" business was unusual, the kind of formal thing they never did. ("Jasper was reserved," De said, "but he wasn't *that* reserved!") When the day came, De and his wife went down to the building on Pearl Street where Jasper and Bob Rauschenberg lived. In those days Pearl Street was so beautiful and nar-

row that if there was a car parked on it you couldn't get by. Jasper's loft usually had paint and materials strewn all over, De said, because he worked there, too, but this particular Wednesday it was immaculate, there wasn't a sign of his everyday life visible, except that on the walls were *all* his early paintings—the big American Flag, the first Targets, the first Numbers. (For me, just thinking about what that must have been like was thrilling.) "I was knocked out," De said. "You feel something like that with your insides; the words for it come later—*dryness, austerity . . .* And to think there were people who'd seen those pictures when they were first painted and had laughed, just like they'd laughed at Rauschenberg!"

I've often wondered why people who could look at incredible new art and *laugh* at it bothered to involve themselves with art at all. And yet you'd run into so many of these types around the art scene.

De always said that the hardest thing was to have a friend who was an artist whose work you just couldn't respect: "You have to stop being friends with them, because it's too hard to look at their work and think, 'yuk.'" So everyone that De was friends with he respected. At a party of his once, I heard him answer the phone and tell someone, "Yes, I *do* mind, because I don't like his politics." Someone had wanted to bring Adlai Stevenson.

As we sat at "21" (I remember I had the *National Enquirer* in my lap—I was fascinated by all the Thalidomide stories) we talked about the art around town—about Claes Oldenburg and Jim Dine's street exhibit at the Judson Gallery, about Oldenburg's beach collages in a group show at the Martha Jackson, about Tom Wesselmann's first exhibit of the Great American

Nude series at the Tanager Gallery—but my mind kept going back to what De had just told me about that exhibition that Jasper had made for himself in his own loft. De was such good friends with both Jasper and Bob that I figured he could probably tell me something I'd been wanting to know for a long time: why didn't they like me? Every time I saw them, they cut me dead. So when the waiter brought the brandy, I finally popped the question, and De said, "Okay, Andy, if you really want to hear it straight, I'll lay it out for you. You're too swish, and that upsets them."

I was embarrassed, but De didn't stop. I'm sure he saw that my feelings were hurt, but I'd asked him a question and he was going to let me have the whole answer. "First, the post–Abstract Expressionist sensibility is, of course, a homosexual one, but these two guys wear three-button suits—they were in the army or navy or something! Second, you make them nervous because you *collect* paintings, and traditionally artists don't buy the work of other artists, it just isn't done. And third," De concluded, "you're a commercial artist, which really bugs them because when *they* do commercial art—windows and other jobs I find them—they do it just 'to survive.' They won't even use their real names. Whereas *you've* won *prizes*! You're *famous* for it!"

It was perfectly true, what De said. I was well known as a commercial artist. I got a real kick out of seeing my name listed under "Fashion" in a novelty book called *A Thousand New York Names and Where to Drop Them*. But if you wanted to be considered a "serious" artist, you weren't supposed to have anything to do with commercial art. De was the only person I knew then who could see past those old social distinctions to the art itself.

•••

What De had just told me hurt a lot. When I'd asked him, "Why don't they like me?" I'd naturally hoped to get off easier than this. When you ask a question like that, you always hope the person will convince you that you're just paranoid. I didn't know what to say. Finally I just said something stupid: "I know plenty of painters who are more swish than me." And De said, "Yes, Andy, there are others who are more swish—and less talented—and still others who are less swish and just as talented, but the *major painters* try to look straight; you play up the swish—it's like an armor with you."

There was nothing I could say to that. It was all too true. So I decided I just wasn't going to care, because those were all things that I didn't want to change anyway, that I didn't think I *should* want to change. There was nothing wrong with being a commercial artist and there was nothing wrong with collecting art that you admired. Other people could change their attitudes, but not me—I knew I was right. And as for the "swish" thing, I'd always had a lot of fun with that—just watching the expressions on people's faces. You'd have to have seen the way all the Abstract Expressionist painters carried themselves and the kinds of images they cultivated, to understand how shocked people were to see a painter coming on swish. I certainly wasn't a butch kind of guy by nature, but I must admit, I went out of my way to play up the other extreme.

The world of the Abstract Expressionists was very macho. The painters who used to hang around the Cedar bar on University Place were all hard-driving, two-fisted types who'd grab each other and say things like "I'll knock your fucking teeth out" and "I'll steal your girl." In a way, Jackson Pollock had to die the way

he did, crashing his car up, and even Barnett Newman, who was so elegant, always in a suit and monocle, was tough enough to get into politics when he made a kind of symbolic run for mayor of New York in the thirties. The toughness was part of a tradition, it went with their agonized, anguished art. They were always exploding and having fist fights about their work and their love lives. This went on all through the fifties when I was just new in town, doing whatever jobs I could get in advertising and spending my nights at home drawing to meet deadlines or going out with a few friends.

I often asked Larry Rivers, after we got to be friends, what it had really been like down there then. Larry's painting style was unique—it wasn't Abstract Expressionist and it wasn't Pop, it fell into the period in between. But his personality was very Pop—he rode around on a motorcycle and he had a sense of humor about himself as well as everybody else. I used to see him mostly at parties. I remember a very crowded opening at the Janis Gallery where we stood wedged in a corner at right angles to each other and I got Larry talking about the Cedar. I'd heard that when he was about to go on "The $64,000 Question" on TV, he passed the word around that if he won, you could find him at the Cedar bar, and if he lost, he'd head straight for the Five-Spot, where he played jazz saxophone. He did win—$49,000—and he went straight to the Cedar and bought drinks for around three hundred people.

I asked Larry about Jackson Pollock. "Pollock? Socially, he was a real jerk," Larry said. "Very unpleasant to be around. Very stupid. He was always at the Cedar on Tuesdays—that was the day he came into town to see his analyst—and he always got completely drunk, and he made a point of behaving badly to every-

one. I knew him a little from the Hamptons. I used to play saxophone in the taverns out there and he'd drop in occasionally. He was the kind of drunk who'd insist you play 'I Can't Give You Anything but Love, Baby' or some other songs the musicians thought were way beneath them, so you'd have to see if you could play it in some way that you wouldn't be putting yourself down *too* much. . . . He was a star painter all right, but that's no reason to pretend he was a pleasant person. Some people at the Cedar took him very seriously; they would announce what he was doing every single second—'There's Jackson!' or 'Jackson just went to the john!'

"I'll tell you what kind of guy he was. He would go over to a black person and say, 'How do you like your skin color?' or he'd ask a homosexual, 'Sucked any cocks lately?' He'd walk over to me and make shooting-up gestures on his arm because he knew I was playing around with heroin then. And he could be really babyish, too. I remember he once went over to Milton Resnick and said, 'You de Kooning imitator!' and Resnick said, 'Step outside.' Really." Larry laughed. "You have to have known these people to believe the things they'd fight over." I could tell from Larry's smile that he still had a lot of affection for that whole scene.

"What about the other painters?" I asked him. "Well," he said, "Franz Kline would certainly be at the Cedar every night. He was one of those people who always got there before you did and was still there after you left. While he was talking to you, he had this way of turning to someone else as you were leaving, and you got the feeling of automatic continuity—sort of, 'So long . . . So this guy comes over to me and . . .' and while you may have flinched at his indiscriminate friendliness, he did have the virtue of smiling and wanting to talk all the time. There were always

great discussions going on, and there was always some guy pulling out his poem and reading it to you. It was a very heavy scene." Larry sighed. "You wouldn't have liked it at all, Andy."

He was right. It was exactly the kind of atmosphere I'd pay to get out of. But it was fascinating to hear about, especially from Larry.

The crowd at the opening had thinned to the point where we could move out of our corner. "You didn't go to the Cedar 'to see the stars,' though," Larry added. "Oh, sure, you may have liked being in their aura, but what you came back for night after night was to see your friends . . . Frank O'Hara, Kenneth Koch, John Ashbery . . ."

The art world sure was different in those days. I tried to imagine myself in a bar striding over to, say, Roy Lichtenstein and asking him to "step outside" because I'd heard he'd insulted my soup cans. I mean, how corny. I was glad those slug-it-out routines had been retired—they weren't my style, let alone my capability.

Larry had mentioned that Pollock came in from the country every Tuesday. That was part of the big out-of-the-city-and-into-the-country trend that the Abstract Expressionist painters had started in the late fifties when they were beginning to make money and could afford country places. Right in the middle of the twentieth century, artists were still following the tradition of wanting to get out there alone in the woods and do their stuff. Even Larry had moved to Southampton in '53—and stayed out there for five years. The tradition was really ingrained. But the sixties changed all that back again—from country to city.

One of the first people Ivan brought by to see me that July was a new young "curatorial-assistant-with-no-specific-duties" at the Met. Henry Geldzahler had grown up in Manhattan, gone to

Yale and then to grad school at Harvard. Before coming back to New York from Cambridge, he'd gone to see Ivan, who had a gallery that summer in Provincetown. "I'm about to go back to New York," he announced, "and I want you to tell me who I should meet, what I should do, what I should say, how I should act, speak, dress, think, carry on . . ." Ivan gave him a thirty-minute rundown and once they were both back in New York, they started going around together to all the artists' studios. They were both avid to pick up new art before it got to the galleries—they'd drop by artists' studios and lofts to catch a look at works before they were even finished. Just days after Ivan came up to my place for the first time, he discovered Jim Rosenquist, and Henry had taken him down to see Tom Wesselmann.

When Henry and Ivan came in, I could see Henry doing an instant appraisal of every single thing in the room. He scanned all the things I collected—from the American folk pieces to the Carmen Miranda platform shoe (four inches long with a five-inch heel) that I'd bought at an auction of her effects. Almost as quickly as a computer could put the information together, he said, "We have paintings by Florine Stettheimer in storage at the Met. If you want to come over there tomorrow, I'll show them to you." I was thrilled. Anyone who'd know just from glancing around that one room of mine that I loved Florine Stettheimer had to be brilliant. I could see that Henry was going to be a lot of fun. (Florine Stettheimer was a wealthy primitive painter, a friend of Marcel Duchamp's, who'd had a one-woman show at the Museum of Modern Art in 1946, and her sister Carrie had made some fabulous dollhouses that I loved at the Museum of the City of New York.)

Henry was a scholar who understood the past, but he also understood how to use the past to look at the future. Right away

we became five-hours-a-day-on-the-phone-see-you-for-lunch-quick-turn-on-the-"Tonight-Show" friends.

Of course, it's easy for a young person to support new ideas. He comes onto the scene fresh. He doesn't have any positions to defend or modify, no big time or money invested. He can be a brat, say whatever he pleases, support whatever and whoever he wants to without having to think, "Will they ever invite me to dinner again?" or "Will this conflict with that letter I wrote to *Art Forum* three years ago?" In the last half of '60 Henry and I were both, in our very different ways, coming fresh into and up against the intrigues and strategies of the New York art scene, so that was good for at least four hours a day on the phone right there.

Henry liked all the rock and roll I kept playing while I painted. He told me once, "I picked up a new attitude toward the media from you—not being selective, just letting everything in at once." And over the years I picked up a lot from Henry; I often asked him for advice. He liked to compare our relationship to ones between the Renaissance painters and the scholars of mythology or antiquity or Christian history who doled out the ideas for their subjects.

I was never embarrassed about asking someone, literally, "What should I paint?" because Pop comes from the outside, and how is asking someone for ideas any different from looking for them in a magazine? Henry understood that, but some people had contempt for you when you asked their advice—they didn't want to know anything about how you worked, they wanted you to keep your mystique so they could adore you without being embarrassed by specifics.

Take my commercial drawings. By the time Ivan introduced me to Henry, I was keeping them absolutely buried in another part of the house because one of the people Ivan had brought by before had remembered me from my commercial art days and asked to see some drawings. As soon as I showed them to him, his whole attitude toward me changed. I could actually see him changing his mind about my paintings, so from then on I decided to have a firm no-show policy about the drawings. Even with Henry, it was a couple of months before I was secure enough about his mentality to show them to him. Henry knew that the only thing that counted was what showed up on canvas—not where the idea came from or what you were doing before you painted it. He understood my style, he had a Pop attitude himself. So I was especially never embarrassed about asking him for ideas. (That kind of thing would go on for weeks whenever I started a new project—asking everyone I was with what they thought I should do. I still do it. That's one thing that has never changed; I hear one word, or maybe misunderstand somebody, and that puts me on to a good idea of my own. The object is just to keep people talking, because sooner or later a word gets dropped that throws me on a different train of thought.)

It was Henry who gave me the idea to start the Death and Disaster series. We were having lunch one day in the summer at Serendipity on East 60th Street and he laid the *Daily News* out on the table. The headline was "129 DIE IN JET." And that's what started me on the death series—the Car Crashes, the Disasters, the Electric Chairs. . . .

(Whenever I look back at that front page, I'm struck by the date—June 4, 1962. Six years—to the date—later, my own disaster was the front-page headline: "ARTIST SHOT.")

•••

I asked Ivan for ideas, too, and at a certain point he said, "You know, people want to see *you*. Your looks are responsible for a certain part of your fame—they feed the imagination." That's how I came to do the first Self-Portraits. Another time he said, "Why don't you paint some cows, they're so wonderfully pastoral and such a durable image in the history of the arts." (Ivan talked like this.) I don't know how "pastoral" he expected me to make them, but when he saw the huge cow heads—bright pink on a bright yellow background—that I was going to have made into rolls of wallpaper, he was shocked. But after a moment he exploded with: "They're *super*-pastoral! They're ridiculous! They're blazingly bright and vulgar!" I mean, he loved those cows, and for my next show we papered all the walls in the gallery with them.

It was on one of those evenings when I'd asked around ten or fifteen people for suggestions that finally one lady friend of mine asked me the right question: "Well, what do you love most?" That's how I started painting money.

There were times, though, when I didn't follow advice—like when I told Henry I was going to quit painting comic strips and he didn't think I should. Ivan had just shown me Lichtenstein's Ben Day dots and I thought, "Oh, why couldn't *I* have thought of that?" Right then I decided that since Roy was doing comics so well, that I would just stop comics altogether and go in other directions where I could come out first—like quantity and repetition. Henry said to me, "Oh, but your comics are fabulous—they're not 'better' or 'worse' than Roy's—the world can use them both, they're both very different." Later on, though, Henry realized, "From the point of view of strategy and mili-

tary installation, you were of course correct. That territory had been preempted."

Ivan got a bunch of us hooked on going out to the Fox Theater in Brooklyn to see Murray the K's rock-and-roll shows—Martha and the Vandellas, Dion, Little Stevie Wonder, Dionne Warwick, the Ronettes, Marvin Gaye, the Drifters, Little Anthony and the Imperials, and everybody else you could imagine. Each group did their hit song of the week, only the headliner did more than one or two numbers. But even he was only on for about fifteen minutes. I can't remember if there was a band or if they all lip-synced to their own records, which was actually the way the kids liked it best, with every sound exactly the way it was on the records—like if they were seeing, say, the Crystals, they'd expect to hear every little rattle in the Phil Spector production.

The audience was mixed, black and white, but the black acts got most of the applause. Murray the K would be up on stage screaming his "Ahhh-vey!'s" and talking about the "submarine races" and doing all his radio routines with the "Dancing Girls" and the Murray the K dancers. The kids would be going crazy all around us and Ivan would be screaming along with them one minute and the next minute saying things like "It's so naive! It's full of spirit and high rhythm! All the messages are basic love and alienation! There's no complex worldly wisdom! It's just good straightforward stuff with tremendous force and conviction!" (As I said, that was the way he really talked.)

We'd see the acts over and over. The Fox was a real movie palace, all velvet ropes and brass and marble fountains and purple and amber lights—sort of Moorish, with its high, dark lobby, always so cool in the summer—thousands of kids walking around, drinking sodas and smoking cigarettes. Ivan said to

me years later, "Those days were very meaningful for me because I loved the music so much."

(Of course, like everybody else in the fall of '61, we were also running down to the Peppermint Lounge on 45th Street. As *Variety* headlined, "NEW 'TWIST' IN CAFE SOCIETY—ADULTS NOW DIG JUVES' NEW BEAT.")

"I've lost a fortune over the years, thanks to my lack of objectivity about you," David Bourdon complained to me once. What he meant was that we were such good friends that he didn't ever know what to think of my art, so he passed up the chance to buy a lot of my paintings in the early days when they were selling very cheap. David wasn't one of the people who'd laughed at my work in the beginning. But on the other hand, he wasn't one of the people who'd told me it was great, either.

We'd met in the fifties through a mutual friend who did the Bonwit Teller windows. David wrote art criticism (this was before he worked for the *Village Voice* and long before he worked for *Life*), and we both collected art. Soon we were going around to galleries together.

At the end of the fifties there was a year or so when I didn't see him at all, and then one day he called up and said, "I just picked up a magazine and read that a new artist named Andy Warhol is painting soup cans. Is that *you*?" I asked him if he wanted to come over and see for himself if that was me. He got right on the subway in Brooklyn Heights, where he lived, and was at my house in less than an hour. I showed him my work and waited for him to say something, but he just stood there looking puzzled. Finally he said, "Well, put yourself in my position: I've only known you as a commercial artist, and now

you've become a painter, and yet you're still painting commercial art subjects. Frankly, I don't know what to think."

At least he hadn't laughed. I realized that I could always learn from David's reactions how people in the art world who were sympathetic to my work but at the same time a little leery of it would react. I suppose it's always good to have at least one intelligent skeptic for a friend—you can't have only supporters around you, no matter how much you happen to agree with them.

I'd call David excitedly every time I saw my name in some art column as if to say, "*Now* will you admit Pop is legitimate?" And he'd say, "Well, I still don't know. . . ." It was sort of a game, a regular routine.

(David tells me that I used to be generally much friendlier, more open and ingenuous—right through to '64. "You didn't have that cool, eyeball-through-the-wall, spaced look that you developed later on." But I didn't *need* it then like I would later on.)

When Ivan brought Leo Castelli up to my studio, the place was a mess, with the big canvases strewn around the living room—painting was a lot messier than drawing. Leo looked my stuff over, the Dick Tracys and the Nose Jobs in particular, and then said, "Well, it's unfortunate, the timing, because I just took on Roy Lichtenstein, and the two of you in the same gallery would collide."

Ivan had warned me that Leo was going to tell me, "The two of you in the same gallery . . ." so I can't say I wasn't prepared, but still I was really disappointed. They bought some small paintings to ease the blow and promised that even though they weren't taking me on, they'd do everything they could to

get me shown someplace else, and that seemed so nice it made me want to be with them even more.

To be successful as an artist, you have to have your work shown in a good gallery for the same reason that, say, Dior never sold his originals from a counter in Woolworth's. It's a matter of marketing, among other things. If a guy has, say, a few thousand dollars to spend on a painting, he doesn't wander along the street till he sees something lying around that "amuses" him. He wants to buy something that's going to go up and up in value, and the only way that can happen is with a good gallery, one that looks out for the artist, promotes him, and sees to it that his work is shown in the right way to the right people. Because if the artist were to fade away, so would this guy's investment. As usual, De put it better than anybody else: "Think of all those third-rate works in the basements of museums that you never see, and of all the works that were destroyed, sometimes by the artists themselves. What survives is what the taste of the ruling class of the period decrees should survive, and this usually turns out to be the most effective work done within the canons and terms of that class. Go back as far as the time before Giotto, the time of Cimabue, there were hundreds and hundreds of Italian painters around, but today most of us only recognize the names of a handful. People who care about painting may be able to name five, and scholars may know as many as fifteen, but the rest are all painters whose paintings are as dead as they are."

So you need a good gallery so the "ruling class" will notice you and spread enough confidence in your future so collectors will buy you, whether for five hundred dollars or fifty thousand. No matter how good you are, if you're not promoted right, you won't be one of those remembered names.

But there was more than that involved in why I wanted Castelli to take me on; it wasn't only the business side of it. I was like a college kid wanting to get into a certain fraternity or a musician wanting to get on the same record label as his idol. Being part of Castelli's stable was just something that I knew would make me happy, and even though he'd turned me down, I still had hope that he'd take me on later.

Meanwhile, Ivan was doing a lot for me. He took slides and photographs of my paintings and sometimes he even carried the paintings over personally to other dealers. It was unusual for a dealer to be pushing a painter like this to other dealers, since they could always think, "If he's so good, why don't *you* take him?" Ivan would leave my paintings with them on a "trial basis"; the galleries would look at my things and say, "Crass! Outrageous!" and mean exactly that; then Ivan would come back and tell me kindly, "I'm afraid they don't perceive the larger element in your work."

Henry Geldzahler was also pounding the pavements for me. He offered me to Sidney Janis, who refused. He begged Robert Elkon. ("I'm sure I'm making a big mistake," he told Henry, "but I just can't.") He approached Eleanor Ward, who seemed interested but said she didn't have room. Nobody, but nobody, would take me. Henry and I would talk every day on the phone about the progress he was making. This dragged out for over a year. He'd tell me, "They're only resisting you because you're such a natural. They're afraid of you because the continuity between your commercial work and your fine art work is so obvious." Still . . .

I had the Green Stamps and the Campbell's Soup Cans scattered in galleries all around New York, but my first show was

out in Los Angeles, at Irving Blum's gallery in 1962. (I didn't go out for that first one but I went out for the one there the next year.) Irving was one of the first people Ivan had brought to my studio, and when he saw my Superman, he'd laughed. But it was different the next year; after he saw that Castelli had taken on Lichtenstein, he came back and offered me a show.

In August '62 I started doing silkscreens. The rubber-stamp method I'd been using to repeat images suddenly seemed too homemade; I wanted something stronger that gave more of an assembly-line effect.

With silkscreening, you pick a photograph, blow it up, transfer it in glue onto silk, and then roll ink across it so the ink goes through the silk but not through the glue. That way you get the same image, slightly different each time. It was all so simple— quick and chancy. I was thrilled with it. My first experiments with screens were heads of Troy Donahue and Warren Beatty, and then when Marilyn Monroe happened to die that month, I got the idea to make screens of her beautiful face—the first Marilyns.

Henry phoned one afternoon and said, "Rauschenberg just called to ask me about silkscreening, and I told him, 'Why ask me—ask Andy.' I said I'd arrange for him to come up to your place and have a look around."

Henry came up with Rauschenberg that same evening. The gallery owners Ileana and Michael Sonnabend were there, and David Bourdon, and a young Swedish artist was with them.

Nothing to do with the art world was ever lost on David, who later recalled the scene for me in detail: "You got out the Marilyns, and then, because Rauschenberg hadn't ever been to

see your things, you showed him some of the early works, including the wide painting of green Coke bottles repeated hundreds of times across the canvas. It wasn't even stretched, you didn't have the room to stretch the big ones and usually you kept them rolled up. You showed him the repeated Coke bottles and told him you were going to crop the picture to make the bottles go right to the edge of the frame. He offered that the alternative was to leave a bare strip of canvas at the edge—if what you wanted was to show people that you meant exactly that many Coke bottles and not an infinite number." Over the years I came to realize more and more that Rauschenberg was one of the few artists who were generous about new artists' work. David went on, "He was very interested in the silkscreens and asked where you got them. Up to then he'd been transferring images by putting lighter fluid on magazine and newspaper illustrations and then rubbing it onto the paper—a very painstaking process. He was impressed when he saw that with a silkscreen you could get an image larger than life and use it over and over again."

What I remember about that visit was Bob's leaving, saying he had to meet someone for dinner, and a little while later Henry and I decided to go to Saito, a Japanese restaurant on West 55th Street. When we walked in, who should be there but Bob, sitting with Jasper Johns. It was one of those awkward coincidences, seeing someone right after you've just said all your good-byes.

Not too long after that, Henry brought Jasper by to see me. Jasper was very quiet. I showed him my things and that was that. Of course, I thought it was terrific that Rauschenberg and Johns had both come up; I admired them so much. After Jasper had gone,

David Bourdon said, "Well, Henry was trying to be the helpful connection, but Jasper didn't look too thrilled to be here."

"What do you mean?" I said.

"Did you see his face when you dragged out your pictures? All anguish."

"Was it really?" I couldn't tell. And anyway, you never know—sometimes people are just thinking about their own problems. But certainly, compared to Rauschenberg, who was generally so enthusiastic, Jasper seemed like a moody type of person.

It was De who finally got Eleanor Ward to give me my first New York show, at her Stable Gallery. It was off Madison Avenue by then, but it had once occupied the most beautiful space in New York—on Seventh Avenue and 58th Street, right off Central Park South. It had been an actual stable where rich people kept their horses, and in the spring when the wetness was in the air, you could still smell the horse piss, because that's a smell that never goes away. For stairs there was a ramp where the horses used to walk. To use a real stable space and call it the Stable Gallery was a very modern idea for the fifties, which generally was a time when people put on airs: usually they remodeled and redecorated, and things like the high school gym at prom time were "made over," to camouflage what they basically were. But in the sixties, you'd go and play up what a thing really was, you'd leave it "as is."

Like, in '67 when we helped open a discotheque called the Gymnasium; we called it that because it was in what had been a real gym, so we just left all the work-out equipment—the mats and barbells and things—lying around the dance floor. (And then, in '68 when somebody else opened a discotheque called

the Church in an old building on the West Side, they left all the religious fixtures exactly the way they were: even the confessional booths stayed—they just installed pay phones in them.) Playing up what things really were was very Pop, very sixties.

Anyway, De arranged to meet Eleanor at my studio one evening in '62. We sat around talking for an hour or so, having a few drinks, until De said bluntly, "Well, come on, Eleanor. The point of all this, after all, is are you going to give Andy a show or not, because he's very good and he should have one." She took out her wallet and looked through the bill compartment. Then she held up a two-dollar bill and said, "Andy, if you paint me this, I'll give you a show."

After Eleanor had gone, De warned me to be careful of her because of how she'd treated Rauschenberg and Cy Twombly. All he meant was that she hadn't given them a whole lot of attention, not like she had her big guns like Noguchi. At the time when she was showing Rauschenberg's work, he was actually the janitor at the gallery—she had him sweeping around with a broom!

I was thrilled to finally have a show of my own in New York. Eleanor was an absolutely beautiful, aristocratic woman. She could easily have been a model or a movie star—she resembled Joan Crawford—but she loved art so much, she just lived for it. She felt every artist with her gallery was one of her babies, and she called me her Andy Candy.

My first New York show—in the fall of '62—had the large Campbell's Soup Cans, the painting of a hundred Coke bottles, some Do-It-Yourself paint-by-numbers paintings, the Red Elvis, the single Marilyns, and the large gold Marilyn.

By the beginning of '63 my work area at home was a total mess. The canvases were spread out all over the living room and the

ink from the silkscreens was getting on everything. I knew I had
to rent a studio to paint in. A friend named Don Schrader had
come across an old firehouse on East 87th Street, a hook and
ladder company that some guy had leased from the City of New
York for about a hundred dollars a year, and the guy offered to
sublet part of it to me. As soon as I moved my stuff over there,
I began to look around for an assistant. I started asking friends
if they knew of any art school-type kids who needed work.

I'd met the surrealist poet Charles Henri Ford at a party that his
sister Ruth Ford, the actress, who was married to Zachary Scott,
gave at her apartment in the Dakota on Central Park West and
72nd Street, and Charles Henri and I began going around to-
gether to some of the underground movie screenings. He took
me to a party that Marie Menken and her husband Willard
Maas, underground filmmakers and poets, gave at their place in
Brooklyn Heights at the foot of Montague Street.

 Willard and Marie were the last of the great bohemians.
They wrote and filmed and drank (their friends called them
"scholarly drunks") and were involved with all the modern poets.
Marie was one of the first to do a film with stop-time. She filmed
lots of short movies, some with Willard, and she even did one
on a day in my life.

 The Maases were warm and demonstrative and everybody
loved to visit them. They lived at the very top of one of those
nice, old, turreted apartment buildings. Their place had a big
dining room where Willard and Marie would set out tons of
food, and off that was a living room which everybody loved be-
cause it was in one of the round turrets. Then there was a
rooftop garden, and behind that was a little cottage that they'd

built as Marie's own place; she and the dogs would hide away there, it was sort of her private domain.

The first time I went out to their house with Charles Henri, Marie was the only person there who'd ever heard of me. She introduced me to the poets Frank O'Hara and Kenneth Koch and she had her arms around me and was telling them how famous I was going to be someday, and that sounded great to me. Naturally I thought she was wonderful. Later on I put her in a lot of my movies like *Chelsea Girls* and *The Life of Juanita Castro*. Mario Montez, the underground film star, used to insist that Marie looked just like Broderick Crawford in drag. Now I know you can say that about a lot of women who are past a certain age, but Marie's resemblance to Broderick Crawford was remarkable.

I was doing a lot of work—I'd been in a group show down in the Washington, D.C., Gallery of Modern Art in April, and I was going to have another show at the Ferus in September, and I had another at the Stable coming up. I definitely needed some help and in June '63 I asked Charles Henri again if he knew of anybody who could help with the silkscreen process. Charles said he did know someone, Gerard Malanga, a student at Wagner College on Staten Island, and he brought us together at a poetry reading at the New School. Gerard, a young kid from Brooklyn, came to play a big role in our life at the Factory. Marie and Willard were sort of godparents to him.

I liked Gerard; he looked like a sweet kid, in sort of a permanent reverie, it seemed—he made you want to snap your fingers in front of his face occasionally to bring him around. He wrote a lot of poetry. He'd met a lot of intellectuals through Willard and Marie. The great thing, though, was that he really did seem to know about silkscreening. He started working for me

right away—for $1.25 an hour, which he always reminds me was
the New York State minimum wage at the time. In his first days
with me I overheard him on the phone telling Charles Henri that
he found me frightening—the way I looked and everything—
and then I heard him lower his voice even more and confide to
Charles, "Frankly, I think he's going to put the make on me."

The structure in the hook and ladder company was pretty scary.
You literally had to hopscotch over the holes in the floor. And
the roof leaked. But we didn't really notice all that much, we
were busy getting the Elvises and the Liz Taylor silkscreens ready
to ship out to California. One night that summer there was a
terrible thunderstorm and when I came in the next morning, the
Elvises were sopping wet—I had to do them all over again.

Those were the quiet days. I didn't talk much. Neither did Ge-
rard. He'd take poetry breaks where he'd go off and write in a
corner, and sometimes when people came by to see my work,
he'd give a reading to them. I'd hear him intoning lines like "The
whole situation here seems precarious/. . ."

Gerard kept up with every arty event and movement in the
city—all the things that sent out fliers or advertised in the *Voice*.
He took me to a lot of dank, musty basements where plays were
put on, movies screened, poetry read—he was an influence on
me in that way. He talked sometimes in sort of an archaic liter-
ary dialect that he must have picked up reading old poems, and
sometimes in a sort of Brooklyn-Boston accent, dropping his *r*'s.

We went out to Coney Island a few times that summer (my first
time on a roller coaster), groups of whoever was around—
people like Gerard; Jack Smith, the underground filmmaker-

actor; Taylor Mead, the underground actor; Wynn Chamberlain, the Magic Realist painter; and Nicky Haslam, a new art director at *Vogue*. Nicky had come over from London the year before when his friend, the photographer David Bailey, was bringing his newest model, Jean Shrimpton, over to work for *Vogue*. (Only *Vogue* hadn't used his photographs right away; at first, they had him working just at *Glamour*, where Jean Shrimpton modeled junior clothes.)

It was from Nicky that we first started really hearing about the mod fashion revolution in England that had started in '59 or '60. Nicky may actually have started the frilly men's shirt look because I remember him getting curtain lace at Bloomingdale's and tucking it up his sleeves and everybody would be asking him where he got the "great shirt" because they'd never seen anything like it. He made us aware of the new men's fashions—the short Italian jackets and the pointed shoes ("winklepickers")—and of the way the cockneys now were mingling with the upper classes and things were getting all mixed in and wild and fun. Nicky would remark that there weren't really any *young* people here like there were in England—that kids here went from being juveniles straight into "young adults," whereas in England the kids eighteen and nineteen were having a ball. Or starting to, anyway—it was a new age classification.

We all went to the Brooklyn Fox together, too. I hadn't been there with Ivan in quite a while. In fact, I wasn't seeing so much of Ivan now, because I was more on the filmmaking and literary circuit, going to all those holes-in-the-walls with Gerard. But I was still visiting all the galleries and keeping up with the art scene too.

• • •

In those days I didn't have a real fashion look yet. I just wore black stretch jeans, pointed black boots that were usually all splattered with paint, and button-down-oxford-cloth shirts under a Wagner College sweatshirt that Gerard had given me. Eventually I picked up some style from Wynn, who was one of the first to go in for the S & M leather look.

The girls that summer in Brooklyn looked really great. It was the summer of the Liz-Taylor-in-*Cleopatra* look—long, straight, dark, shiny hair with bangs and Egyptian-looking eye makeup. The Brooklyn counterpart to the Greenwich Village scene around Sixth Avenue and 8th Street was Flatbush Avenue, which was divided mostly between the collegiate-looking kids and the "hitters." And then over on Kings Highway were the kids who lived with their parents and went to high school in Brooklyn and then hung around the Village on weekends.

This was the summer before the Motown sound got really big, and it was also the last summer before the English Invasion. The show at the Fox had the Ronettes, the Shangri-Las, the Kinks, and Little Stevie Wonder. Also, we were watching Murray the K before he got to be super-famous for being the American disk jockey who had the best rapport with the Beatles.

It was a great summer. The folk-singer look was in—the young girls with the bangs were wearing shifts and sandals and burlapy things; but looking back, I can see that maybe by way of the Cleopatra look, folk evolved into something slick and fashionable that would eventually become the geometric look. But this summer, at least, folk and hip were blending.

President Kennedy was over by the Wall in West Berlin saying *"Ich bin ein Berliner,"* and the two "Career Girls" were mur-

dered—they lived down the street from me and I remember passing all the police cars. And this was the summer, too, before the first bombing in Vietnam, the summer of civil rights marches down south, the summer right before the sixties went all crazy for me, before I moved my work space to the 47th Street Factory and the media started writing me up in the new setting with all the superstars. But in this summer of '63 there were no superstars yet; in fact, I'd only just gotten my first 16-mm camera, a Bolex.

Although I didn't buy a movie camera till some time in '63, it had certainly occurred to me to be a do-it-yourself filmmaker long before then, probably because of De. His interest had started to shift from art to movies around '60. For five hundred dollars he'd managed to produce a movie called *Sunday* that a friend of his, Dan Drasin, had made about the Sunday the police had suddenly outlawed folk singing in Washington Square Park because they said it brought out a lot of undesirable types—meaning blacks and folk singers—and so everybody had congregated down there to protest. It was one of the first "rebellions" of the sixties. De had taken me over to the Film-Makers' Co-operative to see a screening of *Sunday*.

The Film-Makers' Coop was run by a young Lithuanian refugee by the name of Jonas Mekas. It was in a loft on the corner of Park Avenue South and 29th Street, across from the Belmore Cafeteria where the cabbies hung out day and night. And day and night there were screenings going on at the Coop. Jonas actually lived there, in one of the corners: he once told me he slept under the table. Although I didn't come to know him personally until late '63, I went to a lot of his screenings at the Coop

and also down at the Charles Theater on East 12th Street, a meeting place for underground filmmakers, and then midnights at the Bleecker Street Cinema.

One night as I was walking home from the art supply store with some brushes, past the little old German ladies in Yorkville sweeping their sidewalks, I realized I'd forgotten to get my mother her Czech newspaper. I turned back and ran into De, who said he'd just delivered fifty thousand dollars to CBS. When he'd first approached them about the documentary he wanted to do called *Point of Order* about the McCarthy hearings, they'd denied that they had any of the original footage of the hearings, but when he told them he could prove that they had all 185 hours of it stored away in their warehouse in Fort Lee, New Jersey, they admitted it, but they still refused to sell him the rights to use it in a film because why raise that old issue. Later Dick Salant from CBS called De and said they had changed their mind, that they would sell after all, for fifty thousand dollars plus fifty cents on every dollar of profit. De said okay—provided they agreed never to use more than three minutes of footage without his permission.

I asked De where he'd gotten the fifty thousand dollars from—those were the things that really interested me—and he said from Eliot Pratt of the Standard Oil/Pratt Institute Pratts. "Eliot Pratt is a left-wing liberal who hates McCarthy," De explained. "We had lunch and I just told him about the movie and that I didn't know exactly how much it would end up costing, and he said, 'I'll write you a check for a hundred thousand. Will that be enough to start with?' The bill for our hamburgers came to four dollars. Eliot left a ten-cent tip for the waiter. Then we

went back to his house to work out the financing." Rich people are so strange about money.

De had gotten interested in filmmaking initially because of a movie called *Pull My Daisy*. Robert Frank, the underground filmmaker, and Alfred Leslie, the Abstract Expressionist painter, had gotten together to do it with Jack Kerouac, who'd had the original idea, and there were always fights about whose film it was—the ads said something different every time. De told me, "Robert shot it and it's in his style, but he didn't know how to put a film together, so Alfred got involved in the final cutting and now they both take credit for all of it. But like most films, it's the work of more than one person." A stockbroker named Walter Gutman put up the twelve thousand dollars to make it. (He used to write a great Wall Street market letter as if it were a personal letter—he'd say, "Buy AT&T, and I think Rothko's paintings are going to go up, too.")

Robert Frank had called De up and said, "I hate articulate people, but I happen to like you and we need help. We think we want to dub this film into French. Can you come over?" I went over there with De and they ran the film for him. David Amram the composer was in it, and Dick Bellamy the art dealer—he played a bishop preaching to people on the Bowery—and Larry Rivers played a railroad guy, and Ginsberg and Corso were in there, and Delphine Seyrig was incredibly beautiful in it with the American flag blowing over her. Kerouac was at this dubbing session, claiming he spoke French fluently, but when he began to speak it you could hear his Massachusetts accent—*"Ju swee Jacques Ker-ou-ac"*—and then something about his family being French nobility in the fourteenth century,

which had nothing to do with this movie on the Bowery, of course, so it was very funny.

I went out to Old Lyme, Connecticut, a lot of weekends that summer. Wynn Chamberlain was renting the guest house on Eleanor Ward's property and he had gangs of his friends out there the whole time. Once, Eleanor visited the guest house and got really, really upset when Taylor Mead came into the living room dressed up in drag and announced to her, "I'm Eleanor Ward. Who are *you*?"

Jack Smith was filming a lot out there, and I picked something up from him for my own movies—the way he used anyone who happened to be around that day, and also how he just kept shooting until the actors got bored. People would ask him what the movie was about and he would say things that sounded like a takeoff on the "mad artist"—"The appeal of an underground movie is not to the understanding!"

He would spend years filming a movie and then he'd edit it for years. The preparations for every shooting were like a party—hours and hours of people putting makeup on and getting into costumes and building sets. One weekend he had everyone making a birthday cake the size of a room as a prop for his movie *Normal Love.*

The second thing I ever shot with a 16-mm camera was a little newsreel of the people out there filming for Jack.

He was also an actor in other people's underground movies. He said that he did it for the therapy, because he couldn't afford "professional help," and that wasn't it brave of him to take psychoanalysis in such a public way.

Jack played the title role in *Dracula,* a movie I shot later in the year. He really got into the part. He claimed that as he put

his makeup on, he was slowly transforming himself, letting his soul pass out through his eyes into the mirror and back into him as Dracula, and he had this theory about how everyone was "vampirical" to a certain extent because they "made unreasonable demands." The filming went on for months. I remember one scene where my first female superstar, Naomi Levine, was sleeping on a bed and Jack was out on the balcony. He was supposed to sneak in, go over to the bed, and do some little thing—eat a peach or bite into a grape, I can't remember exactly. David Bourdon was in the scene, and Sam Green, the art dealer, and Mario Montez, who'd just come back from a fashion session somewhere, and Gregory Battcock, the art and film critic, who was in a sailor suit; and they were the four human bedposts holding the canopy up over this bed. I was shooting with my Bolex, little three-minute reels, and everyone was going crazy because we had to shoot the scene over and over because Jack just couldn't do it: he was so disoriented that his sense of timing was gone, and he just could not figure out how to get from the balcony over to the bed in three minutes. The farthest he ever got was two feet from the pillow.

Since there were usually as many as forty people out in Old Lyme every weekend, there were never enough beds; but most of the guests didn't sleep anyway. I was awake a lot myself—I'd started taking a fourth of a diet pill a day (Obetrol) that winter after I saw a picture of myself in a magazine where I looked really fat. (I did like to eat a lot—candy and very rare meat. I loved them both. Some days I'd just eat one or the other all day long.) And now, because I was awake so much, I started having more time on my hands.

I could never finally figure out if more things happened in the sixties because there was more awake time for them to happen in

(since so many people were on amphetamine), or if people started taking amphetamine because there were so many things to do that they needed to have more awake time to do them in. It was probably both. I was taking only the small amount of Obetrol for weight loss that my doctor prescribed, but even that much was enough to give you that wired, happy go-go-go feeling in your stomach that made you want to work-work-work, so I could just imagine how incredibly high people who took the straight stuff felt. I only slept two or three hours a night from '65 through '67, but I used to see people who hadn't slept for days at a time and they'd say things like "I'm hitting my ninth day and it's glorious!"

That summer out in Old Lyme was a prelude to all the craziness later. People were up all night wandering around the grounds smoking dope or playing records back at the house. Every weekend was a nonstop party—no one broke the weekend up into days, everything just flowed into everything else.

Seeing everybody so up all the time made me think that sleep was becoming pretty obsolete, so I decided I'd better quickly do a movie of a person sleeping. *Sleep* was the first movie I made when I got my 16-mm Bolex.

John Giorno was a stockbroker who had dropped out and become a poet. (Late in the sixties he started the telephone Dial-A-Poem.) John and I have reminisced about the weekend I shot *Sleep*; it was one of the hottest weekends ever—mosquitoes everywhere. "I came in drunk and passed out," John says, "and when I woke up in the middle of the night, you were sitting in a chair in the room looking at me in the dark—I could tell it was you by your white hair. I remember asking, 'Andy, what are you doing here?' and you said, 'Gee, you sleep so well,' and you

got up and left. Then later, when Marisol and I were riding back to New York on the train with you, you said you were going to buy a camera and make a movie."

The great thing about staying out at Wynn's was that nobody ever locked their doors—in fact, nobody really had doors to lock, everybody just drifted around and slept wherever. And of course, that made it really convenient to film, since the first thing you do when you want a film star is "check his availability."

The people who entertained were the ones who really made the sixties, and Wynn Chamberlain entertained a lot, not only out in the country but also at his Bowery place. It was way down near Lil's Bowery Follies, and when you walked in, there was a painting by Wynn of a brown and white shoe with a bubble coming out of it saying, "Palm Beach, blah blah blah." Everybody used to go to Wynn's parties—all the artists and dancers and underground filmmakers and poets.

When I was with the Stable Gallery from the end of '62 to early '64, Marisol and Bob Indiana were, too. We used to go around to openings and parties together, and they were both in some of my early movies. The painting style that everybody accepted and that dominated the art scene was still Abstract Expressionist. The post–Abstract Expressionist painters had come along afterward and the Hard Edge geometrics, too, but the last thing to happen in art that was completely accepted was Abstract Expressionism. So when Pop appeared, not even the style it followed had been fully accepted yet! The resentment against Pop artists was something fierce, and it wasn't coming from just art critics or buyers, it was coming from a lot of the older Abstract Expressionist painters themselves.

This attitude was brought home to me in a very dramatic way at a party given by an Abstract Expressionist painter, Yvonne Thomas, mainly for other Abstract Expressionist painters. Marisol had been invited, and she took Bob Indiana and me with her. She was always very sweet to me—for instance, whenever we were out together, she used to insist on taking me home instead of the other way around. When we walked into that room, I looked around and saw that it was chock full of anguished, heavy intellects.

Suddenly the noise level dropped and everyone turned to look at us. (It was like the moment when the little girl in *The Exorcist* walks into her mother's party and pees on the rug.) I saw Mark Rothko take the hostess aside and I heard him accuse her of treachery: "How could you let *them* in?"

She apologized. "But what can I *do*?" she told Rothko. "They came with Marisol."

For my second show at the Ferus Gallery in Los Angeles—the Liz-Elvis show—I rode cross-country from New York in a station wagon with Wynn, Taylor Mead, and Gerard. It was a beautiful time to be driving across America. I think everyone thought I was afraid to fly, but I wasn't—I'd flown around the world once in the fifties—it was just that I wanted to see the United States; I'd never been west of Pennsylvania on the ground.

Wynn was tall and lanky, a very good Magic Realist painter who was beginning to get a little interested in Pop. Taylor I knew a little, from out at Old Lyme. He was one of the first underground film stars, starting out in North Beach in San Francisco in the fifties in Ron Rice's *The Flower Thief* and Vern Zimmerman's *Lemon Hearts,* which I'd seen over at the Film-Makers' Coop. A couple of days before we were supposed to leave, Henry

came by the studio with Taylor, who he'd bumped into wandering around near the Met. That's what Taylor used to love to do all day—drift all over town in that way he had that people called pixieish or elfin or wistful. He always had a slight smile on his face and in his eyes—one of them drooped, and that was a little trademark. He looked so chronically relaxed you felt that if you lifted him up by the back of his neck, his limbs would just dangle. I mean, he looked like he didn't have a nervous system, that was the attitude he had. He'd never seen any of my work, but he'd just read an article about my Campbell's Soup Cans in *Time,* and when Henry introduced us, he said, "You are the Voltaire of America. You're giving America just what it deserves—a can of soup on the wall!"

Taylor agreed to split the cross-country driving with Wynn—Gerard and I didn't know how to drive. I frankly couldn't believe from looking at Taylor that he really knew how to drive—I've always been surprised at the people who can drive and the people who can't.

I knew the whole thing would be fun, especially since Dennis Hopper had promised us a "Movie Star Party" when we got there.

I'd met Dennis a couple of months earlier through Henry, on the same day that I'd introduced Henry to the young English painter David Hockney. Dennis bought one of my Mona Lisa paintings on the spot and then he and Henry and David and I went up to the sound stage on West 125th Street where Dennis was doing an episode on the TV show "The Defenders."

Wynn and Taylor and Gerard came to pick me up. We threw a mattress into the back of the station wagon and took off.

The radio was on the whole time—full blast. As a matter of fact, I was the one who insisted on blasting it because I get very nervous about people falling asleep at the wheel. You sure get to know the Top Forty when you make a long trip like that—over and over again, the same songs: Lesley Gore, the Ronettes, the Jaynettes, Garnet Mims and the Enchanters, the Miracles, Bobby Vinton . . . And there were long stretches where there was lots and lots of country and western. And everywhere we drove through was so different from New York.

James Meredith had enrolled at Ole Miss just the year before, but New York seemed much closer to Europe than to the Deep South. Dancing clubs in Paris were just starting to be called *discothèques* and there were all these new looks—the Chelsea look, Edwardian, Carnaby Street mod. This was the summer when the styles and music and attitudes that would shortly be shipped over as the English Invasion were all happening in London. And with all the nonstop jet flights, people were popping over from Europe all the time, three or four times a year instead of once a year like in the old days when the trip took fourteen hours, and they started buying apartments here, too. The minute their planes touched down, they'd go straight to dancing places like L'Interdit, which had opened in '63, or to Le Club, which was run by Olivier Coquelin for friends of his like the Duke of Bedford, Gianni Agnelli, Noël Coward, Rex Harrison, Douglas Fairbanks, Jr., Igor Cassini, Borden Stevenson—the international swingers. I sat at Le Club one night staring at Jackie Kennedy, who was there in a black chiffon dress down to the floor, with her hair done by Kenneth—thinking how great it was that hairdressers were now going to dinners at the White House.

Ole Miss seemed pretty far removed from what was going on in New York.

When we drove cross-country that October of '63, the girls were still wearing cashmere sweaters with little round necklines and tight, straight fifties skirts. There was a time gap in those days of up to three years between when new fashions showed up in New York City and when they filtered out to the rest of America. (By the end of the sixties, though, with media life-style pop coverage so fast and furious, this gap had almost closed.)

The movie marquees we passed were featuring titles like *Cleopatra, Dr. No,* and my favorite, *The Carpetbaggers,* which I'd seen three times before I left New York.

We stopped to eat at all the Carte Blanche places. That was the credit card I had, and those were the places I trusted, anyway. But Taylor got bored with that. Somewhere around Kansas he began screaming over the "honey-loves" on the radio, "I'm leaving this tour right now if we don't eat where *I* want to eat for a change!" He had a big thing about truck stops and truck drivers.

Taylor had a slow, easy, if-anyone-happens-to-care delivery. He would just very occasionally glance at Wynn or Gerard or me as he talked, and always, as he got to the endings of his little stories, he'd lift his chin up up and away and stare out the car window into the distance as he finished up. He told us about all the poetry readings he gave in '60 down on MacDougal Street in a basement theater run by a guy who sat around during performances with a shotgun on his lap because the authorities were trying to close him down. One night, Taylor said, Leonard

Lyons, the newspaper columnist, came in with Anna Magnani, Tennessee Williams, and Frankie Merlow, Tennessee's longtime lover. Taylor stood up and read his poem "Fuck Fame," and Lyons wrote a whole column on him. And then another time Frankie came in and handed Taylor a couple of checks for a hundred dollars each, signed by Tennessee. Taylor talked about all the poets and performers who were around in those Village places, names I had scarcely heard of then—like a guy with shoulder-length hair who played the ukulele named Tiny Tim, and a young folk singer named Bob Dylan, who had one or two albums out by this time but wasn't a big name yet.

"I gave Bob Dylan a book of my poems a couple of years ago," Taylor said, "right after the first time I saw him perform. I thought he was a great poet and I told him so." A Woody Guthrie song playing on the radio, "So Long, It's Been Good to Know You," had prompted Taylor's story. "And *now*," Taylor started to laugh, "now when he's a big sensation and everything, he asked me for a free copy of my second book. I said, 'But you're *rich* now—you can afford to *buy* it!' And he said, 'But I only get paid quarterly.'"

(Taylor confessed to me a couple of years later, "The minute I heard Bob Dylan with his guitar, I thought, 'That's it, that's what's coming in, the poets have *had* it.'")

When he was twenty-two, Taylor had quit his job as a broker at Merrill Lynch in Detroit. I wondered what Taylor had been doing at a job like that in the first place. "Well, my father, Harry Mead, was the political boss of Michigan," he explained. "He was one of Roosevelt's favorites, and his official title was Wayne County Democratic Chairman, but he was also head of the Liquor Control Commission and the WPA in the Detroit area.

He'd made the resident partner of Merrill Lynch in Detroit the state treasurer, and so the treasurer felt obligated to give Harry Mead's son a job." Taylor spent most of his time there studying graphs on how to beat the market. "I finally figured out a system," he said, "and it really spooked the boys at Merrill Lynch." I asked him what kind of a system. "I could have made a fortune," he said. "I told my father about it. The only trouble was he didn't get around to buying the stock I'd recommended until after the point when I would have already *sold* it! And *that*," Taylor said dryly, "was the only opportunity my father ever gave me to prove myself."

I couldn't imagine Taylor poring over stock market graphs and charts, but then, I couldn't imagine him driving, either, and there he was, at the wheel.

When Taylor left his stockbroker job in Detroit, he had just fifty dollars in his pocket. "Kerouac's *On the Road* put me on the road," he said, "and Allen's *Howl*, which had just come out, had a big effect on me."

Taylor was in San Francisco in '56 when the beat poetry scene got going. One day he stood up on a bar and over the noise all the drunks were making, started screaming some poems he'd written. Ron Rice saw that scene and began following him around, filming him with black and white war surplus film stock.

"Ron is such a devil." Taylor smiled (Ron was still alive at this point; he didn't die until a year or so later). "Stealing his girl friends' support checks, running off with all the theater receipts, chasing people down the street with his camera trying to film them—and everybody loves him. He took a film course once at the Cooper Union and then he made a film of people ice skating. Then together we made *The Flower Thief*. I had to fight him

all the way to get him not to put a blue wash on it. I told him, 'Look, Ron, in a few years that kind of thing will be *over.*'"

After San Francisco, Taylor came east and read at coffee shops like the Epitome in the Village. He'd hitched cross-country five times by then, and that's how he knew all about the truck stops.

I told him, fine, he could pick out the next place we stopped for dinner. After directing Wynn on lefts and rights for a few miles, he steered us into a big truck stop. We sat in a booth over on the side—and were, in fact, a sideshow. I don't know what it was, exactly, about the way we looked, but the alien alert was on; people were turning to look at the "freaks." I thought we looked normal enough—our clothes were pretty conventional—but it was obviously *something*, because *everybody* was staring. One by one they came up to us, all friendly and smiling, but studying us—beautiful blond kids, girls in ponytails and ironed blouses, boys in crew cuts or long, slicked-back farmer cuts—and they all said, "Where you from?" When we told them New York, they stared more, wanting—they said—to just "dig us." After that experience we went back to Carte Blanching.

The farther west we drove, the more Pop everything looked on the highways. Suddenly we all felt like insiders because even though Pop was everywhere—that was the thing about it, most people still took it for granted, whereas we were dazzled by it—to us, it was the new Art. Once you "got" Pop, you could never see a sign the same way again. And once you thought Pop, you could never see America the same way again.

The moment you label something, you take a step—I mean, you can never go back again to seeing it unlabeled. We were seeing the future and we knew it for sure. We saw people

walking around in it without knowing it, because they were still thinking in the past, in the references of the past. But all you had to do was *know* you were in the future, and that's what put you there.

The mystery was gone, but the amazement was just starting.

I was lying on the mattress in the back of our station wagon looking up at the lights and wires and telephone poles zipping by, and the stars and the blue-black sky, and thinking, "How could an American debutante marry a guy and go off to live with him in Sikkim?" I'd brought about fifty magazines with me and I'd just been reading about Hope Cooke. How could she do it! America was the place where everything was happening. I never understood, even, how Grace Kelly could leave America for Monaco, which didn't seem nearly as sad as going to Sikkim. I couldn't imagine living in a tiny, nothing little place in the Himalayan Mountains. I didn't ever want to live anyplace where you couldn't drive down the road and see drive-ins and giant ice cream cones and walk-in hot dogs and motel signs flashing!

"Could you turn the radio up a little? It's my favorite song," I yelled to the front. Actually I couldn't stand the song, but I didn't want Wynn to nod off at the wheel.

The Hollywood we were driving to that fall of '63 was in limbo. The Old Hollywood was finished and the New Hollywood hadn't started yet. It was the French girls who had the new star mystiques—Jeanne Moreau, Françoise Hardy, Sylvie Vartan, Catherine Deneuve, and her tall, beautiful sister, Françoise Dorléac (who would die horribly in a car crash in '67). But this made Hollywood *more* exciting to me, the idea that it was so vacant. Vacant, vacuous Hollywood was everything I ever wanted to

mold my life into. Plastic. White-on-white. I wanted to live my life at the level of the script of *The Carpetbaggers*—it looked like it would be so easy to just walk into a room the way those actors did and say those wonderful plastic lines. I kept raving about that movie all the time to people in Hollywood, but for some reason I was calling it *The Howard Hughes Story* so nobody knew what I was talking about.

We made it in to Los Angeles in three days. When we arrived, we discovered there was a World Series going on and all the hotels were filled. (Baseball had been big news in New York all summer, too—but only because the Mets lost over a hundred games in their second season.) We called Dennis Hopper and his wife, Brooke, right up and she called up her father, the producer Leland Hayward, in New York and got him to give us his suite at the Beverly Hills Hotel. (Her mother was the beautiful actress Margaret Sullavan, who'd killed herself the year before.)

Dennis assured us the Movie Star Party was on for that very night.

The famous Bel-Air fire in '61 had burned the Hoppers' house to the ground. Their new house out in Topanga Canyon was furnished like an amusement park—the kind of whimsical carnival place you'd expect to find bubble-gum machines in. There were circus posters and movie props and red lacquered furniture and shellacked collages. This was before things got bright and colorful everywhere, and it was the first whole house most of us had ever been to that had this kiddie-party atmosphere.

Brooke and Dennis had met in *Mandingo,* a play that closed on Broadway after just a few performances. Dennis wasn't getting much film work at this point; he was doing photography then,

and also, he was one of the few people out in California who collected Pop—he had my Mona Lisa painting up, and one of Roy's paintings, too. I'd first seen him playing Billy the Kid on one of those Warner Brothers television westerns in the fifties—"Cheyenne" or "Bronco" or "Maverick" or "Sugarfoot"—and I remember thinking how terrific he was, so crazy in the eyes. Billy the Maniac.

The Hoppers were wonderful to us. Peter Fonda was at the party that night—in those days he looked like a preppy mathematician. (He'd been on Broadway a couple of seasons earlier in a play at the same time that his sister, Jane, was doing her first Broadway run, too.) Dean Stockwell, John Saxon, Robert Walker, Jr., Russ Tamblyn, Sal Mineo, Troy Donahue, and Suzanne Pleshette—everybody in Hollywood I'd wanted to meet was there. Joints were going around and everyone was dancing to the songs we'd been hearing on the car radio all the way across the country.

This party was the most exciting thing that had ever happened to me. I only wished I'd brought my Bolex along. I'd left it back at the hotel. The party seemed the most natural thing to take pictures of—after all, I was in Hollywood, accompanied by an underground film star, Taylor. But I felt embarrassed about letting people see me with a camera. I was self-conscious shooting even people I knew—like the ones out at Wynn's country place. The only time I hadn't been shy about filming was with *Sleep* because there the star was asleep and nobody else was around.

After a dazzling party like that, my art opening was bound to seem tame, and anyway, movies were pure fun, art was work. But still, it was thrilling to see the Ferus Gallery with the Elvises in the front room and the Lizes in the back.

Very few people on the Coast knew or cared about contemporary art, and the press for my show wasn't too good. I always have to laugh, though, when I think of how Hollywood called Pop Art a put-on! *Hollywood??* I mean, when you look at the kind of movies they were making then—those were supposed to be *real*???

Marcel Duchamp was having a retrospective at the Pasadena Museum, and we were invited to that opening. When we got there, they didn't want to let Taylor in because he wasn't dressed "properly": he was wearing a sweater that was way too long for him; it belonged to Wynn, who was so tall that the sweater hung down past Taylor's hands and knees. He had to roll the sleeves up and up till they settled somewhere around his wrists—they looked like life preservers. After a while the door people relented and let us in.

All the L.A. Society swells were there. Brooke and Dennis were the only "movie people." A photographer from *Time* or *Life* or *Newsweek* muscled past Taylor to get a picture of Duchamp and me, and Taylor started screaming, "How dare you! How dare you!"

This was the first of the countless times during the sixties that I would hear that phrase screamed. The sixties were one confrontation after another, till eventually every social obstacle had been confronted. I'm convinced that the attitudes behind the mass confrontations in the last part of the sixties came from these minor scuffles at the doorways to parties. The idea that anybody had the right to be anywhere and do anything, no matter who they were and how they were dressed, was a big thing in the sixties. The fifties' idea of youth rebellion was motorcycles and leather jackets and gang wars—all that stuff from the movies—

but everybody in the fifties did ultimately stay in their own places—everybody stayed right where they "belonged." I mean, down south Negroes were still riding in the backs of buses.

By the end of the party, Duchamp had invited Taylor to his table when he realized that he was a famous underground actor/poet. I talked a lot to Duchamp and his wife, Teeny, who were great, and Taylor danced all night with Patty Oldenburg—she and Claes had been living in California for a year "to get the feel of a new environment," she said, so they could send back a "bedroom" for a group exhibit at the Sidney Janis Gallery in early '64. (Claes had done *The Store* on the Lower East Side in '61, and in '62 he'd changed the name of the Ray Gun Manufacturing Company to the Ray Gun Theater and staged happenings like *Injun* and *World's Fair* and *Nekropolis* and *Voyages* and *Store Days* down there around all his soft sculpture.)

They served pink champagne at the party, which tasted so good that I made the mistake of drinking a lot of it, and on the way home we had to pull over to the side of the road so I could throw up on the flora and fauna. In California, in the cool night air, you even felt healthy when you puked—it was so different from New York.

Somewhere in here the girl who you could call my first female superstar arrived in Los Angeles—Naomi Levine. She was staying with the sculptor John Chamberlain and his wife, Elaine, in Santa Monica. Before we left New York, Gerard and Wynn had introduced us at a performance at the Living Theater on Sixth Avenue and 14th Street, and then we'd all gone up together to a black-tie opening at the Museum of Modern Art. Naomi was working at F. A. O. Schwarz, the Fifth Avenue toy store, but she was also making films; she was very film-studentish. Jonas Mekas

had just printed something in his "Movie Journal" column in the *Voice* about one of her movies getting confiscated (and one of Jack Smith's, too) by a New York film-processing lab for having nudity in it—and they hadn't merely confiscated it, they'd gone ahead and actually destroyed it! Naomi said she was in L.A. to raise money for the Film-Makers' Coop. But Gerard and Taylor kept claiming that she was in love with me and that that's why she'd flown out, that she was disappointed we hadn't invited her along for the ride.

Out in Hollywood, I kept thinking about the silly, unreal way the movies there treated sex. After all, the early ones used to have sex and nudity—like Hedy Lamarr in *Ecstasy*—but then they suddenly realized that they were throwing away a good tease, that they should save it for a rainy day. Like, every ten years they would show another part of the body or say another dirty word on screen, and that would stretch out the box office for years, instead of just giving it away all at once. But then when foreign films and underground films started getting big, it threw Hollywood's timetable off. They would have wanted to have everybody waiting out another twenty years to see total nudity while they milked every square inch of flesh. So Hollywood began to say that they were "protecting the public morality," when the fact was they were just upset that they were going to be rushed into complete nudity when all along they'd been counting on lots of money from a long-drawn-out striptease.

By this time I'd confessed to having my Bolex with me, and we decided to shoot a silent Tarzan movie around the bathtub in our suite at the Beverly Hills Hotel—with Taylor as Tarzan and Naomi as Jane.

Wynn knew a tall, red-headed kid from Harvard named Denis Deegan out there who knew John Houseman, so then we did some filming at John's house, where we met Jack Larson, who'd been Jimmy Olsen on television's "Superman" and who at this point was writing operas. We all went down to the pool and Naomi took her clothes right off and jumped in the water. Taylor was supposed to climb a tree but he couldn't, so he yelled for a stunt man. Dennis appeared and climbed the tree to get a coconut for him. (When Taylor saw the rushes back in New York, he said, "You know, I've always liked Dennis's acting, but it's usually so rigid. This is the most relaxed on camera I've ever seen him." In '69 when *Easy Rider* came out, Taylor reminded me of that day again. "I think that afternoon by the pool was a turning point for Dennis," he said. "It opened up new possibilities for him." Maybe so, I thought. You never know where people will pick things up and where they won't.)

We moved out of the Beverly Hills Hotel to the Venice Pier where Taylor had lived when he was going to the Pasadena Playhouse in the fifties. He still knew a lot of people there. We threw a party by the carousel that Taylor sort of planned and since he was a vegetarian, it was all cheese. But it was hot weather and the cheese was smelly and it ran all over everything, and people were hopping around picking the splinters they'd gotten from the wooden horses out of themselves and wiping the runny cheese off their hands.

Another party that I especially remember from the two weeks we were in California was given for us by a sort of eccentric Green Stamps heir at the house of a friend of his. Louis Beech Marvin III was building his own house out there, an enormous round thing called Moonfire Ranch in Topanga Canyon with a bed that went up on pylons twenty or thirty feet in the

air—he had fourteen white German shepherds guarding the place. (What he really wanted to do, he said, was buy an island and have it be like Noah's Ark, with a pair of every animal on it. He did get his island, and he got a lot of the animals, too, but they were always dying on him.) Meanwhile, while he was building this incredible house, he lived on the grounds in a trailer filled with dirty laundry.

For a while there in the early sixties, it looked like a real solid art scene was developing in California. Even Henry Geldzahler felt he had to make a trip out once a year to check on what was happening. But there weren't enough dealers there and the museums weren't active enough, and the people just weren't buying art—they were satisfied looking at the scenery, I guess.

We took the *Easy Rider* route back, through Vegas, then down through the southern states.

Right after we got back to New York we sent the *Tarzan* film to the lab. (We used to give our film to a go-between, a little old lady, who would bring it over to Kodak for us.) When the rushes came back, Taylor decided he would edit it himself, so he worked on cutting and splicing it and he put a sound-on-tape sound track on and we went over to Jerome Hill's at the Algonquin Hotel one night to screen it.

Jerome was the grandson of the Minnesota railroad magnate James Hill and he was as generous as he was rich. He was busy shooting *Open the Door and See All the People* in 16-mm, which Taylor had been in, too. He had also made *Sand Castles,* and through his private foundation he supported a lot of artistic projects—groups like the Living Theater.

A young actor by the name of Charles Rydell was at that *Tarzan* screening. We had a mutual friend named Nancy March

who'd introduced us in the pouring rain on my first day in New York years before. Charles had been working in Nedick's then, and I was just off the bus from Pittsburgh, but I hadn't seen him—at least, not to talk to—since. However, I'd happened to catch his performance in *Lady in the Dark* with Kitty Carlisle at the Bucks County Playhouse, and I told him so right away. He thought I was putting him on—he looked at me as if to say, "Oh, come on—*no*body saw me in that." He was a very big man with a big temper and a great sense of humor. He could really bellow, and he had the deep, full voice to do it right. At the *Tarzan* screening there was a fat guy named Lester Judson who every couple of minutes would point at the screen and say, "This isn't a movie—it's a piece of shit! You call this a movie?" Finally Charles got fed up and almost blasted him off the chair with "Oh, shut up, Lester! Here you're putting it down and this whole underground thing is just trying to get started!"

I liked Charles and I asked if I could call him to be in a movie of mine sometime. He said sure, any time.

One of the things that happens when you write about your life is that you educate yourself. When you actually sit down and ask yourself, "What *was* that all about?" you begin to think hard about the most obvious things. For instance, I've often thought, "What is a friend? Somebody you *know*? Somebody you talk to for some reason over a period of time, or what?"

When people describe who I am, if they don't say, "Andy Warhol the Pop artist," they say, "Andy Warhol the underground film-maker." Or at least they used to. But I don't even know what the term *underground* means, unless it means that you don't want anyone to find out about you or bother you, the way it did

under Stalin and Hitler. But if that's the case, I can't see how I was ever "underground," since I've always wanted people to notice me. Jonas says that the film critic Manny Farber was the first to use the word in the press, in an article in *Commentary* magazine about neglected low-budget Hollywood directors, and that then Duchamp gave a speech at some Philadelphia opening and said that the only way artists could create anything significant was to "go underground." But from the different types of movies people applied it to, you couldn't figure out what it meant—aside, of course, from non-Hollywood and nonunion. But did it also mean "arty" or "dirty" or "freaky" or "plotless" or "nude" or "outrageously camp"? When I use the word myself to describe our movies, all I mean is very low-budget, non-Hollywood, usually 16-mm. (Luckily, at the end of the sixties the term was retired and replaced by "independently made films," which was probably what "underground movies" should have been called from the beginning.)

When the independent filmmakers grouped together in '59 to form the New American Cinema Group, the organizing force behind it was Jonas Mekas. The N.A.C.G.'s stated purpose was to look into all the different ways of financing and distributing independently made movies. Along with Jonas there was Shirley Clarke, Lionel Rogosin, and De on the original board of directors. Before long, though, the way it is with most movements, factions developed when members realized that they had different ideas about how to get the main objective accomplished, and also that they had misunderstood each other all along on what the main objective was. Mainly, there were two types of underground film people: the ones who looked at their films from a scholastic or intellectual point of view—as works of art—and

thought of themselves as "underground filmmakers," and the ones who looked at their films as commercial vehicles and thought of themselves as "independent filmmakers and distributors." Out of what survived of the New American Cinema Group, Jonas created the Film-Makers' Co-operative.

Although at first Jonas seemed to be interested in both the scholarly and the commercial aspects of making films, by the end of the sixties it was clear that what he really was, was a scholar—he seemed completely content running his Anthology Film Archives. And by then, of course, he was famous.

As De told me, "Jonas is very clever, particularly at promoting himself. He took over that movie column in the *Voice* at zero pay—which was what the *Voice* paid in those days—because he realized it was a good place to pull together a huge following. Which it was. But what the rest of us were looking for was a way to make films independently of Hollywood, and get them distributed to audiences, not to *archives*!"

And Taylor said, "Ron Rice and I gave Jonas *The Flower Thief* to distribute and do you know where he opened it? Way down at the Charles Theater on the Lower East Side! When we'd wanted Madison Avenue! We didn't realize he was into a scholastic, museum-burial, archive-type number. I mean, who needs that? The things Jonas would do to an audience—like give them an entire evening of Stan Brakhage. I mean, talk about an ivory tower intellectual!" (Taylor softened toward Jonas the year he went to Rome, though, because Jonas had told Fellini that Taylor was the "number-one actor in America," so Fellini staged a grand reception for him on the set of *Juliet of the Spirits*.)

You have to understand where Jonas came from, though, to understand his attitude toward movies. For him, they were like political art. I doubt that he ever once thought of a movie as

entertainment. He was one of those people who are serious about everything, even when they laugh.

The farm he was born on in Lithuania got taken over by the Soviet Union when he was seventeen. Two years later the German army pushed the Soviets out, and the Nazis came along. All during the German occupation, he was involved in underground publishing. When he and his brother, Adolph, were about to be arrested by the military police, somebody gave them fake papers so they could get into the University of Vienna. "But we were caught," Jonas told me, "and sent to a forced labor camp near Hamburg where we spent most of the war, and after the war we spent five years in various displaced persons camps."

He studied literature and philosophy in the American-occupied part of Germany till '49, when the United Nations refugee organization brought him to the United States. "We were helpless," he told me. "We went wherever we were pushed by the various forces."

There were jobs waiting for Jonas and his brother in Chicago but when they got to New York, they decided to stay right there. They got work in Brooklyn factories—bed factories, boiler factories—"making little nothings," loading trucks on the docks, cleaning parts of ships; and from practically their first day in New York, they went to almost every film showing at the Museum of Modern Art.

Jonas didn't learn a word of English until after the war. Once, when I asked him how he got so interested in film, he said, "To write in a language, you have to be born to it, so I could never really communicate through writing. But in films you work with images, and I saw that I could use something other than written language to shout about what had happened to me and everyone else in the war." (The first film he did, *Guns*

of the Trees in '61, was literally full of shouting and spitting, as if he were getting the whole war out of his system.) Jonas had as serious a view of film as he had of life. He was the most un-Pop person I can think of in the sixties, he was such an intellectual. But he was also a great organizer, and he gave the people making small films a place to show them.

In '61, when Jonas was having screenings in the Charles Theater on Avenue B and 12th Street down on the Lower East Side, the young guys who owned the theater let him have open screenings where people could show any films of theirs they wanted.

These places where people could get together and exchange ideas were a lot like a party. I used to see some of the programs and open screenings at the Charles until it closed in '62, and I also used to go with friends to the Film-Makers' Coop on Park Avenue South, which was also where, as I said, Jonas lived in a corner: after being pushed around from country to country, he finally felt like he had a home.

After the Charles closed, Jonas started midnight screenings at the Bleecker Street Cinema till, he explained, "They thought we were ruining business for them, so they threw us out." From there they started to screen at a small legitimate theater on East 27th Street called the Gramercy Arts Theater, right around the corner from the Coop.

I brought *Tarzan and Jane, Regained Sort Of* to Jonas and then as I started doing the *Kiss* series, I'd bring those in one by one and he'd screen a *Kiss* before each new program. I brought in some newsreel-type dance films I'd made, too, and then I decided, oh, why not bring in *Sleep,* which I'd actually faked by looping footage, so although it was hours of a person sleeping, I hadn't actually shot that much. When someone found out before the screening exactly what it was going to be and said he

wouldn't sit through it all for anything, Jonas got a piece of rope and tied him to a chair to make an example out of him. I guess Jonas realized it was me he should have tied down instead, because he couldn't get over it when I got up and left after a few minutes, myself. Sometimes I like to be bored, and sometimes I don't—it depends what kind of mood I'm in. Everyone knows how it is, some days you can sit and look out the window for hours and hours and some days you can't sit still for a single second.

I've been quoted a lot as saying, "I like boring things." Well, I said it and I meant it. But that doesn't mean I'm not bored by them. Of course, what I think is boring must not be the same as what other people think is, since I could never stand to watch all the most popular action shows on TV, because they're essentially the same plots and the same shots and the same cuts over and over again. Apparently, most people love watching the same basic thing, as long as the details are different. But I'm just the opposite: if I'm going to sit and watch the same thing I saw the night before, I don't want it to be essentially the same—I want it to be *exactly* the same. Because the more you look at the same exact thing, the more the meaning goes away, and the better and emptier you feel.

At the end of '63 when I decided to shoot *Blow Job*, I called up Charles Rydell and asked him to star in it. I told him that all he'd have to do was lie back and then about five different boys would come in and keep on blowing him until he came, but that we'd just show his face. He said, "Fine. I'll do it."

We set everything up for the next Sunday afternoon, and then we waited and waited and Charles didn't show up. I called

his apartment and he wasn't there either, so then I called Jerome Hill's suite in the Algonquin and he answered the phone and I screamed, "Charles! Where are you?" and he said, "What do you mean, where am I? You know where I am—*you* called *me*," and I said, "We've got the cameras ready and the five boys are all here, everything's set up." He was shocked; he said, "Are you crazy? I thought you were *kidding*. I'd never do *that*!"

We wound up using a good-looking kid who happened to be hanging around the Factory that day, and years later I spotted him in a Clint Eastwood movie.

In the fall of '63 I started going around more and more to poetry readings with Gerard. I would go absolutely anywhere I heard there was something creative happening. We went down to the Monday night poetry readings organized by Paul Blackburn at the Café Le Metro on Second Avenue between 9th and 10th streets where each poet would read for five or ten minutes. On Wednesday nights there was a solo reading. Poets would just get up and read about their lives from stacks of papers that they had in front of them. I've always been fascinated by people who can put things down on paper and I liked to listen for new ways to say old things and old ways to say new things.

Almost every group event in the sixties eventually got called a "happening"—to the point where the Supremes even did a song by that name. Happenings were started by the artists, but the fashion designer Tiger Morse made them more pop and less art—by having fashion shows in swimming pools and just generally staging big crazy parties and calling them "happenings."

I guess I went down to my first Judson Church "happening" because of Rauschenberg—he was arranging the lighting

there and I wanted to see it. I called up David Bourdon and told him to come with me to this beautiful concert there by Yvonne Rainer called *Terrain,* and later David said it was the most modern dance thing he'd ever been to.

After one of those Judson concerts, David and I walked over to a party at Claes Oldenberg's on East 2nd Street that was more like a happening. It was a pleasant Sunday afternoon and everybody sort of drifted up to the roof—Rosenquist, Ruth Kligman, Ray Johnson, a whole bunch of people. That afternoon, Claes started getting a little aggressive up there on the roof, and it was scary because he was so huge and there were no railings on this roof and people were drinking a lot and sort of shoving each other. Claes took a pair of scissors out and cut the pocket right off Rosenquist's shirt, then he held it up in the scissors and said, "This is Rosenquist's heart," sort of brandishing the little patch of cloth at us all. Then he walked over to the edge of the roof and opened the scissors. He released the cloth, and we all watched it flutter slowly down to the street.

I was still working in the firehouse studio and going down to the Judson Church a lot with Gerard and Charles Henri Ford and other friends to see the dance concerts there, and that's where I first saw the James Waring Experimental Dance Company that was doing a new kind of "underground," low-budget ballet.

Jimmy made all his own costumes out of beads and feathers, just putting the materials together as he went along. He lived on Tompkins Square on the Lower East Side where you could still rent whole floors of rooms for just thirty or forty dollars a month. I'd lived in that part of town myself when I first got to New York, on Avenue A and St. Mark's Place. Even just a little bit of work a month could pay your rent down there. Right up

till the summer of '67, before drugs came in, the East Village was, in a way, a very peaceful place, full of European immigrants, artists, jazzy blacks, Puerto Ricans—everybody all hanging around doorstoops and out the windows. The creative people there weren't hustling work, they weren't "upwardly mobile," they were happy just to drift around the streets looking at everything, enjoying everything—Ratner's, Gem's Spa, Polish restaurants, junk stores, dry goods stores—maybe go home and write in a diary about what they'd enjoyed that day or choreograph something they'd gotten an idea about. They used to say that the East Village was the bedroom of the West Village, that the West Village was the action and the East Village was the place you rested up in.

By the early sixties the Judson dance concerts were a full-time dance theater. They could stage a whole ballet for no more than fifty dollars—the kids in the company would ransack friends' apartments for props and go down to Orchard Street and pick through materials for costumes. The same went for the plays done at places like the Café La Mama and the Caffe Cino, where a lot of the Judson dancers performed when they weren't waiting on tables.

Everything was low-budget to the point of no-budget in those places. Joe Cino probably never made a profit of over fifty dollars in his whole time there. At the end of the month he'd pass the hat for rent—but he loved it that way. He was a nice person—short and hairy, always fighting his pasta fat with diet pills.

Around the Judson Church I ran into somebody I knew named Stanley Amos. (We had a friend in common who'd taught art history to policemen at City College so that when somebody's Georgian silver, say, was stolen, the police would know

how to spot what they were out there looking for. This friend got busted for something like "sodomy in a steam bath" and lost his teaching job. The incident was written up in all the papers, and I always guessed that it inspired a few subsequent popular plays.) Stanley had come over from London where he'd been the publisher of a literary magazine called *Nimbus*. Now he was the New York art critic for an Italian newspaper. We'd been part of the same gang when we ran along the Tuesday night art gallery party circuit together. We'd break from 57th Street and go over to the Café Winslow on 55th to get away from the crowd for a little bit. Then we'd go back onto the circuit and then out to dinner or more drinks with people we'd bumped into along the way. When I first met Stanley, he was trying to get backing for an art gallery of his own, and it looked like he'd found his pot of butter, but then the rich backer, who was from a Michigan toilet company family, died and Stanley moved downtown into an apartment on West 3rd Street around the corner from the Judson. The front part of the floor he lived on was Tom O'Horgan's loft. Tom was then a musicologist or something (later he directed the musical *Hair*); he was interested in ancient instruments and had reconstructed a lot of them all by himself. (A couple of years later, the Velvet Underground had a loose subletting arrangement there, so Stanley's place became the scene for a lot of parties and movie shootings.)

"I guess I've always been what might be called a bohemian," Stanley once reflected. "I've lived on the fringes of the art world and not contributed very much to it." But Stanley was effacing himself too much, because he was another one who opened his doors wide to all the creative people around. At Stanley's there were always playwrights scribbling in a corner and Judson dancers rehearsing and people sewing their costumes up. He

didn't have much money—he bought and sold a few antiques and did some freelance articles—but he couldn't have been more generous with his time and living space.

When you say that the Judson performers were a "dance company," it makes them sound much more established than they were. The company was always pulled together just when they had a performance coming up, but in the time between, they did odd jobs and took a lot of classes. It's always surprising to me to think how small the downtown New York City avant-garde scene was in relation to how much influence it eventually had. A generous estimate would be five hundred people, and that would include friends of friends of friends—the audience as well as the performers. If you got an audience of more than fifty, it was considered large.

South of 14th Street things were always informal. The *Village Voice* was a community newspaper then, with a distinct community to cover—a certain number of square blocks in Greenwich Village plus the entire liberal-thinking world, from flower boxes on MacDougal Street to pornography in Denmark. The combination of extremely local news with international news worked well for the *Voice* because the Village intellectuals were as interested in what was happening in the world as in what was going on around the corner, and the liberals all over the world were interested in the Village as if it were a second home.

Two major feeders of personalities and ideas into the early Factory were the San Remo/Judson Church crowd and the Harvard/Cambridge crowd. The San Remo Coffee Shop on the corner of MacDougal and Bleecker streets in the Village was where I met Billy Name and Freddy Herko. I'd been going there

since '61, when it was a lot artier—a few poets and a lot of fags coming down from the 53rd Street and Third Avenue area. It was a big thing in those days to "go to the Village," to places like the Gaslight and the Kettle of Fish. But around '63 when you walked into the San Remo through the frosted glass doors with flower designs, past the long bar and the booths, it was all full of hustlers who usually sat on the railing of Washington Square Park who'd been taken to the San Remo for one-draft beer. All the amphetamine men—"A-men"—fags on speed who would howl laughing at the very thought of going to a "gay bar," loved the San Remo because it wasn't really a gay bar, there were very few gay-world clichés there.

Not everyone at the San Remo was gay, of course, but the stars of the place certainly were. Most of the customers were just there to watch the performance. A lot of the San Remo boys used to write for a mimeographed sheet called *The Sinking Bear* (named after a poetry magazine that was around then called *The Floating Bear*), which was one of the first underground newsletter/papers. One of these was Ondine—or "Pope Ondine," as he was occasionally called. Ondine would sit in a booth with his Magic Markers and write replies to people with sex queries/problems for his column, "Beloved Ondine's Advice to the Shopworn," and the "problems" would be coming to him on notes passed from the other booths as fast as he could reply. One afternoon Ondine rushed in with an "appalled" look on his face, and as he put his flight bag down on the table, he pointed back toward Washington Square Park and said, incredulously, "A guy just said to me, 'Would you like to go to a gay bar?'!" Ondine shook his head, laughing in disbelief, "*Horrible* experience. . . ." The San Remo was almost entirely A-men. I say "almost entirely," because I remember being introduced to the Duchess for

the first time there, and a few minutes later, the owner came over and asked me, "Do you know her?" and when I said yes, he told me, "Then take your friend and get out." I never did find out what she'd done, she was such a terror. She was a well-known New York post-deb, a part-time lesbian on speed who could put even the A-men in their places. I hung around the San Remo a lot and got to know some faces and bodies I'd be seeing drift in and out of the 47th Street Factory day and night during the next few years.

The Judson dancer I was absolutely fascinated with was a very intense, handsome guy in his twenties named Freddy Herko who conceived of everything in terms of dance. He was one of those sweet guys that everybody loved to do things for simply because he never remembered to do anything for himself.

He could do so many things well, but he couldn't support himself on his dancing or any of his other talents. He was brilliant but not disciplined—the exact type of person I would become involved with over and over and over again during the sixties. You had to love these people more because they loved themselves less. Freddy eventually just burned himself out with amphetamine; his talent was too much for his temperament. At the end of '64 he choreographed his own death and danced out a window on Cornelia Street.

The people I loved were the ones like Freddy, the leftovers of show business, turned down at auditions all over town. They couldn't do something more than once, but their one time was better than anyone else's. They had star quality but no star ego—they didn't know how to push themselves. They were too gifted to lead "regular lives," but they were also too unsure of themselves to ever become real professionals.

Still, I used to wonder how Freddy could be so talented and not be on Broadway or in a big dance company. "Can't they see how incredible he is?" I'd think to myself.

He didn't start taking dancing lessons till he was nineteen. After he graduated from high school in a small town just north of New York City, he enrolled in NYU night school—during the day he gave piano lessons. Eventually, he transferred to Juilliard School of Music, but he didn't do well there; he kept missing classes and exams. But when he saw the American Ballet Theater's performance of *Giselle*—which was the first dancing he'd ever seen aside from on television—he suddenly felt he had to become a dancer. He applied for a scholarship to the American Ballet Theater School, got one, and within a year was choreographing himself in one of their programs. He was involved in some off-Broadway productions, too—going on tour in New England and up to Canada. Pretty soon he was on one of those Sunday morning dance shows on television.

Then he went on "The Ed Sullivan Show" and got stage fright.

The scary thing is how you could dance in front of so many small audiences so often and never even have it occur to you that dancing in front of national television cameras might completely freak you. When Freddy got out onto Ed Sullivan's stage, all of a sudden, he confided to me, he felt as if the blood in his wrists had stopped flowing, and he had to ask someone from the back row to trade places with him in the front line. Afterward he ran out of the theater and back down to the Village, to the security he felt there.

By then he was taking so much amphetamine. He had the classic symptom: intense concentration *but*! only on minutiae. That's what happens to you on speed—your teeth might be

falling out of your head, the landlord might be evicting you, your brother might be dropping dead right next to you, *but*! you would have to, say, get your address book recopied and you couldn't let any of that other stuff "distract" you. And that's what happened to Freddy—instead of concentrating on the main idea of his dance pieces, he'd get all involved with fixing an arrangement of feathers or mirrors or beads on a costume, and he was never able to see his choreography jobs through to the finish. At one point when he really needed money, he decided to sell marijuana, but he couldn't concentrate on that, either, and wound up handing it all away to friends.

The whole Village dance scene was really moving by '62. Judson Church was putting on concert after concert, and Jill Johnston was reviewing dance for the *Voice*.

And it wasn't only "dance pieces" that were being put on at the Judson Church. Tom O'Horgan, for example, did a wonderful oratorio in two parts there called *The Garden of Earthly Faucets*. The first part was supposed to get everybody involved in the action, and the second part was the action itself. A guy with his lower half encased in a box advanced across the church. Inside the box was somebody giving him a blow job. While he was being blown, he gave signals to a prearranged group of people to join in a paean of choruses and dances and light changes— the audience was all waving things and throwing them, with every theatrical device you could think of all coming together at the point where he came in the box.

One of the dances that Freddy Herko choreographed for the Judson was a Mozart ballet where the audience was confined to

two rows in the outer perimeter so that there would be a very large space open in the center. The sound over the loudspeaker was a phonograph needle being put on a record, and then a Mozart pastorale kind of music started playing. Shepherdesses appeared in romantic tutus and overdraped classical Watteau-like outfits and began to dance. But then the phonograph went wrong and they had to start all over again, only this time they couldn't seem to get anywhere. The rest of the dancers came in anyway, but finally they got so mad they just ignored the phonograph completely and suddenly it was the sound of their own drumming feet that was getting them going and instead of dancing the formal dances, they turned into a circle of runners around the church and, little by little, they pulled the whole audience into a snake coiling around and around till gradually they all slowed down and . . . stopped.

For another of his ballets Freddy canvassed the shops that sold window-display material till he got the glitter he wanted—the idea of using cheap, sleazy elements was unusual at the time because of the cliché aspect. Freddy's piece started from a soft note on the organ in the darkened church. A little light appeared in the center of the balcony, and as the organ note swelled, the light grew till you saw a woman leaning over the light base. She was draped in chiffon and looked more like a mound of light with a face on top of it than a real woman. Slowly, she lifted her arms, picking up a little glitter, and as the crescendo increased, so did the glitter until she became a cloud of glitter in a light. Then she faded away into silence and darkness.

Stanley told me, "One night, I was walking with Billy Name and Freddy on the Lower East Side. There was no wind, but it was very cold, it was winter. We came to a group of buildings

that were being razed. One of them was a church. There was sort of an altar place you could just make out in the rubble. Freddy rushed across the street into a store that was still open and bought a penny candle, came back and took all his clothes off, lit the candle, and danced through the set for the life of the candle."

This spring of '63 I had met a just-married, twenty-two-year-old beauty named Jane Holzer. Nicky Haslam took me to a dinner at her Park Avenue apartment. David Bailey was there, and he'd brought the lead singer in a rock-and-roll group called the Rolling Stones that was then playing the northern cities of England. Mick Jagger was a friend of Bailey's and Nicky's and he was staying down at Nicky's apartment on East 19th Street at the time.

"We met him when he was Chrissy Shrimpton's maid," Nicky told me, "Jean's younger sister. She put an ad in the paper—'Cleaner wanted'—and up turned Mick. He was a student at the London School of Economics; he was just cleaning flats to pay his way. And then she fell in love with him. We kept telling her, 'But Chrissy, he's so awful looking,' and she'd say, 'Not really.'"

This is a little like prehistory, because almost nobody in America then had heard of the Rolling Stones—or the Beatles. At Jane Holzer's dinner I'd noticed Bailey and Mick. They each had a distinctive way of dressing: Bailey all in black, and Mick in light-colored, unlined suits with very tight hip trousers and striped T-shirts, just regular Carnaby Street sport clothes, nothing expensive, but it was the way he put things together that was so great—this pair of shoes with that pair of pants that no one else would have thought to wear. And, of course, Bailey and

Mick were both wearing boots by Anello and Davide, the dance shoemaker in London.

The next time I ran into Jane, on Madison Avenue, she was just back from the big '63 summer in London when everything had really started to happen there. She couldn't stop raving about a club in Soho in back of Leicester Square, the Ad Lib, where the Beatles would walk by your table—the kind of place where, say, Princess Margaret could come in and nobody would even bother to look up, the beginning of the melting pot in class-conscious London.

Jane looked terrific standing there in the new look—pants and a sweater. Her jeans were black—I guess she'd picked that up from Bailey, who'd photographed her a lot while she was over there. I could see that she'd also picked up his way of talking, which, aside from being cockney, was to add "sort-of-thing" at the end of her sentences sort-of-thing. And she talked about the "Switched-On Look," which was a phrase she said Bailey had coined.

Jane said she couldn't wait to get back to Europe. (Getting to Europe was a running theme in the sixties—everyone was either just coming back or just about to go or trying to get to go or trying to explain why they weren't already there.) She was such a gorgeous girl—great skin and hair. And so much enthusiasm—she wanted to do everything. I asked her if she wanted to be in a movie and she got excited: "Sure! Anything beats being a Park Avenue housewife!"

The first movie Jane did for me was *Soap Opera*, filmed over P. J. Clarke's, the Third Avenue pub. It was subtitled *The Lester Persky Story* in tribute to Lester, who eventually became a movie producer. Lester introduced the hour-long commercial on tele-

vision in the fifties that had Virginia Graham showing you all the different ways you could use Melmac, or Rock Hudson doing vacuum-cleaning demonstrations. Lester let us use footage from his old TV commercials, so we spliced sales-pitch demonstrations of rotisserie broilers and dishware in between the segments of *Soap Opera*.

When President Kennedy was shot that fall, I heard the news over the radio while I was alone painting in my studio. I don't think I missed a stroke. I wanted to know what was going on out there, but that was the extent of my reaction.

In a little while Henry Geldzahler called up from his apartment and said that he'd been having lunch at the Orthodox Jewish restaurant on 78th and Madison, downstairs, where everyone from the Met and the NYU Art Institute always ate, and that the waiter had said in Yiddish, "*De President is geshtorben,*" and Henry had thought he meant the president of the cafeteria.

He was so affected when he found out it was Kennedy that he went right home and now he wanted to know why I wasn't more upset, so I told him about the time I was walking in India and saw a bunch of people in a clearing having a ball because somebody they really liked had just died and how I realized then that everything was just how you decided to think about it.

I'd been thrilled having Kennedy as president; he was handsome, young, smart—but it didn't bother me that much that he was dead. What bothered me was the way the television and radio were programming everybody to feel so sad.

It seemed like no matter how hard you tried, you couldn't get away from the thing. I rounded up a bunch of people and got them to come over and we all went out to one of the Berlin bars on 86th Street for dinner. But it didn't work, everyone was

acting too depressed. David Bourdon was sitting across from Susi Gablik, the art critic, and John Quinn, the playwright, and he was moaning over and over, "But Jackie was the most glamorous First Lady we'll ever get. . . ." Sam Wagstaff, down from the Wadsworth Atheneum in Hartford, tried to console him, and Ray Johnson, the artist, kept dipping dimes into the mustard we were using on our German frankfurters, then going out to drop the mustard-covered dimes into the telephone slot.

A few months before, I'd gotten the word that the hook and ladder company building would have to be vacated soon, and in November I found another loft, at 281 East 47th Street. Gerard and I moved all my painting equipment—stretchers, canvases, staple guns, paints, brushes, silkscreens, workbenches, radio, rags, everything—over to the space that would soon turn into the Factory.

The neighborhood wasn't one that most artists would want to have a studio in—right in midtown, not far from Grand Central Station, down the street from the United Nations. My loft was in a dirty brick industrial building—you walked into a gunmetal-gray lobby and to your right was a freight elevator that was just a rising floor with a grate. We were on the next-to-the-top floor; there was an antiques place called the Connoisseur's Corner on the floor above us. We were right across the street from the YMCA, so there were always guys around with those little bus depot–type valises that probably have socks and shaving cream in them. And there was a modeling agency nearby, so there were plenty of girls with portfolios around, and lots of photography labs in the area.

The Factory was about 50 feet by 100, and it had windows all along 47th Street looking south. It was basically crumbling—

the walls especially were in bad shape. I set up my painting area with the workbench near the front by the windows, but I kept most of the light blocked out—that's the way I liked it.

At the same time that we were making the move to 47th Street, Billy Name and Freddy Herko were leaving their apartment downtown. Freddy went to stay somewhere else in the Village and Billy came up to live in the Factory.

The back of the loft space gradually became Billy's area. Right from the beginning it had an aura about it that was sort of secret; you never really knew what was going on there—strange characters would walk in and say, "Is Billy around?" and I'd point them toward the back.

A lot of them were people I recognized from the San Remo, and after a while I got to know the regulars—Rotten Rita, the Mayor, Binghamton Birdie, the Duchess, Silver George, Stanley the Turtle, and, of course, Pope Ondine. They were always discreet about what they did back there. No one so much as took a pill in front of me, and I definitely never saw anyone shoot up. I never had to spell anything out, either; there was sort of a silent understanding that I didn't want to know about anything like that, and Billy was always able to keep everything cool. There were a couple of toilets in Billy's area and a slop sink and a refrigerator that was always stocked with grapefruit juice and orange juice—people on speed crave vitamin C.

The Factory A-men were mostly fags (they knew each other originally from Riis Park in Brooklyn), except for the Duchess, who was a notorious dyke. They were all incredibly skinny, except for the Duchess, who was incredibly fat. And they all mainlined, except for the Duchess, who skin-popped. All this I only found out later, because at the time I was very naive—I mean, if you

don't actually see a person shooting up, you don't believe they could really be doing it. Oh, I'd hear them call someone on the wall pay phone and say, "Can I come over?" and then they'd leave and I'd just assume they were going to pick up some amphetamine. But where they went I never knew. Years later I asked somebody who'd been around a lot then where exactly all the speed had been coming from, and he said, "At first, they got all their speed from Rotten, but then his speed got so bad he wouldn't even touch it himself, and from then on, everybody got it from Won-Ton." That was a name I'd heard a lot, but I'd never laid eyes on him. "Won-Ton was really short and barrel-chested and he never left his apartment—he always answered the door in the same shiny satin latex royal blue Jantzen bathing suit. That was all he ever wore." Was he a fag? I asked. "Well"—this person laughed—"he was living with a woman, but you got the idea he'd do anything with just about anybody. He worked in construction—he had something to do with the Verrazano Bridge." But where did Won-Ton get the speed? "That was something you just didn't ask."

Billy was different from all the other people on speed because he had a manner that inspired confidence: he was quiet, things were always very proper with him, and you felt like you could trust him to keep everything in line, including all his strange friends. He had this way of getting rid of people immediately if they didn't belong. If Billy said, "Can I help you?" in a certain way, people would start to actually back out. He was a perfect custodian, literally.

For a while Gerard also lived at the Factory, but that didn't last too long. Billy and his crowd took over the scene there. The big

social thrust behind the Factory from '64 through '67 was amphetamine, and Gerard didn't take it. Gerard was a different type—he was more apt to take a down like Placidyl when he took anything, which he usually didn't—a few downs, a little acid, some marijuana, but nothing regularly.

Amphetamine doesn't give you peace of mind, but it makes not having it very amusing. Billy used to say that amphetamine had been invented by Hitler to keep his Nazis awake and happy in the trenches, but then Silver George would look up from the intricate geometric patterns he was drawing with his Magic Markers—another classic speed compulsion—and insist that it had been invented by the Japanese so they would export more felt-tip pens. Anyway, they both agreed that it hadn't been invented by any Allies.

All I knew about Billy was that he had done some lighting at Judson Church and that he'd been a waiter at Serendipity. He gave the impression of being generally creative—he dabbled in lights and papers and artists' materials. In the beginning he just fussed around like the other A-heads, doing all the busy stuff, fooling with mirrors and feathers and beads, taking hours to paint some little thing like the door to a cabinet—he could only concentrate on a little area at a time—and sometimes he was so high he wouldn't even realize that he'd just painted it. He wasn't into astrology and charts and occult things yet.

I picked up a lot from Billy, actually—just studying him. He didn't say much, and when he did, it was either very practical and mundane or very enigmatic—like if he was ordering from the Bickford's coffee shop downstairs, he'd be completely lucid, but if you asked him what he thought of something, he'd quietly say things like "You cannot be yes without also being no."

• • •

Billy was a good trasher; he furnished the whole Factory from things he found out on the street. The huge curved couch that would be photographed so much in the next few years—the hairy red one that we used in so many of our movies—Billy found right out in front of the "Y."

In the sixties good trashing was a skill. Knowing how to use what somebody else didn't, was a knack you could really be proud of. In other decades people had sneaked into Salvation Armies and Goodwills, embarrassed that somebody might see them, but in the sixties people weren't embarrassed at all, they bragged about what they could scavenge here and there. And nobody seemed to mind when a thing was dirty—I'd see people, kids especially, drinking right out of a cup they'd just found in the trash.

One day Billy brought in a phonograph from somewhere. He had a big collection of opera records—I think it was Ondine who started him on that. They both knew every obscure opera singer—I mean, singers no one had ever heard of—and they haunted the record stores for all the out-of-prints and private recordings. They loved Maria Callas best of all, though. They always said how great they thought it was that she was killing her voice and not holding anything back, not saving anything for tomorrow. They could really identify with that. When they'd go on and on about her, I'd think of Freddy Herko, the way he would just dance and dance until he dropped. The amphetamine people believed in throwing themselves into every extreme—sing until you choke, dance until you drop, brush your hair till you sprain your arm.

The opera records at the Factory were all mixed in with the 45's I did my painting to, and most times I'd have the radio on while the opera was going, and so songs like "Sugar Shack" or

"Blue Velvet" or "Louie, Louie"—whatever was around then—were blended in with the arias.

Billy was responsible for the silver at the Factory. He covered the crumbling walls and the pipes in different grades of silver foil—regular tinfoil in some areas, and a higher grade of Mylar in others. He bought cans of silver paint and sprayed everything with it, right down to the toilet bowl.

Why he loved silver so much I don't know. It must have been an amphetamine thing—everything always went back to that. But it was great, it was the perfect time to think silver. Silver was the future, it was spacy—the astronauts wore silver suits—Shepard, Grissom, and Glenn had already been up in them, and their equipment was silver, too. And silver was also the past—the Silver Screen—Hollywood actresses photographed in silver sets.

And maybe more than anything, silver was narcissism—mirrors were backed with silver.

Billy loved reflecting surfaces—he'd prop broken bits of mirror here and there and paste little sections of them onto everything. This was all amphetamine busywork, but the interesting thing was that Billy could communicate the atmosphere to people who weren't even taking drugs: usually people on speed created things that only looked good to them. But what Billy did went past the drugs. The only things that ever came even close to conveying the look and feel of the Factory then, aside from the movies we shot there, were the still photographs Billy took.

The mirrors weren't just decoration. They got used a lot by everybody primping for parties. Billy especially spent a lot of time looking at himself. He positioned the mirrors so he could see his face and body from every angle. He had a dancer's strut that he liked to check in motion.

1964

Everything went young in '64.

The kids were throwing out all the preppy outfits and the dress-up clothes that made them look like their mothers and fathers, and suddenly everything was reversed—the mothers and fathers were trying to look like their kids. Even at art openings, the new bright-colored short dresses were stealing the show away from the paintings hanging on the walls. To go with the new clothes, hairdressers were doing either cropped, slick little cuts or incredibly huge teased-out jobs; and as for makeup, lipstick was finished and the big thing was eye makeup—iridescent, pearlized, goldenized—stuff that gleamed at night.

Generally speaking, girls were still pretty chubby, but with the new slim clothes coming in, they all went on diets. This was the first year I can remember seeing loads of people drink low-calorie sodas. (Amazingly, lots of the people who got thinner looked better and younger ten years later at the end of the sixties than they had at the beginning. And of course, tits and muscles were on the way out along with fat, because they bulged too much in clothes, too.) Since diet pills are made out of amphetamine, that was one reason speed was as popular with Society women as it was with street people. And these Society women would pass out the pills to their whole family, too—to their sons and daughters to help them lose weight, and to their husbands to help them work harder or stay out later. There were so many people from every level on amphetamine, and although

it sounds strange, I think a lot of it was because of the new fashions—everyone wanted to stay thin and stay up late to show off their new looks at all the new clubs.

The Beatles' first U.S. tour was that summer, and all of a sudden everybody was trying to be English. The British pop groups like the Beatles, the Dave Clark Five, the Rolling Stones, Herman's Hermits, Gerry and the Pacemakers, the Kinks, the Hollies, the Searchers, the Animals, the Yardbirds, and so forth, came along and changed everybody's idea of what was hip from the last vestiges of the tough, big-city teenage look into mod and Edwardian. American boys would fake cockney accents to pick up girls, and whenever they found a real person from London, they'd try to keep him talking and talking so they could get his accent down.

All that summer a young English kid named Mark Lancaster—the English Pop artist Richard Hamilton, whom we'd met at the Duchamp party in Pasadena the year before, had told him to look me up—was coming to the Factory every day, so I got to watch the Anglophilia up close. People would come over to talk to him as he helped me stretch the Flowers for my first show at Castelli coming up in the fall, and the small black and blue Jackies, the funeral image, and some big square Marilyns with different-color backgrounds, and one Jackie-Liz-Marilyn combo. Mark and I would work with Lesley Gore singing "You Don't Own Me" and Dionne Warwick doing "A House Is Not a Home" and bouncy hits by Gary Lewis and the Playboys and Bobby Vee playing.

Technically, Mark didn't have a cockney accent, or even a London one; he was from Yorkshire. Still, the first thing kids would ask him was "Do you know the Beatles?"—which sur-

prised him because by then the hottest ticket in England was the Rolling Stones; the Beatles had been the summer before's thing.

When Mark walked into the Factory for the first time, fresh from his student flight, he couldn't get over the fact that the "lift" was silver and self-service and that the girl who had gotten on right after him, Baby Jane, had this huge head of hair and these high little boots.

We were right in the middle of shooting another scene for *Dracula.* I was sitting on a couch with Jack Smith and Billy; and Rufus Collins, the dancer, and Ondine were around in the background, and Gerard and Jane. Jack was busy with his usual elaborate preshoot preparations, getting a set of fruits and baskets together, and Naomi Levine was darting around, looking very busy and excited.

The first thing I asked Mark was did he want to be in the movie, and he said sure, then everybody started taking off their clothes. He got out of his suit and joined the group molding silver foil jock straps around their underwear. It was so funny to watch people running off to answer the phones in their silver diapers. Gregory Battcock, the art and film critic, had come in, and Sam Wagstaff, who looked like an ageless Clark Kent, and Sam Green, who was working at the Green Gallery that summer. (He loved the way everyone assumed it was his gallery when he said he was "Sam Green from the Green Gallery." Actually, it was run by Dick Bellamy, who was backed by Bob Scull.)

Since Jack was doing the organizing, there were at least ten people in and out of the movie that day. I ran the camera and did the zoom thing, and after we finished, everyone just sat

around in foil for a while. Then, as Mark remembers it, he thought, "Well, that was very nice," and put his suit back on and came over to thank me for letting him come by. I just said, "See you tomorrow"—I always just said, "See you tomorrow"— so after that he kept coming back every afternoon, and since it was boring to just hang around, he began helping me stretch paintings.

We were still doing *Kiss* movies that summer and Mark did one with Gerard.

I had fun introducing Mark to people in the art world because then after he'd meet them we'd have more people to gossip about while we stretched. He'd come back from Frank Stella's studio down on Orchard Street and tell me about the big shaped metallic paintings Stella was doing, or about how Marisol sat down next to him at the Cedar bar and asked him, "Do you think I should go to Sidney Janis?" or about who was down at Bob Indiana's loft, or about Roy Lichtenstein's seascapes with clouds and horizons and his new series of landscapes.

The World's Fair was out in Flushing Meadow that summer with my mural of the Ten Most Wanted Men on the outside of the building that Philip Johnson designed. Philip gave me the assignment, but because of some political thing I never understood, the officials had it whitewashed out. A bunch of us went out to Flushing Meadow to have a look at it, but by the time we got there, you could only see the images faintly coming through the paint they'd just put over them. In one way I was glad the mural was gone: now I wouldn't have to feel responsible if one of the criminals ever got turned in to the FBI because someone had recognized him from my pictures. So then I did a picture of Robert Moses instead, who was running the fair—a

few dozen four-foot squares of Masonite panels—but that got rejected, too. But since I had the Ten Most Wanted screens already made up, I decided to go ahead and do paintings of them anyway. (The ten certainly weren't going to get caught from the kind of exposure they'd get at the Factory.)

The thing I most of all remember about the World's Fair was sitting in a car with the sound coming from speakers behind me. As I sat there hearing the words rush past me from behind, I got the same sensation I always got when I gave an interview—that the words weren't coming out of me, that they were coming from someplace else, someplace behind me.

I guess Mark met everyone in the New York art scene that summer, not necessarily at the Factory but probably because of it. "You'd stand there painting," Mark remembers, "and you'd say, 'Do you think Picasso's ever heard of us?' and then you'd send me off to see people." I sent him to dinner at Henry Geldzahler's, and through Henry he met Jasper Johns and Stella and Lichtenstein and Ellsworth Kelly, and then once I sent him as a get-well present to Ray Johnson who was in Bellevue Hospital with hepatitis. We went down together to that art gallery near Washington Square that Ruth Kligman, who'd been Jackson Pollock's girl friend and was right in the car with him when he was killed, was running with her new husband, Mr. Sansegundo. They screened movies every night and Jonas would be there with underground filmmakers like Harry Smith and Gregory Markopoulos. John Chamberlain and Neil Williams were around a lot, too, looking identical—they dressed alike and they both had big butch moustaches and were always drunk.

The really funny thing about all this was that the whole time Mark was making notes and taking photographs because when

he went back to England he was planning to go around giving lectures and showing slides! He said that the people over there were just as fascinated by what they had heard was going on here as Americans were by London.

One thing I've always liked to do is hear what people think of each other—you learn just as much about the person who's talking as about the person who's getting dished. It's called gossip, of course, and it's an obsession of mine. So one afternoon as we stretched Marilyns, when Mark remarked that he thought Gerard was very "complicated," I was in like a flash and asked him just what he meant by that.

"Well," he said, "he doesn't want anyone else to be as close to you as he is. He told me once, 'When it's one-to-one with Andy, it's very easy, but when you're in a group, Andy creates competition between people so he can watch problems being played out. He loves to see people fighting and getting jealous of each other, and he encourages people to gossip about each other.'"

"What did he mean?" I asked him.

"Well, say, like we are right now." Mark smiled. "Here I'm gossiping about him to you, and then at some point you'll get *him* to tell you exactly what he thinks of *me*."

"Oh, really?" I said.

"Yes. And I suppose he also meant that, for example, when we leave here tonight, you'll be going on somewhere, but you'll never say who else is invited—you'll just contrive in an elegant fashion to make sure the people you don't want to be there aren't. . . . And you'll do it all without saying a word, or by saying something very oblique—some people will realize they have to fall away, and some people will just know they can come along."

"Oh, really?" I said, letting the subject drop—I mean, you can't gossip about yourself.

We usually worked till around midnight, and then we'd go down to the Village, to places like the Café Figaro, the Hip Bagel, the Kettle of Fish, the Gaslight, the Café Bizarre, or the Cino. I'd get home around four in the morning, make a few phone calls, usually talk to Henry Geldzahler for an hour or so, and then when it started to get light I'd take a Seconal, sleep for a couple of hours, and be back at the Factory by early afternoon. As I walked in, the radio and the record player would both be blasting— "Don't Let the Sun Catch You Crying" mixed with *Turandot,* "Where Did Our Love Go?" with Donizetti or Bellini, or the Stones doing "Not Fade Away" while Maria Callas did *Norma.*

A lot of people thought that it was me everyone at the Factory was hanging around, that I was some kind of big attraction that everyone came to see, but that's absolutely backward: it was me who was hanging around everyone else. I just paid the rent, and the crowds came simply because the door was open. People weren't particularly interested in seeing me, they were interested in seeing each other. They came to see who came.

I'd gotten myself a 35-mm still camera and for a few weeks there I was taking photographs, but it was too complicated for me. I got impatient with the f-stops, the shutter speeds, the light readings, so I dropped it. But Billy started using the camera and his "Factory Fotos" caught the exact mood of everything that was happening—embalmed-in-action: the smoky atmosphere, the parties, the broken bits of mirrors, the silver, the velvets, the planes of faces and bodies, the fights, the clowning, even the

attitudes and the depression. Billy had the magic timing that could get it all at the right split second. We had one of those early copying machines at the Factory, a Verifax—sprayed silver, naturally—and Billy used to fool around copying photographs and negatives on that. At first he sent his pictures out to be developed, but then he got a darkroom together and he took more and more and more. Billy didn't go out too much. If he needed some film or something, either he'd call for it or he'd ask Gerard or somebody to pick it up.

"I adored Billy," Mark told me years later. "He took all that speed and yet he never changed toward people. He hardly ever said a word, but they knew he was their friend. At the end of the summer, when I was leaving, he gave me a beautiful photograph of himself with a hard-on. He was so very sweet."

Everybody adored Billy. Henry Geldzahler told me that once when the underground star Paul America gave him (Henry) the first LSD he'd ever taken and then left him, Billy came by and found him all alone on the bathroom floor, freaking out, and he held him in his arms for hours, until the trip was over.

Mark went up to Cape Cod a few times. Dick Smith, the English artist, was honeymooning up there, and Ivan Karp was there; and Motherwell and his wife, Helen Frankenthaler, were living in Provincetown, where Walter Chrysler had his museum in an old church; and Mailer was just down the street from the Motherwells. Mark had fallen in love with Bloomingdale's; he bought all his clothes there, but everyone in Provincetown, as soon as they heard his accent, kept complimenting him on his "fantastic English clothes." One Monday afternoon at the Factory, he told me that Mailer had walked over to him at a party over the weekend and punched him in the gut.

I was impressed. "Norman Mailer actually punched you?" I said. "How great. . . . Why?"

"That's what I asked *him*. He said it was for wearing a pink jacket."

Norman Mailer was one of the few intellectuals that I really enjoyed.

I didn't leave the city on weekends that summer the way I had the one before. I thought, "Where could be more fun than this, with everybody you know coming by all the time, and you're getting work done yet?" It was a constant open house, like the format of a children's TV program—you just hung around and characters you knew dropped in.

Of course, an "open house" has its risks:

One day late in '64, a woman in her thirties, who I thought I'd maybe seen a few times before, came in, walked over to where I'd stacked four square Marilyns against a wall, took out a gun, and shot a hole right through the stack. She looked over at me, smiled, walked to the freight elevator, and left.

I wasn't even scared; it just seemed like I was watching a movie. I asked Billy, "Who was that?" and he told me her name. Ondine and I flipped through the stack and saw that the bullet had passed through two blue Marilyns and an orange one. I said, "But what does she do? Does she have a job?" Ondine and Billy both answered together, "Not that we know of . . ."

Billy's friends were outrageous. As much as you trusted Billy, that's how much you'd never trust any of the people he knew. There was no problem about it, though, because they never expected anyone to trust them, they knew they were ridiculous. But there were varying degrees of untrustworthiness. Some of

them would go right into your pocket and steal everything you had. Some of them would only steal half of what you had. Some of them would give you a bad check or try to sell you a bad electric typewriter ("All it needs, honestly, is the cord thing"). Some of them would only steal from big chain stores. There were lots of different codes that you could never figure out, and once in a while they'd catch you off guard and you'd think, "This time they mean it, they really will come right back with the change."

Even when they didn't mean to steal, you'd still be missing things because, like they'd say, "We don't steal, we transfer." And it was true, they'd take things from you and then in their place you would find other people's stuff. It was as if they thought they lived in an apartment that had four hundred rooms—they didn't distinguish all the apartments they hung around in as separate places. Even Billy was like this—they were all so spaced. They weren't taking things to get money or anything; they would simply, say, take my jacket and leave it at someone's house, and take his gold cigarette lighter and leave it for me on the couch at the Factory—they were just moving objects around the city.

When I first met Rotten Rita, he was still employed, at some factory that made fabrics—velvets or something—and he'd come by with yards of this and swatches of that. This was before he started stealing cars but probably during his bad check period.

In those days, he and Binghamton Birdie always went around together. Rotten was about six feet tall, and he had kind of a collegiate look, like a goofy computer repairman—very sharp, chiseled comic-book features. And Birdie was a good-looking type with big muscles; he looked like something out of a physique magazine.

Billy didn't stay at the Factory all the time; he alternated between there and Henry Geldzahler's apartment in the West Eighties, which he used to house-sit when Henry went out of town. It was crazy that people would trust him so much, but they did—I mean, when you think of the scene he was involved in (of all the people in New York City, his best friends happened to be the ones you were having him there to protect your property against). Henry trusted Billy the way everyone did, including me; there was just something about him that made you feel he was "in charge."

Rotten and Birdie and Ondine would be over at Henry's house a lot when Billy was house-sitting it. One summer Henry came back from a weekend in Provincetown and walked in and found "a big fat naked woman" lying on his gneiss marble table poking a needle into her ass. (It was summertime and the stone table was the coolest surface to lie on.) That was his introduction to the Duchess.

"At that point," Henry told me years later, "I thought, 'I am out of my mind to be letting this happen.' I thought about morality, and then I thought, 'God. I want to go on going to work and writing articles and giving lectures so this won't happen to me.'" (He was getting up every morning as usual and going to his job at the Metropolitan Museum, and when he'd come home in the evening, his answering service would tell him, "The Mayor called" or "The Duchess will call back"—the operators were very impressed with his social life.)

When Billy house-sat at Henry's, he'd glide around the parlor floor with a cigarette holder between his first and fourth fingers (he looked like he was playing a flute) checking to see that nothing was missing, especially the small Al Hansen Hershey Bar

painting on the wall of the two-by-four kitchen—it was a big favorite of the A-heads. In the living room there was a big Chamberlain car crash sculpture attached to the wall, and a black easy chair where Henry would smoke his cigars. The Duchess would come by the Factory and announce things like "Debbie Dropout's been at Henry Geldzahler's for a week because Spanish Eddie's trying to kill her." I never understood how Henry could give those characters the run of his house. I would never go that far—the Factory was a different thing from where I lived—I wouldn't want to go home to that kind of insanity, ever.

Henry had one of the first loft beds around, complete with its own stairs. It was halfway between the floor and the fourteen-foot ceiling. One night he came home and opened the big sliding door to his bedroom and there in his bed were Billy, Ondine, and Silver George swathed in velvet (they were all incredible velvet freaks). *Tosca* was playing at top volume and Ondine sang/shouted "Mar-i-o MAR-I-O!" as he dove off the loft bed onto the floor.

If you looked at Ondine from an angle or from the back, he was very striking because he had beautiful dark Italian hair. He wore the basic jeans–T-shirt uniform that everyone wore, and he usually carried an airline flight bag. His face would have been actually handsome, but there was something too arch about it: the mouth was pure Ondine, a sort of quizzical duck's mouth with deep smile lines around it.

As for Silver George, he looked like an anthropology project—big (over six feet tall), Neanderthal, hairy-chested, and with eye ridges and a Beatle haircut dyed three different shades a month.

Silver George went home to Brooklyn on the day of his mother's funeral that summer and he noticed that his father

looked "depressed," so when the old man went to the refrigerator for milk, George slipped some Methedrine into his Rice Krispies. His father immediately began darting around the house dusting the rooms. And when Silver George phoned Billy a little later, he reported, "The patient is responding nicely. I'm sure he'll enjoy the funeral enormously."

Another time, when Henry was traveling in Europe, his secretary stopped by to check on the apartment and discovered Billy shrunken to about ninety pounds. He'd draped the loft bed in black velvet and was lying on top of it like it was a catafalque—it all looked like something out of a Spanish painting. The girl called the psychiatrist Ernie Kafka, who diagnosed a severe case of dehydration and prescribed vitamins.

The only thing "underground" about American underground movies—I mean, in the strict political sense of having to hide from some authority—was that in the early sixties there was the big censorship problem with nudity. The fifties had been *Lolita*-scandal time—even as late as '59 there was the big deal about Grove Press publishing *Lady Chatterley's Lover* and later on about Henry Miller's *Tropic of Cancer*. The censorship policies in this country have always completely baffled me because there was never a time when you couldn't walk into any 42nd Street peep show and see all the cocks and cunts and tits and asses you wanted, then suddenly out of the blue the courts would single out one popular movie with a few racy scenes in it for "obscenity."

Some underground filmmakers actually kind of hoped the police would seize their movies so they'd get in all the papers for being persecuted for "freedom of expression," and that was always considered a worthy cause. But it was pretty much a fluke

who the police arrested and who they didn't and after a certain point it all got boring for everyone.

The first movie of mine that was seized was a two-minute-forty-five-second one-reeler that I'd shot out in Old Lyme of everybody during the filming of Jack Smith's *Normal Love*—the one where the cast made a room-size cake and got on top of it. Actually, it was seized by mistake—what the police were out to get was Jack's *Flaming Creatures*.

Jonas's Coop had moved from the Gramercy Arts Theater to the building Diane di Prima and some of the other poets used on St. Mark's Place on the southeast corner of the Bowery. After *Flaming Creatures* was seized, the screenings there stopped for a little while. Then Jonas rented the Writers Stage on 4th Street between Second Avenue and the Bowery and he screened Genet's *Un Chant d'amour* there. "I knew that Jack's would be a difficult case to fight," Jonas told me, "with nobody really knowing who he was, and I felt that Genet—for the right or wrong reasons—would be a better case because he was a famous writer. And I was right—when they clubbed us that time for obscenity, we won."

After all the court cases Jonas realized that he needed some type of umbrella nonprofit organization, so he created the Film Culture Non-Profit Organization, which published *Film Culture* magazine and sponsored screenings and other things. During that period they had screenings in "respectable" places—like that Washington Square art gallery of Ruth Kligman's—so they wouldn't be closed down again by the police. Ruth's was where Jonas showed a lot of Marie Menken's films and in the fall we showed *Blow Job* there publicly for the first time.

Jonas had screened his film of the Living Theater's production of *The Brig* in that building on St. Mark's and the Bowery be-

fore the police seized *Flaming Creatures* there. I was intrigued
with the equipment he'd used—for nine hundred dollars he'd
shot the whole thing in sync sound. It was eighty minutes long,
and he'd done it with the Auricon camera that was used by jour-
nalists a lot to shoot live situations since it recorded sound di-
rectly on the film—all you had to do was hold the camera. The
quality of the sound was primitive, of course, but still it was sync
sound. Jonas showed me how to operate the Auricon and I used
it right away to film, of all things, *Empire,* which had no dia-
logue. A boy named John Palmer gave me the idea: we shot the
Empire State Building from an office in the Time-Life Building
that belonged to a friend named Henry Romney, who around
that time was trying to buy the rights to *A Clockwork Orange,*
saying that he wanted me to film it using Nureyev, Mick Jagger,
and Baby Jane Holzer as stars.

In June of '64 the Rolling Stones had come over to play some
American cities and the tour was a big disappointment to them.
They'd wound it up at Carnegie Hall on a bill with Bobby
Goldsboro and Jay and the Americans. They had a big hit with
"Tell Me," and they did have a following, but they were no su-
pergroup yet in the United States—all anybody cared about over
here was the Beatles. In October they came back for another
try—they played the Academy of Music down on 14th Street
and on the twenty-fifth they were slated for *The Ed Sullivan
Show* for the first time. With the idea to get more publicity for
them—which was what they badly needed—Nicky Haslam and
some other friends of theirs planned a party at Jerry Schatzberg's
photography studio on Park Avenue South for the Friday night
before the Sullivan show. (Ed Sullivan must have learned his les-
son after he turned down young Elvis in the fifties when he

could have had him cheap, only to pay a record price for him later on, because in the sixties Ed was the first with all the English pop groups.) That was also Baby Jane Holzer's twenty-fourth birthday, so what it evolved into was a party for her with the Stones as the star guests. Jane had just started to appear in big *Vogue* fashion spreads, and Clay Felker, the editor of the *New York Herald Tribune* Sunday magazine supplement (he revived it as *New York* magazine a couple of years after the *Tribune* folded) had assigned Tom Wolfe to write a piece on her.

Nicky had left *Vogue* to be the art director of A & P heir Huntington Hartford's short-lived magazine called *Show.* Hunt himself interviewed Nicky for the job: "First he analyzed my handwriting," Nicky told me, "and then he asked me to kiss his wife so he could see how she reacted, and then he gave me the job." Nicky used Jane on a *Show* cover—a David Bailey photograph of her in a yachting cap and World's Fair sunglasses, with an American flag between her teeth.

Mick was staying down at Nicky's on East 19th Street again, and so was Keith Richards, who had Ronnie the Ronette spending a lot of time there with him—the Ronettes were very big then, after "Be My Baby" and "Walking in the Rain."

The theme of the party was going to be "Mods vs. Rockers," so on the night of the party, to make it look authentic, Nicky went over to an S & M leather bar on 33rd Street and Third Avenue called the Copper Kettle, where he'd just taken his friend Jane Ormsby-Gore dressed as a boy (she was the daughter of the British ambassador to Washington) and invited all the leather boys to come by later on but to really bust their way in to make it look like a real confrontation between mods and rockers. The leather boys did come, but since nobody even tried to stop them, they just wandered in with no problem—and no impact.

Then for a band, Nicky had gone over to the Wagon Wheel on West 45th Street to ask the all-girl house band, Goldie and the Gingerbreads in their gold lamé outfits and stiletto heels, if they wanted to play at the party. They did, and they played until five in the morning, with the floors shaking so badly we were amazed at the bounce.

The party was a smash even though the Stones were so shy they stayed way upstairs in Jerry's apartment most of the time. It got written up in all the papers, and it did as much for Baby Jane as it did for the Stones—Tom Wolfe's "Girl of the Year" article on her, which defined her as the new type of Pop sixties girl and was eventually part of his *Kandy-Kolored Tangerine-Flake Streamline Baby* book, featured the party.

The Rolling Stones weren't the only ones with foreign publicity problems. I realized I had some myself when I had a major show at a gallery in Canada and I didn't sell one thing. Gerard went up with me to Toronto on the train. The day of the opening we loitered around the gallery, but nobody showed up—nobody. Gerard went out to browse around and came back with some poetry books that you could only get in Canada (there was one by a poet called Leonard Cohen who nobody in the States had heard of yet), so he was thrilled, but I was feeling like a total dud. The gallery was about to close, so you can imagine how relieved I was when a tubby, red-cheeked high school kid all out of breath came running up to me with a three-ring notebook in his hands and puff-puffed, "Oh! Thank God you're still here— I'm doing my term paper on you." By this point I was really thrilled to see him. He said he had picked me to do his term paper on because his cousin had seen my Elvis Presley show in Los Angeles the year before but also because I hadn't done that

much yet so he wouldn't have to do too much research. All I could think of was that if I was still this big a nobody in Canada, then Picasso certainly hadn't heard of me. This was definitely a setback, because I'd sort of decided by then that he might have.

Everyone always reminds me about the way I'd go around moaning, "Oh, when will I be famous, when will it all happen?" etc., etc., so I must have done it a lot. But you know, just because you carry on about something doesn't mean you literally want what you say. I worked hard and I hustled, but my philosophy was always that if something was going to happen, it would, and if it wasn't and didn't, then something else would.

My art was still considered peculiar, and when I was first at Castelli, my work didn't sell too well. But then the Flowers show came up and a lot of those paintings got sold, though still no one seemed to want to pay a good price for the early cartoon pictures.

I was happy at Castelli, I knew they were doing everything they could for me, but Ivan sensed that I was uncomfortable when I got low prices. One day he said to me, "I know you feel you're not getting the right prices for your early work, but at this point people still feel it's too peculiar and aggressive and that the subject matter isn't appropriate—that they couldn't live with it. And now that you're using silkscreens, they don't like that either. They just don't understand what you're doing. But you're being very patient, Andy, and I think this year things will change."

I was glad to hear it. Changing the subject, I said, "Gee, Ivan, you really should come by and visit us. You never do anymore."

What Ivan said to me then made me realize for the first time that he didn't like the Factory scene. I'd always assumed he was just too busy to come all the way to midtown—after all, my studio used to be much closer to the gallery. But now I had to face

the fact that it wasn't the distance that was keeping Ivan away. I started to get the idea when he said, "Andy, I know a lot of people think it's glamorous over there at your studio, but to me it's just—gloomy. Your art is partly voyeuristic, which is completely legitimate, of course—you've always liked the bizarre and the peculiar and people at their most raw and uncovered—but it's not so much a fascination for me. I don't need to see that so much. . . . You have a group of people around you now that's essentially destructive. Not that they set out to be necessarily, but . . ." Ivan shook his head, not finishing. "I'd rather see you in a small crowd or just alone like this. I guess I'm just totally embedded in the art community—it's wholesome and I feel comfortable in it."

We never for a second stopped being friends, but from then on we understood that it was really only art that was our common ground. And it suddenly occurred to me that Henry Geldzahler was the only friend from '60 that I was still seeing a lot of. Or at least I was talking to him a lot—three to five hours a day. He was involved in all the same things I was—the art scene and the Factory/movie scene. He was someone who was as fascinated by the bizarre as I was—we were both open to involvements with crazy people.

All during '64 Freddy Herko had been taking a lot of amphetamine. Like so many people on speed, he'd think he was doing creative things when he wasn't. He'd sit there with a compass and a Rapidograph and twenty or thirty Pentels and make intricate geometric designs on a little pad with dirty fingerprints all over it and think he was doing something beautiful and clever.

Freddy would come by the Factory a lot to see Billy. He'd left some of his clothes and costumes there in a trunk—all the

amphetamine dingle-dangles, the flowers made out of broken mirrors, and the cloaks and feathered hats and pasted-on jewels—someone had once described Freddy as "a seventeenth-century macaroni." He had the rest of his belongings scattered around downtown in different friends' apartments. At the Factory he'd walk in, talking so fast, with his shoulder bag slung behind him, sit down, and show me his drawings, then leap up—he danced in leaps wherever he went. Amphetamine symptoms were still new to me, I didn't even recognize them, I didn't even know about the amphetamine compulsion to draw little patterns. I only thought, "Gee, this person is an incredible dancer. High-strung and neurotic maybe, but really creative."

One of the saddest times with Freddy was when Gerard and I and a couple of other people went with him to visit his Aunt Harriet at her apartment in the Fifties—it had a lot of big mirrors in it, so Freddy was leaping around; it must have been like being in dancing class. Whenever he stayed still long enough, Aunt Harriet hugged him.

As we were leaving, she gave Freddy some money, and then this is the really sad part—she pressed a dollar bill into each of our hands because she said she wanted Freddy's friends to have a little something, too.

I filmed Freddy three times. The first time was just a short dance thing on a roof. The second was a segment for *The Thirteen Most Beautiful Boys* where Freddy sat nervously in a chair for three minutes, smoking a cigarette. And the third was called *Roller Skate,* and Freddy was the star of it. He put a skate on one foot and we filmed him rolling on it all over town and over in Brooklyn Heights, day and night, gliding in dance attitudes and looking as perfect as the ornament on the hood of a car. We filmed glide after glide of him, keeping the camera going. When

it came time to take the skate off, his foot was bleeding, but he'd been smiling the whole while and he was still smiling, wearing a WMCA Good Guys sweatshirt.

Freddy spent the months before he died with a girl dancer over in an apartment near St. Mark's Church, taking more and more amphetamine. He began staying inside, never going out. He never smiled anymore. He withdrew from the whole apartment into one single room, and then from the room to the end of the hall, and then from the end of the hall into a walk-in closet—he'd stay in there for days at a time in his mess of textiles and beads and records. Oh, he would occasionally come out to make a few ballets but then he'd go right back in. Finally the girl dancer asked him to leave, and he moved down to the lower Lower East Side.

One night he showed up at Diane di Prima's to borrow a record and invited everyone there to a performance; he said he was going to leap off the top of his building downtown.

A few days later, on October 27, he turned up at an apartment on Cornelia Street that belonged to Johnny Dodd, who did the lighting for the Judson Church concerts. The front door to Johnny's apartment was bolted and sealed with nails driven through the jamb, but there was a panel, maybe ten inches wide and three feet high with hinges, that by really stooping you could get through. The door had gotten this treatment because of Freddy; he'd kicked it in a few times.

What Freddy did when he got inside was go and take a bath. The apartment was stuffed with stage props and collage things— gold fabric covering bare brick walls, a Tintoretto-like eighteenth-century baroque heaven scene on the ceiling, a picture of some ballerinas framed with a toilet seat, a photograph of Orion the Witch of Bleecker Street, a portable wall of postage stamps, and

so forth. After his bath, Freddy put Mozart's *Coronation* Mass on the hi-fi. He said he had a new ballet to do and he needed to be alone. He herded the people there out of the room. As the record got to the "Sanctus," he danced out the open window with a leap so huge he was carried halfway down the block onto Cornelia Street five stories below.

For the twenty-six nights following Freddy's death, the group at Diane di Prima's apartment met formally to read the Tibetan Book of the Dead. The ritual involved making sacrifices, and most people pulled out a few of their hairs and burned them.

There was a memorial service for him at Judson Church, but so many people showed up that there was another one for him, at the Factory. We showed the three films.

(It's so strange to look back on that last year of Freddy's life when he retreated into that closet, because in '68 Billy Name did the very same thing, went into the darkroom closet and didn't come out.)

The Sculls, Bob and Ethel, were big—very big, the biggest—collectors of Pop Art, and of course they got to know all the Pop artists and through collecting and knowing all the artists, they made quite a place for themselves in the booming sixties art scene. To celebrate the opening of Philip Johnson's new building for the Museum of Modern Art, the Sculls gave a party, and at that party Ethel Scull seated herself next to Mrs. Lyndon Johnson. There they were, sitting together. A few years before, *no*body—not even a *gossip columnist*—would have known who Ethel Scull was, yet in the period between '60 and '69, the Sculls more than anyone else came to symbolize success in the art scene at the collecting end. A lot of the swinging mod couples in the

sixties started to collect art, and the Sculls were models and he-roes for these people. The collection of Pop Art that Bob Scull had acquired was already legendary. He was in the taxicab busi-ness, but he'd been smarter than all those people at the muse-ums. He'd pulled off what everyone who collects dreams of—he built the best collection by recognizing quality before anybody else was on to it, while it could still be bought cheap.

Ethel Scull (in those days, she liked to be called "Spike") gave a lot of big, generous parties, where she somehow always managed to instigate little intrigues and feuds that would peak in embarrassing scenes. She had the "You're-my-friend-this-week" style that made for tense dramas.

For example, I was at a party of theirs when they still lived out in Great Neck on Long Island. It was their debut party in the art world. I guess they'd finally gotten their collection to the point where they wanted to show it off. It was a great place, the art was fantastic, and there were beautiful flower arrangements all over the place. In the middle of the party, Jim Rosenquist's wife happened to pluck a carnation from one of the centerpieces. Ethel zeroed in on her and screamed, "You put that right back! Those are *my* flowers!" Ethel could sure give people something to talk about.

For my Flowers opening at Castelli, Ethel gave a party at the Factory with that southern girl-around-town Marguerite Lamkin. Up until they gave that party together, the two women were good friends. They had it catered by Nathan's Famous with hot dog carts and french fries and hamburgers—there was a real boardwalk atmosphere. Senator Javits and his exuberant wife, Marion, were there, and Allen Ginsberg in a tam-o'-shanter, and Jill Johnston, the *Voice* dance critic, was climbing up the silver

pipes. Fred McDarrah from the *Voice* was there taking a lot of pictures. Even the police stopped by.

The two ladies had hired Pinkerton detectives and stationed them downstairs, and you absolutely had to show your invitation or they wouldn't let you in. I'd told a lot of my friends to come—I mean, I didn't know there were going to be guards there—and every one of them got turned away at the door. They were all mad at me for not being right down there to get them in, but whenever a situation looked like it was going to be problematic, I usually tried to stay out of it.

De was Marguerite's date—they were good friends. He'd gotten her some writing jobs, and now she was a correspondent on the New York scene for some English newspapers. (She had a map of midtown Manhattan on her wall at home with little flags that she moved around when people would phone and tell her where they were having lunch or dinner.)

Marguerite, De, and I took the action in from a corner. We watched Bob Scull running around in some sort of checked jacket. He went over to a major young painter and shoved a fifty-dollar bill at him and said, "We're about to run out of soda water—go get some." The young guy just stared at him like "Up yours."

De shook his head. "That guy is impervious," he said. It was true, no gaffe could ever affect him. De said, "In a way, he's the oddest figure out of this whole scene, because at one level he's coarse beyond description—beyond imagination! And yet at another, he really saw what was going on and put his money out." Then De laughed and added, "Ver-ry ver-ry lit-tle of it. A teent-zy, teent-zy amount. But enough to get the best—you can't take that away from him . . ."

It's a strange thing to be talking about someone in a big crowd and then watch them from a distance being exactly the

way you're describing them. There was Bob Scull stomping around, giving orders. Who could ever figure out how a man who behaved like that socially could have such a keen sense for art?

The postscript to that night is that Ethel and Marguerite argued for weeks over how much each of them had spent for what—adding up hot dogs, tallying bottles, practically dragging paper cups out of the garbage to count them—and they wound up hating each other. It was a great party.

That fall, David Bourdon started writing on art for the *Village Voice*. When I'd heard they were looking for an art person, I'd introduced him to the *Voice* theater critic, Michael Smith, who I knew from the San Remo/Judson Church crowd.

Shortly after David got the job, he called me and said, "Well, now that I'm working for the *Voice*, do you think I'm chic enough for people to come all the way out to Brooklyn Heights if I give a party?"

Gerard and Billy and Ondine and I rode out to the Heights in a limo. As soon as we got there, Billy announced to David that his party was on our "circuit" for that night, and David got really offended at that, at our "lack of commitment," he said, and then he kept asking sarcastic questions like were we sure we weren't allotting him too much of our time. But that type of hurt, paranoid attitude was part of David's sense of humor—setting himself up as an articulate underdog.

He had a big crowd—this was right after Freddy Herko died, and that was about the only Judson dancer who wasn't there. When I saw Susan Sontag, I asked David how he'd snagged her, because she was considered the dazzling intellect of the year. She'd just published her famous essay in the *Partisan Review* on the differences between high, middle, and low "camp," and she was very

influential—she wrote about literature, pornography, films (especially Godard), art, anything. David told me that he'd heard she didn't think too much of my painting—"I hear she suspects your sincerity," he said. Well, that was no surprise, since a lot of dazzling intellects felt that way. I didn't go over to talk to her, but I watched her from where I was sitting. She had a good look—shoulder-length straight dark hair and big dark eyes, and she wore very tailored things. She really liked to dance, too; she was jumping all around the place. Everybody then was doing the frug or the jerk-style dances, to the Beatles and the Supremes mostly. But the song that everybody wanted to hear over and over again was "I'm In with the In Crowd"—they played it every other song.

All through '64 we filmed movies without sound. Movies, movies, and more movies. We were shooting so many, we never even bothered to give titles to a lot of them. Friends would stop by and they'd wind up in front of the camera, the star of that afternoon's reel.

Once De started making movies, he never went back to the art scene. In the past year we'd only seen each other a couple of times, at parties. But then I bumped into him one afternoon on the street and we went to the Russian Tea Room for a drink. We sat there gabbing about what we'd been doing, and I offered that since we were both doing movies now, wouldn't it be great to do one together. Now, with people who know me, I'm famous for this sort of thing—proposing collaborations. (I'm also famous for not spelling out what the collaboration will consist of—who'll do what—and lots of people have told me how frustrating that can be. But the thing is, I never know exactly what I want to do, and the way I see it, why worry about things like

specifics beforehand, since nothing may ever come of the project? Do it first, then look at what you've got, and *then* worry about who did what. But most people would disagree with me, saying it's better to have an understanding at the outset.) When I suggested doing some sort of a joint production to De, I was just being impulsive. But De was always so practical, he squelched my suggestion right away, saying that our lives and styles and politics (I can't remember if he was calling himself a Marxist yet) and philosophies were just too different.

I must have looked very disappointed, because he held up his drink and said, "Okay, Andy, I'll do something for you that I'm sure nobody's ever offered to do for you and you can film it: I'll drink an entire quart of Scotch whiskey in twenty minutes."

We went right over to 47th Street and made a seventy-minute film. De finished the bottle before I reloaded at the halfway point, but he wasn't showing the liquor yet. However, in just the little while it took to put more film in the camera, he was suddenly on the floor—singing and swearing and scratching at the wall, the whole time trying to pull himself up and not being able to.

Now, the thing was, I didn't really know what he'd meant when he told me, "I'll risk my life for you." Even when I saw him crawling around on all fours, I just thought of it simply as someone being really drunk. Then Rotten Rita, who was hanging around, said, "Marine Corps sergeants keel over dead from that. Your liver can't take it."

But De didn't die, and I called the movie *Drink* so it could be a trilogy with my *Eat* and *Sleep*. When the little old lady we used as a go-between brought it back from the lab, I called De to come over and see it. He said, "I'm bringing my woman and an English friend and I hope no one else will be there." There

was no one at the Factory right then anyway, except for Billy and Gerard and me and a couple of people who looked like they were on their way out. But as soon as I hung up, a gang of Gerard's friends happened to walk in, and by the time De got there, there were around forty people all over the place. We ran the film and after it was over, De said to me, "I'll probably sue you if you ever screen it publicly again." I knew he'd never sue me, of course, but that was his way of telling me not to have a print made of it.

At the end of '64 we made *Harlot,* our first sound movie *with* sound—*Empire,* the eight-hour shot of the Empire State Building, had been our first "sound" movie with*out* sound. Now that we had the technology to have sound in our movies, I realized that we were going to be needing a lot of dialogue. It's funny how you get the solution to things. Gerard and I were down at the Café Le Metro for one of the Wednesday night poetry readings when a writer named Ronnie Tavel was reading passages from his novel and some poems. He seemed to have reams of paper around; I was really impressed with the sheer amount of stuff he'd evidently written. While he was reading, I was thinking how wonderful it was to find someone so prolific just at the point when we were going to need "sounds" for our sound movies. Immediately after the reading I asked Ronnie if he'd come by the Factory and just sit in a lounge chair off-camera and talk while we shot Mario Montez in *Harlot,* and he said fine. As we left Le Metro, Gerard sneered, "Your standards are really ridiculous sometimes." I guess he thought I was too impressed with the quantity of stuff Ronnie turned out. But the thing was, I liked the content, too, I thought he was really talented.

• • •

Mario Montez, the star of *Harlot,* was in a lot of off-off-Broadway plays and doing a lot of underground acting for Jack Smith and Ron Rice and Jose Rodriguez-Soltero and Bill Vehr. And this was all in addition, he told me, to his regular job: working for the post office. Mario was one of the best natural comedians I'd ever met; he knew instinctively how to get a laugh every time. He had a natural blend of sincerity and distraction, which has to be one of the great comedy combinations.

A lot of Mario's humor came from the fact that he adored dressing up like a female glamour queen, yet at the same time he was painfully embarrassed about being in drag (he got offended if you used that word—he called it "going into costume"). He used to always say that he knew it was a sin to be in drag—he was Puerto Rican and a very religious Roman Catholic. The only spiritual comfort he allowed himself was the logic that even though God surely didn't *like* him for going into drag, that still, if He really hated him, He would have struck him dead.

Mario was a very sympathetic person, very benign, although he did get furious at me once. We were watching a scene of his in a movie we called *The Fourteen-Year-Old Girl,* and when he saw that I'd zoomed in and gotten a close-up of his arm with all the thick, dark masculine hair and veins showing, he got very upset and hurt and accused me in a proud Latin way, "I can see you were trying to bring out the worst in me."

Ronnie Tavel appeared for the *Harlot* shooting and he and a couple of other people just talked normally off-camera. Sometimes the talk was about what we were shooting and other times it wasn't—I loved the effect of having unrelated dialogue. After that Ronnie did quite a few scenarios for us—*The Life of Juanita*

Castro, Horse, Vinyl, The Fourteen-Year-Old Girl, Hedy (*The Shoplifter*), *Lupe, Kitchen,* and others. I enjoyed working with him because he understood instantly when I'd say things like "I want it simple and plastic and white." Not everyone can think in an abstract way, but Ronnie could.

1965

In January '65 I met Edith Minturn Sedgwick. She'd just come to New York that summer. She'd been in a car accident and her right arm was in a cast. We were introduced by Lester Persky, but we were bound to meet anyway, since I'd gotten to know quite a few people from the Cambridge/Harvard group she was part of. A lot of them hung out at the San Remo.

Edie's family went all the way back to the Pilgrims—she was related to Cabots, Lodges, Lowells. Her great-uncle Ellery had been the editor of the *Atlantic Monthly,* and her great-grandfather was the Reverend Endicott Peabody, the founder of the Groton School. And somebody on her grandmother's side had invented some basic industry like the trolley or the elevator, so they were rich, too. Edie's parents had moved as far away from New England as you could get—to California—but her brother was an undergraduate at Harvard and Edie was in Cambridge, too. She was studying sculpture with Lily Swann Saarinen, the ex-wife of the famous architect Eero Saarinen, and living in a small studio on Brattle Street where Longfellow and people like that had lived in all those glamorous old houses. She used to drive around town in her Mercedes to parties, lots of them given by her own brother. The two Sedgwicks were beautiful rich kids who knew how to have a good time in Cambridge.

Donald Lyons, who was studying classics then at the Harvard graduate school, remembers how Edie took a bunch of friends to the Ritz-Carlton one night for dinner after a very drunken all-day lawn party and how all of a sudden she got up

and started dancing on the tabletop and how the management very very politely asked them to leave. They stuffed all the silverware they could lay their hands on into their pockets, but then as they were leaving, Edie tripped at the top of the stairs and all the knives and forks and spoons spilled out of her purse and went avalanching down the stairs. Even with that the management was polite to her because they knew her father—it was just "Tsk, tsk, don't do this again, dear."

For her twenty-first birthday party, Donald told me, Edie had "rented the Charles River boathouse and invited about two thousand people. 'Edie in Cambridge'—it was right out of Gatsby."

Danny Fields was one of the first people in the early sixties to come down from Cambridge. He'd just quit Harvard Law School and set up a life in New York, and so he was like Information Central for the other Cambridge kids when they came to town.

I'd met Danny at a party on 72nd Street. It was a Sunday that one of the newspaper supplements was illustrating a lead story with my Campbell's Soup Can, and Danny happened to have the paper with him. I was sitting on a couch next to Gerard and Arthur Loeb of the Wall Street Loebs. I borrowed Danny's paper to see how the soup can had come out. Meanwhile, a crazy, beautiful fashion model was crawling snake-style toward Arthur, groveling and telling him how much she was in love with him and begging him to please, please, marry her.

Denis Deegan was across from us. He'd been out in California when we were there in the fall of '63. He was tall and congenial, very Irish-looking with his red hair and blue eyes. He was staying with a friend on 19th Street near Irving Place, and when you asked him what he did, he'd smile beautifully and say,

"Nothing whatsoever." The glamorous young kids in the sixties didn't work. You couldn't say that they were "unemployed," because the idea of working never even came up, yet they always had the best clothes and all the plane trips they wanted. Rich people were especially free with their money then, supporting kids that they liked having around, so these kids would just get up in the afternoon, make a few phone calls, play a few records, decide what they were going to do later on, party all night, and then start all over again the next day.

Danny says he'll always remember that Sunday afternoon we met, because that was when he decided he wanted to really get to know all these people better. "You were sitting there reading my paper and Gerard was talking to Denis and Arthur was kicking the beautiful French model in the face with his good leg. She got upset and ran for a window that was open from the top and climbed up onto the ledge. Nobody paid the slightest attention to her. You just glanced up from the newspaper and said so calmly, 'Ooo. Do you think she'll really jump?' and went back to reading. Finally I couldn't stand it any longer and I ran over and opened the window from the bottom and pulled her back in, and when I turned around, everyone was still just sitting there chatting and I thought, 'Gee, this is a very cool crowd. I think I'll pursue this. . . .'"

"The first time I saw Edie," Danny said, "she'd just driven down from Boston with Tommy Goodwin and they stopped by the apartment that Hal Peterson and David Newman were subletting on Riverside Drive around 78th. The World's Fair had just opened and we were all going out there the next day. The radio was going full blast; the Beach Boys were singing 'I Get Around.'

When Edie came in and saw her girl friends, she started jumping up and down and pretty soon everyone was jumping up and down and hugging and kissing each other. They all looked so collegiate—Shetland sweaters and circle pins and little pleated skirts. And Edie was so pretty and bubbly and big-eyed. Everyone stayed up all night talking and walking along Riverside Drive.

"Tommy Goodwin was staying with me then," Danny went on. "God, he was beautiful. At Harvard everybody was in love with him. His mother and father were both very famous doctors. He was good friends with Chuck Wein and that whole bunch and he would just sort of hang around New York and carry cameras and let everybody fall in love with him. Edie stayed at my place for about two weeks when Tommy was there—she spent most of her time sitting in the window, talking and laughing on the phone all day, smoking cigarettes. She had a little group picture of a few members of her family, taken when they were all checked into the same Society mental institution during the same period—Silver Hill, I think it was. It cost three hundred a day for each of them, she told me, so that was cozy."

Edie used to talk about her childhood as if it were a nightmare straight out of Dickens. At first I always believed everything the kids told me about their parents, but as the years went by and I'd now and then meet one of the parents, I wasn't so sure.

"When I first met Edie, she was so fresh," Danny continued. "She'd have a couple of drinks, but that was it." Then he added, "I could see, though, that she *wanted* to take other things. The people coming in from Cambridge always had acid with them—it wasn't even illegal yet, that's how long ago this was. It was brown on sugar cubes, and they'd put it in my refrigerator—it looked so harmless but it was probably enough for two thou-

sand doses. They'd sit at my kitchen table with medicine drop-
pers, bopping their shoulders to the Supremes, dripping the
LSD onto the little cocktail sugar cubes. Edie took some acid
when she was staying with me, as sort of a debutante giggle.

"Then one day they started to move her trunks in and I got
a little nervous, but by September she was in her own apartment
on East 63rd Street. She'd sort of decided to become a model."

One of the people who was friends with everyone in that
Cambridge crowd summed up the relationships this way: "The
whole thing was the beautiful Ivy League boys, the clever fag-
gots who loved them, and the beautiful debutante girls the beau-
tiful Ivy League boys loved."

Why did they all come to New York? "These kids from
Cambridge in their early twenties," Danny said, "represented in-
herited wealth, inherited beauty, and inherited intelligence.
These were the most glamorous young people in all America. I
mean, they were *so* rich and *so* beautiful and *so* so smart. And so
crazy. But up in Cambridge, all together, all they could think
was, 'Oh, God, we're so bored, we're so tired of going to classes.
We want to move out into the *real world*.' Moving out into the
real world meant getting their picture in the papers and getting
written up in the magazines."

I've always been fascinated by the assumptions that rich kids
make. A lot of them think it's normal, the way they live—be-
cause it's all they've ever known. I love to watch their minds op-
erate. There are two kinds of rich kids—the ones who're always
trying to act poor and prove that they're just like everybody else
and who secretly worry that people only like them for their
money, and the ones who just relax and have fun with it, who
even play it up. The second kind are fun.

• • •

It wasn't surprising that Edie should vaguely decide to be a model. This was the year when the idea of "modeling" held more excitement for a girl Edie's age than it ever had before. It had always been glamorous to model—but now it could be outrageous, too. Very soon, Edie would be innovating her own look that *Vogue, Life, Time,* and all the other magazines would photograph—long, long earrings with dime-store T-shirts over dancer's tights, with a white mink coat thrown over it all.

A discotheque called Ondine (just a name coincidence—no connection with our Ondine) opened on East 59th Street at the very beginning of '65, and that was where you started seeing lots of beautiful girls in mini-skirts (they weren't even called that yet, though), short and pleated and with stripes and dots and big colors and stretchy knits.

Everyone started going to Ondine right away, all the celebs in town. The girls there were beautiful—Gerard picked Marisa Berenson up there one night on her very first modeling trip to New York and brought her by the Factory for a screen test.

Edie went there all the time, throwing a lot of money around in the beginning when she still had it, picking up the check for as many as twenty people every night. She still had her arm in a cast from the car accident, and she'd be swinging it around, standing on top of the tables. She always kept both her feet solidly planted on the table or the floor or whatever—as if she was afraid she'd lose her balance and topple over if she lifted one of them, she was so stoned all the time there, just drinking, having a great time. Her dance moves were sort of Egyptian, with her head and chin tilting in just the right, beautiful way. People called it the Sedgwick, and Edie was the only one who did it—

everybody else was doing the jerk to "The Name Game," "Come See about Me," "All Day and All of the Night."

We partied all night but we also prepartied all afternoon, just hanging around the Factory. The Duchess was always so high on speed that any little thing could send her into an hour-long monologue and I'd just sit there and watch the show. When the news came over the radio in February that Malcolm X was just shot up in Harlem, they were interviewing people at his Hotel Teresa headquarters and that was all the Duchess needed to hear:

"The Hotel Teresa! That's where I had my last abortion."

"You went up to Harlem for an abortion?" I gasped. "Why didn't you go back to your classy Fifth Avenue doctor where you got your first one?"

"Because the first one was the worst pain of my whole life. He did the one where he sticks his hand all the way up me with one of those banana things. *For ten minutes?* It was excruciating."

"He didn't give you a shot for the pain?" I said.

"*Nothing.* He didn't want me to pass out in his office and not be able to get home."

"But isn't anything better than going up to Harlem for an abortion? Weren't you scared?"

"I couldn't face pain again like that first time," she said, "but after the Teresa, my dear, I wished I had. Some woman did one of those packing jobs on me. She told me to go home and exercise, to not just lie in bed, and to call her when I got labor pains in seventeen hours. The next morning—first thing—I went up and down the escalators at Bloomingdale's about fifty times. Then I went home and I was so out of my mind with the

pain that I threw a shoe through the TV. Finally it just dropped in the toilet, my dear, and I haven't been pregnant since."

Just then, from the back of the Factory, we could hear Ondine's voice, apologizing to a trick, "But look how big it is, I'm just sorry it doesn't work on you."

David Whitney, a young kid who worked at the Castelli Gallery, stepped out of the elevator with two very suburban women from Connecticut who were "interested" in my art. I was standing there doing some Flowers for my Paris show coming up in May and talking to the women when Ondine came out from the back holding a huge jar of Vaseline and launched into a whole big tirade against drag queens and transvestites, maintaining that if you couldn't do whatever you wanted to without *any* clothes on—*least* of all women's—then you should forget about sex altogether.

And then he looked at the women—both of them were certainly looking at him—and demanded, "And for the last time, what is a 'gay bar'? What *is* it? Can you tell me?" The ladies just stared at him. One looked intrigued, and the other didn't have any expression at all. Ondine kept it up: "As a homosexual, I will not go to one—why should I be segregated?!"

"That's right—" the Duchess agreed, "—you should be *isolated*. . . ."

"It was the best party of the sixties." That's how Lester Persky rated the party he gave at the Factory for "The Fifty Most Beautiful People" in the spring of '65. "There was certainly no better party. It lasted until five the next afternoon. Did anyone keep a list of who was there?" Lester wanted to know. Of course not.

Judy Garland was definitely there. I watched as five boys car-

ried her in off the elevator on their shoulders. It was odd because that night, for some reason, nobody seemed to notice her. I noticed her, though. I always noticed Judy Garland.

The same way rich kids fascinated me, show business kids fascinated me even more. I mean, Judy Garland grew up on the MGM lot! To meet a person like Judy whose real was so unreal was a thrilling thing. She could turn everything on and off in a second; she was the greatest actress you could imagine every minute of her life.

Even though Lester was the host, since he'd had to go pick Judy up, he didn't get to his own party until very late. Judy was famous for not being ready. For not even dreaming of being ready. She was late for everything. The cameras never rolled until she stepped in front of them, so naturally everything should wait for her all her life, right? She was living at 13 Sutton Place, Miriam Hopkins's house with the red doorway, which everyone used to rent, and you'd walk in and a couple of hours later she'd be almost ready to start getting ready.

When the boys who'd carried her in that night finally set her down on her feet, she started to wobble, so then they picked her back up and set her down on the couch. I went over to Lester and asked him where he'd been all this time. Of course, I knew exactly where he'd been—waiting for Judy—but I hoped my question would get him going, and it did:

"I picked her up," Lester began, holding his drink, looking around the loft, trying to see who was there. David Whitney danced by in the arms of Rudolph Nureyev. "And then after about an hour I said, 'Judy, don't you think we'd better be going?' She told me no, no, there wouldn't be anybody there yet. I said, 'But, Judy, I'm the *host.* I *have* to be there.' Finally, *finally,* we're outside on the street and I raise my hand to hail a cab and

her boyfriend very nonchalantly waves it on. So I raise my hand again, a cab pulls up, and the boyfriend waves it on again. . . ." Tennessee Williams danced by in the arms of Marie Menken.

While Lester and I talked, some boys were attending to Judy. She spotted us and started to get up, but she sank back into the couch. Lester waved brightly, blew her a kiss, and went right on spieling. "*Finally,* after three or four taxis, I asked the guy, 'Is it a *Checker* cab you want or something?' and he said, 'Oh, no, Miss Garland hasn't been in *public* transportation in *years.*' And I said, 'Well, look, I'm not suggesting we take a *bus*—this is a taxi!' But she wouldn't go. There was no way she would even consider it. I was desperate. I said to her, 'Well, can we walk, then? It's only eight blocks.' 'No,' she said. . . .

"The boyfriend went back inside and phoned some old beaten-up limousine service in the Bronx that used to be on call to MGM, and so we had to wait another hour for the limousine to get there . . ."

Edie looked beautiful that night, laughing a lot with Brian Jones. Gerard and the Duchess were staring hard at Juliet Prowse, who'd just broken up with Frank Sinatra. She was really striking, too.

Judy was on her way over to us and when she was a few steps away, she announced to Lester, "I will definitely star in Tennessee's play." Lester whispered to me that she'd been on this kick all night—she'd decided that she wanted to play Flora Goforth in *The Milk Train Doesn't Stop Here Anymore,* which was the first movie Lester was going to produce. (The title was changed to *Boom* for the movie.) Then for a few minutes, she gave us all the different ways she could play Flora until Lester interrupted her and said in a joking way: "The funny thing is, Judy, that Tennessee thinks of you as a great *singer* rather than a great *actress.*"

The funny thing was that that was exactly how Tennessee did feel at the time, I'd heard him say so.

As soon as the words were out of Lester's mouth, he knew he'd made a big mistake; Judy wouldn't drop it. For hours it was "When did he say that? What did he mean? What was he thinking of? How dare he! Where is he?"—every variation on the theme that you can think of.

Finally Judy walked up to where Tennessee was standing with Allen Ginsberg and William Burroughs and pointed back at Lester. "*He* said that *you* said that I can't *act*!"

Lester was going crazy. "My God! She's transmogrified one *remark* into a complete *visitation*!" He went over to where they all were and I could see the drama going on for at least another hour.

Meanwhile, one of my favorite people, Brigid Berlin, had come over and was busily telling me a story. I didn't realize why, though, until she was all finished, and as usual with Brigid, that took a long time.

"Once," she said, "I was out with some piss-elegant queen who said he'd been to one of my infamous lunches on Fire Island the summer I was spending all my money." She was talking about the summer she married a window dresser, came into a trust fund, and spent practically all of it throwing parties in Cherry Grove, renting helicopters to fly into the city to pick up her mail. Brigid was another one of those people I loved who didn't take money seriously, who knew how to have fun with it. Of course, she was from a rich family and she knew that even if they didn't exactly support her, she'd still always be in close contact with money.

Brigid's father was Richard E. Berlin, the president of the Hearst Corporation, and she'd grown up on Fifth Avenue overhearing phone conversations between her father and U.S. presidents. She'd told me that the first time she saw Judy Garland

in *The Wizard of Oz,* it was in the screening room at San Simeon and teenaged Elizabeth Taylor was sitting right next to her. But by the time I met Brigid, she was living in two-star hotels, mostly on the West Side, under the name of Brigid Polk. Her parents were totally disgusted with the way she'd gone through so much money that summer and weren't going to pay for her anymore except for her basic hotel bill. Brigid and her younger sister, Richie, had never gotten along with their parents anyway, and by this time they'd each been told, "You live your life, your father and I will live ours." When Brigid brought her window dresser fiancé home to meet the family, her mother told the doorman to tell him to wait on a bench across the street in Central Park. Then she handed Brigid her wedding present—a hundred-dollar bill—and told her to go to Bergdorf's and buy herself some new underwear with it. Then she added, "Good luck with that fairy." However, right after that an old family friend died, leaving each of the four Berlin kids a big trust fund. Brigid's was totally gone by October. But she was so charming she could always talk anybody into cab fare.

So I knew exactly what period of her life she was talking about, the minute I heard her say she had a limousine, because she sure didn't have limousines anymore.

"Anyway," she said, "this queen I was out with invited me to stop by his townhouse. He said, 'I live with Mahhhhn-tee,' and when I heard that, I thought, why not? Because I hadn't seen Monti Rock III since I made scrambled eggs for him in Cherry Grove. As soon as we got to this townhouse, he went right upstairs, leaving me all alone in the living room. It was about six o'clock in the morning and the sun was beginning to come in the windows and there I'm sitting, waiting for Monti Rock III. A guy with tousled hair and horn-rim glasses on came down in

a blue terry-cloth robe and said hello to me very nicely and put on some music. . . ." I looked over at Edie, who was mussing Brian Jones's hair and laughing with Donald Lyons.

"Andy, *listen* to this, it's funny!" Brigid said. "The guy came over and sat down next to me on the couch, and I just sat there waiting for Monti. Meanwhile the guy who brought me came in and began fixing drinks. I admired a miniature French chair and he said, 'That was a gift from Liz,' and it still didn't click until I turned to the side and realized that this guy with his arm around me was Montgomery Clift! And I was *wrecked.* All I could think to say was 'You were great in *Judgment at Nuremberg.*'

"There!" Brigid said, pointing across the room, and now I saw why she'd been telling me about Monty Clift—he was there at the Factory, too. I asked Brigid if she'd gone over yet to say hello, and she said, "No, he's too out of it."

Suddenly I heard Judy scream, "Rudy!" and she staggered forward with her arms out toward Nureyev, who yelled back, "Judy!" and walked toward her, and it was stagger/step/Rudy!/Judy! back and forth until she fell around his neck saying, "You filthy Communist! Do you know that Tennessee Williams thinks *I* can't act? Let's go find out if he thinks *you* can dance . . ."

The "What does he *mean* I can't *act?*" chaos went on into the next day, and she made Lester give her a dinner that night so she could continue to confront Tennessee.

Judy's favorite meal was spaghetti, but I didn't know it in those days—I always assumed Lester was just being cheap, having pasta all the time. But that was actually all she ever wanted. We'd go to the Café Nicholson on East 58th Street a lot and even when it was closed, Johnny Nicholson would come in especially to cook his special spaghetti for Judy. He'd even go over

to Lester's to cook it for her there—which was what happened that night. We were all sitting around the table and Judy was telling us how Mr. Mayer—she always called Louis B. Mayer "Mr. Mayer"—had her under analysis for years, and Tennessee asked her, "Well, did it help any?"

"No, it obviously didn't," she said to Tennessee, "because according to *you* I still can't *act*." Then she turned to the rest of us and continued, "But how *could* it help? I would never tell him the truth."

And Tennessee was appalled. "You lahhhhed to yo' analyst? Oooo, that's a crahhhhm, that's a see-yin!"

Judy said she found out later that her analyst was on the MGM payroll and was being paid by Mr. Mayer to tell her, "Don't fight with your employers—they love you." And Lester just couldn't get over that, he kept saying over and over, "That's a frightening thing . . . really frightening . . ."

Then Judy burst out laughing, opening her mouth wide, with strands of spaghetti overflowing at the corners, and started singing: "*Some-where / o-ver the rain-bow*"—I just couldn't believe it. I thought, "This is outrageous. Here's *Judy Garland* sitting right across from me belting 'Somewhere Over the Rainbow' with a mouth full of spaghetti!"

Gerard always said that it was at "The Fifty Most Beautiful People" party that the stars went out and the superstars came in, that there were more people staring at Edie than at Judy. But to me, Edie and Judy had something in common—a way of getting everyone totally involved in their problems. When you were around them, you forgot you had problems of your own, you got so involved in theirs. They had dramas going right around

the clock, and everybody loved to help them through it all. Their problems made them even more attractive.

You never had to buy things in the sixties. You could get almost anything for free: everything was "Promotion." Everybody was pushing something, and they'd send cars for you, feed you, entertain you, give you presents—that's if you were invited. If you weren't invited, things would run about the same, only they wouldn't send the car. Money was flowing, flowing.

A publicist once asked Danny Fields, "How can I get the Factory people to come to this opening?" Danny told him, "No problem. You don't even have to tell them what it is. Just send a limousine, and tell them to go downstairs. I guarantee when it pulls up they'll all file right into it." We did.

I remember when Sam Green had to get his entire apartment furnished free in one day that spring. He'd gotten so excited about moving that he'd already invited hundreds of people to a party at his new place the next night before he realized that he didn't have anything for them to sit on. So he was up at the Factory all day making calls. I'd hear him phoning kindergartens, saying desperate things like "But what about those mats that the kiddies take their naps on? Couldn't I rent some of those? Because you see, I'd have them back to you the next afternoon. . . ." He hung up the phone and moaned, "What can I dooooo? I've only got fifty-six dollars in my checking account!" I told him he'd think of something.

"But listen," he said. "I've called everywhere—Hertz Rent-A-Cushion. Everything's so *expensive*." I told him, "You're being dumb, Sam. If you're willing to pay for it, they know you're

poor: rich people don't *pay* for things. Tell them you want it *free*. Don't be such a loser. Think rich. Call Parke Bernet, call the Metropolitan Museum!"

Sam thought of a better one. He dialed a famous fur designer he'd met at a party the week before, refreshed the introduction, then plunged into "I'm giving a party tomorrow night . . . What? . . . Oh, no, no, I'm not *inviting* you, it's just this boring business thing I'm stuck with—for some art collectors, but *Life* is sending their photographer to cover it and they want some kind of a theme, a texture or something. They've seen Warhol's Silver Factory and they feel they've got to have wall-to-wall something, so I told them I'd have my apartment done up for them in plastic or fur or whatever. 'Photogenic,' you know . . ." etc., etc.

The next morning a truck pulled up in front of Sam's new place on West 68th Street with forty-two thousand dollars' worth of furs, bonded, and he signed for them. He threw them all over the place—even out on the terrace—and that night everyone was lying around on minks and lynxes and foxes and seals, with hundreds of candles and a big fire blazing—the place looked great.

There were a few guys in the latest velvets and silk shirts, but not too many—the boys were still mostly in blue jeans and button-down shirts. Edie brought Bob Dylan to the party and they huddled by themselves over in a corner. Dylan was spending a lot of time then up at his manager Al Grossman's place near Woodstock, and Edie was somehow involved with Grossman, too—she said he was going to manage her career.

I'd met Dylan through the MacDougal Street/Kettle of Fish/ Café Rienzi/Hip Bagel/Café Figaro scene, which Danny Fields claims got started when he and Donald Lyons saw Eric Ander-

sen, the folk singer, on MacDougal and thought he was so hand-
some they went up and asked if he wanted to be in an Andy
Warhol movie. "How many times did we all use *that* one?" Danny
laughed. And after that Eric got interested in Edie and suddenly
we were all just around the Village together. But I think Edie ac-
tually knew Dylan because of Bobby Neuwirth. Bobby was a
painter who originally started singing and guitar playing up in
Cambridge just to make money to paint with, he told me once.
Then he hooked up with Dylan and became part of that
group—he was something like Dylan's road manager-confidant.
And Bobby was a friend of Edie's.

At Sam's party Dylan was in blue jeans and high-heeled boots
and a sports jacket, and his hair was sort of long. He had deep
circles under his eyes, and even when he was standing he was all
hunched in. He was around twenty-four then and the kids were
all just starting to talk and act and dress and swagger like he did.
But not many people except Dylan could ever pull that anti-act
off—and if he wasn't in the right mood, he couldn't either. He
was already slightly flashy when I met him, definitely not folksy
anymore—I mean, he was wearing satin polka-dot shirts. He'd
released *Bringing It All Back Home,* so he'd already started his rock
sound at this point, but he hadn't played the Newport Folk Fes-
tival yet, or Forest Hills, the places where the old-style folk people
booed him for going electric, but where the kids started going
really crazy for him. This was just before "Like a Rolling Stone"
came out. I liked Dylan, the way he'd created a brilliant new style.
He didn't spend his career doing homage to the past, he had to
do things his own way, and that was just what I respected. I even
gave him one of my silver Elvis paintings in the days when he
was first around. Later on, though, I got paranoid when I heard
rumors that he had used the Elvis as a dart board up in the

country. When I'd ask, "Why would he do that?" I'd invariably get hearsay answers like "I hear he feels you destroyed Edie," or "Listen to 'Like a Rolling Stone'—I think you're the 'diplomat on the chrome horse,' man." I didn't know exactly what they meant by that—I never listened much to the words of songs— but I got the tenor of what people were saying—that Dylan didn't like me, that he blamed me for Edie's drugs.

Whatever anyone may have thought, the truth is I never gave Edie a drug, ever. Not even one diet pill. Nothing. She certainly was taking a lot of amphetamine and downs, but she certainly wasn't getting any of them from me. She was getting them from that doctor who was shooting up every Society lady in town.

Now and then someone would accuse me of being evil—of letting people destroy themselves while I watched, just so I could film them and tape record them. But I don't think of myself as evil—just realistic. I learned when I was little that whenever I got aggressive and tried to tell someone what to do, nothing happened—I just couldn't carry it off. I learned that you actually have more power when you shut up, because at least that way people will start to maybe doubt themselves. When people are ready to, they change. They never do it before then, and sometimes they die before they get around to it. You can't make them change if they don't want to, just like when they do want to, you can't stop them.

(I did eventually find out what Dylan did with that silver Elvis. More than ten years later, at a time when similar paintings of mine were estimated at five or six figures, I ran into Dylan at a party in London. He was really nice to me, he was a much friendlier person all around. He admitted that he'd given the painting away to his manager, Al Grossman, and then he

shook his head regretfully and said, "But if you ever gave me an-
other one, Andy, I wouldn't make that mistake again. . . ." I
thought the story was finished then but it wasn't. Shortly after-
ward I happened to be talking to Robbie Robertson, guitarist in
the Band, and he started to smile when I told him what Dylan
had just told me. "Yeah." Robbie laughed. "Only he didn't ex-
actly *give* Grossman the painting—he *traded* it. For a sofa.")

Sixty-five was a friendly year, though, on the whole. Everybody
mixed and mingled together all over town. Marisol was at Sam's
fur party, and Patty and Claes Oldenburg, and Larry and Clarisse
Rivers. Sam walked around feeding people grapes, telling any-
body who asked where the furs had come from. That was very
sixties—being proud of getting things for free. In the fifties
people made believe they'd paid a lot for stuff, but in the sixties
they would be embarrassed to admit it if they had.

We filmed a lot of movies over at Edie's place on 63rd Street near
Madison. Things like the *Beauty* series that was just Edie with a
series of beautiful boys, sort of romping around her apartment,
talking to each other—the idea was for her to have her old
boyfriends there while she interviewed new ones. All the movies
with Edie were so innocent when I think back on them, they
had more of a pajama-party atmosphere than anything else.

Edie was incredible on camera—just the way she moved.
And she never stopped moving for a second—even when she
was sleeping, her hands were wide awake. She was all energy—
she didn't know what to do with it when it came to living her
life, but it was wonderful to film. The great stars are the ones
who are doing something you can watch every second, even if
it's just a movement inside their eye.

Whenever you went over to Edie's, you felt like you were about to be arrested or something—there were always a lot of cops patrolling her block (they were guarding some consulate across the street). When I first knew her, she had a limousine and driver parked out front at all times, but after a little while, the limo was gone. Then she stopped buying couture clothes. Someone told me that she'd finally used up her whole trust fund and that from now on she was going to have to live on five hundred dollars a month allowance from home.

But I still couldn't figure out whether she really had money or not. She was wearing dime-store T-shirts instead of designer clothes, but still it was a fabulous look that anyone would have wanted to have. And she was still picking up the checks every night for everybody—she'd sign for everything every place we went. But again, I couldn't figure out if she knew the management or if somebody was paying all her bills or what. I mean, I couldn't figure out if she was the richest person I knew or the poorest. All I knew was that she never had any cash on her, but then that's a sign of being *really* rich.

I filmed a movie—*Poor Little Rich Girl*—of Edie talking about being a debutante who'd just spent her inheritance—talking on the phone, walking back to her bed, showing off the white mink coat that was her trademark.

I always wanted to do a movie of a whole day in Edie's life. But then, that was what I wanted to do with most people. I never liked the idea of picking out certain scenes and pieces of time and putting them together, because then it ends up being different from what really happened—it's just not like life, it seems so corny. What I liked was chunks of time all together, every real moment. Somebody once asked Mario Montez what working

with me was like, did I "rehearse" the actors, etc., and Mario told
them that since rehearsing was related to editing, naturally some-
one who wouldn't edit his movies wouldn't rehearse them either.
That was exactly right. I only wanted to find great people and let
them be themselves and talk about what they usually talked about
and I'd film them for a certain length of time and that would be
the movie. In those days we were using Ronnie Tavel scripts for
some of the movies, and for others we just had an idea or a theme
that we gave people to work with. To play the poor little rich girl
in the movie, Edie didn't need a script—if she'd needed a script,
she wouldn't have been right for the part.

L'Aventura was a restaurant near Bloomingdale's that we used to
hang out at. We went there or to the Ginger Man every night
for a while in '65—after the Factory, eight or ten of us, lots of
the Cambridge kids, and usually Gerard.

The way it was working out was that Gerard influenced
everything we did away from the Factory, while Billy had got-
ten to be the main influence at the Factory itself. Gerard kept
up with fashion and the arts and he was good at inviting all the
celebrities we met to come by the Factory. And since he abso-
lutely worshiped fame and beauty, he made the celebs feel good,
even if nobody else who was hanging around recognized them.

One May afternoon when we were filming a movie at
L'Aventura, a young kid named Stephen Shore came by to take
pictures of us. He'd made a short film that was shown at the
Film-Makers' Coop the same night in February as my *The Life
of Juanita Castro* and afterward he'd come over to me and asked
if he could come by the Factory—he was taking still photo-
graphs and had heard that there was a lot going on there.

I was busy doing the Flowers for my Paris show at the end of the month and working on self-portraits and the cow wallpaper. I'd be at the table for hours, cutting up pieces of colored paper to see how things would look in different colors, and Stephen took a lot of pictures of me like that. Gerard was usually over in a corner doing poetry that he based on lines from other people's work, so he would have an open book in one hand and be writing with the other. Billy would just be in the back, picking out opera records from the stack beneath the metal counter where the record player was and talking to his friends when they came by. Occasionally he'd hang up a sign that said NO HANGING OUT or NO DRUGS ALLOWED ON THE PREMISES to discourage people who weren't discreet, especially after I'd gotten very upset at seeing a guy I'd never laid eyes on before standing in the middle of the Factory shooting himself up. I definitely did not want any trouble from the police, and Billy knew that.

Stephen could never get over the people at the Factory. I heard him tell someone once, "They just sit there. It's not like they're reading, it's not like they're meditating, it's not even like they're sitting watching: they're just *sitting*—staring into space and waiting for the evening's festivities to begin."

For my show in Paris, Ileana Sonnabend was going to send me a boat ticket, but instead, I talked her into sending four plane tickets so Edie and Gerard and Chuck Wein could come along with me. Chuck was a tall, good-looking Harvard guy with blond hair and green eyes, and he and Edie were together a lot— he gave her "career advice," she said.

In France they weren't interested in new art; they'd gone back to liking the Impressionists mostly. That's what made me decide to send them the Flowers; I figured they'd like that.

Ileana was Rumanian. She'd been married to Leo Castelli for many years, and now she had a gallery of her own in Paris. She was glad to send the extra tickets, she said, because she knew that an artist would get more attention—especially in Paris— with a beautiful girl on his arm.

Edie and I had gone to the Metropolitan Museum opening of "Three Centuries of American Painting" in April. Lady Bird Johnson and a whole lot of other swells were there, but the photographers seemed to zero in on us. Edie had her hair cut very, very short and dyed silver to match mine, and that night she looked especially terrific in pink pajamas over just a body stocking. We got a lot of press for that—we even had our picture taken with Lady Bird—so we were eager to get over to Paris and see what would happen there.

We stayed in a suite in a little hotel on the Left Bank, the Royale Bison, where young movie stars like Jane Fonda stayed, near Ileana's gallery at 37 Quai des Grandes-Augustins.

We had fun in Paris, staying up all night, going to nightclubs like Castel's and New Jimmy's, which was Régine's club. At Castel's there was this crazy thing where the music would suddenly stop and everyone would just dive onto the dance floor and feel each other up—a free-for-all grope—skirts pulled up, pants pulled down—this happened three or four times a night. They'd just filmed part of *What's New, Pussycat?* at Castel's, and it seemed like the whole town was popping with stars like Terence Stamp, Ursula Andress, Peter Sellers, Woody Allen, Romy Schneider, Capucine, Shirley MacLaine, Peter O'Toole, Dali, Zou Zou, Donald Camel, Vadim, Jane Fonda, Catherine Deneuve, Françoise Dorléac, Françoise Sagan, Jean Shrimpton.

Edie had arrived in France wearing a white mink coat over her T-shirt and tights and carrying one little suitcase. When she

"unpacked" at the hotel, I saw that the only thing she'd brought with her was another white mink coat! She wore one of them to Castel's that night and when someone offered to check her coat, she clutched it around her and said, "No! It's all I've got on!" She had a low, husky voice that always sounded like she'd been crying. The French adored her—and she adored Paris; she'd lived there for a while when she was nineteen, studying art.

I was having so much fun in Paris that I decided it was the place to make the announcement I'd been thinking about making for months: I was going to retire from painting.

Art just wasn't fun for me anymore; it was people who were fascinating and I wanted to spend all my time being around them, listening to them, and making movies of them. I told the French press, "I only want to make movies now," but when I read the papers the next day, they said that I was "going to devote my life to the cinema." The French have their way with English—I loved it.

We didn't go straight back to New York. Everybody wanted to go to Tangier, so I said fine, and a guy we'd run into in Paris, Waldo Balart, decided to come with us.

Waldo's sister had been married to Fidel Castro, who divorced her right before he became premier. There were glamorous rumors that Waldo had escaped from Cuba with a million dollars in a suitcase. (He was very generous and he certainly did support a lot of people, so if the suitcase really existed, there were a lot of people living out of it.) We'd shot *The Life of Juanita Castro* over at his house on West 10th Street in the Village early that year, with a Ronnie Tavel script inspired by Waldo, and Waldo was also in it. Cuba was a running political topic at the time. That past December Che Guevara had been down the

street from the Factory at the United Nations giving a speech. (They'd just installed the Marc Chagall stained-glass windows there, I remember.)

Our movie had a group of people talking about "fags on the sugar plantation." Everyone adored the idea that Raul, the real-life brother of Fidel, who was a defense minister or something like that, was supposed to be a transvestite, so that was a big camp. And even campier were Fidel's on-the-record attempts to become a Hollywood star—we tried to pick him out in an Esther Williams movie that Waldo swore he'd appeared in as an extra.

I was happy as we left Paris for Tangier, because I felt sure, what with all the publicity we'd just gotten in the French press, that Picasso must have heard of us at last. (One afternoon as we were sitting at a sidewalk café, little Paloma Picasso had walked by. Gerard recognized her immediately from seeing her picture in *Vogue*.) Picasso was the artist I admired most in all of history, because he was so prolific.

Tangier smelled everywhere like piss and shit, but naturally everyone thought it was great because of all the drugs.

When we finally got on the plane to go back to New York—we had our seat belts fastened and everything—Chuck leaped up and said, "Wait a minute, I'll be right back." He ran down the steps of the plane and disappeared. We took off. All the way across the Atlantic, I wondered if there was something he knew that we didn't, like, say, that there was a bomb on the plane or drugs in our baggage. When we got to customs, they really checked me out, coming in from Tangier and all that. I was positive they'd give Edie duty problems about the two white mink coats—I mean, after all, it was *June*—but they never even checked her.

Chuck came in on the next flight. I realized he might have bolted just because he'd gotten one of those cosmic flashes that our plane was going to crash. He was from Harvard, after all, which was early LSD country. I never did find out for sure, though.

We brought back a lot of burnouses from Tangier—striped ones that turn up on a lot of people in our photographs and movies from that period.

We drove straight from the airport down to the Village for a double bill of *A Hard Day's Night* and *Goldfinger* and then over to Arthur—we didn't even bother to drop our bags off, we just kept the car.

When you walked into Arthur, straight in front of you was the restaurant and the dancing room was to the right. It was all dark brightness. It was Sybil Burton Christopher's club, of course, and Sybil was an upbeat, outgoing woman—everything was fun! wit-ty! a ball!—the energetic English type that wants everybody to have fun. I met so many stars at Arthur—Sophia Loren, Bette Davis—everybody but Liz Taylor Burton—but the most thrilling thing was meeting an astronaut, Scott Carpenter. (Right in the beginning of June '65, the U.S. space program had two astronauts orbiting who'd just done the first "walk in space" outside their capsule.)

When I got settled being back in New York, Ivan and I had a talk about my decision to retire from painting. I told him as a friend, "I've really stopped painting, Ivan. Maybe I'll do a commission or a portrait once in a while, but at this point I'm bored." Ivan understood what I meant—that I didn't want to keep repainting successful themes. He told me how remarkable

it was that I'd been able to make another career for myself, in movies. I asked him again if he wanted to be in one someday, and he said, "Oh, no, Andy, I'm much too wholesome."

At the time I announced my retirement, Pop Art was finally getting serious attention from art historians and museums.

At the end of June, one really hot night, there was a big party at the Factory for John Rublowsky and Ken Heyman's book, *Pop Art,* and the loft was stifling. The girl next to me in a plastic Courrèges dress, sweating, said that wearing it was like sitting naked on a kitchen chair; it was sticking to her. She had a copy of the book and asked me to autograph it. As I leafed through the pages and looked at the colorplates, I was completely satisfied with being retired: the basic Pop statements had already been made.

In '65 a lot of the girls had the Big Baby look—short little-girl dresses with puffy little sleeves—and they wore them with light-colored tights and those flat school shoes with the straps across them. The tights weren't really tights, though, because when the girls bent over you could see the tops of their stockings where they were attached to garter belts. It's hard to believe that young girls were still wearing contraptions like panty girdles, but they were. (Underwear wouldn't completely disappear until '66, when girls like International Velvet would walk down the street in the dead of winter with no stockings and no underwear. Granted, they'd have on fur coats—but then they were fur *mini*coats!)

More and more boutiques were sprouting up in New York-Paris-London-Rome. New clothes styles were coming out so fast that boutiques were the quickest, most moneymaking way for the really creative designers to get them to the public. With '64 the garment industry got confused—the mass manufacturers

didn't know how much of the market the new look would take over permanently. They didn't know if the new stuff was just novelty playclothes or if girls would start wearing it all to the office, too. Most of the multimillion-dollar manufacturers were being very cautious at first, naturally, and while they hedged, the boutiques moved in.

Paraphernalia opened late in '65, and another trend started—stores opening late in the morning, even noontime, and staying open till maybe ten at night. Paraphernalia sometimes stayed open till two in the morning. You'd go in and try on things and "Get Off My Cloud" would be playing—and you'd be buying the clothes in the same atmosphere you'd probably be wearing them in. And the salespeople in the little boutiques were always so hip and relaxed, as if the stores were just another room in their apartment—they'd sit around, read magazines, watch TV, smoke dope.

This was the summer of "Satisfaction"—the Stones were coming out of every doorway, window, closet, and car. It was exciting to hear pop music sounding so mechanical, you could tell every song by sound now, not melody: I mean, you knew it was "Satisfaction" before the first fraction of the first note finished.

Dylan played his first electronic concerts this summer. The Byrds had done their version of his "Mr. Tambourine Man," and the Turtles had done "It Ain't Me, Babe." He was out of folk and into rock and he'd switched from social protest songs to personal protest songs, and the more private he got, the more popular he got, and it seemed like the more he said, "I'm only me," the more the kids said, "We're only you, too." If Dylan had just been a poet with no guitar, saying those same things,

it wouldn't have worked; but you can't ignore poetry when it shoots into the Top Ten.

That summer, for the first time really, pot was all over the place. But acid still wasn't, it certainly wasn't being dropped out of helicopters yet. You still had to "know somebody."

Not that much dope was being handed around on the Village streets yet, although the Duchess had a friend who hung out around Washington Square with the M taken off the M & Ms and told the kids from the boroughs, "It's dynamite dope, only *don't chew it* because if you do you'll die. See, it has to dissolve *after* it gets to your stomach." He'd deal sugar to little girls from Brooklyn—he wouldn't even bother to mash it up, he'd just take a box of granulated Domino out of his jacket and pour it into something. How did he get away with it? "I'm a spade, man," he'd explain. "They *worship* me. They want to shoot up, I say, 'You girls should sniff it, stay high longer, ask somebody.'"

Kids were so naive about drugs in '65. Nobody knew how to buy dope yet—but a lot of people sure knew how to sell it.

When *Vinyl* was shown at the Cinemathèque down on Lafayette Street in late summer, Gerard brought a young filmmaker named Paul Morrissey by to see it. Paul had been around the underground movie scene for years. He lived downtown in an old storefront on East 4th Street and he and Donald Lyons had gone to Fordham University in the Bronx together. One day in '60, Donald told me, when they were both seniors, "Paul got hold of an 8-mm camera and stole some priests' vestments from behind the altar at Fordham church, and then we went over to the Botanical Gardens with another friend of ours and Paul

filmed us—me as a priest celebrating a brief Mass, giving Communion to an altar boy, and then shoving him off a cliff. It was a silent short. Paul called it *Dreams and Daydreams*." Donald had gone on to graduate school in classics at Harvard and Paul had stayed in New York, working first at an insurance company and then for the Department of Social Services.

(Long after I got to know him—in '69, right before he was going to shoot *Trash*—I saw a couple of his other early films when he showed them one afternoon at the Factory just for fun. One was a color film of a fifties hustler-type kid with slicked-back hair and close-set eyes reading a comic book slowly, slowly, so he looked semiliterate. The other was a black and white one shot on machine gun surplus film, the kind they use when planes take movies of enemy territory. It showed a couple of his social work cases, a black boy and girl shooting heroin and getting their rushes, and with that one Paul put on a reel-to-reel tape of Dionne Warwick singing "Walk On By" and "You'll Never Get to Heaven If You Break My Heart"—he said that was the sound he always screened it with.)

So Gerard introduced us at the *Vinyl* screening in the summer of '65. Paul was busy chatting with Ondine and I said, "How do you know Ondine?" And he said, "How could you *not*?"

They'd been discussing a favorite topic, the Roman Catholic Church, and someone made a crack about "creeps like you two in the Church." Ondine lifted up his head, got very imperious, became the Pope, and informed the "heretic" that it was "a far, far better thing to have creeps like us *in* the Church than on the outside working against it!" Then he turned to Paul with a raised finger and counseled, "My son, we must see a great lesson in this . . ."

Paul and Ondine had one big thing in common aside from the Church—they were both nonstop talkers and everybody just shut up when they were around in order to let the show go on. But with Paul it was a much more subtle thing because he wasn't exactly performing, he was just naturally very outspoken and witty.

Paul didn't take drugs—in fact, he was against every single drug, right down to aspirin. He had a unique theory that the reason kids were taking so many drugs all of a sudden was because they were bored with having good health, that since medical science by now had eradicated most childhood diseases, they wanted to compensate for having missed out on being sick. "Why do they call it experimenting with *drugs?*" he'd demand. "It's just experimenting with *ill health!*"

He had a real "angry young man" look, in photographs especially—he'd always scowl and put his chin down. He dressed in army surplus–type clothes—thirteen-button sailor pants and turtlenecks—while the rest of us all wore the blue jeans–T-shirt uniform. He wasn't into mirrors a lot. He was tall and a little birdlike, with curly hair that he was just starting to keep very full and disheveled in the Dylan style.

Paul knew more about the critical and historical approaches to film—especially Hollywood films—than anybody who'd ever been around the Factory. He knew all the Hollywood trivia, all the character actors, all the obscure scenes in all the obscure movies that all the big stars had been in. He loved George Cukor and John Ford and John Wayne, and he knew about all the cinematographers—foreign and American. He was a very big fan.

Paul had strong opinions about everything. He thrived on being contrary. He had a habit of starting everything off with "No, but . . ."—just in case somebody had said something. And

he was mysterious. The running question was, did he have a sex life or not? Everyone who'd ever known him insisted that he did absolutely nothing, and all his hours seemed accounted for, but still, Paul was an attractive guy, so people constantly asked, "What *does* he do? He must do something . . ."

When he'd introduced us, Gerard had said, "This is a friend of mine, Paul Morrissey, he's very resourceful." And right away Paul began coming by the Factory while we were shooting, to see how we did things and if there was any way he could get involved. At first he just swept the floor or looked through slides and photographs. He'd been wanting to start shooting sound movies himself, but he didn't have the money to rent all the sound equipment. He was fascinated to see our setup and he asked Buddy Wirtschafter, who was then our sound man, a lot of questions. Gerard was right, Paul was very resourceful—eventually to the point where he came to seem magical to us.

We had a videotape machine around the Factory for a few months that summer and fall. It was the first home recording equipment I'd ever seen—and I definitely haven't seen anything like it since, either. It wasn't portable, it just sort of sat there. It was on a long stalk and it had a head like a bug and you sat at a control panel and the camera rejointed itself like a snake and sort of angled around like a light for a drawing board. It was great-looking.

Norelco gave me this machine to play with. Then they gave a party for it. Then they took it away. The idea was for me to show it to my "rich friends" (it sold for around five thousand dollars) and sort of get them to buy one. I showed it to Rotten and Birdie and they wanted to steal it. I remember videotaping

Billy giving Edie a haircut out on the fire escape. It was the new toy for a week or so.

The party for the machine was held underground, on the abandoned New York Central Railroad tracks on Park Avenue under the Waldorf-Astoria. You went in through a hole in the street. There was a band and Edie came in shorts, but there were people all dressed up in gowns who were screaming and dodging the rats and roaches and everything—it was the real thing, all right. Also being promoted at this party was a magazine called *Tape* that was just starting up—and just finishing up, too, as it turned out. It was print supplemented by cassette tapes that you were supposed to play while you read, only it never caught on.

In August there was a big party at Steve Paul's the Scene on West 46th Street; Steve had been the publicist for the Peppermint Lounge. Jackie Kennedy showed up at the Scene one night, and Steve blew up the newspaper articles of it and that put his place on the map.

I didn't even know who was giving the party or what it was for—as usual, we all just went. Somebody said it was a groupie ball—in honor of all the girl groupies who hung out there—but then I read later in some magazine that it had been given by Peter Stark, the son of Ray Stark the producer and the grandson of Fanny Brice, as a going-back-to-school party for himself. During the party, the Scene people projected some of our movies on the wall, something with Edie in her underwear.

Liza Minnelli was there with Peter Allen—I think they were engaged then, Judy had fixed them up. (Liza was just starting out, doing *Flora the Red Menace* on Broadway, dancing with a cast on her leg, even. At the Scene that night I saw a couple of

guys pointing out Liza's and Edie's legs as the best in town.) Jane Holzer was there and Marion Javits and Huntington Hartford and Wendy Vanderbilt and Christina Paolozzi, who was the first model to appear nude in *Harper's Bazaar*. Joan Bennett and Walter Wanger's beautiful daughter, Stephanie, was there—she was married to Winston Guest's tall, handsome son, Freddy—and Gary Cooper's daughter, Maria, and Melinda Moon and one of those tall, leggy, aristocratic Cushing girls from Newport.

Mel Juffe, the evening reporter for the *Journal American,* the afternoon paper, was covering the party, and he decided to write it up as a complete mystery since nobody seemed to know who was giving the party or what it was for. And even after he covered it, it was still a mystery. When the photographs came in, he told me, all the guys in the city room at the *Journal American* stood around trying to guess which was "Edie" and which was "Andy."

By now we were getting pretty notorious around town for being at every party, and reporters loved to write us up and take our picture, but the funny thing was, they didn't really know what to say about us—we looked like "a story," but they didn't really know who we were or what we were doing. And the reporters weren't the only ones who were confused. Eric Emerson, a dancer I met in '66, told me he'd spent that entire year following Tiger Morse around at parties because he thought she was "Andy Warhol who could get me into underground movies." He'd asked somebody once what I looked like and the person had told him, "He's around here someplace—silver hair and sunglasses," and just then Eric flashed on Tiger, who fit that description, too.

Mel met Edie for the first time at that party at the Scene and he really fell for her. When he wrote his party story up, he used the

word *beaming* a few times to describe her. Much later he told
me he felt she was very weak and very strong both—a little girl
who could really take command of a situation when she wanted
to. He made a date to meet us at Arthur after he put his story
to bed, and he was around a lot for the next few months, fasci-
nated, watching Edie.

"When I was seeing you and Edie," he reminded me, "you
two were at your absolute pinnacle as a media couple. You were
the sensation from about August through December of '65. No-
body could figure you out, nobody could even tell you apart—
and yet no event of any importance could go on in this town un-
less both of you were there. People gladly picked up your checks
and sent cars for you—did anything and everything to get to en-
tertain you. And one of your favorite jokes at the time was shov-
ing different people forward and saying they were you . . ."

I remember one afternoon a group of us, including Edie and
Gerard and Mel and Ingrid Superstar, a big tall blonde from
New Jersey who'd just come on the scene, all walked over to the
opening of *Darling* at the Lincoln Art Theater on West 57th
Street. As usual, the movie was over by the time we got there.
Mel pointed at two bottles of champagne with six paper cups set
on a table out in the lobby and laughed—"This is *easily* the tacki-
est party of the season. . . ." And as if that weren't bad enough,
the manager was just getting up to make a speech—with a mi-
crophone yet—to a group of people who'd sort of wandered in
off the street. Somebody must have told him, "Edie and Andy
are here," because he spent two minutes giving a warm welcome
to "Edie and Andy," thanking them profusely for coming, be-
fore he looked around, blank, and said, "Now, uh, will Andy and
Edie please step forward?" He had absolutely no idea which ones
we were. So Edie and I pushed Ingrid and Gerard toward him,

and the manager thanked them some more. It was a case of "We're thrilled to have you. Who *are* you?" But that was the way it was all over town—people were glad to have us at their parties, but they weren't exactly sure why they should be glad. It was a lot of fun because it made absolutely no sense.

After that gala opening, we went down to a place on Christopher Street called the Masque that only lasted a couple of weeks. Everybody there dressed in tinfoil and the only thing they served was Coca-Cola. The guy who ran it had asked Brigid to work as the official hostess, but she'd refused. Before the Masque closed down for good, Ingrid got to give a poetry reading there, and she was thrilled when Dylan wandered into it.

Ingrid was just an ordinarily nice-looking girl from Jersey with big, wide bone structure posing as a glamour figure and a party girl, and what was great was that somehow it worked. She was a riot. She watched all the other girls and would sort of put on airs and try to do what they did. It was so funny to see her sitting there on the couch next to Edie or, later, Nico and International Velvet, putting on makeup or eyelashes exactly the way they did, trading earrings and things and beauty tips with them. It was like watching Judy Holliday, say, with Verushka. We would tease her endlessly, like tell her she was in the running for the next Girl of the Year.

"Fabulous!" Ingrid said. "What do I have to do to make it?"

"Go into seclusion," somebody advised her.

"I can't go into *seclusion*—I'm lonely enough as it *is!*"

In the middle of all her airs, she'd suddenly come from behind like that with total honesty that cut right to the point. Deep down, Ingrid was absolutely unpretentious.

We took her everywhere with us, she was so much fun, so easygoing—the type of girl who'd jump up and do the pony no

matter what year it was. And she wore go-go boots, she really did, and her poems were good, really good, half poetry and half comedy. And everywhere we went, she thought she knew somebody. You know the routine: "Is that—? That guy looks like this guy I— Is it? . . . Is it? No, it really *looks* just like him, though . . ."

During the summer and fall, Edie started saying she was unhappy being in underground movies. One night she asked Mel and me to meet her at the Russian Tea Room for a "conference." She wanted him to arbitrate while she explained to me how she felt about her career. That was one of her standard ploys—getting everyone involved in whether she should do this or that. And you really did get involved. That night she said she'd decided that she definitely was going to quit doing movies for the Factory.

Jonas Mekas had just offered us a lot of consecutive nights' screenings at the Cinemathèque to do whatever we wanted with, and we thought it would be fabulous to have an Edie Sedgwick Retrospective—meaning, all of her films from the last eight months. When we'd first thought of it, we all thought it was hilarious, including Edie. In fact, I think Edie was the one who thought of it. But now, this night at dinner, she was claiming that we only wanted to make a fool out of her. The waiter moved the Moscow Mules aside and put our dinners down, but Edie pushed the plate aside and lit up a cigarette.

"Everybody in New York is laughing at me," she said. "I'm too embarrassed to even leave my apartment. These movies are making a complete fool out of me! Everybody knows I just stand around in them doing nothing and you film it and what kind of talent is that? Try to imagine how I feel!" Mel reminded her that she was the envy of every girl in New York at that moment,

which she absolutely was—I mean, everybody was copying her look and her style.

Then she attacked the idea of the Edie Retrospective specifically, saying that it was just another way for us to make a fool out of her. By now I was getting red in the face; she was making me so upset I could hardly talk.

I told her, "But don't you *understand*? These movies are art!" (Mel told me later that he was floored when he heard me say that: "Because your usual position was to let other people say that your movies were works of art," he said, "but not to say it yourself.") I tried to make her understand that if she acted in enough of these underground movies, a Hollywood person might see her and put her in a big movie—that the important thing was just to be up there on the screen and let everybody see how good she was. But she wouldn't accept that. She insisted we were out to make a fool of her.

The funny thing about all this was that the whole idea behind making those movies in the first place was to be ridiculous. I mean, Edie and I both knew they were a joke—that was why we were doing them! But now she was saying that if they really were ridiculous, she didn't want to be in them. She was driving me nuts. I kept reminding her that *any* publicity was good publicity. Then, around midnight, I was so crazy from all the dumb arguing that I walked out.

Mel and Edie stayed up talking until dawn, and finally she made some sort of "decision." "But you could never expect anything too systematic from Edie's thinking," Mel told me later, "because the next afternoon when I called her, everything she'd 'decided' was all changed around."

That was essentially the problem with Edie: the mood shifts

and the mind changes. Of course, all the drugs she was taking by now had a lot to do with that.

Anyway, she did make some more movies with us.

We were showing our films like *Screen Test,* the *Beauty* series, and *Vinyl* all that summer at the Factory and at the Film-Makers' Coop, which was now down on Lafayette Street. Even though we never knew ourselves till the very last minute which films we were going to screen, somehow, as if by magic, the people who were in the movie, or friends of theirs, would always know to turn up. (*Screen Test* was Ronnie Tavel off-camera interviewing Mario Montez in drag—and finally getting him to admit he's a man. And *Vinyl* was our interpretation of *A Clockwork Orange* with Gerard as a juvenile delinquent in leather saying lines like "Yeah, I'm a J.D.—so what.")

Over the Labor Day weekend we went out to Fire Island to shoot *My Hustler* starring Paul America. Lester Persky had "discovered" Paul at the discotheque Ondine and brought him around to the Factory. Paul was unbelievably good-looking—like a comic-strip drawing of Mr. America, clean-cut, handsome, very symmetrical (he seemed to be exactly six feet tall and weigh some nice round number). I don't remember how he got the name Paul America, unless it was because he was staying at the Hotel America on West 46th Street between Sixth and Seventh avenues, a super-funky midtown hotel that was the kind of place Lenny Bruce, say, stayed in.

The minute we got off the Fire Island ferry, lugging our movie equipment in all those heavy metal suitcases, we had to rush to meet a friend of Rotten Rita's called the Sugar Plum Fairy

in a gay bar in Cherry Grove so he could show us the way to the house we were supposed to be staying at. As the two Pauls— Morrissey and America—walked through the bar holding the suitcases high over their heads and maneuvered their way through the crowd, someone yelled, "Oh, look! Honeymooners!"

We filmed *My Hustler* in black and white. It was the story of an old fag who brings a butch blond hustler out to Fire Island for the weekend and his neighbors all try to lure the hustler away.

Years later I read an interview with Paul America in *The New York Times* where he stated that he'd been on LSD all during the shooting. I didn't know that, specifically, at the time, but what I did know was that there was a *lot* of it out there that weekend. We were with the Cambridge kids again, and they were slipping it into everything. I made sure I only drank tap water, and I only ate candy bars where I could tell if the seal had been broken. Believe me, I knew these people well enough to know that if you spent a weekend with them, you'd get a dose of acid if you weren't careful.

Speaking of acid, Gerard took his first trip shortly after we moved to the Factory in January of '64. I walked in one day and there he was with a broom in his hand, crying and sweeping up the loft. Now this—the sweeping—was the kind of thing Gerard never did. He was a good worker as far as stretching and crating went, but one of his big shortcomings was that he could be very slobby (you'd open up his desk drawer and mixed in with notebooks and papers would be his dirty laundry), so when I saw him actually sweeping up, I was stunned. I said to Billy, "What's wrong with him?" And Billy lifted his head up and turned to me slowly and said, "He's . . . tripping." Apparently Billy was, too.

Everybody has different stories about who had acid that weekend and who didn't. All anyone agrees on is that we had a Crystals record called "He Hit Me (and It Felt Like a Kiss)" playing over and over day and night, which everyone loved because the lyrics were so sick. Gerard said that the acid was in the eggs and that everybody ate the eggs, including him. Stephen Shore said that he saw the Sugar Plum Fairy put it in the orange juice and that everybody drank the juice, except him. For months afterward Gerard insisted that the acid was in the scrambled eggs and that I had some. We had long fights about it.

"Everybody ate the scrambled eggs, Andy. *Paul* ate the eggs, *I* ate the eggs, *you* ate the eggs—we *all* ate the eggs! I *saw* you eat them. Admit it!"

"I did *not,*" I'd insist. "I knew they were going to put it in the eggs, so of course *I didn't eat any.* I wasn't eating anything there anyway!"

"Andy, I *saw* you eat them."

"You were tripping, right? So then you hallucinated it, because *I* didn't have any."

"Why don't you just admit it," Gerard would keep saying. "It was beautiful, a beautiful trip. No one had a bad trip, not even Paul *Morrissey!* I mean, when we found him beside the boardwalk in the fetal position, he was *smiling.* . . ."

"Look, Gerard, maybe *Paul* ate the eggs, maybe *you* ate the eggs, maybe *everybody in Cherry Grove* ate the eggs, but *I* did *not!*"

"Andy. We came into the kitchen and you were on the floor picking up the garbage and putting it into bags in a very childish, very peculiar way."

Gerard obviously thought people only cleaned when they tripped. I could never convince him that I absolutely hadn't had

anything that was going around, that I was really living off candy
bars and tap water the whole weekend.

It was funny to watch them all tripping, though. The night
everyone was on acid, they marched in a pilgrimage from the
house to the beach, pretending they were Columbus or Balboa
or, anyway, someone out to discover the New World—and it
was all very primal until somebody looked down at the Fire Is-
land shoreline and saw a jar of Vaseline.

This is the only time I know of that Paul Morrissey appar-
ently got dosed with LSD and I noticed he was much more care-
ful about what he ate at parties after that weekend. As I said,
Paul was against *all* drugs and he definitely hadn't wanted to take
any LSD, so he was embarrassed about it to the point where he
began to deny the whole thing. However, I saw him in the fetal
position beside the boardwalk, and, to tell you the truth, he *was*
smiling.

By now we were obsessed with the mystique of Hollywood, the
camp of it all. One of the last movies we made with Edie was
called *Lupe*. We did Edie up as the title role and filmed it at
Panna Grady's apartment in the great old Dakota on Central
Park West and 72nd. Panna was a hostess of the sixties who put
uptown intellectuals together with Lower East Side types—she
seemed to adore the drug-related writers in particular. We'd all
heard the stories about Lupe Velez, the Mexican Spitfire, who
lived in a Mexican-style palazzo in Hollywood and decided to
commit the most beautiful Bird of Paradise suicide ever, com-
plete with an altar and burning candles. So she set it all up and
then took poison and lay down to wait for this beautiful death
to overtake her, but then at the last minute she started to vomit

and died with her head wrapped around the toilet bowl. We thought it was wonderful.

Edie would still vacillate between enjoying the camp of making movies with us and worrying about her image, and by vacillate I mean she'd go back and forth from hour to hour. She could be standing, talking to a reporter, and she'd look over at us and giggle, then tell him something arch like "I don't mind being a public fool—as long as I'm communicating myself and reaching people." That was one side of her, putting the media on like that. But then fifteen minutes later, she'd be having a dead serious tantrum that she wasn't being taken seriously as an actress. It was a little insane.

Larry Rivers had a retrospective at the Jewish Museum on upper Fifth Avenue in September, and I'll always remember the way the people there were dressed. Larry poked me excitedly and said, "Look at that girl! Girls are showing parts of their bodies in public now that they've never shown before! You have the desire and then you have an object that somehow catches it, and then you have this incredible bursting out!" Larry was looking around the place, as excited by the bright colors and all the styles as I was. (He was talking about the girls, because the boys weren't that brave yet. But in a couple of more years you could look around any party and be saying the same things about the boys.) It was good that people were coming dressed like this to art openings. In another year, though, they'd be skipping the openings altogether and just going straight to Max's, which became the gallery for that whole attitude.

•••

We went to Philadelphia a few times in '64 and '65. Sam Green knew a lot of people there, and carloads of us would drive down. In '65 Sam got made the director of exhibits at the Institute of Contemporary Art on the University of Pennsylvania campus. We used Philadelphia as a backdrop for a lot of the movies we shot, and we screened quite a few of our movies down there, too. Sometimes Sam's rich distant cousin Henry McIlhenny would have dinners for us in his townhouse on Rittenhouse Square with a footman behind every chair and we'd be sitting there in Queens College sweatshirts. (Cecil Beaton was at one of those dinners and when I asked him if I could do his portrait, he said of course, so we went right upstairs and I drew his foot with a rose between his toes.)

When Sam started at the institute, there was an advisory board and a university governing thing, and a couple of the governors wanted to have Gauguin and Renoir retrospectives. Sam told me, "Fortunately they don't have the budget to do anything that boring." What he suggested instead was that they have an Andy Warhol retrospective. They were very reluctant at first, so he told them that if they agreed to this Pop thing, they could all work on an Abstract Expressionist show next and wouldn't that be fun. Finally they decided that they couldn't make this decision themselves, they'd have to send a delegate up to New York to make it for them.

Sam had this good friend called Lally Lloyd—her husband was H. (for Horatio) Gates Lloyd, one of the heads of the CIA, and she herself was a Biddle from the Main Line with a big estate. Sam introduced us at a dinner that the art dealer Alexandre Iolas gave for Nicky de St. Phalle at the Café Nicholson. (Right before the dinner he'd told me, "Now *please* don't do your monosyllabic shy act and ruin everything.") Mrs. Lloyd was

telling me how flattering it was that I was considering their tiny little museum for a show (it would be my first nongallery show, actually) when out of the blue I asked her if she wanted to be in a movie.

"She asked you what she'd have to do," Sam reminded me, "and when you deadpanned, 'Have sex with Sam,' she thought you were so outrageous that from then on everything went beautifully—and the main thing was she liked your work. And she got the museum advisory board to allot four thousand dollars for the exhibition. Of course, it wound up costing a lot more, but we raised the rest ourselves by getting you to do the Green Stamps poster for the exhibition and having blouses made out of silk printed up with Green Stamps on them, and there was even enough silk left over to make a tie for me. And then, remember, I wheedled actual labels out of the Campbell's Soup Company and printed the invitation for the October 7–November 21 exhibit on the back side of them."

Sam arranged about four solid months of publicity before the show. He got a few of our films screened in theaters around town and on the Penn campus, and he sent Philadelphia society reporters up to New York to interview us. "I've told them to make sure to get scandalous photos."

Sam had Society teeth and a beard and he especially liked Society ladies who were dying not to be stuffy anymore. He'd say things to them like "There's this madman named Warhol who brings his entourage into your house and apparently makes an entire movie in an afternoon. You must meet him." And since Sam knew about drag queens and offbeat things, the ladies thought he was fun. I met a lot of grand gals with Sam who were out looking for fun.

• • •

One thing, you'd never have to arrange for a photographic sitting at the Factory. It would all just happen. On almost any afternoon in '65 you could count on having Billy there listening to Callas, Gerard writing poetry or helping me stretch, a great little high school go-fer with a Beatle haircut named Joey Freeman coming in and out with paint supplies, Ondine going back and forth from Billy to me to the phone, a few kids just hanging around dancing the afternoon away to songs like "She's Not There" and "Tobacco Road," and there'd be Edie maybe putting on makeup in the mirror. Baby Jane would stop by a lot, although she was never one to hang around all day. Then there'd always be some art collector types wandering around—guys in three-piece suits touring women in leopard-skin coats through, looking from side to side, "inspecting."

Reporters and photographers would arrive and try to figure out what was going on.

Since I never knew what was going on myself, I loved to read the articles. It was always interesting to see which reporters concentrated on which people—if they were fascinated with the boys or the girls, and going along from there, which boys or girls. They had their pick of who to write about, so you could tell more about the reporters than the Factory from reading their stuff. The Factory brought out strange things in people. By "strange" I don't necessarily mean "wild! uninhibited!" I mean atypical—it could even bring out, say, a puritanism that a person didn't know he had. A reporter from the *Washington Post* once told me that she'd picked the Andy Warhol Factory for an assignment when she was a student at the Columbia University School of Journalism and that she'd had a nervous breakdown in the middle of it. She went to her professor and told him she didn't think she could be a journalist after all, that she was going

to drop out, that she just couldn't handle the assignment, didn't know what to say about the place, couldn't be objective, etc., etc. The professor sat her down, she said, and told her, "Look. What you've just been through is like a freak accident—it will never happen again. You picked the Warhol Factory as your subject, and even veteran reporters who spend days there don't know what to make of it—they come away not even knowing how they should spell *Factory*! Just forget about this experience. Pick another topic and things will go better, you'll see."

So Sam got Philadelphia reporters to come by with their notepads to glance around. In those days practically no one tape-recorded news interviews; they took notes instead. I liked that better because when it got written up, it would always be different from what I'd actually said—and a lot more fun for me to read. Like if I'd said, "In the future everyone will be famous for fifteen minutes," it could come out, "In fifteen minutes everybody will be famous."

By now Edie had been in both *Time* and *Life,* and a lot of the Philadelphia people had seen our movies of her, and all the reporters had stimulated everybody's imagination about what really went on at the Factory. Still, we didn't expect the mob scene that eventually happened at the opening.

I didn't get a student perspective on that opening until '68 when I met a girl named Lita Eliscue who was working for the *East Village Other.* Back in '65 she'd been an undergraduate at Penn ("in Candice Bergen's class," she volunteered) and she told me, "The people who sponsored you were the Tastemakers, the ones who were already out in the real world doing glamorous things, and of course glamour was what everyone was looking for. So

when we heard that you were coming down, we all wanted to see and touch New York! Myth! Glamour!" Lita was a very little girl, under five feet. I used to introduce her as the Monet Jewelry heiress because her father owned Monet Costume Jewelry. (I asked her once why he'd named it that and she said it was because he liked French Impressionism.) In '68, when she was telling me all this, she was in her twenties but she looked like she was still twelve—her face was absolutely preteen—but then out of her mouth would come this very modulated, officious voice that would every once in a while break into giggles. "And when people come face to face with a myth," she continued, "they want to become part of it themselves. Some of the kids at school pretended they actually knew you, Andy. If they'd been to New York once in their lives, they were now suddenly saying they'd been to a party you were at or even worse, they'd actually describe what the Factory looked like—partly from a magazine and partly out of their imaginations."

When we walked into the Philadelphia opening, there were floodlights turned on us and television cameras. It was very hot and I was all in black—T-shirt, jeans, short jacket, what I always wore in those days—and the yellow-lens wraparound sun/ski glasses didn't keep the glare out; I wasn't ready for it.

There were four thousand kids packed into two rooms. They'd had to take all my paintings—my "retrospective"—off the walls because they were getting crushed. It was fabulous: an art opening with no art! Sam stood there in his white jacket and Green Stamps silk tie—the members of the advisory board were running around in their Green Stamps silk blouses—and told the press that nobody came to art openings to see the art any-

way. The music was going full blast and all the kids were doing the jerk to songs like "Dancin' and Prancin'" and "It's All Over Now" and "You Really Turn Me On."

When the kids saw me and Edie walk in, they started actually screaming. I couldn't believe it—one day you're in an art gallery in Toronto and not one person comes in all day to see you, and then suddenly there are people who get hysterical at the sight of you. It was so crazy. Older people in evening gowns were next to kids in jeans. They had to lead us through the crowd—the only place we wouldn't get mobbed was on some iron stairs that led up to a sealed-off door. They put guards at the bottom of the steps so nobody would rush us. All the people we came down from New York with were on these steps—Paul, Gerard, Chuck Wein, Donald Lyons, David Bourdon, and Sam, too. Edie was wearing a pink Rudi Gernreich floor-length T-shirt dress made out of stretchy Lurex-type material. It had elastic sleeves that were supposed to stay rolled up but she unrolled one of them about twelve feet past her arm—perfect for this setup, because she could have a drink in one hand and be draping and dipping and dangling her sleeve over the heads of the crowd below. She was putting on the performance of her life. Every guy wanted to be up there with her—she was looking around for somebody she knew who was going to school down there, calling out for him and everything, and you could tell from the faces on all the boys that they were really envious of whoever it was.

We were on those steps for at least two whole hours. People were passing things up to be autographed—shopping bags, candy wrappers, address books, train tickets, soup cans. I signed some things but Edie was signing most of them "Andy Warhol" herself. There was no way to leave—we knew we'd be mobbed

as soon as we came down. Finally the officials ordered the fire department to break through the sealed off door behind us with crowbars, and we were led out that way, through a library, onto the roof, over an adjoining building, down a fire escape, and into waiting police cars. Now things were getting really interesting.

I wondered what it was that had made all those people scream. I'd seen kids scream over Elvis and the Beatles and the Stones—rock idols and movie stars—but it was incredible to think of it happening at an *art* opening. Even a Pop Art opening. But then, we weren't just *at* the art exhibit—we *were* the art exhibit, we were the art incarnate and the sixties were really about people, not about what they did; "the singer / not the song," etc. Nobody had even cared that the paintings were all off the walls. I was really glad I was making movies instead.

My old friend David Bourdon had seen it happen with his own eyes and was as amazed as I was; he couldn't believe that anyone would actually mob someone like me. "They treated you like a star . . ." he said, very perplexed. But then he rationalized it by saying that it was the first time I'd brought a glamorous superstar to a public appearance in America—which was true. "Well, last year Baby Jane got a lot of attention as the 'Girl of the Year.' . . ." (Tom Wolfe's *Kandy-Kolored Tangerine-Flake* had come out with his profile of her in it and was a best seller, so Jane got a big recycling of publicity.) "And so now," David went on, "Edie is the 'Girl of '65.' . . . So the fashion magazines are interested in you because of the girls, so I guess now you have art and movies *and* fashion covered. . . ." What David also could have mentioned was that I'd recently bought a tape recorder, with the idea of getting a book published. I'd gotten a letter from an old friend that said everybody we knew was writing books, and that's what made me want to. So I was on my way to hav-

ing literature covered, too. (Imagine people screaming in Scrib-
ners, that beautiful old bookstore on Fifth Avenue.)

But this wasn't any master plan, it was just the way things
were turning out. You can't engineer things like this: for all I
knew, every newspaper and magazine from now on might go
and crop me out of every picture and print Edie with, say, Ge-
rard, as the "new couple"—they could certainly do that if they
wanted to, you can't *make* people want you. The way David was
talking was like I'd planned it all out. But his theory was inter-
esting: that the more departments of a newspaper or magazine
that might have a reason to do a story on you, the better chance
you had of getting publicity; that you just had to spread your-
self very thin and that then maybe *some* of the things you did
would catch on. I would have felt like a public relations genius
if I'd thought all that out in advance. As near as I could figure,
why it was all happening was because we were really interested
in everything that was going on. The Pop idea, after all, was that
anybody could do anything, so naturally we were all trying to
do it all. Nobody wanted to stay in one category; we all wanted
to branch out into every creative thing we could—that's why
when we met the Velvet Underground at the end of '65, we were
all for getting into the music scene, too.

A week or so after Philadelphia I got a real lesson in show busi-
ness and Pop style. Just when you think you're getting famous,
somebody comes along and makes you look like a warm-up act
for amateur night. Pope Paul VI. Talk about Advance PR—I
mean, for centuries!

Definitely the most Pop public appearance tour of the six-
ties was that visit of the Pope to New York City. He did it all in
one day—October 15, 1965. It was the most well-planned,

media-covered personal appearance in religious (and probably show business) history. "Never Before in This Country! One Day Only! The Pope in New York City!"

The really funny thing for us, of course, was that Ondine was known in our crowd as "the Pope," and one of his most famous routines was "giving the papal bull."

The (real) Pope and his entourage of aides, press, and photographers left Rome early that morning on an Alitalia DC-8. Eight hours and twenty minutes later, they got off the plane at Kennedy with the Pope's shiny robes blowing in the wind. They drove in a motorcade through Queens—the streets were lined with people—through Harlem crowds, and then down to the jammed-for-blocks St. Patrick's Cathedral area in the Fifties where the Pope seemed to want to go out into the "audience" but you could see his aides talking him out of it. After all the stuff in the cathedral he ran down the street to the Waldorf-Astoria, where President Johnson was waiting. They exchanged gifts and talked for a little under an hour about world troubles. Then it was over to address the UN General Assembly (essentially he said, "Peace, disarmament, and no birth control"), out to Yankee Stadium to say Mass in front of ninety thousand people, over to the closing World's Fair to see Michelangelo's *Pietà* in its Pop context before it went back to the Vatican, and back out to Kennedy and onto the TWA plane, saying, when the reporters asked him what he liked best about New York, *"Tutti buoni"* ("Everything is good") which was the Pop philosophy exactly. He was back in Rome that same night. To do that much in that short a time with that kind of style—I can't imagine anything more Pop than that.

We watched most of the Pope's tour of New York on TV at the Factory. He came right by our window on his way over to

the UN—there were Secret Service people jumping all over the roofs. Ondine was going crazy with the real Pope in town; he was running back and forth from the window in a cape. Edie was on the couch getting made up, looking into a hand mirror, flinging her earrings over her shoulder. (Her hair was really short and the earrings really did go all the way down to her shoulders so the only thing to do was treat them like long hair.) Ingrid was next to her, doing basically the same routine. Chuck Wein was there and Ivy Nicholson, a beautiful fashion model, in Courrèges boots. Naomi Levine was standing next to me in one of those moods where she wanted to argue about Pop Art and whether I was "fraudulent" or not, and finally she wandered away and I was left just standing there thinking about how Pope Paul VI himself had gone right by the Factory that afternoon—I mean, the *Pope, the* Pope!

Tennessee Williams came by later and we talked about suicide. Just that day we'd screened one of our movies called *Suicide* for someone where this kid who has nineteen scars on his wrist points to each one and gives the story of why he tried to kill himself that time. I told Tennessee about how Freddy Herko had danced out the window—Tennessee was the right one to talk to about *that.*

Paul Morrissey came over to Tennessee and told him how disappointed we were that we couldn't afford to buy the rights to any of his properties but that there was no one in the world who could think up better names, so "How much would you charge for just a few titles?" Tennessee thought that was very funny and he gave us *The* for free.

In the weeks right after the Philadelphia opening, Sam booked a lot of local screenings for our movies, and the whole time the

exhibit was on, he kept the publicity going by promising we'd be coming back soon for more personal appearances. On November 9 we got an afternoon train down to Philly.

Sam had limos waiting to take us to the Barclay Hotel in Rittenhouse Square where we'd stayed before. The last time, Edie and I had ordered up fifty breakfasts for everybody who was visiting us and charged them to the Institute of Contemporary Art, but later on the hotel had had a lot of trouble collecting from the institute, so they weren't exactly happy to see us back. We weren't even going to spend the night this time—Sam had just booked a couple of rooms for us to use to wash and change in. At first the hotel said he had to rent a separate room for each of us, but finally he got them to agree to let him rent just two rooms—but then they insisted that one room would have to be for the girls and the other for the boys and that "guests" could only visit the room that was for their own sex. It was ridiculous—just like a fifties bedroom comedy. But when we arrived, it all of a sudden got very sixties, because the hotel made a big issue out of our hair.

The management took one look at us and right there in the lobby started to determine each person's "sex" by how long their hair was. They escorted Edie, giggling, to the "boys' room" (she was wearing pants, so that'd clinched it) and they sent Gerard and Paul to the "girls' room" because they both had longish curly hair. They sent me up after Edie to the "boys' room"—we were the only two people in it, but Sam could "visit" us because he had short hair.

We were really laughing hard, and Paul and Gerard were fighting with someone out in the corridor when Edie, who had the TV on, started getting very excited, saying there was a big power blackout in the Northeast over eight states and two Cana-

dian provinces, and we were missing it! We all wanted to get right back up to New York, but we were scheduled to go to a screening and pose for pictures. We checked right out of the hotel, ran over to the theater, did our number there quick, and jumped into a limousine for the return trip.

All the way back to New York, we kept hoping the blackout would still be going on when we got there. We couldn't go through any tunnels—the radio was saying they couldn't ventilate them without electricity—and when we got to the bridge, we couldn't see any lights on the whole Manhattan skyline, just car headlights. The moon was full and it was all like a big party somehow—we drove through the Village and everybody was dancing around, lighting candles. Chock Full o' Nuts looked so elegant all lit by candles. There were no traffic lights on, so of course everything moved very slowly—the buses were just creeping. People in suits and briefcases were sleeping in doorways, because all the hotels were booked solid, and Governor Rockefeller had had to open the armories up.

There were cute National Guard soldiers around helping people up out of the stuck subways and I thought that down there must be the worst place to be—the only thing that could ruin a beautiful idea like this. It was the biggest, most Pop happening of the sixties, really—it involved everybody.

After driving around a little, we went over to Ondine and then on to Le Club where we stayed until the lights started going on around four. Then all around the city things started coming to life like the Sleeping Beauty castle.

The next day, the Duchess told us she'd been in her pill doctor's office on Fifth Avenue when the lights went out. A lot of people used to go to this one particular doctor—he gave them what they wanted.

"I was in Doctor Pill's office and I was thrilled. I thought, 'This is it, the big haul.' I stuffed as much as I could get my hands on into my pocketbook while he went out to see what was happening, and I ran out of there across to the park and sat down by the Met. I couldn't wait to see what I'd gotten. It turned out to be some green iron pills, some Phisohex, and lots of that green soap doctors use. I didn't get *anything*, my dear. But oh, what a place to be in the dark . . ."

"Is he a *legal* doctor?" I asked, because I knew all the kids got drugs there and I'd heard that some drag queens were getting hormone shots from him—I mean, it sounded like a big social club up there.

"Well, naturally he's not legal when he does abortions, but yes, he's a legal doctor."

"And he's never gotten in trouble with the police?"

"Oh, they *know* about him, but it'll take years to get him. They've got to have proof—they've almost got to catch him doing it . . ."

"But why would a real doctor take a chance like that?"

"He needs the money, he gambles. He bets on the trotters every day—that's where it all goes. So he has to do abortions and charge a fortune for pills. But if I give him, say, an old invitation to a debutante ball or something—one of those fancy engraved ones—he gives me a bottle of amphetamine for free because he wants to impress his friends."

"Oooo," I said, "he must be creepy. Is he?"

"No. Actually, I adore him."

"How much did your abortion cost?" I asked her.

"A lot. Eight hundred dollars. But he followed up on me that night, and they don't usually do that, you know? They usually just dump you afterward. He brought me home and gave

me orange juice and tea, and every day for five days he came over to give me penicillin injections. Believe me, it was worth the eight hundred dollars. His office has paintings by movie stars who are too famous to mention." She laughed, and then she mentioned them.

On a Wednesday night in the middle of December, NBC aired a program called "Hollywood on the Hudson." At the Factory only Paul was watching—the famous cinematographer James Wong Howe was being interviewed, one of his favorites. Someone was taking "We Gotta Get Out of This Place" off the record player and putting on the Beatles' new album, *Rubber Soul*. Then there were more interviews—with Darryl Zanuck, Blanche Sweet, Douglas Fairbanks, Sidney Lumet, Rock Hudson. Suddenly Paul jumped up and said that a section on *me* was just starting, and we all ran over to the set. (Later I thought that if I'd known I was going to be on and had been sitting around waiting, it wouldn't have been half as exciting—I thought, "This is what happens to famous people all the time—walking by a TV set and just happening to hear about themselves.")

The next day as I walked along 57th Street I realized how powerful television is, because so many of the Christmas shoppers were pointing at me and saying, "It's him," and "No, it's not, look at the hair," and "Yes, but the sunglasses," and "Yes . . . no," etc. Up until then I'd been in *Time* and *Life* and all the newspapers a lot and nothing had ever made me be recognized this much, but now just a few minutes on TV had really done it.

One night in December the Film-Makers' Coop screened my movie of Henry Geldzahler smoking a cigar. Henry and I were still good friends; we still spent hours every day talking to each

other on the phone, but right about now, Henry met a boy named Christopher Scott and they started living together, and there's nothing more depressing than calling up somebody you've been calling up for years, any time of the day or night you felt like it, and suddenly someone else is answering the phone and saying, "Yes, just a minute." It takes the fun out of it. So Henry and I started drifting apart gradually, cutting down on the phone time—he wasn't always "available" anymore. I could only be really good friends with unattached people, that's just the way I am—if they're married or living with somebody, I would just forget them, usually. And they'd usually forget about me, too. Henry and I stayed friends, but the immediacy of it was fading.

After the screening Jonas and I talked about what was happening in films. He'd just written in one of his *Voice* columns that he thought cinema had "come to maturity" in the years from '60 to '65. Now he was talking about filmmaking as an "art of duality," saying that there were two kinds of movies—the abstract, visual kind and the narrative kind. What *I* think was happening at this point was that commercial moviemakers were learning and incorporating from underground movies but that underground movies weren't developing their narrative techniques as much as they might have—so commercial movies were coming out way ahead. Commercial moviemakers had always known that a movie couldn't make it big without a coherent story line, but now they were starting to do the narrative things with a freer style.

1966

As '65 turned to '66, the big new interest at the Factory was a group of musicians that called themselves the Velvet Underground. For New Year's, the Velvets, Edie, Paul, Gerard, and I all went to the Apollo Theater up in Harlem, then raced back downtown to watch ourselves on the evening news. Eventually we passed out in front of the TV. Then later, when I went out on the street to go home, it was impossible to get a cab because the great Transit Strike had started that midnight, just as John Lindsay, the city's Hollywood-handsome, love-comic beautiful new mayor, was stepping into office. That was another "happening," sort of like the blackout—people walking hundreds of blocks to work or riding bikes or hitching rides.

In January, Jonas moved the Film-Makers' Cinemathèque from Lafayette to West 41st Street. He was in the middle of a series called Expanded Cinema where artists like Jack Smith and La Monte Young and Robert Whitman would combine cinema images and projectors with live action and music. I remember Oldenburg's piece where he dragged a bicycle down the aisle from the last row of the theater while a movie was being projected, and I remember Rauschenberg where he was a walking light metaphor, so beautiful to look at, electrified and standing on glass bricks holding a live wire and fluorescent tubes—the artist Arman had made glass shoes for him so that the electricity wouldn't be conducted.

We'd met the Velvets through a filmmaker friend of Jonas's named Barbara Rubin, who was one of the first people to get

multimedia interest going around New York. She knew a lot of rock and folk performers, and she'd sometimes bring people like Donovan and the Byrds by the Factory.

The Velvets had done tapes for filmmakers to use while they projected their movies and they'd played live behind the screen during some screenings at the Lafayette Street Cinemathèque. But where we first really became aware of how fabulous and demented their act was at the Café Bizarre on West 3rd Street— "On Go-Go Street for nine bucks a night," as Lou Reed, the sort of lead Velvet, put it.

When Barbara Rubin asked Gerard to help her make a movie of the Velvets playing at the Bizarre, Gerard asked Paul Morrissey to help, and Paul said why didn't I come along, and so we all went down there to see them. The Bizarre management wasn't too thrilled with them. Their music was beyond the pale— way too loud and insane for any tourist coffeehouse clientele. People would leave looking dazed and damaged. Anyway, the Velvets were about to get fired. We talked to them a little bit that same night while Barbara and her crew went through the audience pushing the blinding sun gun lights and the cameras in people's faces and asking, "Are you uptight? Are you uptight?" until they reacted, and then she would hold the cameras and lights on them while they got madder or cringed more or ran away or whatever.

We liked the Velvets and invited them to come by the Factory.

Paul wanted to do some shows with them. Coincidentally, we'd just been approached by a producer who'd taken over a film studio out on Long Island that he wanted to turn into a discotheque. He claimed that this studio was originally the airplane hangar that Lindbergh took off from. It was around seventeen

thousand square feet and had a three-thousand-person capacity and he was going to call it Murray the K's World. He said he wanted the Factory crew to be disco mascots and hang out there every night making movies so he could get publicity for the place. Paul thought there should be a house band since Jordan Christopher's house band at Arthur did so well, and the producer said that if we could come up with a band, maybe he'd just call the place Andy Warhol's World.

So when we'd gone to the Bizarre to see the Velvets that time, what Paul was trying to do was psyche out how they'd be in a big airplane hangar of a discotheque and how they'd go down with the kids. If any band then could fill up seventeen thousand square feet with blasting sound, it was the Velvets. We liked the idea that their drummer was a girl, that was unusual. Sterling Morrison and Lou Reed—and even Maureen Tucker—wore jeans and T-shirts, but John Cale, the Welsh electric viola player, had a more parochial look—white shirts and black pants and rhinestone jewelry (a dog collar–type necklace and bracelet) and long black spiky hair and some kind of English accent. And Lou looked good and pubescent then—Paul thought the kids out on the Island would identify with that.

Another idea we had in mind when we went to check out the Velvets was that they might be a good band to play behind Nico, an incredible German beauty who'd just arrived in New York from London. She looked like she could have made the trip over right at the front of a Viking ship, she had that kind of face and body. Although Nico got more and more into the swirling capes and medieval monastery look as the sixties went on, when she first came on the scene she dressed very mod and spiffy in white wool pants, double-breasted blazers, beige cashmere turtle-necks, and those pilgrim-looking shoes with the big buckles on

them. She had straight shoulder-length blond hair with bangs, blue eyes, full lips, wide cheekbones—the works. And she had this very strange way of speaking. People described her voice as everything from eery, to bland and smooth, to slow and hollow, to a "wind in a drainpipe," to an "IBM computer with a Garbo accent." She sounded the same strange way when she sang, too.

Gerard had met her in London that spring and given her the Factory number to call if she ever came to New York. She called us from a Mexican restaurant and we went right over to meet her. She was sitting at a table with a pitcher in front of her, dipping her long beautiful fingers into the sangría, lifting out slices of wine-soaked oranges. When she saw us, she tilted her head to the side and brushed her hair back with her other hand and said very slowly, "I only like the fooood that flooooats in the wiiine."

During dinner, Nico told us that she'd been on TV in England in a rock show called "Ready, Steady, Go!" and right there she pulled a demo 45 rpm out of her bag of a song called "I'll Keep It with Mine" that had been written for her, she said, by Bob Dylan, who'd been over there touring. (It was one of a few pressings that had Dylan playing the piano on it, and eventually Judy Collins recorded it.) Nico said that Al Grossman had heard it and told her that if she came to the United States, he'd manage her. When she said that, it didn't sound too promising, because we'd heard Edie telling us so much that she was "under contract" to Grossman and nothing much seemed to be happening for her— having a well-known manager was never a guarantee that things would really happen for you. (We were still seeing Edie, but we weren't showing her films anymore—the idea of the Edie Sedgwick Retrospective at the Cinemathèque had fizzled out, and it looked like our contribution to the Expanded Cinema series would be something with the Velvet Underground instead.)

Nico had cut a record called "I'm Not Sayin'" in London (Andrew Oldham, the Stones' producer, had produced it), and she'd also been in *La Dolce Vita*. She had a young son—we'd heard rumors that the father was Alain Delon and Paul asked her about that immediately because Delon was one of his favorite actors, and Nico said yes, that it was true and that the boy was in Europe with Alain's mother. The minute we left the restaurant Paul said that we should use Nico in the movies and find a rock group to play for her. He was raving that she was "the most beautiful creature that ever lived."

Nico was a new type of female superstar. Baby Jane and Edie were both outgoing, American, social, bright, excited, chatty—whereas Nico was weird and untalkative. You'd ask her something and she'd maybe answer you five minutes later. When people described her, they used words like *memento mori* and *macabre*. She wasn't the type to get up on a table and dance, the way Edie or Jane might; in fact, she'd rather hide under the table than dance on top of it. She was mysterious and European, a real moon goddess type.

I was invited to speak at the annual banquet of the New York Society for Clinical Psychiatry by the doctor who was chairman of the event. I told him I'd be glad to "speak," if I could do it through movies, that I'd show *Harlot* and *Henry Geldzahler*, and he said fine. Then when I met the Velvets I decided that I wanted to "speak" with them instead, and he said fine to that, too.

So one evening in the middle of January everybody at the Factory went over to the Delmonico Hotel where the banquet was taking place. We got there just as it was starting. There were about three hundred psychiatrists and their mates and dates—and all they'd been told was that they were going to see movies

after dinner. The second the main course was served, the Velvets started to blast and Nico started to wail. Gerard and Edie jumped up on the stage and started dancing, and the doors flew open and Jonas Mekas and Barbara Rubin with her crew of people with cameras and bright lights came storming into the room and rushing over to all the psychiatrists asking them things like:

"What does her vagina feel like?"

"Is his penis big enough?"

"Do you eat her out? Why are you getting embarrassed? You're a psychiatrist; you're not supposed to get embarrassed!"

Edie had come with Bobby Neuwirth. While the crews filmed and Nico sang her Dylan song, Gerard noticed (he told me this later) that Edie was trying to sing, too, but that even in the incredible din, it was obvious she didn't have a voice. He always looked back on that night as the last time she ever went out with us in public, except for a party here and there. He thought that she'd felt upstaged that night, that she'd realized Nico was the new girl in town.

Nico and Edie were so different, there was no good reason to compare them, really. Nico was so cool, and Edie was so bubbly. But the sad thing was, Edie was taking a lot of heavy drugs, and she was getting vaguer and vaguer. Her Society lady attitude toward pills had changed to an addict attitude. Some of her good friends tried to help her, but she wouldn't listen to them. She said she wanted a "career" and that she'd get one since Grossman was managing her. But how can you have a career when you don't have the discipline to work at anything?

Gerard had noticed how lost Edie looked at that psychiatrists' banquet, but I can't really say that I noticed; I was too fascinated watching the psychiatrists. They really were upset, and some of them started to leave, the ladies in their long dresses and

the men in their black ties. As if the music—the feedback, actually—that the Velvets were playing wasn't enough to drive them out, the movie lights were blinding them and the questions were making them turn red and stutter because the kids wouldn't let up, they just kept on asking more. And Gerard did his notorious Whip Dance. I loved it all.

The next day there were long write-ups about the banquet in both the *Tribune* and the *Times*: "SHOCK TREATMENT FOR PSYCHIATRISTS" and "SYNDROMES POP AT DELMONICO'S." It couldn't have happened to a better group of people.

In January, when the Cinémathèque moved to 41st Street, the Velvets and Nico played together again and we screened *Vinyl* and *Empire* and *Eat* in the background and Barbara Rubin and her crew ran around the audience as usual with movie cameras and bright lights. Gerard was up on the stage whipping a long strip of phosphorescent tape in the air. The whole event was called "Andy Warhol Up Tight."

These were still the days when you could live on practically no money, and that was about what the Velvets seemed to have. Lou told me that for weeks at a time he and John would go without eating anything but oatmeal and that for money they'd donate blood or pose for the weekly tabloids that needed photos to illustrate their shock stories. The caption to one of Lou's pictures said he was a maniac sex killer who'd murdered fourteen children and recorded their screams so that he could jerk off to the tape every midnight in a Kansas barn; and John's picture appeared with the story of a man who'd killed his lover because the lover was going to marry his sister and the man didn't want his sister to marry a fag.

Paul asked Lou how the Velvets happened to have a girl drummer and he said, "Very simple. Sterling knew her brother, who had an amplifier, and he told us we could use it if we let his sister drum for us." They needed more amplifiers, though, and we called up a few equipment places trying to get them free, but the best we could do was get a few dollars knocked off when we paid cash. Then the Velvets started practicing at the Factory with their drums, tambourine, harmonica, guitars, Autoharp, maracas, kazoo, car horn, and pieces of glass that they hit.

A reporter once asked Paul if we paid the Velvets, and when Paul said no, the reporter wanted to know what they lived on. Paul had to consider that for a second, then he offered, "Well, they eat a lot at parties."

I was getting a reputation for taking no less than twenty people everywhere I went, including—especially—to parties. It was like one whole party walking into another one whenever we arrived. Nobody really minded, though—they knew when they invited me in the first place that I wouldn't be coming alone.

The Rolling Stones were around town that February. Brian Jones was a good friend of Nico's and he and Dylan came up to the Factory together one afternoon when the Velvets were rehearsing and I was working—with David Whitney and David White, both from the gallery, beside me—on my Silver Pillows for a show at Castelli that was coming up in April. (I'd used the pillows, too, in a Merce Cunningham dance concert, and they meant something special to me: it was while I was making them that I felt my art career floating away out the window, as if the paintings were just leaving the wall and floating away.)

There were two little high school girls over in another area transcribing down to the last stutter some reel-to-reel tapes of Ondine that I'd made in the late summer of '65 for my taped novel. My original idea had been to hang in with him for a whole twenty-four hours—he never slept—but I didn't quite make the complete twenty-four on the first session and had to finish up the balance on one more day.

I'd never been around typists before so I didn't know how fast these little girls should be going. But when I think back on it, I realize that they probably worked slow on purpose so that they could hang around the Factory more, because these girls were *really* slow—I mean, like a page and a half a day.

Little Joey, the Factory go-fer, was there when Brian and Dylan walked in, and he was thrilled out of his mind. He'd just turned fifteen and these were his two idols. (The Stones around that time were doing "Get Off My Cloud" and "As Tears Go By" and "19th Nervous Breakdown." And Dylan was between the *Highway 61* album and *Blonde on Blonde,* which wouldn't be released till the coming summer. He was the first rock person I can remember who got super-popular strictly on albums—he hadn't had a big hit single except for "Like a Rolling Stone," although around that time his "Positively 4th Street" came on the radio now and then where he runs into an old friend in the Village and puts him down, and all the kids loved that.) The little typists were going crazy, too, trying to get over for a good look at Brian. Then Allen Ginsberg and Peter Orlovsky dropped by.

The Duchess was frantic because nobody was paying attention to her, to whether she should lose a hundred pounds and put her hair in pigtails or just switch from Honey Amber to Tawny Peach Blush-on. She wasn't impressed with Dylan or the

Rolling Stones because she was over thirty and never listened to rock if she could help it. She glanced over toward tiny Dylan and even more tiny Brian with his pale, pale skin and fluffy strawberry blond hair and said as loud as she could, "Those aren't *men,* my dear. I like them tall and craggy and divine like Greg Peck." Then the Duchess got up on a bicycle that someone had propped against a wall and started pedaling around the red couch just as Jane Holzer walked in. I was asking Brian about a certain beautiful but dizzy English actress we both knew.

"We heard you were seeing her," I said, pointedly.

He picked up one of the silver pillows.

I was taping and held the mike over to him, "Come on, Brian. Did you fuck her?"

"I would have to say . . ." he began, slowly.

"You can lie," Allen Ginsberg called over.

"Yeah, you can lie," I said.

Brian passed up the option. "I would say twice, only. Who hasn't?" He picked up my wrist to examine the ruby studs I always kept in the pleated white shirt I wore—over my T-shirts— to paint in. "I can admit her, but there are some people I can't admit. There's always someone we can't admit we've done it with, wouldn't you say?" He faded off, looking around.

I tried to bring his attention back. "So where did you fuck her?" I asked him.

"At someone's country house—one of those English parties where every generation is invited and all the mad grandmothers who dance like chickens come on to you. . . ." He stared blankly at the Duchess, who was jabbing a syringe into her fanny while she rode the bike. She was absolutely desperate for attention.

• • •

We did screen tests of Brian and Dylan while Gerard fought with Ingrid Superstar over whose turn it was to pay for the malteds: the poor delivery kid from Bickford's stood around, frustrated, until Huntington Hartford arrived and finally settled the tab. Ingrid hugged him and gave him a big smooch. Hunt had just invited us to use his Paradise Island in the Bahamas any time we wanted an exotic shooting location.

When the Duchess saw Hunt, she forgot about wanting attention and decided to concentrate on striking him for fifty dollars. They knew a psychiatrist who had this game going—he gave her Desoxyn prescriptions whenever she let him listen in while she talked dirty to people, and so she had a routine arranged with Hunt that when she'd call him with a cue line, he'd pretend to be a john getting excited by the dirty talk—and then she would get her prescription. Huntington Hartford was a great friend of Ingrid's, too—he had an eye for pretty girls and he liked to pop into the Factory now and then to see who happened to be around.

It was Gerard, actually, who would recruit a lot of the beautiful, photogenic girls for the Factory. He would see a girl in a magazine or at a party and really make a point of finding out who she was—he'd turn these interests of his into sort of poetic "quests." Then he'd write poems about the girls and tell them all they'd get a screen test when they came by.

Nico sang some of the new songs for Brian and Dylan that Lou and John had just written for her—"I'll Be Your Mirror" and "All Tomorrow's Parties."

Paul wasn't the type to primp in the mirror, but when we'd be going out with Nico, you couldn't help noticing that he'd check out how he looked a few times. But if he thought she was

the most beautiful woman in the world, a lot of people would agree. Whenever he'd find her picture in magazines for ads like London Fog raincoats that she'd done the year before, he'd tell her to never *never* smile in pictures—Paul thought beauties should never smile or look happy in photographs. But then ironically, Paul was maybe the one person in the world who could always make Nico laugh. And they'd have "arguments" all the time about drugs—like the one they were having that afternoon.

"If you keep taking the LSD, Nico," Paul warned, "your next baby will be born all deformed. They're finding these things out now."

"No, it's not truuuuue," Nico said. "We'll get better and better drugs, and make *fantastic* children."

Meanwhile, the phone at the Factory was ringing more than usual because we'd just put an ad in the *Voice* that read: "I'll endorse with my name any of the following: clothing, AC-DC, cigarettes, small tapes, sound equipment, ROCK 'N' ROLL RECORDS, anything, film, and film equipment, Food, Helium, Whips, MONEY; love and kisses Andy Warhol. EL 5-9941." We had so many people hanging around all the time now that I figured in order to feed them all we'd have to get other people to support them—like find a restaurant that wanted us to hang around that would give us free meals.

There were so many of us now that we were even starting to have trouble getting into parties. People didn't mind the ten or twelve kids that I used to show up with on my arm, but when it started to be over twenty, they'd try to throw some of them out. We'd just gone over to a party given by a girl who was some relation of Winston Churchill's, and Jayne Mansfield was inside—and we'd been turned away at the door. They said *I* could

come in, but nobody else, so we all just left, which killed me because I really wanted to meet Jayne Mansfield.

All during January and February we were meeting with the disco producer about opening the airplane hangar discotheque with the Erupting (it wasn't "Exploding" yet) Plastic Inevitable (E.P.I.) in Roosevelt Field in April. The producer had come down to the Expanded Cinema series at the Cinémathèque the night the Velvets played there. It was the first time he'd ever heard them perform, and although he'd said "great, great" when we asked him how he liked the show, looking back on it, I can see that he must have hated it but didn't want to cancel with us till he covered himself by finding something to take our place.

In March we drove down to Rutgers to play at their college film society—Paul, Gerard, Nico, Ingrid Superstar, a photographer named Nat Finklestein, a blond girl named Susanna, Barbara Rubin, a young kid named Danny Williams who was working the lights, and an Englishman named John Wilcock, who was one of the first journalists to cover the counterculture. We went into the Rutgers cafeteria to eat before the show, and the students couldn't take their eyes off Nico, she was so beautiful it was unreal, or off Susanna, who was going around picking food off their plates and dropping it grape-style into her mouth. Barbara Rubin was filming the kids, and the guards were following her telling her to stop, then somebody came over wanting to check our "cafeteria pass" and Gerard started yelling at them and there was a big commotion. We got kicked out, of course, but fortunately it all made people want to see the show, which until then hadn't been doing too well in advance sales.

We did two shows for over 650 people. We screened *Vinyl* and *Lupe* and also movies of Nico and the Velvets while they were playing. It was fantastic to see Nico singing with a big movie of her face right behind her. Gerard was dancing with two long shining flashlights, one in each hand, twirling them like batons. The audience was mesmerized—when a college kid set off the fire alarm system by holding a match near it, nobody paid any attention to it.

I was behind one of the projectors, moving the images around. The kids were having a lot of trouble dancing, because the songs sometimes started out with a beat but then the Velvets would get too frenetic and burn themselves out, losing the audience long before that. They were like audio-sadists, watching the dancers trying to cope with the music.

A few days later, we left New York for Ann Arbor in a rented van to play at the University of Michigan. Nico drove, and that was an experience. I still don't know if she had a license. She'd only been in this country a little while and she'd keep forgetting and drive on the British side of the road. And the van was a real problem—whenever it stopped, it was hard to get it started again, and not one of us knew anything about cars.

A cop stopped us at a hamburger drive-in near Toledo when a waitress got upset and complained to him because we kept changing orders, and when he asked, "Who's in charge here?" Lou shoved me forward and told him, "Of all people—Drella!" ("Drella" was a nickname somebody had given me that stuck more than I wanted it to. Ondine and a character named Dorothy Dyke used it all the time—they said it came from combining Dracula and Cinderella.) We spent the night in a motel near there, and once again it was the-boys-in-one-room-the-

girls-in-the-other scene, even though somebody kept telling the little old lady who ran the place, "But we're all queer."

At Ann Arbor, we met up with Danny Fields, who'd just been made the editor of a teenage magazine, *Datebook*. He was out there covering the concert. I hadn't seen him in a while.

"Well," he laughed, "I finally have an identity of my own. Up until now, I was just a groupie with no real reason to exist."

"And to think you launched your career," Lou reminded him, "getting out the *wrong side* of a limousine."

Nico's driving really was insane when we hit Ann Arbor. She was shooting across sidewalks and over people's lawns. We finally pulled up in front of a nice big comfortable-looking house, and everyone started unloading the van. Danny wouldn't believe that anyone was going to let "a truckload of freaks" pull up and walk right into their house until a beautiful woman came running out to meet us. She was Ann Wehrer, whose husband, Joseph, was involved with the early "happenings" and had arranged for the E.P.I. to come out there.

Ann Arbor went crazy. At last the Velvets were a smash. I'd sit on the steps in the lobby during intermissions and people from the local papers and school papers would interview me, ask about my movies, what we were trying to do. "If they can take it for ten minutes, then we play it for fifteen," I'd explain. "That's our policy. Always leave them wanting less."

Danny remembers that one interviewer asked if my movies had been influenced by the thirties and forties and that I told him, "No, the tens. Thomas Edison really influenced me." And as a matter of fact, we had a strobe light with us for the first time. The guy we rented spotlights from in New York had brought it to the Factory to show us—none of us had ever seen one before. They weren't being used yet in the clubs. The strobes were

magical, they went perfectly with the chaos music the Velvets played, and that long piece of phosphorescent green Sylvania tape that Gerard was now using for his dance numbers, whipping that around, looked terrific when the strobes flashed on it.

When we got back to New York, Paul tried to pin the disco producer down to a definite date for the opening, but he just kept assuring us, "Don't worry." Then somehow we found out that he'd already hired the Young Rascals to open the place.

Paul and I went down to meet the Velvets at the Café Figaro—they were staying at an apartment just down the street—to tell them that the big gig had fallen through. When we walked in, they were already there, sitting around in their wraparound "girl watcher" dark glasses, all in a great mood, full of plans for the gala opening.

"We have a new number using John's thunder machine," Lou said as we sat down; then he laughed. "For the second time this week, a cop threatened us. He came up to the apartment and told us to go out into the country someplace if we were going to play that kind of stuff. This is a week after he stopped us on our way out the door and accused us of throwing human shit out our windows. . . . The awful thing is that it was *just possible*." Lou's voice was dry and flat, and he had droll timing with a little Jack Benny in it.

"We want to play all in the dark so the music will be the only thing. Tomorrow we're going to go to used car lots and buy hundreds of car horns and wire them all up so the honking will be nonstop."

"Yes, no, that's great, but listen—" Paul started to tell them, but Lou just went on, more and more enthusiastic.

"We're going to play some of the ferocious songs that no one listens to anymore—the ones that run underneath everything we usually play—like 'Smoke from Your Cigarette' and 'I Need a Sunday Kind of Love' and 'Later for You, Baby'—everybody's going crazy over all the old blues people, but let's not forget about the Spaniels and people like that. And we're working on Sterl to play trumpet again; he's been too busy looking for a psychiatrist to get him out of the army." Sterling was right across the table, telling John about a friend of his with aquaphobia who slept on air mattresses in the Hamptons in case the sea level rose and carried rubber diver's fins in the backseat of his car in case the 59th Street Bridge should ever collapse while he was crossing it. "He feels that with the fins, he won't be screwed. . . ." Sterling was an on-again off-again English lit student but he struck you as a preoccupied scientist type. His thought patterns seemed very methodical. It was as if he got up in the morning, got a certain thought, then spent all day developing it—he might, say, pause for an hour, but when he started talking again, it would be to make an "additional point," or to "clarify," no matter what everyone else had been talking about in between.

I noticed that Paul was eavesdropping on the conversation of two people at the next table. Incredibly, they were talking about a big Polish dance hall they'd just rented over on St. Mark's Place that they didn't know what to do with. Paul swiveled around and introduced himself. He told them he lived around that neighborhood and hadn't ever noticed a big dance hall. The two introduced themselves—they were Jackie Cassen and Rudy Stern. They told us they did "sculpture with light" and that they'd rented this big Polish dance hall called Stanley's the Dom (*Polsky Dom Narodny—Dom* is Polish for "home") but that they

wouldn't be ready to use it till May and that they didn't know what to do with it for April. Paul asked if we could go and see it right away. We left the Velvets at the Figaro without telling them about the airplane hangar falling through—it's always better to wait with bad news till you have some good news to go with it.

The Dom was perfect, just what we wanted—it had to be the biggest discotheque dance floor in Manhattan, and there was a balcony, too. We sublet it immediately from Jackie and Rudy—I gave them the rent check, Paul had a fight with the owner over the insurance, then we signed a few papers, and the very next day we were down there painting the place white so we could project movies and slides on the walls. We started dragging prop-type odds and ends over from the Factory—five movie projectors, five carousel-type projectors where the image changes every ten seconds and where, if you put two images together, they bounce. These colored things would go on top of the five movies, and sometimes we'd let the sound tracks come through. We also brought down one of those big revolving speakeasy mirrored balls—we had it lying around the Factory and we thought it would be great to bring those back. (The balls really caught on after we revived the look, and pretty soon they were standard fixtures in every discotheque you walked into.) We had a guy come down with more spotlights and strobes that we wanted to rent—we were going to shine them on the Velvets and all around the audience during the show. Of course, we had no idea if people would come all the way down to St. Mark's Place for night life. All the downtown action had always been in the West Village—the East Village was Babushkaville. But by renting the Dom ourselves, we didn't have to worry about whether "man-

agement" liked us or not, we could just do whatever we wanted to. And the Velvets were thrilled—in the Dom, the "house band" finally found a house. They could even walk to work.

The Velvets were staying in an apartment on 3rd Street in the West Village above a firehouse, across the street from the Gold Bug, near a Carvel place and a drugstore. The apartment belonged to Tom O'Horgan, but Tom had sublet it to Stanley Amos, who was living in the back part (the front and back apartments were joined in the middle by a semisecret doorway), and all of Tom's furniture and fixtures were still in it. In the early days of the Velvet Underground, everybody from the Factory spent a lot of time just hanging around down there, going to Chinatown at two in the morning, then up to the Flick on Second Avenue in the Fifties for ice cream at four, or over to the Brasserie.

Tom's apartment looked just like a stage set. The living room was raised and there were long mirrors on both sides of the door with primitive instruments hanging down them from the ceiling. And there were lots of dried flowers and a big black coffin and a couple of chairs with lions' heads on the arms. The room itself was pretty bare—just a few big pieces of furniture. And then there was the heating system—a fifteen-foot gold dragon built onto the ceiling with flames from the heater shooting out its open mouth.

People on amphetamine didn't really have "apartments," they had "nests"—usually one or two rooms that held fourteen to forty people, with everyone paranoid that somebody would steal their stash or their only magenta Magic Marker or let the water in the bathtub overflow into the pharmacy downstairs.

John Cale used to sit in the front room for days and days with his electric viola, barely moving. Maureen—Mo—the girl drummer, was somebody I could never figure out: she was very innocent and sweet and shy, so then what was she doing there?

The foyer of Stanley's apartment in the back was dark and had jungle murals of a stuffed parrot and of monkeys eating oranges painted on the walls. The only light came from a big black spider lamp whose tail lit up. Then you walked through another small hall into a library that had a fur rug and a beaded lamp and a brick wall, and into the main room, where there was a wonderful piece of art by Johnny Dodd—a portable wall of sixty-one thousand canceled George Washington postage stamp heads cut out with a nail clipper. (Johnny had put an ad in the *Voice* to get all the stamps.) There were Tiffany lamps all over the place, too, and Art Nouveau Mucha prints in colors like beige and dark green of women with flowing hair, and wind-up Indians beating tom-toms, and lots of tapestries and Persian rugs. It looked like a battle of the set decorators.

There was a houseboy who came in once every few days, and Stanley explained that this boy was a homosexual, a Roman Catholic, and an alcoholic who'd dress up in little sailor suits to go out cruising but first he always had to get drunk, otherwise he felt too guilty. He straightened up Stanley's apartment to make the extra money to get drunk on. It was a good thing Stanley had him, too—after the Glitter Festivals.

Stanley had a bureau drawer that was completely filled with bags of glitter—no clothes or anything, just glitter. (It was where Freddy Herko had stored it for his dance concerts, and after Freddy killed himself, Stanley left it all just the way it was.) He would open the drawer and pass out the bags, and about half the people there would drop acid and shower sparkles in the air

till the whole house was covered in them and Judson dancers would twirl through the room with flowers in their hair and the whole floor would change color because it was the multicolored kind of glitter, and outside the kitchen window people would be swinging in a hammock that was strung up across the dead-end alleyway. Most of the guys stayed calm—except for the usual jokes and hysterical laughing—but Ingrid Superstar would go over to the mirrors, put her hands on her face, and start to freak out, hallucinating over and over again, "I'm so ugly, so ugly," and everyone would try to cheer her up by taking out their cocks and doing ventriloquism, making them talk to her—*that* always got her laughing—but she would only stay distracted for a few minutes and then they'd have to think up something else—it was like trying to make a little kid stop crying.

The other half of the room would be paranoid on amphetamine, staring at the half that was tripping on the LSD. They were each other's audience.

Lou and Ondine would have furious fights over trading Desoxyn for Obetrols—Desoxyn was twice as expensive and had fifteen milligrams of Methedrine, whereas Obetrols apparently had that much Meth plus something like five milligrams of sulfate. I could never figure out what they were talking about, which one was better.

And Rotten Rita used to come in with his homemade speed that everyone knew was the worst in the world. Periodically he'd try to upgrade his credibility by giving somebody their money back, but then the next day he'd be in there trying to sell them the exact same stuff back again, but telling them that it was a much superior batch so naturally it was more expensive. But as Lou said, "It's part of the natural environment to have Rotten do things like that. That's why he's 'Rotten.'" Once, I asked the

Duchess why Rotten was also called the Mayor, and she said, "Because he screws everybody in town."

The Turtle was the switchboard operator at a modest mid-town hotel, but he also dealt drugs on the side. He would trade heroin to somebody for Placidyls and then stand back and watch them shoot up once and go to sleep. Then, while they were passed out, he'd grab the rest back and swear to them when they woke up, "Man, you're crazy. You did up *three times.*"

The Duchess would rip off her blouse, pull a bottle of vodka out of her bag, swig it, then give herself a poke of speed in the fanny, right through her jeans, then pull them down to show everybody her abscesses (even the boys were a little shocked at that). She'd shoot up anywhere—waiting in a movie line, if she felt like it.

Richie Berlin would sit writing quietly in a corner in khaki shorts and kneesocks and a little necktie—sort of a bird-watching outfit—and she'd tell anyone who tried to talk to her, "Go back to Europe and leave me alone."

Stanley didn't care much about music. There were only a few records in the place—an avant-garde jazz thing called "Bells" and some classical Indian music (this was right before the big sitar craze started) and two 45's—"Sally Go Round the Roses" from '63 and a thing called "Do the Ostrich" that Lou had written and recorded after reading in Eugenia Sheppard's fashion column that ostrich feathers were going to be big that season. (Lou had had a job writing for a budget record company that made those "three-for-ninety-nine-cents" records that they sold in bargain stores. As "The Beachnuts" he'd tuned all his guitar strings to the same note and bashed away like crazy screaming, "Do the Ostrich!" till the record people made him stop. But then, later on, when the company was low on products, they listened to it

again and decided why not, that maybe it could be a hit after all. So they pressed it, but people kept returning it to the stores for refunds because it was a defective pressing. There'd always be someone new at Stanley's who didn't know what that record was who'd say, "Oh, what's this?" and put it on.)

Silver George would usually be taking amphetamine, dying part of his hair another color, and lying on his stomach on the bed holding a coat hanger up to a clear light bulb with one hand and holding on to a big plant with the other. He had two pet theories: one, that the Japanese had promoted amphetamine so that they could keep their postwar labor force working around the clock, and, two, that plants needed electricity supplements. His idea was to attract the electricity from the light bulb with the metal hanger and transmit it through his body to the plant. The plant was in a wooden stand; it was so big I always wondered where he'd gotten it from—he probably just walked out of some office building lobby with it, but he said no, he'd just "befriended" it. Whoever walked through the room he'd tell, "Look at it move. Did you see it move? Now *look,* I'm not kidding." And one time, I have to admit, I did see it twitch.

At two o'clock every morning a six-foot-six blond hospital orderly dressed in his whites walked into Stanley's. He was the only person who actually contributed toward the rent—he'd been an ethnologist in Canada working with Eskimos for the Canadian government, he said, but then they'd transferred him to desk work so he decided to move to New York. Before getting a job at St. Vincent's Hospital in the Village, he'd sold hot dogs in Union Square. He didn't even take drugs; he just sat around chatting very pleasantly with whoever was there, and then around five in the morning he'd go off to sleep. He lived there for about two months and then one day he just didn't come back.

Another sort of permanent person there was a young kid named Ronnie Cutrone who was living in the back part with his girl friend. He was from Brooklyn and he'd been hanging around the Village since he was eleven—"because I loved all the dykes on Sixth Avenue over by 8th Street, they sold me Tuinals—Olga the Terrible, Sonny, Tommy . . ."

Ronnie told me that he used to go cruising with that clique of lesbians near the Women's House of Detention where the inmates screamed down at their lovers out the windows of that huge Deco building in the triangle where all those streets meet— 8th and Sixth Avenue and Christopher and Greenwich—over to Howard Johnson's and Prexy's and on to Pam-Pam's, a luncheonette that was open all night on Sixth Avenue, and go with them to dyke hangouts like the Club 82.

I remembered seeing Ronnie for the first time at a sort of folksy party the year before down around MacDougal Street. I was going out and he was coming in and we'd collided, stepping over Bob Dylan, who happened to be lying on the stairs looking smashed and having a great time, reaching up under the girls' skirts when they walked over him up to the party (some of them liked it and some of them didn't—whatever, he'd just laugh), and Ronnie and I couldn't get past each other so he looked down at Dylan and told him, "I loved that crazy rolling organ, man."

Ronnie was hard to figure out because he always had a steady girl friend, but then he really adored being around all the amphetamine queens. Admittedly, his girl friends were always very boyish-looking; I guess he just liked that style. "At one point, I really tried to be gay," he told me, "because everybody I knew was and it looked like fun, but it didn't work out." He

was an early super-bopper and a great dancer—whatever new dancing club was happening, he'd be there.

A bunch of us would leave the Dom really late and go to the after-hours clubs around the Village—Lou knew them all. At the Tenth of Always (named after the Johnny Mathis song "The Twelfth of Never") there'd always be one same little blond boy every night who'd get drunk and turn to Lou and demand, "Well, *are* you a homosexual or not? *I* am and I'm *proud* of it." Then he'd smash his glass on the floor and get asked to leave. And then there was Ernie's: no liquor, no music, no food—just a back room with jars of Vaseline on the table.

We took out a half-page ad in that week's *Voice* that read:

Come Blow Your Mind

the Silver Dream Factory presents the first

ERUPTING PLASTIC INEVITABLE

WITH

Andy Warhol

The Velvet Underground

AND

Nico

We had *My Hustler* playing uptown at the Film-Makers' Coop in the Wurlitzer Building on West 41st Street. And even farther uptown on that Saturday there was my opening of the silver helium-filled pillows at the Castelli Gallery with my yellow and pink cow wallpaper all over. (In the full ad for the Dom

opening, it had spelled out that there would be no show on Saturday night "due to uptown art gallery opening.")

So now, with one thing and another, we were reaching people in all parts of town, all different types of people: the ones who saw the movies would get curious about the gallery show, and the kids dancing at the Dom would want to see the movies; the groups were getting all mixed up with each other—dance, music, art, fashion, movies. It was fun to see the Museum of Modern Art people next to the teeny-boppers next to the amphetamine queens next to the fashion editors.

We all knew something revolutionary was happening, we just felt it. Things couldn't look this strange and new without some barrier being broken. "It's like the Red Seeeea," Nico said, standing next to me one night on the Dom balcony that looked out over all the action, "paaaaarting."

All that month the limousines pulled up outside the Dom. Inside, the Velvets played so loud and crazy I couldn't even begin to guess the decibels, and there were images projected everywhere, one on top of the other. I'd usually watch from the balcony or take my turn at the projectors, slipping different-colored gelatin slides over the lenses and turning movies like *Harlot, The Shoplifter, Couch, Banana, Blow Job, Sleep, Empire, Kiss, Whips, Face, Camp, Eat* into all different colors. Stephen Shore and Little Joey and a Harvard kid named Danny Williams would take turns operating the spotlights while Gerard and Ronnie and Ingrid and Mary Might (Woronov) danced sadomasochistic style with the whips and flashlights and the Velvets played and the different-colored hypnotic dot patterns swirled and bounced off the walls and the strobes flashed and you could close your eyes and hear cymbals and boots stomping and whips cracking and tambourines sounding like chains rattling.

Ondine and the Duchess would shoot people up in the crowd if they halfway knew them. Once, from the balcony, I saw blood spurt in a strobe flash across Pauline de Rothschild and Cecil Beaton. Later Ondine came running out of the bathroom screaming that he'd dropped his "spike" down the toilet by mistake. Paul yelled, "Good!" and he really meant it—we were afraid they'd jab somebody they didn't know.

People in the crowd would come over and introduce themselves and it was all unreal. You wouldn't think about it at the time, but the strobe would freeze the moments in your brain and you'd pull them out months or years later. Like "This is Karen Black," and that second would somehow flash back the next year when you saw the same face in *You're a Big Boy Now.*

The kids at the Dom looked really great, glittering and reflecting in vinyl, suede, and feathers, in skirts and boots and bright-colored mesh tights, and patent leather shoes, and silver and gold hip-riding miniskirts, and the Paco Rabanne thin plastic look with the linked plastic disks in the dresses, and lots of bell-bottoms and poor-boy sweaters, and short, short dresses that flared out at the shoulders and ended way above the knee.

Some of the kids at the Dom looked so young that I wondered where they got the money for all those fashionable clothes. I guess they were doing a lot of shoplifting: I'd hear little girls with bangs say things like "Why should I *pay* for it—I mean, it's going to fall apart tomorrow." By the end of the sixties shoplifting detection was a major industry, but in '66, it was still a fairly primitive operation, usually just guards at the store doors—and meanwhile the kids could be in the dressing rooms stuffing their bags full, or else their pocketbooks, since the new clothes were all so skimpy.

Boutiques started opening up around St. Mark's Place, and

used fur coat places and, of course, Limbo. Limbo was the most popular place in the area, because it was basically army-navy surplus (at first) and all the kids had started wearing military clothes. I recall an item in Howard Smith's *Voice* column about Limbo's selling strategy/psychology—it said a lot about the way the kids were thinking: the store couldn't sell a bunch of funny-looking black hats, so one morning they made a sign that said, "Polish Rabbis' Hats" and they were sold out by that afternoon.

One night at the Dom, Paul and I were in our usual spot, standing on the balcony watching all the kids dancing when we saw a small, muscular blond kid make a ballet leap that practically spanned the dance floor. We went downstairs to talk to him. His name was Eric Emerson and it turned out he was a friend of Ronnie Cutrone's and Gerard's.

A few days later, Paul and I stopped by to see him at a storefront down on Avenue A or B on the Lower East Side, right around the corner from where the *East Village Other* had its offices then. Eric had built the wall divisions and done all the carpentry in the place himself and after finishing the he-man construction work, he'd brought in his little sewing machine and started sewing dresses—that was the kind of person Eric was, you couldn't hold him down in any category.

"Where did you learn how to build things?" Paul asked him.

"My father's a construction worker in Jersey, and he always made me cut pieces of wood to fit." He gestured self-consciously. "I would look at things and then go after my image, so now I always know about how things are built." He shrugged and smiled.

"But where did you learn how to ballet dance?" Paul asked him.

"My mother, she was sending me to ballet school constantly, you know, and then I danced with the Music Mountain Group up in North Jersey, and then with the New Jersey Ballet Company in Orange—we did *Brigadoon, Kismet, Most Happy Fella,* things like that."

"But where did you learn how to *sew*?"

"I was in California last year and I met a wonderful woman who told me, 'Just do something that you love doing, and then, no matter what it is, you'll be able to sell it.' She was the mother of one of my friends; her husband made, you know, the headlights on Thunderbirds. She really knew a lot and we were very close. She taught me how to sew, and she also showed me how to keep a journal and write my thoughts down in it." Eric showed us his "trip book," filled with the poetry and drawings he'd made while he was on LSD.

"How old was she?" Paul said.

"Fifty-five, maybe."

"And you were having sex with her?"

Eric wouldn't answer that. "She was very beautiful to me," he said simply, and sincerely.

Toward the end of April, a club called the Cheetah opened on Broadway and 53rd Street. It was a big operation, with a fifteen-hundred capacity, done up very slick with colored lights and vinyl strips hanging off the ceiling, and movies and slides and closed circuit TV, and spin-offs like a television room and a boutique.

And bands—the Velvets played at the opening; I saw Monti Rock III dash by in a glittering gold outfit, looking, he said, for Joan Crawford.

The Cheetah was the brainchild of Olivier Coquelin, and when it was in the planning stages, Olivier had asked me and

Edie to be the host and hostess there—Andy & Edie's Up, he wanted to call it. But he and his backers were good business people and in those days we weren't—we were so loose when it came to things like schedules and contracts, and also, we never wanted to commit ourselves to anything; all we wanted was to run around and have a good time. So the next thing I knew, their beautiful slick club was opening—without me—and it was a sensation.

The clothes the guys wore at Cheetah showed that they were catching up with the girls, discoing in the new styles—polka-dot shirts and bell-bottoms and boots and little caps.

But the most remarkable thing was that there was not one drop of liquor on the premises (they figured it would be impossible to check I.D.'s for thousands of kids who would all be right around the legal age limit), and nobody missed it. The kids weren't really drinking much anymore anyway—drugs were the new thing on their minds; liquor seemed old-fashioned.

We put up the front money ourselves to produce the Velvets' first album, hoping that some record company would come along later and buy our tapes. We rented time for a couple of days in one of those small recording studios on Broadway, and it was just Paul and me in the control booth, and Little Joey, and Tom Wilson, who'd produced Bob Dylan and who happened to be a friend of ours, just there helping informally.

The image the Velvets had of themselves as a rock group hadn't included Nico originally—they didn't want to turn into a backup band for a chanteuse. But ironically, Lou wrote the greatest songs for her to sing—like "Femme Fatale" and "I'll Be Your Mirror" and "All Tomorrow's Parties"—her voice, the words, and the sounds the Velvets made all were so magical together.

The album came out great, a classic, yet the whole time it was being made, nobody seemed happy with it, especially Nico. "I want to sound like Bawwwhhhh Deee-lahhn," she wailed, so upset because she didn't.

Since we had a date to play the Trip in L.A. when our subleased month at the Dom was up, we only had time to record half the album in that Broadway studio—"All Tomorrow's Parties," "There She Goes Again," and "I'm Waiting for My Man." (We didn't finish till we got out to the coast; we did some more taping there, and then MGM decided to back us the rest of the way.) I was worried that it would all come out sounding too professional. But with the Velvets, I should have known I didn't have to worry—one of the things that was so great about them was they always sounded raw and crude.

Raw and crude was the way I liked our movies to look, and there's a similarity between the sound in that album and the texture of *Chelsea Girls,* which came out of the same time.

The Trip was a club on Sunset Strip that Donovan had told us about the last time he'd been up to the Factory, and right after that, a manager named Charlie Rothchild had mentioned to Paul that he could get a booking for the Velvets there from May 3 to 29. So Paul went out ahead of us to scout things and wound up renting the Castle from Jack Simmons, an actor with real estate savvy, for the Velvets to stay in. Back at the Factory, we packed up the whips and chains and strobes and mirrored ball and followed.

After the Velvets opened, a lot of people wondered if they could last the full three weeks, and critics wrote things like "The Velvet Underground should go back underground and practice." But the Velvets in their wraparound shades and tight striped

pants went right on playing their demented New York music, even though the easygoing L.A. people just didn't appreciate it; some of them said it was the most destructive thing they'd ever heard. On opening night, a couple of the Byrds were in the audience, and Jim Morrison, who looked really intrigued, and Ryan O'Neal and Mama Cass were there, kicking up their heels. We read a great comment by Cher Bono the next day in one of the newspapers, and we picked it up for our ads—"It will replace nothing, except maybe suicide." But Sonny seemed to like it all—he stayed on after she left.

The Velvets had been playing the Trip less than a week when the sheriff's office closed it down—suddenly there was this sign on the door telling people to go see Johnny Rivers at the Whiskey A Go-Go down the street instead, which was owned by the same two guys who owned the Trip. It said in the papers that the estranged wife of one of the owners had filed suit for some money she claimed her husband owed her. We all got ready to leave town when somebody advised us that if we stayed in L.A. we would get paid for the whole run, but that if we left town, we'd forfeit it—there was some rule that the musicians' union can make them pay, so we stuck around and sent Local 47 out there after the money for us. (It took three years, but they collected it.) So we had till the end of May to sit it out in L.A.

The Velvets were at the Castle, and some of us were staying at the Tropicana Motel on Santa Monica Boulevard. The Castle was a big medieval stone structure in the Hollywood Hills—with dungeon rooms downstairs and beautiful grounds. It had views of Griffith Park and of all of L.A. and across the way you could see the Frank Lloyd Wright mansion that Bela Lugosi had lived in. Lots of rock groups had stayed at the Castle—Dylan had just been there—and lots more would be staying there all

during the sixties. We were shuttling back and forth between the Castle and our motel. There didn't seem to be as much to do out there as in New York, so we were anxious to get home. Meanwhile, Bill Graham was calling us to come up to San Francisco to play the Fillmore on the bill with the Jefferson Airplane, whom he was managing then (Grace Slick wasn't with them yet, there was another girl singer named Signe), but Lou said he hated the Airplane and would never, never be on a bill with them. (The month before at the Dom, whenever Danny Fields would put an early recording of the Airplane over the sound system while the Velvets took their break, it would drive Lou crazy. Danny accused Lou of being jealous, and Lou said no, that wasn't it, that he just could not stand their music.)

We kept telling Bill Graham we didn't want to go up to San Francisco, that all we were interested in was getting back to New York, which was so true: there were big magazine articles out about the new music scene featuring the Velvets, and we felt it was foolish to be away just at the time we could be rolling in all that publicity.

While we were waiting it out at the Castle, a show of my Silver Pillows was going at the Ferus Gallery on La Cienega—a whole room of the helium-filled silver pillows drifting at different altitudes between the floor and the ceiling, with a green tank of the gas in a corner of the space. I preferred to have all the pillows float scattered—exactly halfway to the ceiling—but instead they were bunching up and there were even some fizzled ones on the floor that the helium had leaked out of. We spent all one afternoon tying lead fishing weights to them to get them moving, floating in between, bumping into each other, but it was impossible to make them sit still in the middle of the air, because one

of them would always drift away and start a chain reaction. There was a big silver and black photograph of me on one wall and on another wall a black and white one of the pillows floating out of the Factory window back in New York.

Bill Graham was still after us to go up to San Francisco at the end of the month—he even came down to L.A. to try to persuade us.

"I can't pay you much money, but I believe in the same beautiful things that you do," he said intensely, looking around at all of us.

Paul finally broke down and said okay, that we'd go there, but after Graham left, everyone dished the West Coast rhetoric—we weren't used to that kind of approach. "Was he *serious?*" Paul laughed. "Does he think we actually *believe* in this? *What* 'beautiful things'?"

That's what so many people never understood about us. They expected us to take the things we believed in seriously, which we never did—we weren't intellectuals.

Paul blamed LSD for the decline of humor in the sixties. He said the only person on LSD who had a sense of humor left was Timothy Leary.

In a way he was right, because when we went up to San Francisco, whenever we tried to have fun with somebody, they would act like "How dare you make a joke!" Everybody seemed to be taking the Cosmic Joke so seriously they didn't want you to make little uncosmic jokes. But on the other hand, the kids on acid did seem happy, enjoying all the simple things like hugs and kisses and nature.

The San Francisco scene was bands and audiences grooving

together, sharing the experience, whereas the Velvets' style was to alienate people—they would actually play with their backs to the audience!

Anyhow, we were out of our element, for sure.

"They call this a *light show*?" Paul said, looking at the stage during the Airplane's act, where they had projections from the glass with fluid on it. "I'd rather sit and watch a clothes dryer in the laundromat."

A lot of friction developed between Bill Graham and us. It was just the difference between New York and San Francisco attitudes. What was funny was that Graham's business style was New York—the fast, loud-mouth operator kind of thing—but then what he was saying were San Francisco flower child things. The end came when we were all standing around in the back of the Fillmore watching some local band onstage. Paul was continuing the same type of LSD put-down commentary that he'd been making all day—comments that I could see were really rubbing Graham the wrong way.

"Why don't they take heroin?" Paul suggested, pointing to the group on stage. "That's what all the really *good* musicians take." Graham didn't say anything, he just fumed. Paul knew he was driving him good and crazy so he kept it up. "You know, I think I'm really all for heroin, because if you take care of yourself, it doesn't affect you physically." He took a tangerine out of his pocket and peeled it in one motion, letting the peels fall on the floor. "With heroin you never catch cold—it started in the United States as a cure for the common cold."

Paul was saying everything he could think of to offend Bill Graham's San Francisco sensibility, but in the end it was dropping the tangerine peels on the Fillmore floor—which he had

done totally unconsciously—that brought on the showdown. Little things mean a lot. Graham stared down at the peels, and he got livid. I don't remember his exact words, but he started yelling—things like:

"You disgusting germs from New York! Here we are, trying to clean up everything, and you come out here with your disgusting minds and *whips*—!" Things along that line.

On the plane coming home, Paul reflected, "You know, there's a lot to be said against San Francisco and its love children. People are always so boring when they band together. You have to be *alone* to develop all the idiosyncrasies that make a person interesting. In San Francisco, instead of becoming outcasts like you're *supposed* to when you take drugs, they organize communities around it! Then they get pretentious and call it a religion—then they get hypocritical and say some drugs are good, others are bad. . . .

"L.A. I liked," Paul continued, "because the degenerates there all stay in their separate suburban houses, and that's wonderful because it's so much more modern—people isolated from each other. . . . I don't know where the hippies are getting these ideas to 'retribalize' in the middle of the twentieth century. I mean, in New York and L.A. people take drugs purely to *feel good* and they admit it. In San Francisco they turn it into 'causes' and it's so tedious. . . . There's a lot to be said for the hardcore New York degenerates. After one day in San Francisco you realize how refreshing and unpretentious they are. . . . But what I'm really praying for is a great resurgence of good old alcoholism . . ."

After California, the Velvets played Chicago—a club called Poor Richard's in the Old Town section. Nico was off in Ibiza and

Lou was in the hospital with hepatitis, but Ingrid Superstar was there, and Mary Might, and Angus MacLise was subbing for Lou. The club had advertised for dancers to come and "try out" for the show—which was just a good gimmick to get kids into the place and out there on the dance floor.

Poor Richard's was inside an old church—it was so hot in there—and we projected the movies and slides from the balcony. We met two kids there who lived just outside Chicago—Susan Pile and Ed Walsh—and they'd read about Edie and me in *Time* and *Newsweek* and seen a lot of photos of Baby Jane in *Vogue* and I guess it must have all seemed really glamorous to them—the Campbell's Soup Cans and the parties and the idea of instant stardom. They were trying to do everything as "New York" as possible.

Every single night the Velvets were there, Ed and Susan came by, and each night their outfits got more silver and elaborate—"whips" made out of tinfoil, aluminum outfits (Paraphernalia had opened a boutique by then in Chicago). Everyone just assumed the two of them were part of the show. "It's great," Ed said. "We're instant stars in Chicago—which is exactly what we fantasized would happen if we met Andy Warhol."

The experience of playing in the heat of Chicago in a club that had no air conditioning didn't go over too well with the E.P.I., and since the Dom didn't have air conditioning either, Paul told Stanley, the landlord, that we would wait and rent it again when it got cool in the fall.

The Factory felt more strange to me than ever that summer. I loved it, I thrived there, but the atmosphere was totally impenetrable—even when you were in the middle of it, you didn't know what was going on.

The air didn't really move. I would sit in a corner for hours, watching people come and go and stay, not moving myself, trying to get a complete idea, but everything stayed fragmentary; I never knew what was really happening. I'd sit there and listen to every sound: the freight elevator moving in the shaft, the sound of the grate opening and closing when people got in and went out, the steady traffic all the way downstairs on 47th Street, the projector running, a camera shutter clicking, a magazine page turning, somebody lighting a match, the colored sheets of gelatin and sheets of silver paper moving when the fan hit them, the high school typists hitting a key every couple of seconds, the scissors shearing as Paul cut out E.P.I. clippings and pasted them into scrapbooks, the water running over the prints in Billy's darkroom, the timer going off, the dryer operating, someone trying to make the toilet work, men having sex in the back room, girls closing compacts and makeup cases. The mixture of the mechanical sounds and the people sounds made everything seem unreal and if you heard a projector going while you were watching somebody, you felt that they must be a part of the movie, too.

I was in my surfer look for the second summer in a row, blue and white T-shirts. Most people who came by to see me wouldn't even recognize me at first if I wasn't painting, because the pictures in the newspapers usually showed me wearing my leather outfits from the Leather Man down in the Village. But it was summer—the summer of the Spoonful's "Summer in the City" song, as a matter of fact—and it was just too hot for my trademark look. So because I didn't look like what they expected, people often didn't notice me.

One afternoon I watched a tall guy with dark curly hair step out of the elevator carrying a big manila envelope under his arm.

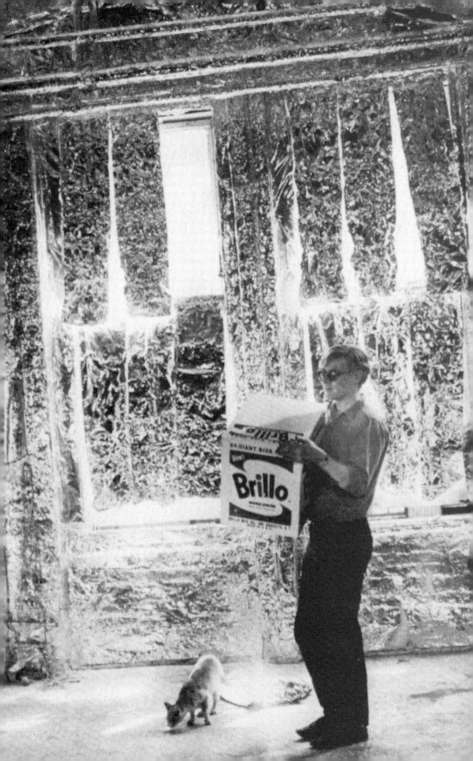

Above: Lester Persky, Tennessee Williams, and Andy. *The spaghetti hit the fan when Lester told Judy Garland what Tennessee thought of her acting.* PHOTO: DAVID MCCABE. Below left: Andy and Ondine. *Ondine was brilliant. I followed him around, taping him for twenty-four hours, and made it into a book.* PHOTO: FACTORY FOTO. Below right: Ingrid Superstar and Edie. *Ingrid was a good sport. You could always get her to jump up and do the Pony, no matter what year it was.* PHOTO: FACTORY FOTO.

Emile de Antonio
following a demonstra-
tion in the late sixties
at the U.S. Senate.
*I got my art training
from De.* PHOTO:
LORRAINE GRAY.

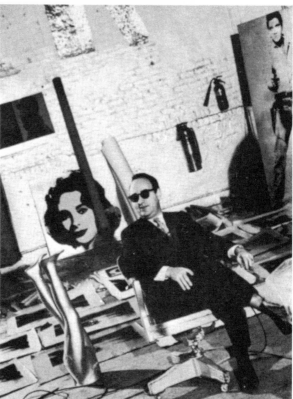

Ivan Karp at the
Factory. *People loved
Ivan's style of art
dealing—loose and
personal. We went to
rock-and-roll shows
together.* PHOTO:
FACTORY FOTO.

Henry Geldzahler about to be filmed. *Henry and I talked on the phone for five hours out of every twenty-four.* PHOTO: FACTORY FOTO

Jasper Johns and Andy. *I always wondered what Jasper really thought of me.* PHOTO: FACTORY FOTO.

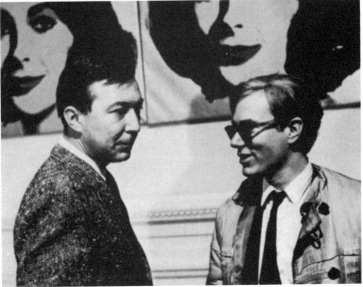

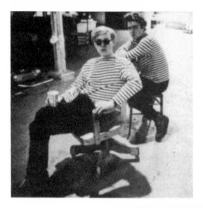

Andy and Gerard Malanga. *Gerard wrote poetry and he'd take me around to lots of readings in the Village.* PHOTO: STEPHEN SHORE.

Right: Chuck Wein. PHOTO: STEPHEN SHORE. Below: Edie Sedgwick and Andy at the Scene. *Edie dyed her hair silver to match mine and the photographers couldn't tell us apart.* PHOTO: FACTORY FOTO.

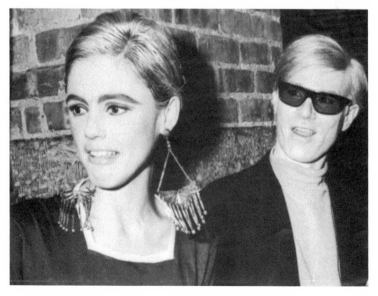

Nico. *She'd been in La Dolce Vita. Someone said she sang like an "IBM computer with a Garbo accent."* PHOTO: PAUL MORRISSEY.

Photographers never had to arrange for "sittings" at the Factory—all they had to do was come by and shoot. PHOTO: STEPHEN SHORE.

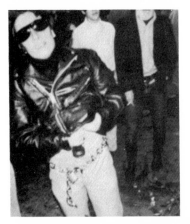

Vera Cruise. PHOTO: FACTORY FOTO.

Andy, Fred Hughes, Patrick, and
Taylor Mead. *Taylor called me
"incompetent" as a filmmaker in '64
and went off to live in Paris.* PHOTO:
FACTORY FOTO.

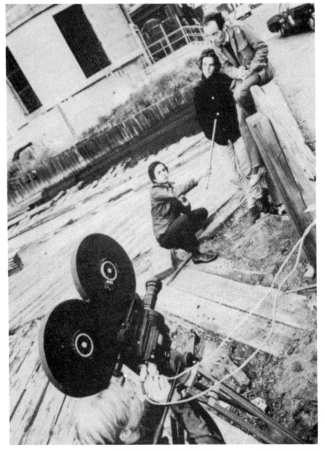

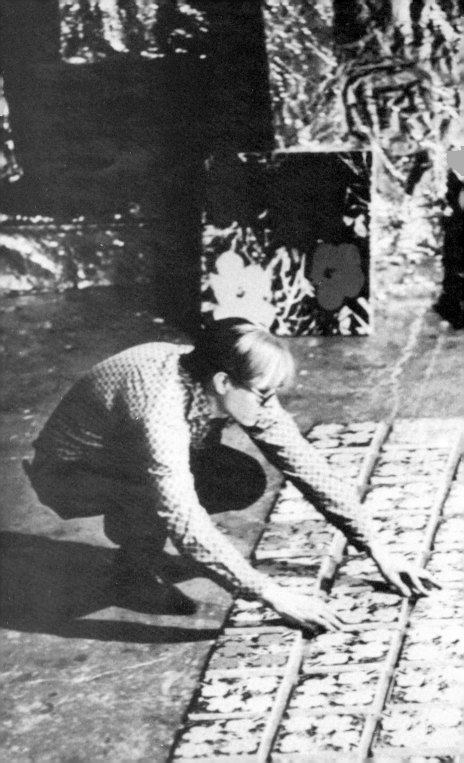

Andy in the hospital after he was shot. *I was in surgery for about five hours. At one point I died and they brought me back. For days I wasn't sure if I really was alive or not.* PHOTO: FACTORY FOTO.

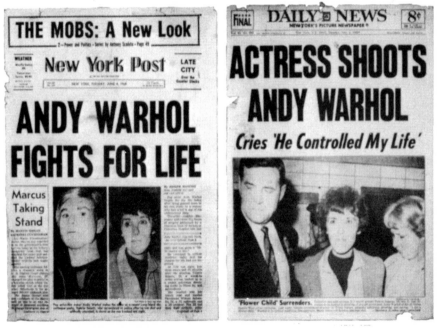

Andrea Feldman and
Geraldine Smith.
PHOTO: FACTORY FOTO.

Jackie Curtis, She.
PHOTO: FACTORY FOTO.

Jackie Curtis, He.
PHOTO: SANDY DENNIS.

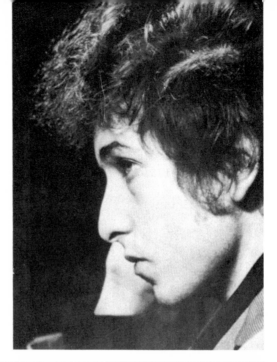

Bob Dylan at the Factory. *I liked Dylan a lot, the way he'd created a brilliant style. But I got paranoid when I heard that he was using an Elvis painting I gave him for a dart board.* PHOTO: FACTORY FOTO.

Andy and Paul Morrissey. PHOTO: FACTORY FOTO.

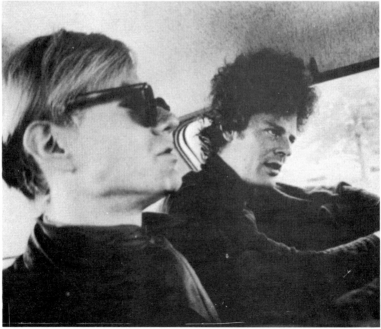

Susan Bottomly, known as International Velvet. *Susan would spend hours stroking on her Fabulash.* PHOTO: FACTORY FOTO.

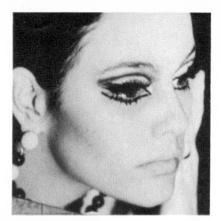

Eric Emerson. *Eric was impossible to figure out, full of contradictions.* PHOTO: FACTORY FOTO.

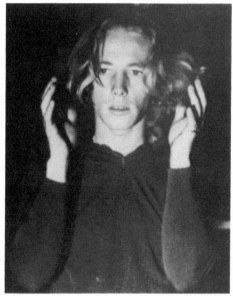

Opposite: Clockwise, Andy holding Nico's son Ari, Lou Reed, Nico, John Cale, drummer Maureen Tucker, Mary ("Mary Might") Woronov, Sterling Morrison, Gerard Malanga. *The Exploding Plastic Inevitable was a package—the Velvet Underground plus Nico plus dancers, with a light show over the whole works.* PHOTO: FACTORY FOTO.

Ingrid Superstar. *Ingrid wrote some good poems.* PHOTO: FACTORY FOTO.

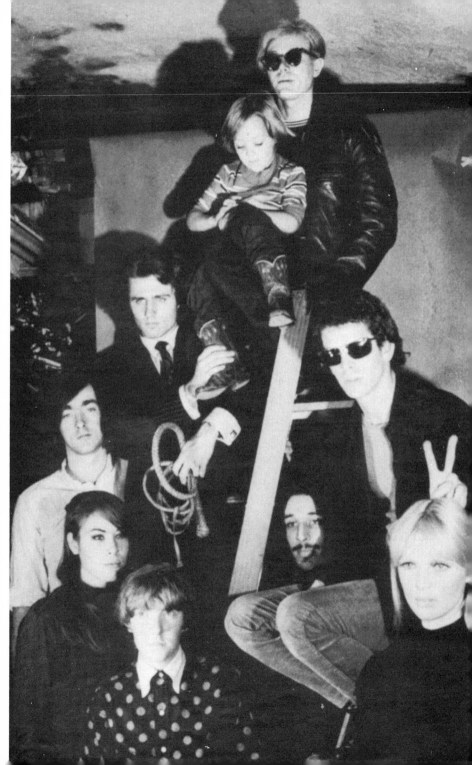

Above: Viva and Brigid taking a bath in *Tub Girls*. PHOTO: FACTORY FOTO. Left: Viva. *For a few months of '67–'68, Viva and I were inseparable.* PHOTO: FACTORY FOTO.

Tom Baker and Ultra Violet. *Ultra had purple hair and a French accent.* PHOTO: FACTORY FOTO.

Joe Dallesandro, Patti D'Arbanville, and Geraldine Smith in *Flesh*. PHOTO: JED JOHNSON.

Eric Emerson, Tom Hompertz, and Joe Dallesandro. PHOTO: FACTORY FOTO.

Candy Darling. *Candy was the most striking drag queen I'd ever seen. On a good day, you couldn't believe she was a man.* PHOTO: PETER BEARD.

He was wearing a suit from the new Pierre Cardin men's boutique in Bonwit Teller's. The kids were lying around reading or just staring into space, and Paul was busy fussing with the projector. Nobody looked up from what they were doing—nobody ever did—so the guy didn't know who to talk to and he just started wandering around, looking at the canvases, the screens, the vinyl, the plastic, the crumbling walls. If anybody "received" people at the Factory, it was Gerard, but he'd just gone out to mail invitations to one of his poetry readings. The guy walked three-quarters of the way through the Factory till he saw me sitting in my corner and almost jumped—it was so hot I hadn't moved for an hour. He handed me the envelope.

It was from the artwork department at MGM Records.

That summer I was doing the album cover for *The Velvet Underground & Nico,* the jacket that eventually became the stick-on banana that you peeled off and there was a flesh-colored banana fruit underneath. (I'd originally considered doing a plastic surgery series for the cover, and I'd sent Little Joey and a friend of his, Dennis, out to medical supply houses for photographs and illustrations of nose jobs, breast jobs, ass jobs, etc.—they brought me back hundreds! Little Joey was working full-time at the Factory this summer, picking me up at my house at eleven-thirty every morning. He'd grown a few inches and dropped about twenty pounds of baby fat since we'd met him in the fall.)

The guy who'd come in with the envelope said his name was Nelson Lyon and explained that he'd been over at MGM doing some work (he'd designed the *Doctor Zhivago* album cover for them that had just gotten a Grammy) when he heard someone call for a messenger to go to the Factory. Nelson offered to bring the package himself. "I wanted to meet you," he told me that day.

Years later, after he got to be a good friend, he elaborated: "I'd been at the Dom when you first opened it, so when I got to the Factory building that day I recognized Gerard Malanga coming out. He told me, 'It's five flights up,' and I looked at him in his leather outfit, and at this elevator cage and thought, 'Holy shit, this is like the entrance to hell.' Then when I wandered into that silver place, not one person moved, everybody was so cool. For all you knew, I could've been the district attorney or a *Times* reporter, a narcotics agent, whatever—nobody cared. And then I saw *you* sitting there in your dark glasses with your silver hair and your mouth open a little, just blending into everything. . . . I can't explain it but there was something about the Factory at that time . . . it was a juncture in history; you wanted to stay in that atmosphere and become part of it, and yet you didn't even know what it was. And you know, the more you involved yourself in it, the more of a mystery it was."

One day in July, Susan Pile came to the Factory. It was her first time in New York and she'd just been uptown taking a preview look at the Barnard/Columbia campus in Morningside Heights where she'd start school that September. Next she was on her way out to the Newport Folk Festival because there was a big rumor going around that Dylan would be there again.

"You mean," I said to her, "that you're actually going all the way from Chicago to Rhode Island just to see Bob Dylan?"

She laughed. "No. To *possibly* see him."

Paul had come over, and when he heard that, he groaned and shook his head.

Susan told us that right after the Velvets played Chicago, the Jefferson Airplane was there on their first tour outside San Fran-

cisco, and that a new group called Big Brother and the Holding Company had also just played on Wells Street.

"You look so fashionable," I told her. She was wearing a little checked Betsey Johnson minidress with a scoop neck and huge sleeves. She clicked open her suitcase and flashed a little sliver of a silver dress, another Betsey Johnson number, and said that as a matter of fact, the new singer with Big Brother and the Holding Company—a girl named Janis Joplin—had absolutely no clothes and so she'd borrowed this silver dress of hers to wear onstage. She and Ed liked Big Brother a lot, Susan said, and they'd gone every night to see them, the way they'd done with the Velvets.

When people don't have regular working hours, they start finding personal problems to worry about, and if they can't find any, they make some up. And when these people are on drugs, they can have as many as twenty dramas a day going on. No matter how little the problem is, it's always a big scene—they get as upset if they think somebody stole their laundry pickup ticket as when their boyfriend doesn't come home. More, actually.

Everything just then was getting really complex, because free love and bisexuality had come in, and people weren't supposed to be getting jealous anymore, so the discussions would all start out very cool and impersonal and abstract between two people who were having sex with the same third person, but then they'd always wind up tearing the third person apart together. And that's how the mystique went out of a lot of romances and the comedy came in.

We'd sit in gardens or sidewalk cafés for hours, and I'd listen to everyone discuss abstract things like whether some new

person was "definitive" enough to become a superstar or whether someone else was too "self-absorbed" or "self-destructive." I was fascinated by the way people could read so much into so many things, but then you never knew if you were getting to know the person or getting to know the drug they were on. It would all get so paranoid and psychological, and it would start from something as innocent as, "Did he *know* he had crabs when he borrowed the pants?"

This summer, a lot of people were living (or "staying"—it seemed like nobody actually "lived" anyplace anymore) on the Upper West Side—kids like Eric and his girl friend, Heather, and Ronnie, and Pepper, a southern girl who was in some of our movies—especially in the blocks between Broadway and Central Park West. I never knew who was staying with who, it was just sort of a circuit up there then. And there were also a lot of people staying down at the Chelsea Hotel on West 23rd Street, a whole group of our friends. Brigid swore that she never went into her own room there more than once a week—the rest was just in-house visiting, running from room to room.

Susan Bottomly (who became known as International Velvet in our movies) was the new girl in town. She was only about seventeen—a very tall brunette, very beautiful. When I think back on all the beauties we knew, I realize there was something special about the way they all held their heads and moved their arms. There were other girls who were just as beautiful as Susan Bottomly was, but her way of moving made her extra beautiful. People constantly wanted to know, "Who is she?"

Susan's father was a district attorney in Boston. Her family had money and they paid for her room at the Chelsea and sent

her an allowance. She always had the most expensive makeup and the newest clothes. She also had one of the few bodies that could really bring out the ultimate look in a dress like, say, the ones Paco Rabanne made out of plastic disks or like the short black "discotheque dress." And with her long neck, she could wear the new big earrings the way nobody else could.

Susan would spend hours putting on the latest makeup, stroking on Fabulash over and over again, painting her eyes three different shades of brown, brushing the rouge slowly, slowly, up and out, with those big fat sable brushes from the theater makeup stores, outlining her lips, then whiting them out. Watching someone like Susan Bottomly, who had such perfect, full, fine features, doing all this on her face was like watching a beautiful statue painting itself.

Gerard stayed with Susan at the Chelsea for the first couple of months she was in town, and all that time he was writing poems to her and about her. Her parents weren't happy with her new "career"—modeling in New York—and later on, when she was the cover of *Esquire,* photographed in a garbage can ("Today's Girl, Finished at 18"), they were really upset, she said. But they went on supporting her, and she went on supporting lots of her friends. A typical scene at the Factory was Susan writing a letter to her father asking him to please send some more money, then handing it over to Gerard. Gerard would put it in this attaché case he'd just started using. Then he'd tote this letter over to the Grand Central Station Post Office—very businesslike in the briefcase—and mail it Special Delivery up to Boston. Toward the end of the summer, though, Susan took in an additional roommate—a shrill character from Cambridge who wore a button over his ass that said, "The Fleet's In." Gerard used to complain bitterly that this "new element" was doing everything

possible to break him and Susan up. By the fall Susan was going with someone more her own age named David Croland, and Gerard after a few false starts got involved with the beautiful fashion model Benedetta Barzini, the daughter of Luigi, who wrote *The Italians,* and so then he was writing poems to and about *her.*

Tiger Morse opened her tiny new boutique called Teeny Weeny on upper Madison Avenue at the end of August. Her policy there was man-made materials only—vinyl, Mylar, sequins. There were mirror bricks all over the walls. Wherever I saw fragmented mirrors like that around a place, I'd take the hint that there was amphetamine not too far away—every A-head's apartment always had broken mirrors, smoky, chipped, fractured, whatever—just like the Factory did. And Tiger did take a lot of amphetamine. She always boasted, "I am living proof that speed does *not* kill."

A little bit later Tiger got the backing of some big company to design a line of pajamas and nightgowns for them, and to launch that, she gave a big party at the Henry Hudson Baths on West 57th Street that was sort of a fashion show "happening" around the pool, with models walking out onto the diving board, sometimes diving in, sometimes just turning around and walking back. As I said, it was Tiger who made happenings pop, turning them from something artistic into big parties. She'd stand around in her silver jeans and huge sunglasses, having a ball herself. People got so drunk they jumped into the pool with all their clothes on and then later tried to dive to the bottom for things like wallets that had fallen out of their pockets.

I'd done a few movie sequences with Tiger at her old boutique, Kaleidoscope, on East 58th Street, above Reuben's Restau-

rant, where she had about six seamstresses sewing for her and hundreds of jars of beads and sequins all around. Before that she'd sold her clothes out of a house on 63rd Street near Madison. In those days she did very expensive, chic, silk-and-satin brocade-and-lamé-type designs for women who wanted nicely made couture-type dresses—a little froufrou sometimes—the kind of outfits that would have a hand-stitched lining that was more elaborate than the dress itself. Then Tiger went off to England, and after she came back she went plastic and started to make dresses out of shower curtains. Eventually she took over the Cheetah boutique on Broadway, right outside the club—it stayed open as late as Cheetah did, and people would just pop in and buy new disco clothes on their way in to dance.

Tiger designed that famous dress that said "Love" on the front and "Hate" on the back. And she did dresses that lit up on the dance floor, only there would always be some problem with the technology—the lights wouldn't work or the batteries would be dead, etc. Women used to have old-fashioned problems like slips hanging and bra straps showing, but now there was this whole new slew of problems.

I've heard people say, "Tiger Morse was a fraud." Well, of course she was, but she was a *real* fraud. She'd make up more stories about herself for the newspapers than I did. Nobody knew where she came from, really, but who cared? She was an original, and she showed a lot of people how to have fun.

We met David Croland at a party Paraphernalia had for those big earrings he designed. Like a lot of other jewelry and clothes designers, he had a contract with Paraphernalia, which was by now like a little department store with branches in cities and towns all over the country, from Los Angeles to Washington,

D.C. It was all great-looking stuff, and almost everything in the store would disintegrate within a couple of weeks, so that was really Pop—like, a designer we knew named Barbara Hodes crocheted her dresses by hand for Paraphernalia and they looked fantastic, but they'd completely unravel if the girls caught them on a nail or a splinter. Paraphernalia had become a really mass boutique, which was sort of a contradiction—now if you designed for them, you had to be able to make *lots* of whatever you made, enough to send out to their stores all over the country. The masses wanted to look nonconformist, so that meant the nonconformity had to be mass-manufactured.

I was standing with Susan Bottomly at the party for David. She pointed him out to her Cambridge roommate and told him to "get him." Il Mio had low chandeliers and the first thing David did was pick two crystal drops with the chains attached and adapt them right there into beautiful earrings for Susan. ("We were all such thieves in those days," David said to me once. "Remember all the times you walked out of Arthur with those big thick goblets?") After Il Mio, we all walked over to a party in an apartment on Fifth Avenue, and Susan and David locked themselves into the bathroom. When they came out finally, Susan informed the people who were screaming to know what they'd been doing in there all that time, "Fucking."

She and David wound up living together for two years. David decided that those crystal earrings looked so good that he'd include them in his line for Paraphernalia, and so after a couple of months, the chandeliers at Il Mio were looking pretty bleak.

A few days later we all went up to Provincetown on Cape Cod where the Velvets were going to play at the Chrysler Museum.

The silver lamé, leather people in our New York group looked totally alien to the tan, healthy-looking Massachusetts kids. When our people—Susan Bottomly, David, Gerard, Ronnie, Mary Might, Eric, Paul, Lou, John, Sterling, Maureen, Faison the road manager—sprawled out on the beach, they looked like a giant Clorox spot on the sand, all those pasty-white New York City bodies out there in a sea of summer tans. Gerard had on his leather bikini, and he looked confident that it would turn somebody on, but everybody up there seemed more into the Boston-Irish look.

Naturally the A-heads were going crazy because they were almost out of amphetamine, and they'd walk around the P-town streets with their hands cupped to their ears as if they were hard of hearing, going "A? A?" trying to score. The night the Velvets played, the police raided the show—somebody had tipped them off that the Velvets had stolen most of the leather braids and whips they were using in their act from a local handicrafts store that afternoon. When the police came in, Mary had just strapped Eric to a post and was doing the S & M whipdance around him. They confiscated the whips and then undid Eric so they could confiscate the straps he was tied with.

The houses we'd rented got really disgusting in the couple of days we were there because the toilets all stopped up—it seemed like no matter where the Velvets went, the toilets would stop up—and so they started scooping handfuls of shit from the toilets and slinging it out the windows. I'd heard references to this habit of theirs, but you don't believe stories like that till you see people running by you with handfuls of dripping shit, laughing.

I remember walking on a street near the beach and looking up and seeing Eric in a bathing suit and high black lace-up boots

dancing pirouettes on a balcony with no railing and a twenty-foot drop. And later, in a grocery store, he talked a kid at the cash register into trading a carton of Marlboros for a Campbell's Soup Can with my signature. I signed by the checkout counter and gave the can to the kid, who handed Eric the cigarettes.

David and Susan got lost from us at one point and decided to move to a hotel. "Susan had the money and the checkbook," he told me a long time later, "so we had to register as 'Mr. and Mrs. Bottomly,' and that," he laughed, "is how the whole problem got started." When I asked him what he meant, he smiled and said, "Oh, come on, you remember what a joke I was in those days, tagging along with Susan to all her modeling jobs, carrying her portfolio, hoping someone would point to me and say, 'Oh, why don't *you* get into this shot, too?' I wanted to be a model then, but what I didn't realize was that I was trying to be a *female* model!"

There weren't very many young, new-style male models then yet. Male modeling didn't get really big until the next year when there were suddenly new men's lines all over the place. But in '66 men were used in photographs still, just to stand there and look butch, to sort of set off the girls and show that the girls were fascinating to them.

All that summer we were shooting the short interior sequences that we later combined to make up *Chelsea Girls,* using all the people who were around. A lot of them were staying at the Hotel Chelsea, so we were spending a lot of time over there. Often, we'd have dinner and sangría at the El Quixote Restaurant downstairs and everybody would be coming and going back and forth from their own rooms or somebody else's. I got the idea to unify all the pieces of these people's lives by stringing them to-

gether as if they lived in different rooms in the same hotel. We didn't actually film all the sequences at the Chelsea; some we shot down where the Velvets were staying on West 3rd, and some in other friends' apartments, and some at the Factory—but the idea was they were all characters that were around and *could* have been staying in the same hotel.

Everybody went right on doing what they'd always done—being themselves (or doing one of their routines, which was usually the same thing) in front of the camera. I once heard Eric telling someone about the direction I gave him for his first scene. "Andy just told me to tell the story of my life and to somewhere along the line take off all my clothes." After thinking for a second, he added, "And that's what I've been doing ever since." Their lives became part of my movies, and of course the movies became part of their lives; they'd get so into them that pretty soon you couldn't really separate the two, you couldn't tell the difference—and sometimes neither could they. During the filming of *Chelsea Girls,* when Ondine slapped Pepper in his sequence as the Pope, it was so for real that I got upset and had to leave the room—but I made sure I left the camera running. This was something new. Up until this, when people had gotten violent during any of the filmings, I'd always turned the camera off and told them to stop, because physical violence is something I just hate to see happen, unless, of course, both people like it that way. But now I decided to get it *all* down on film, even if I had to leave the room.

Poor Mario Montez got his feelings hurt for real in his scene where he found two boys in bed together and sang "They Say That Falling in Love Is Wonderful" for them. He was supposed to stay there in the room with them for ten minutes, but the boys on the bed insulted him so badly that he ran out in six and

we couldn't persuade him to go back in to finish up. I kept directing him, "You were terrific, Mario. Get back in there—just pretend you forgot something, don't let *them* steal the scene, it's no good without you," etc., etc. But he just wouldn't go back in, he was too upset.

Jack Smith always said that Mario was his favorite underground actor because he could instantly capture the sympathy of the audience. And that was certainly true. He lived in constant fear that his family or the people in the civil service job where he worked would discover that he dressed up in drag. He told me that every night he prayed in his little apartment on the Lower East Side for himself and his parents and for all the dead celebrities that he loved, like "Linda Darnell and James Dean and Eleanor Roosevelt and Dorothy Dandridge."

Mario had that classic comedy combination of seeming dumb but being able to say the right things with perfect timing; just when you thought you were laughing at him, he'd turn it all around. (A lot of the superstars had that special quality.)

For her reel in *Chelsea Girls,* Brigid played the Duchess. She got so into the role that she started to think she really was a big dope dealer: she took a dirty hypodermic needle and jabbed Ingrid in the fanny. (The Duchess wouldn't have done it any better herself.) Then, as we filmed, she picked up the phone and called a lot of real people up (who had no idea they were part of her movie scene) telling them about all the drugs she had for sale. She was so believable that the hotel operators, who were always listening in, called the police. They arrived at the room while we were still filming and searched everyone, but all they could come up with was two Desoxyn pills. Still, after people saw Brigid in the movie, they were as scared of her as they were of the Duchess.

• • •

At the end of September, just around the time the Whitney Museum was opening its new building at 75th and Madison, we all flew up to Boston for the opening of a show of my work.

In the middle of the opening David Croland suddenly pointed at a distant wall and said, "Look! Andy! There's a painting in here that you didn't do!" He was indignant.

"Where?" I asked, knowing it was impossible, but very curious to see which painting he would think wasn't mine.

"Over there." He pointed at a Do-It-Yourself canvas I'd done in '62. "That really ugly paint-by-numbers thing."

David was so young he'd missed the first part of my career as a painter, so he had absolutely no idea he was insulting a piece of my work—he thought it was a curator's mistake!

All I muttered was, "Oh. How crazy. How did that get in here?" I mean, after all, occasionally you can look at something you've done and wonder the same thing yourself—"How did *that* get in here . . . ?"

The Velvets played like crazy at the opening, and then about twenty of us invaded a little-old-lady Boston tearoom restaurant. Everybody thought I was going there as a joke, but really, those were the restaurants I truly loved the most—ones just like Schrafft's.

In the fall when Paul went back to rent the Dom, Stanley told him sorry, it was already rented. Al Grossman and Charlie Rothchild opened it as the Balloon Farm and asked the Velvets to play there anyway—upstairs—and they did, since they didn't have anything else to do. So even though it wasn't our place anymore, most people assumed it was a continuation of our Exploding Plastic Inevitable show from the spring.

In the basement there was a bar with a jukebox, and Paul

managed that, off and on, into the next spring and charged admission.

Nico and Lou had a fight. ("I've had it with the dramatic bullshit," he said. "Yeah, she looks great in high-contrast black and white photographs, but I've *had* it.") He said he wouldn't let her sing with them anymore and, moreover, that he was never going to play for her again, either. (That was actually the big problem right there—was she singing with them, or were they playing for her?) As a going-away present, Lou recorded the music she sang to on a cassette tape and handed it to her. Then she started being the chanteuse in the bar downstairs, trying to work a little cassette recorder. But it was pathetic to see this big, beautiful woman singing to music coming out of this cheap little cassette, and in between acts the tears would roll down her face because she just couldn't remember how the buttons worked. And Paul would try to help her—he even bribed the guitar players like Tim Buckley, Jackson Browne, Steve Noonan, Jack Elliot, Tim Hardin—promising them they could do a set alone if only they'd play a little for Nico while she sang. (Jackson Browne and Tim Hardin worked out the best, and Nico eventually recorded some of their songs on her first album, *Chelsea Girl,* which was released in July '67. But everybody wanted to be a star, and nobody really wanted to play backup for anybody, so Nico's problem wasn't solved until John Cale bought her a tiny little organ in '68 and she learned how to play it.) We looped a little 8-mm movie of a guy parachuting and we projected it behind her while she sang, and sometimes we'd show *Kiss.*

Susan Pile, who was working at the Factory now, would come over to the Dom and baby-sit for Ari, Nico's four-year-old son, during the first set, and then take him over to Paul's apartment a couple of blocks away on 10th Street and Second Av-

enue. She'd practice her French on him. He was such a beauti-
ful little kid, and he'd say the strangest things, like "I want to
throw hot snowballs."

Downtown at the big Village Theater, which would later become
the Fillmore East, Dr. Tim Leary was doing shows that Septem-
ber—they were called Celebrations—for the League for Spiri-
tual Discovery—LSD. The idea was to give people a preview,
through a mixed-media show, of what an ideal LSD trip was like.
Leary always had people on the bill with him like LeRoi Jones
and Mark Lane and Allen Ginsberg. Everything about these
shows was so sweet and naive—they told you you should plan
your LSD trips as carefully as you'd plan your itinerary for an
actual vacation, like have specific records to play and paintings
to look at while you tripped—otherwise, Tim said, it would be
like "drug abuse." Paul was laughing through the whole show,
saying, "God, Doctor Leary is wonderful! What a medicine
show!"

Tim was up there, this charming, handsome Irishman, in-
forming his audience, "God doesn't think in words, you see—
He thinks in visual images like"—and then he would gesture
behind him to where all these abstract slides were suddenly pro-
jected over the stage—"*these!*"

Paul got excited. "Look!" he said. "He's doing a complete
copy of our Exploding Plastic Inevitable show! Oh, he really *is*
wonderful. But you know, this is all for the good, because now
that drugs have gotten this commercialized, they're bound to go
right out. I guarantee you that in three months drugs will be fin-
ished completely—look what a joke they are already." (In the
drugged-up years that followed, Paul would admit many times,
"That prediction was my most enormous miscalculation.")

Listening to Tim Leary give his Celebrations that fall was like taking an Acid for Beginners course. By the time the next summer came, if you stood on the corner of 6th Street and Second Avenue, about every other kid who passed by would be tripping on LSD, and 90 percent of the rest would be high on some other kind of drug.

Chelsea Girls was the movie that made everyone sit up and notice what we were doing in films (and a lot of times that meant sit up, stand up, and walk out). Until then the general attitude toward what we did was that it was "artistic" or "camp" or "a put-on" or just plain "boring." But after *Chelsea Girls,* words like *degenerate* and *disturbing* and *homosexual* and *druggy* and *nude* and *real* started being applied to us regularly.

(People reacted very strongly to that movie. A very nice older woman came up to me at a party at the UN once, and after we'd small-talked a little bit, she said how much she wanted to see *Chelsea Girls.* I told her that it didn't play around much anymore but that we could show her some of our newer movies that were easier to get hold of for a screening. She said no, she only wanted to see *Chelsea Girls,* because her daughter had jumped in front of a train right after seeing it. I didn't know what to say to her.)

We opened it at the Film-Makers' Cinemathèque on 41st Street. It was eight hours of film, but since we were projecting two reels side by side on a split screen, it only took about half that time. Parts of it were in color, but it was mostly black and white.

We got our usual sympathetic reviews from the underground writers. But then Jack Kroll wrote a long, fascinating review of it in *Newsweek* that made so many people want to see it that we had to move to a bigger theater, the Cinema Rendezvous

on West 57th Street. Then Bosley Crowther wrote a silly review (it was a reprimand, really) of it for *The New York Times*: "It has come time to wag a warning finger at Andy Warhol and his underground friends and tell them, politely but firmly, that they are pushing a reckless thing too far. It was all right as long as [they] stayed in Greenwich Village or on the south side of 42nd Street. . . . But now that their underground has surfaced on West 57th Street and taken over a theater with carpets . . . it is time for permissive adults to stop winking at their too-precocious pranks . . ."

If anybody wants to know what those summer days of '66 were like in New York with us, all I can say is go see *Chelsea Girls*. I've never seen it without feeling in the pit of my stomach that I was right back there all over again. It may have looked like a horror show—"cubicles in hell"—to some outside people, but to us it was more like a comfort—after all, we were a group of people who understood each other's problems.

In September we started going regularly to a two-story bar/ restaurant on Park Avenue South off Union Square that Mickey Ruskin had opened in late '65. It was called Max's Kansas City and it became the ultimate hangout. Max's was the farthest uptown of any of the restaurants Mickey had ever operated. He'd had a place on East 7th Street called Deux Mégots that later became the Paradox, and then he'd had the Ninth Circle, a Village bar with a format similar to what Max's would have, and then an Avenue B bar called the Annex. Mickey had always been attracted to the downtown art atmosphere—at Deux Mégots, he'd held poetry readings—and now painters and poets were starting to drift into Max's. The art heavies would group around the bar and the kids would be in the back room, basically.

Max's Kansas City was the exact place where Pop Art and pop life came together in New York in the sixties—teeny boppers and sculptors, rock stars and poets from St. Mark's Place, Hollywood actors checking out what the underground actors were all about, boutique owners and models, modern dancers and go-go dancers—everybody went to Max's and everything got homogenized there.

Larry Rivers once said to me, "I've often asked myself, 'What is a bar?' It's a space that has liquor that's usually fairly dark, where you go for a certain kind of social interaction. It's not a dinner party. It's not a dance. It's not an opening. You move in a certain way through this space, over a period of time, and you begin to recognize faces that begin to recognize you. And you may have had experiences with some of these people before which you kind of pick up on in another way in this space."

One night I happened to be at Max's when Larry came in. That afternoon Frank O'Hara had been buried in Springs, Long Island, with Jackson Pollock's grave in the distance, and half the art world had gone out there for the funeral. Larry came over to my table holding a drink and sat down. He looked terrible. He'd been really close friends with Frank. After he was hit by a car, they took him to the nearest hospital, Larry told me, where they didn't realize he was bleeding internally until the next morning, and by then he'd been losing blood for eight hours. Frank's best friends, Larry and Kenneth Koch and Joe LeSueur and Bill de Kooning, were all called to the hospital, and de Kooning and Larry went up to his room to see him. "He thought he was at a cocktail party," Larry said. "It was a dream conversation. And three hours later he was dead. I made this speech at the funeral today—I was practically in tears. I just thought I'd describe what

Frank looked like that afternoon, the marks on his body, the stitches, the tubes coming out of him. But I didn't get to finish because everyone was screaming at me to shut up. . . ." Larry shook his head. It sounded like a very Pop eulogy to me—just the surface things. It was just what I hoped people would do for me if I died. But evidently death wasn't something the people out there in Springs that afternoon wanted to be Pop about.

"It's very selfish of me, I know," Larry said, "but all I can think is that there'll never be anybody who likes my work as much as Frank did. It's like that poem of Kenneth's—'He Likes My Work.'"

It was scary to think that you could lose your life if you were taken to the wrong hospital or if you happened to get the wrong doctor at the right hospital. It sounded to me like Frank wouldn't have died if they'd realized in time that he was bleeding.

I'd known Frank, too. He was kind of small, and he always wore tennis shoes, and he talked a little like Truman Capote, and even though he was Irish, he had a face like a Roman senator. He'd say things like "Listen, Circe, just because you've turned us all into pigs, don't think we're going to forget you're still our queen!"

I started going to Max's a lot. Mickey was an art fan, so I'd give him a painting and he'd give us credit, and everybody in our group could just sign for their dinners until the credit was used up. It was a really pleasant arrangement.

The back room at Max's, lit by Dan Flavin's red light piece, was where everybody wound up every night. After all the parties were over and all the bars and all the discotheques closed up, you'd go on to Max's and meet up with everybody—and it was like going home, only better.

Max's became the showcase for all the fashion changes that had been taking place at the art openings and shows: now people weren't going to the art openings to show off their new looks— they just skipped all the preliminaries and went straight to Max's. Fashion wasn't what you wore someplace anymore; it was the whole reason for going. The event itself was optional—the way Max's functioned as a fashion gallery proved that. Kids would crowd around the security mirror over the night deposit slot in the bank next door ("Last mirror before Max's") to check themselves out for the long walk from the front door, past the bar, past all the fringe tables in the middle, and finally into the club room in the back.

Max's is where I started meeting the really young kids who had dropped out of school and been running around the streets for a couple of years—hard-looking, beautiful little girls with perfect makeup and fabulous clothes, and you'd find out later they were fifteen and already had a baby. These kids really knew how to dress, they had just the right fashion instincts, somehow. They were a type of kid I hadn't been around much before. Although they weren't educated like the Boston crowd or the San Remo crowd, they were very sharp in a comical sort of way—I mean, they certainly knew how to put each other down, standing on chairs and screaming insults. Like, if Gerard walked in with his fashion look really together and had that very serious Roman god-like expression on his face that people get when they think they're looking good, one of the little girls at Max's (the Twin-Twats, they were called) would jump up on the table and swoon, "Oh my God, it's Apollo! Oh, Apollo, will you sit with us tonight?"

I couldn't decide if these kids were intelligent but crazy, or just plain pea-brained with a flair for comedy and clothes. It was

impossible to tell whether their problem was lack of intelligence or lack of sanity.

Edie Sedgwick and Susan Bottomly had gotten to be good friends, although Susan was about five years younger. They'd met in New York in the late winter of '66—two rich, beautiful girls from old New England families.

One afternoon in October, David Croland stopped by the Factory when we were dishing and I asked him right out what he thought of Edie. He was silent for a few seconds and then started out carefully, "Well, she's very unsure of people when she first meets them. . . ." Then he suddenly started laughing at how phony he sounded. "What am I talking about? She's a *snob*. A *big snob*! One of the first nights I met her, at Arthur, I flashed on her huge earrings—half-moons with stars—and I asked her would she please let Susan borrow them for a couple of hours. She pulled them right off her ears and handed them to me. She said, 'I will *give* Susan these earrings. But don't *ever* ask me to *lend* anybody anything.'" David smiled, remembering it. "She's a kleptomaniac who gives everything away. She'll never be at your apartment that you won't find something missing after she's left . . ."

A few days after that conversation with David, the candles that Edie always kept burning in her apartment on East 63rd Street started a fire in the middle of the night, and she was rushed to Lenox Hill Hospital with burns on her arms and legs and back.

I'd seen Edie lighting candles once, and from the absent-minded way she went about it, it was clearly a dangerous routine. I told her she shouldn't, but she naturally didn't listen—she always did exactly what she wanted.

• • •

That fall, after working all day at the Factory, we'd usually go out to Il Mio and then to Ondine and wind up at Arthur.

A band called the Druids had been playing at Ondine for a couple of months. Jimi Hendrix—this was before he was Jimi Hendrix, he was still Jimmy James—would sit there in the audience with his guitar and ask them if he could play with them and they'd say sure. He had short hair and really beautiful clothes—black pants and white silk shirts. This was before he went to England and came back here as the Jimi Hendrix Experience, way before he played Monterey, before the bandanna and the twangy guitar and all that. But he was already playing with his feet. He was such a nice guy, so soft-spoken. One night he told me that he was from Seattle, Washington, and it seemed like he was homesick when he talked about how beautiful it was there, all the water and the way the air was. It's funny but I remember the song that was playing at Ondine while we talked— "Wild Thing" by the Troggs—the song I'd eventually see Jimi do so fantastically himself in '67 at the Fillmore East in his pirate prince look—a green velvet shirt and hat with a pink Musketeer plume. But the night we talked, he was just simple black and white elegant and there was a very sad look to him somehow.

This fall was the first time I remember black people wearing Afros. Everything had changed—from white student-type kids going down south, doing SNCC things, to all-black groups and all-black meetings and all-black demonstrations. Suddenly there was no place for white people in the black problem—the blacks started telling them to just stay home in front of their checkbooks.

• • •

In November the Doors came to New York for the first time and they played at Ondine. When we walked in, Gerard took one look at Jim Morrison in leather pants just like his and he flipped. "He stole my look!" he screamed, outraged. It was true enough—Jim had, I guess, picked it up from seeing Gerard at the Trip.

The girls all went crazy over Jim Morrison—the word got around fast that there was a group with this very cute, very sexy lead singer. The Doors were at Ondine because, according to Ronnie Cutrone, who should know—he hung out there enough—the girl who played the records, Billie, knew them from L.A. (She also knew the Buffalo Springfield from the Coast and she got them a gig there, too, right after the Doors. "In fact," Ronnie told me, "the one and only time I was ever naive enough to try to 'fix Lou [Reed] up' with a girl was with Billie's roommate, Dana. And not only was it a total disaster"—he laughed—"but the Buffalo Springfield happened to be over visiting them during this date, and Lou was very hostile—a lot of 'California trash' remarks—and they weren't so thrilled with him, either . . .")

After the Doors and the Buffalo Springfield played Ondine, the image of the place went from chic to rocking, and groupies started hanging out there, beautiful girls like Devon and Heather and Kathy Starfucker.

It was so obvious just from watching these kids operate that there were new sex maneuver codes. The girls were only interested in the guys that didn't go after them. I saw a lot of girls pass on Warren Beatty, who was so good-looking, just because they knew he wanted to fuck them, and they'd go looking for somebody who looked like he didn't want to, who had "problems."

• • •

When you walked into Ondine, on the right was the coat check, on the left was a red leather couch, then there was the bar, and then a narrow strip with tables in it, and then the back room that was the dance floor, with the record booth at the end of it. Jim Morrison got to be a regular there, and the Doors played there again a few times the following spring. Jim would stand at the bar drinking screwdrivers all night long, taking downs with them, and he'd get really far gone—he'd be totally oblivious—and the girls would go over and jerk him off while he was standing there. One night Eric and Ronnie had to actually carry him out to a cab and take him home to where he was staying in the West Forties.

Jim was supposed to be the star of my first "blue movie"—he'd agreed to bring a girl over and fuck her in front of the camera—but when the time came, he never showed up. He was always very sweet to me, though—in fact, I never saw him be anything but sweet to anybody.

In November we went with the Exploding Plastic Inevitable to Detroit to play at a "mod wedding" that was being sponsored by a supermarket at the Michigan State Fairgrounds during a three-day "Carnaby Street Fun Festival" that also featured Dick Clark, Gary Lewis (right before he got drafted) and the Playboys, Bobby Hebb, the Yardbirds, Jimmy Clanton, Brian Hyland, and Sam the Sham and the Pharaohs. The couple getting married, Gary and Randy (she was "an unemployed go-go dancer" and he was "an artist"), had volunteered to be married publicly so they could get the prize of a free three-day honeymoon in New York City, which included a screen test at the Factory. The parents of the couple watched as I gave the bride away and Nico intoned "Here Comes the Bride." A local radio deejay was the

best man. The bride wore a white minidress and high white satin boots, and the groom wore a plaid Carnaby Street jacket, a cowboy belt, and a wide tie. For a wedding present we gave them an inflatable plastic Baby Ruth bar.

During the ceremony, I painted a paper dress on a model—with ketchup. Earlier that month I had gone out to Abraham & Straus in Brooklyn with Nico and some other kids, to make a personal appearance promoting two-dollar paper dresses in "whitest white twill of Kaycel R" that came with a do-it-yourself paint set. Nico wore the dress while I painted it. I could never understand why paper dresses didn't catch on—they were such a modern idea, so logical. Maybe they just weren't marketed right—I mean, at A & S they were selling them in the notions department! I thought they were so great that I couldn't help doing something with one at that wedding.

When friends were passing through town—or even when they were planning to stay for a few months—Gerard and Paul were great at finding them places to stay. The two of them together functioned like a placement service—they'd call somebody up who had an apartment that the visiting person looked like he belonged in, ranging from Lower East Side to Sutton Place.

As I said, Marie and Willard Maas were like Gerard's godparents—he even kept a lot of his papers and clothes over at their house. I was going somewhere else for Thanksgiving dinner, but I met up with everybody later on at Arthur, and they'd all been out in Brooklyn at Willard and Marie's.

A blond kid from Yale named Jason was in town for the weekend, out on the dance floor watching Susan Bottomly and David Croland, who stood like androids, smack in the middle of all the wild to-the-side bugaloo-type dances going on around

them, staring straight over each other's shoulders with their heads tilted just a little to the side, moving their bodies in a slight roll and a slow shuffle. They were so tall and sexy it looked great. Somebody behind me said that the Dave Clark Five had just come in.

Later that night when we were down at the Tenth of Always, Jason was still studying Susan Bottomly and David, with the same envying expression he'd had at Arthur. When he caught me catching him at it, he said, "Well, what do you expect? They're a sharp couple." Susan was beautiful, and she wore the short sixties clothes so perfectly, but still her body was womanly. Then when she opened her mouth, she sounded sort of dumb—which made her even more perfect. Like a lot of the girls, she carried a few changes of clothes around with her—just tucked a few dresses or skirts into her pocketbook before she went out—and Jason was peeking at a black disco dress she had in her bag, in with all the eye makeup and earrings.

Susan Bottomly's voice was the strangest thing to hear coming out of this girl. Everybody went around doing Susan Bottomly imitations. It was a monotone, but not at all like Nico's: Susan's was a low-pitched American monotone. What she was like was a very beautiful, sexy cow.

Lou Reed and John Cale were there at the Tenth of Always, too, and later they took us to a building at 36 East 30th Street, to a place called something like One-Two-Three because there were three floors of dancing: the first floor was straight, the second floor was gay, and the third floor was lesbian. Lou disappeared into the back of the second floor, and Jason and I went on up to the third.

"I've seen dykes before, but never like this," Jason said, looking around at all the tall girls in capri pants and halter tops

in very striking colors like shocking pink and turquoise. They were all dancing together—to Barbara Lewis singing "Hello Stranger"—and holding each other really tight, and they had good suntans and lots of blond hair teased in flips. "This is the good stuff, all right," he said. "They all look like Angie Dickinson. It's funny—the last time I was in New York, the most degenerate thing I could imagine was getting drunk on three Manhattans. It just doesn't seem like only a year ago."

Shortly after we got back from that mod wedding in Detroit, Truman Capote was having his famous Masked Ball in the grand ballroom of the Plaza Hotel. All the magazines and newspapers were calling it "the party of the decade"—not only was this before the decade was over, mind you, it was before the party had even happened—and there were all these incredible dramas going on over who was invited and who wasn't.

I knew Truman Capote. In the fifties, in my pre-Pop days, I wanted to illustrate his short stories so badly I used to pester him with phone calls all the time till one day his mother told me to cut it out. It's hard to say now what it was that had made me want to connect my drawings with those short stories. Of course, they were wonderful, very unusual—Truman was a pretty unusual character himself—they were all about sensitive boys and girls in the South who were a little bit outside society and made up fantasies for themselves. I could almost picture Truman tilting his head and arranging his words around the pages, making them go together in a magical way that put you in a certain mood when you read them. Truman's book, *In Cold Blood,* about the murder of the Clutter family in Kansas, had come out in a big way the year before. (Nine people from that small Kansas community would be at his party, but not the two

boys who did the murders—they'd been executed in the spring of '65.)

Henry Geldzahler had been invited to the ball, too, and we decided to go to it together, although that year our friendship had really cooled out. The main focus of Henry's life was still art, and the main focus of mine was Pop—Pop anything. Then, as I said before, Henry's personal life had changed and we didn't gab on the phone as much as we once had. And I had a new crowd—I was pretty involved with the Velvet Underground, and Paul Morrissey had brought a lot of new interests to the Factory. (The one thing Paul didn't seem to care anything at all about, though, was contemporary art. Actually, he ridiculed it. What he liked were things like nineteenth-century landscapes that he'd find in junk shops and in the garbage in his neighborhood and then a neighbor of his, an elderly Englishman, would clean and restore them. Paul liked antique things—paintings, furniture, photographs, sculpture, books, etc.—anything but what was happening at the moment.)

By '66 Paul was organizing as many of our excursions around the city as Gerard was. I was pretty passive in those days. I'd go anywhere that I was organized to go, since I wanted to go everywhere, anyway. And there were so many things coming up. As I've said, amphetamine was the big drug in New York in the sixties because there was so much to do that everybody was living double-time or they'd miss half of what was going on. There was never a minute around the clock where you couldn't be at some kind of a party. It's amazing how little you want to sleep when there's something to do. ("Remember how we never went to bed?" somebody said to me in '69, nostalgic already for the '65–'67 era. And it really was a whole era, those two years.)

Everybody was feeling the acceleration. The August '66 issue of *Esquire* announced it was time to call an end to the sixties— "Let the next four years be a vacation," the text read. Then the article opened with a posed photograph of me dressed up as Batman with Nico beside me in a Robin outfit—captioned "Andy What's-his-name"—which I loved. (The Batman image was very popular that year because the remake TV show had gone on in February, so camp was really being mass-marketed—everyone was in on the joke now.) The text of the article was by Robert Benton and David Newman, who were the screenwriters on *Bonnie and Clyde* that would be coming out in '67. (Many years later I read an interview with them in *Film Comment* where they said that the underworld of the thirties and the underground of the sixties were "strange phenomena that the media sponge soaked up and made popular," and they went on to say that it was finding out that the real-life Bonnie Parker had wanted to be a celebrity so badly—sending poetry in to newspapers, etc.— that had flipped them out. Newman said, "The sense of their own style was important; Bonnie and Clyde were like Edie Sedgwick and the other Andy Warhol 'superstars.' They were getting a lot of press, but nobody was quite sure why—just that they were outrageous; aesthetic outlaws.")

So anyway, by the time Henry and I went to Truman's ball, we'd drifted away from a close relationship. At first, it had just been a slow, steady drift, but then in June '66, the Venice Biennale came up, and that was a big drama. At this point we were still talking on the phone a lot to each other—every other day or so. I mean, I talked to him the day before he left on a trip to Egypt and everything was very casual, blah-blah-blah-blah-have-a-nice-trip. But the next day, when I picked up *The New York Times,* I

read that he'd been chosen the commissioner for the Venice Bi-
ennale. He hadn't even mentioned it to me!

At first, I was so hurt that he'd kept the news from me that
when people asked if I'd heard about it from Henry, all I could
say was "Henry who?" But I got over it little by little: I could for-
give his not putting my work in the Biennale (he used Helen
Frankenthaler, Ellsworth Kelly, Jules Olitski, and Roy Lichten-
stein)—that was his business—but I couldn't understand his not
telling me. We were always more reserved with each other after
that, but we stayed pretty friendly—obviously, since here we were
in November going to the big Capote Masked Ball together.

Henry came to pick me up at the Factory, and all the kids
crowded around to see us off in our tuxedos—they were really
proud of me, that I was invited. Henry was wearing a mask of
his own face, and I had sunglasses on and a big cow's head sit-
ting on my shoulders. I didn't wear the cow's head for very long,
though—it was too uncomfortable. The black and white look
of the party had been planned out by Cecil Beaton, and evi-
dently it was based on the Ascot scene in the movie *My Fair
Lady* that Cecil had done all the sets for.

When we got to the Plaza, I was totally intimidated, I'd
never seen such a herd of celebrities before in my life. Truman
had rented a dinner jacket for the doorman of his apartment
building and had him there checking the glamorous names at
the door when you came in. Everyone had been asked to wear
either black or white, and the first black or white people we no-
ticed were Alice Roosevelt Longworth, Katharine Graham (she
was the guest of honor), Margaret Truman's husband Clifton
Daniel, John Kenneth Galbraith, Philip Roth, David Merrick,
Billy Baldwin, Babe Paley, Phyllis and Bennett Cerf, Marella Ag-

nelli, Oscar de la Renta, David O. Selznick, Norman Mailer, Marianne Moore, Henry Ford, Tallulah Bankhead, Rose Kennedy, Lee Radziwill, George Plimpton, Adele Astaire Douglass, Gloria Vanderbilt Cooper, and, as Suzy Knickerbocker would say, "like that." Then Lynda Byrd Johnson brushed past me—she'd just gotten a job at *McCall's* and the gossip columns were putting her together with George Hamilton. Out on the dance floor, Lauren Bacall was dancing with Jerome Robbins and Mia Farrow Sinatra was dancing with Roddy McDowell while her husband, Frank, talked to Pat Kennedy Lawford.

As far as I could tell, this was the densest concentration of celebs in the history of the world. As Henry and I stood there gaping, I told him, "We're the only nobodies here." He agreed.

It was so strange, I thought: you get to the point in life where you're actually invited to the party of parties—the one people all over the world were trying desperately to get invited to—and it *still* didn't guarantee that you wouldn't feel like a complete dud! I wondered if anybody ever achieves an attitude where nothing and nobody can ever intimidate them. I thought, "Does the president of the United States ever feel out of place? Does Liz Taylor? Does Picasso? Does the queen of England? Or do they always feel equal to anyone and anything?" I tried to stick around Cecil Beaton because at least he was someone I knew well enough to say hi to.

I decided to grow along the sidelines, like a good wallflower, and as I was standing there, I heard a Society lady remark, "He's such a good dancer," as she watched Ralph Ellison, the Negro author of *The Invisible Man*.

That's the extent of what I remember about Truman's party. It was a perfect affair for *Mad* magazine to cartoon, because it

was so surreal—I mean, you couldn't look over your shoulder without dropping thirty names.

As for the Biennale, Henry and I didn't clear the air about that for a long, long time. One day years later, he gave me his side of the story.

"When I was asked to be the commissioner, I said yes very quickly and made my choices instantly and intuitively. It wasn't even in my head to say, 'Look, Andy, I want to be the next curator of twentieth-century art at the Met, and I can help you much more in the next fifty years if I do *that* than if I blow my chances by becoming some sort of crazed super-Pop curator.'"

At the time of the Biennale, Henry's boss, Robert Beverly Hale, was about to retire, so Henry was having to be very careful of his image. He said that he felt Pop Art had been "heavily represented" at the previous Biennale in '64: "Castelli staged that all very well. Being Italian, he had lots of connections with the Italian press and the judges. Let's face it, Andy, if I'd included you in the Biennale show, you would have wanted to come over with the Velvet Underground and the movies and the strobe lights and the whole entourage and you would have totally eclipsed the other artists; it just wouldn't have been fair to *them*."

Yes, I thought, that's logical, but still, why couldn't he have told me himself—why did I have to read about it in *The New York Times*?

"Yes, people are fascinated with Pop Art," he went on, "because it's a media event, it's glamorous, it's 'what's happening,' but as an art historian, I felt I also had a high art tradition to protect. I was already identified with Pop Art so much—remember that full page of me in *Life* magazine in a swimming pool at

a *happening*? I just couldn't afford to be exclusively connected with it anymore . . ."

Yes, I thought, all that's true, but still, why had he let me read about it in the newspaper?

"And even considering the show just from the standpoint of how it would look," Henry went on and on, "Helen's and Jules's pictures were soft and smoky, and Ellsworth Kelly's were hard and cool, and I realized that from the point of view of color and contour edge and mechanical surface, Lichtenstein and Kelly at either end with Frankenthaler and Olitski in the middle would make an incredible foursome. Your edges weren't as sharp as Kelly's so you wouldn't've balanced out with him the way Roy did. So it wasn't just that I was being a hideously ambitious careerist—the show did, after all, look good. And remember, Andy, you had actually 'stopped painting' by then."

"Yes, sure," I finally said. "But, I mean, Henry, I understand all that. When it's business, you can't think about friends, and I've always believed in that. But you could have told me before you told *The New York Times.* You owe it to a friend to tell it to them face to face, that's all . . ."

"I know, I know," he conceded. "You're right. I should have bitten the bullet and called you. But I didn't know what to say to you. It was just so easy not to say anything because I was leaving the country the next day."

Well, anyway, I thought, that was very Pop—doing the easiest thing.

I kept up with what was happening in the art scene, even though I wasn't going around to galleries myself as much as I used to. David Bourdon was writing on art for the *Voice,* and he and I would talk on the phone at least once a week and compare notes

on what we'd been seeing. Sometime in '66 David called to tell me that *Life* had offered him a job and he didn't know whether or not to take it—that is, whether taking it would mean he was "selling out" and "going establishment." While we talked, there was a limousine parked outside my house waiting to take me to an opening. I took it over to David's place in Brooklyn Heights first.

It was a beautiful night so we went out for a walk over toward the Brooklyn Bridge, with the limousine following us. David said right off that he felt really uncomfortable with the idea of talking art through the mass media. As we walked across the bridge to Manhattan, I told him, "Just think about all the *money* you'll be making, David. I mean, it's *Life* magazine. Don't be a fool!" The lights in Manhattan looked so inviting as we continued walking toward them, but a policeman stopped us at the other end. It must have looked suspicious, like a drug transfer scene or something, with the limousine lurking.

He took the job.

By November the Velvets had stopped practicing at the Factory and stopped living at Stanley's. Lou was living down on East 10th Street; John Cale was living with Nico, who had just broken up with Eric; Sterling was living with his girl friend; and Maureen was living out on Long Island with her parents.

The Velvets never really went out touring on the road. They'd played Cleveland earlier in the month, but what they would do was play a city and then come right back to New York. They still came by the Factory a lot, though, just to hang out.

One afternoon as I was silkscreening some Jackie canvases, I watched Lou answer the phone, then hand it over to Silver George who identified himself: "Yes, this is Andy Warhol."

That was fine with me. Everybody at the Factory did that. By late '66 I wasn't taking as many calls as I used to—there were just too many. (I think I'd stopped returning the calls on my answering service around the middle of '66.) Anyway, it was more fun to let other people take the calls for me, and I'd sometimes read interviews with me (supposedly) that I'd never given at all, that had been done over the phone.

"You want me to describe myself?" Silver George was saying. He looked at me as if to say, "You don't care if I do this, right?" I asked who it was and when he said it was a high school paper, I motioned for him to go ahead.

"Well, I wear what everybody else around the Factory wears," he said, looking over at me as a reference. "A striped T-shirt—a little too short—over another T-shirt, that's how we like them . . . and Levi's . . . and thick belts and"—he looked down at my feet—"I finally just stopped wearing ugly black engineer boots with the strap across them—I've moved into more refined Beatles boots with a zipper on the side. . . ." He listened for a few moments. "Well, I would call myself—youthful-looking. I have a slightly faggy air, and I do little artistic movements. . . ." I looked up from painting. I'd thought all they wanted was a fashion description, but it didn't matter, I was 99 percent passive in those days, so I just let Silver George go on describing me—whatever he said couldn't be any worse than the way a lot of journalists described me anyway.

"Well, I have very nice hands," he said, "very expressive. People always say how aware they are that they're talented hands. I keep them in repose or touching each other, or sometimes I wrap my arms around myself. I'm always very conscious of where my hands are. . . . But the first thing you notice about me is my skin. It's translucent—you can really see my veins—and

it's gray, but it's pink, too. . . . My build? Well, it's very flat, and if I gain any weight, it's usually all in my hips and stomach. And I'm small-shouldered and I'm probably the same dimension at my waist as I am at my chest. . . ." Silver George really had momentum now. ". . . and my legs are very narrow and I have tiny little ankles—and I'm a little birdlike from my hips down—I sort of narrow in and taper down toward my feet. . . . 'Birdlike,' right . . . and I carry myself very square, like a unit. And I'm rigid—very conservative about my movements; I have a little bit of an old-lady thing there. I don't look like I could walk very far—like maybe just from the door to the cab or something—and my new boots have sort of high heels, so I walk a little like a woman, on the balls of my feet—but actually, I'm very . . . hardy. . . . Okay?"

It sounded like the interview was over. "No, it was no trouble," Silver George told the high school newspaper. "Oh, well, right now we're just working hard, doing lots of projects—have you seen *Chelsea Girls* yet? . . . Yeah, well, will you send us a few copies of the interview when it comes out?"

When Silver George hung up, he said they were really thrilled because they'd heard I never talked and here I'd just said more to them than anybody they'd ever interviewed. They'd also said how surprised they were that I could be so objective about myself.

1967

In January '67 *Chelsea Girls* was still playing but now it was even farther uptown at the Regency on Broadway and 68th, where it had gone the month before when it finally left the Cinema Rendezvous on West 57th. Then Roger Vadim's movie *The Game Is Over,* starring Jane Fonda, which had been prebooked, moved into the Regency and so *Chelsea Girls* moved over to the York Cinema on the East Side. We had an arrangement with the Film-Makers' Distribution Center (FDC), which was then headed by Jonas, Shirley Clarke, and Luis Brigante, to split the net profits fifty-fifty, wherever it played. Everyone was excited about *Chelsea Girls'* being the first underground movie to play a long run in commercial theaters in midtown Manhattan. The FDC was getting calls from commercial distributors who wanted to handle it nationally, but the FDC had already made their own arrangements with the Art Theater Guild, which had art houses all across the country.

Jonas especially was excited; he felt that the success of *Chelsea Girls* was an indication that ordinary people wanted to see underground movies, too. He suggested that we put our films on a bill with some other underground movies that they had down there at the FDC, but Paul really resisted that; he—we—didn't think of our movies as underground or commercial or art or porn; they were a little of all of those, but ultimately they were just "our kind of movie." Also, for all anyone knew yet, the people filling the theaters for *Chelsea Girls* might be there purely for the nudity. So the success of *Chelsea Girls* didn't necessarily

mean that other underground movies would make it—it didn't even mean that our *own* other movies would make it.

One day in early January, in *The New York Times,* right next to a story about Jack Ruby dying in jail of cancer, was an article by their film critic, Vincent Canby: "Adult Themes Head for Screen; Many of Old Taboos Seen Rapidly Disappearing." Most of the piece dealt with *Chelsea Girls* and *Blow-Up,* and it said that David Picker, who was then the number-one vice-president of United Artists, was feeling, along with other big Hollywood types, that the freedom of expression in *Chelsea Girls* would inevitably influence the people who made conventional films. The article went on to describe how MGM, which had financed *Blow-Up,* had formed a new little subsidiary company to release it, which was what most of the big film companies were doing then—forming little companies to release their dirtier movies that wouldn't pass the Production Administration Code, which was the industry's *self*-censorship body. In other words, the studios were making a big show of regulating themselves—setting up and paying for a censorship board to review their clean movies—but when they had a "dirty" one they wanted to get out, they'd just form a new company with a new name and that way they'd be able to stand very aloof from it and moralize all the way to the bank.

We were thrilled to have the attention of Hollywood—now it was only a matter of time, we felt, before "somebody out there" would want to finance some of our breakthroughs instead of just sitting back and commenting on them. I mean, we'd done *My Hustler* back in '65, and now here Hollywood was in '67 just getting ready to shoot a movie called *Midnight Cowboy* about a male hustler in New York City. Paul and I read *Variety* all the

time now, really feeling that at last we were a part of the commercial movie business.

That January we'd go to see movies on 42nd Street like we always did, and then walk up Broadway to 68th Street to check on our own movie audience there. We loved seeing the big marquee, it meant we'd really made it with the people. I felt so good about things then, like we could do anything, everything. I wanted to have a movie playing at Radio City, a show on at the Winter Garden, the cover of *Life*, a book on the best-seller list, a record on the charts. . . . And it all seemed feasible for the first time.

Jerry Schatzberg, who'd been doing the photos for the Stones' record albums, was giving another party for them down at his place on Park Avenue South, on a Sunday night right after one of their appearances on *The Ed Sullivan Show*. We walked over to watch them on color TV at Stephen Shore's apartment on Sutton Place where he lived with his parents.

Little Joey was with us, and that was rare—I'd always tell him he couldn't come places with us because he was under age, especially since his mother would call up occasionally from Brooklyn and say, "Where's my little Joey? Is he getting into trouble?" He said she was always asking him, "What do you want to hang around with all those queers for?"

We were sitting around in this wall-to-wall-carpeted, color-coordinated living room—lots of mirrors and end tables and big sofas—watching the Stones do "Let's Spend the Night Together," which Ed Sullivan had had them modify to "Let's Spend Some Time Together," and "Ruby Tuesday"—Brian Jones was playing the sitar, I think, with a big white hat on. Joey was absolutely begging and pleading to come to the party, so finally I gave in and said okay, since not only did he worship the Stones,

he loved Jerry's photos for their albums. Joey was planning to go to Visual Arts after graduating high school, and after that he wanted to go into "rock graphics." (Before the Beatles kids used to give up rock and roll when they got out of school, but now so many of them were charting out rock-related careers for themselves, rock was such a big industry by this time.)

There were crowds of people outside Jerry's building trying to get into the party. Inside, the first person Joey nudged me about was Zal of the Lovin' Spoonful (they were really popular now—they'd just done "Did You Ever Have to Make Up Your Mind?") and he was in a cowboy hat, too, like Brian was. Joey went to look around for Brian, because that was his favorite Stone, and he finally found him with Keith in a corner holding a drink in both hands, standing not far from Twiggy, who was a new face in town then. Joey, who was only around five feet five inches, was surprised to see that Brian was even shorter than he was. I watched him go over and try to talk to him, and when he got absolutely no response, he sort of poked Brian a few times with his finger—and still nothing happened. So then Joey turned to Keith and said, "I'd just like to tell him how much I admire him," and Keith looked back with the blankest stare that anybody could ever give anyone, so then Joey just gave up. The circles under Brian's eyes were dark and his skin was dead white and his strawberry blond hair looked weird in the lighting. He was wearing the same outfit as Mick that night—a T-shirt with a striped blazer and white pants and white shoes. Keith, though, was in a pin-stripe suit.

Mick was shuttling back and forth between the upstairs, where Jerry lived, and the downstairs, where the party was. I tried to talk to him but every time we'd go over, some girls would

come along and try to rip his clothes off. Then he'd run back upstairs, turn around, and slink down again, literally throwing the girls aside as he walked.

Susan Pile had been working for Gerard part-time for free since the fall, coming down from Barnard on the Broadway IRT every afternoon, over on the shuttle from Times Square to Grand Central, past the "Baked-on-the-Premises" doughnut stand (who would ever want a doughnut baked in the subway, I'd always wondered when I passed there—why didn't they at least pretend they were made somewhere else? Like, "*Not* Baked on the Premises"), up out onto the street, through E. J. Korvettes, and into the Factory. Sometimes I'd notice her studying a little Chaucer in the Bickford's downstairs. Gerard was in his Benedetta Barzini period, writing lots of poems about her, and Susan would type those up and work on the anthology of writings by poets and kids we knew that was published the next year, called *Intransit, The Andy Warhol Gerard Malanga Monster Issue*. She'd sit Japanese-style on a cushion typing at a very low sawed-off silver desk with a missing leg that had been replaced with a stack of magazines. One day as I walked by, I overheard her telling Joey that she was going to have to look for another job because she needed money. I told her that if she would stay and type things for the Factory instead of just for Gerard, we'd give her money. I asked her how much she thought she'd need, and she estimated that since she was being partly subsidized by her parents, she'd only need about ten dollars a week. (That was fifty trips on the subway then.) I immediately began giving her lots of reel-to-reel tapes, the sound tracks to *Chelsea Girls, Kitchen, My Hustler,* things like that, to type, and she did some Ondine

tapes that would go to become part of the Grove Press novel *a* the next year—ones that the high school girls had never gotten to. I was especially glad to have someone typing right there at the Factory, because recently I'd discovered the hard way that you couldn't be too careful: one of the little girl typists had taken a reel of Ondine home with her to Brooklyn to transcribe it there, and when her mother got an earful of the dialogue on the tape, she confiscated it and I never got it back.

The Easter Sunday be-in in Central Park was incredible; thousands of kids handing you flowers, burning incense, smoking grass, taking acid, passing drugs around right out in the open, taking their clothes off and rolling around on the ground, painting their bodies and faces with Day-Glo, doing Far East–type chants, playing with their toys—balloons and pinwheels and sheriff's badges and Frisbees. They could stand there staring at each other for hours without moving. As I said before, that had always fascinated me, the way people could sit by a window or on a porch all day and look out and never be bored, but then if they went to a movie or a play, they suddenly objected to being bored. I always felt that a very slow film could be just as interesting as a porch-sit if you thought about it the same way. And now all these kids on acid were demonstrating the exact same thing.

Since the beginning of the year when Thomas Hoving became Parks Commissioner, the kids were using the parks a lot more—and this be-in was the ultimate use so far. In the middle of April, though, Hoving was scheduled to become director of the Metropolitan, and he seemed to be trying to temper his Pop image a little now, going around reassuring people that he wasn't going to turn the Met into a big "happening."

At the end of April there was another be-in—not as big as the Easter one, but big enough so everybody was looking forward to a fantastic summer in the park.

In the spring, Stash, the son of Stanley from the Dom, called to say that he and the Dom bartender—a good-looking Irish guy, I remember—wanted to open a discotheque in a place he'd found uptown on East 71st Street, a gymnasium, and that he wanted us to be involved—to revive the Exploding Plastic Inevitable there. All during March, Nico was still down at the Dom singing away with Tim Buckley, Jackson Browne, Tim Hardin—whatever musicians Paul could arrange for her to sing with. Leonard Cohen, the Canadian poet, was there quite a few nights in the audience down at the bar, just staring at her. Later on, when he cut a record album, I read a review that said his singing was like he was "dragging one note over the entire chromatic scale," and I couldn't help thinking of all those hours he'd spent listening to Nico. . . .

Pop fashion really peaked about now—a glance around the Gymnasium could tell you that. It was the year of the electric dress—vinyl with a hip-belt battery pack—and there were lopsided hemlines everywhere, silver-quilted minidresses, "microminiskirts" with kneesocks, Paco Rabanne's dresses of plastic squares linked together with little metal rings, lots and lots of Nehru collars, crocheted skirts over tights—to give just the idea of a skirt. There were big hats and high boots and short furs, psychedelic prints, 3-D appliqués, still lots of colored, textured tights and bright-colored patent leather shoes. The next big fashion influence—Nostalgia—wouldn't come till August, when

Bonnie and Clyde came out, but right now everything mod-mini-madcap that had been building up since '64 was full-blown.

Something extremely interesting was happening in men's fashions, too—they were starting to compete in glamour and marketing with women's fashions, and this signaled big social changes that went beyond fashion into the question of sex roles. Now a lot of the men with fashion awareness who'd been frustrated for the last couple of years telling their girl friends what to wear could start dressing themselves up instead. It was all so healthy, people finally doing what they really wanted, not having to fake it by having an opposite-sex person around to act out their fantasies for them—now they could get right out there and be their own fantasies.

Skirts were getting so short and dresses so cut-out and see-through that if girls had still been the sexy *Playboy* or Russ Meyer types, there might have been attacks all over the streets. But instead, to counteract all these super-sexy clothes, to cool down the effect of, say, micro-minis, the kids had new take-it-or-leave-it attitudes about sex. The new-style girl in '67 was Twiggy or Mia Farrow—boyishly feminine.

"Tell It Like It Is" was a big song at the beginning of the year, and that was the new attitude all around. It was an exciting time for pop music. Everybody was waiting for the Beatles' new album to come out (which would be *Sgt. Pepper* finally, in June) but some single cuts from it were already on the radio—"Penny Lane"/"Strawberry Fields" was out in February, and Aretha Franklin's "I Never Loved a Man" was out, and "Mercy Mercy Mercy," "Gimme Some Lovin'," "Love Is Here and Now You're Gone," etc., etc.

•••

The Gymnasium was the ultimate sixties place for me, because, as I said, we left it exactly as it was, with the mats, parallel bars, weights, straps, and barbells. You thought, "Gymnasium, right, wow, fantastic," and when you look again like that at something you've always taken for granted, you see it fresh, and it's a good Pop experience.

Our first weekend at the Gymnasium was also the weekend of the big spring mobilization march against the Vietnam war. Martin Luther King, Jr., and Stokely Carmichael and some other people gave speeches in the Sheep Meadow and then marched down Fifth Avenue. It was a rainy day, and from the Factory window, Paul, Nico, and I watched the crowd crossing 47th Street toward the UN. A face like Nico's looked wonderful in the natural afternoon light—it was made for looking out windows and across deserts, into horizons, etc. I remember her so well standing there in a Tuffin and Foale pants suit with "Happy Together" by the Turtles playing somewhere off in the background.

This was the time that Stokely Carmichael did his catchy "white men having black men fight yellow men" line and he was getting so much coverage in the media then that I noticed him right away later that weekend when I saw him at the Gymnasium dancing with a tall blonde girl.

From the Gymnasium we usually went on to a discotheque called the Rolling Stone, and then to Trude Heller's new place on Broadway and 49th, a few blocks down from Cheetah— "Sweet Soul Music" was the big song at all the clubs—and soon after this, Salvation opened down on Sheridan Square, so there were suddenly all these new places to go.

•••

We went out to Los Angeles in April for the opening of *Chelsea Girls* at the Cinema Theater there. John Wilcock, who'd just started a newspaper in New York called *Other Scenes,* was out there covering our trip, and he published a picture of himself with Paul, Lester Persky, Ultra Violet, Susan Bottomly, me, and Rodney La Rod taken at the opening.

Rodney La Rod was a young kid who hung around the Factory a lot—he claimed he used to be a road manager for Tommy James and the Shondells. He was over six feet tall. He greased his hair and wore bell-bottoms that were too short, and he'd stomp around the Factory, grab me, and rough me up—and it was so outrageous that I loved it, I thought it was really exciting to have him around, lots of action. (When eventually we found out he was under age and I had to stop taking him around with us, everybody unanimously said, "Good," because he drove them crazy.)

This was the first time I had ever traveled with Ultra Violet. She was still a big mystery; nobody knew what her scene was—she kept her life very secret (as opposed to everybody else we knew who were always telling you the most intimate things about themselves). I'd met her one day in '65 when she walked into the Factory in a pink Chanel suit and bought a big Flowers painting that was still wet for five hundred dollars. Her name was Isabelle Collin-Dufresne then and she hadn't dyed her hair purple yet. She had expensive clothes and a penthouse on Fifth Avenue, and she drove a Lincoln that was the same as the presidential one. She was past a certain age, but she was still beautiful; she looked a lot like Vivien Leigh.

Ultra would do almost anything for publicity. She'd go on talk shows "representing the underground," and it was hilarious because she was as big a mystery to us as she was to everybody else.

All the girl superstars complained that Ultra would somehow find out about every interview or photo session they had scheduled and turn up there before they did. It was uncanny the way she always managed to be right on the spot the second the flash went off. She'd tell journalists, "I collect art and love." But what she really collected were press clippings.

Gradually, we pieced together that she was from a rich family of glove manufacturers in Grenoble, France, that she'd come to America as a young girl to visit the painter John Graham (coincidentally in the same building where the Castelli Gallery was), who introduced her around the New York art world, and then when he died, she met Dali, and then she met me, and then she became Ultra Violet.

She was popular with the press because she had a freak name, purple hair, an incredibly long tongue, and a mini-rap about the intellectual meaning of underground movies.

We took *Chelsea Girls* over to the Cannes Film Festival that spring of '67—that is, we took it but we never got to show it. (The situation reminded me of when the Lincoln Center Film Festival had so graciously shown our movies—on little crank-up machines in the *lobby*! Only in Cannes, things didn't even get *that* far.)

The arrangements were all last-minute, just like everything else we did. The night before we left, we took the plane tickets with us when we went to Max's as usual and handed them out there. In addition to Paul and Gerard and me—and Lester Persky, who we were taking along to help us publicize the movie— Rodney La Rod, David Croland and Susan Bottomly, and Eric were coming along. A few hours later, at ten in the morning, we were all together on a plane for France.

When Eric left for Cannes with us, he was leaving a top-floor apartment on Central Park West and 80th Street that he'd painted completely black except for white trim on the woodwork. I asked him who he was letting stay in it while he was gone, and he said, "I just left it."

"But aren't you going back to it?" I asked him.

He shook his head no, vaguely.

"But didn't you leave all your stuff there?" I said.

He shrugged yes, then eventually said, "I was getting all fouled up. Too many people, and things were getting very close, wrapped up into too much drugs and stuff, and that's why I'm, like, really glad you said to come."

Eric had just broken up with his girl friend, Heather—she'd left him and gone off to London. Technically, Eric was married, and I asked him about that.

"I met my wife, Chris, at Ben Frank's in L.A. three years ago," he told me. "I was coming home from my girl friend's and I was tripping and I met her and she had these big turquoise eyes which later turned out to be contact lenses. We fell in love instantly and drove to Las Vegas the same day and got married. I had a daughter with her—Erica. Chris came back to New York with me; that was when I was trying to get a store together, right before I met you. I got really attached to my wife, and when she went out free-loving the way I did, I got crazy and went through a heavy gay scene for a while, and then when I was coming out of that I would do things like offer whatever woman I had with me to Jim Morrison at Ondine, so that I could imagine him having pleasure on my head and there would be this connection between us, Jim Morrison and me—just, you know, like watching people you love get together." Eric got a strange, almost bitter look on his face, thinking about all the times he'd watched

people he loved have sex with people he loved. "It seems," he said, "like anybody that I did love I watched 'get together.'"

I asked him when he'd gotten married for the second time—and if he'd ever even gotten a divorce from Chris. He hadn't. "I sort of got a 'separation' thing from the court," he told me, "but then the people down at the court wanted me to go through this whole thing with more papers and stuff and I just got all fouled up."

I never knew what to think of Eric: was he retarded or intelligent? He could come out with comments that were so insightful and creative, and then the next thing out of his mouth would be something *so* dumb. A lot of the kids were that way, but Eric was the most fascinating to me because he was the most extreme case—you absolutely couldn't tell if he was a genius or a retard.

The strange thing was, I'd assumed that Eric had been with us every night, and it wasn't until he described what he'd been doing for the last few months that I realized I hadn't seen him for quite a while.

When we got to Cannes, we discovered that the guy who was supposedly arranging everything hadn't set up even one showing of the movie. Even Lester, who'd come over to help us publicize it, couldn't do anything; it was too late.

We decided to hang around anyway and just have fun, which we were always good at, going to parties, water skiing, meeting the foreign movie people—we met Monica Vitti and Antonioni, who'd filmed *Blow-Up* at the same time we filmed *Chelsea Girls*. And we met Gunther Sachs, the West German ball-bearing heir who brought us home to meet his wife, Brigitte Bardot. She came downstairs and entertained us like a good European hostess, and I couldn't get over how sweet that

was—to be *Brigitte Bardot* and still bother to make your guests comfortable!

One afternoon we all drove out to a huge, beautiful château in the country. While everyone was taking a look around, the owner was busy telling Susan how beautiful she was and that if only she would stay on there for a few days with him, she could have anything she wanted in the whole house, which was full of old European artworks of every kind. Just then David came back from the house tour—all excited because he'd seen a portrait in one of the bathrooms that he said looked just like him, and everyone else agreed that it did, too.

We were getting ready to leave and the man still hadn't convinced Susan to stay on, but he was a good sport and told her she could have whatever she wanted in the house anyway. David was encouraging her to take the most expensive thing, but instead she whispered to Gerard to show her where the bathroom with the portrait was, and she walked out of the house with that painting under her arm, and she presented it to David in the car riding back through the French countryside. He gave her a kiss—he was thrilled—but after a few seconds he got practical and wondered, "Maybe you should have stayed a couple of days and gotten some furniture, too . . ."

We found out later that it was actually a portrait of Sarah Bernhardt.

In France, Eric didn't want to come around to the parties and things with us. "I can't get into anybody right now; I'm just, like, writing a lot and keeping a journal, and just relating to myself as a companion."

"You do so many trip books," I said. "Whatever happens to them all? Where are they?"

"I have a lot of them that're around, being held for me, but unfortunately, through tripping, I lose a lot . . ."

Eric went off water skiing with Gerard and to one party with us, and then he decided to leave for London—we were going to Paris and Rome first.

In Rome our hotel was taking messages, the same frantic message essentially, every few hours from Eric in London—he'd spent all his money and couldn't pay his hotel bill.

The first thing we had to do when we got to London was go over to Kensington and settle his hotel account. Then I gave him the same basic lecture that I ultimately gave every superstar when I began to feel they were depending on me too much for money. I told him, "Look, Eric, you're young, you're good-looking, and people like to have you around. Don't you realize there are all these incredibly rich people with big beautiful empty houses who are bored? Start thinking rich. Start being grand. You shouldn't have to stay in hotels! We'll introduce you to the swells and you can live off the fat of the land. You've got to start thinking of these things for yourself, though, Eric. We won't always be around to rescue you. Just go out there and be a beautiful house guest and you'll never need a hotel again. You're Entertainment: don't give it away! People like things more when they have to *pay* for them," etc., etc.

In short, I was telling him, "Hustle."

After a couple of days in London, where my most vivid memory is of Rodney La Rod leaping onto Paul McCartney's lap the second he met him (that's what I liked about Rodney—he did all those things you felt like doing but knew you shouldn't), most of us went back to New York. David and Susan decided to go back to Paris for a while, though, and Eric stayed

on in London at the house of my art dealer there, Robert Fraser, who was young, good-looking, and beautifully tailored in pin-stripe suits—*and* he had a gallery in Mayfair.

The Dom went through yet another management transformation in the middle of '67. Jerry Brandt took it over, completely redid the place, and called it the Electric Circus. There was a big opening for that and we all went; we were naturally curious to see what had been done with the discotheque space we'd launched the year before.

The difference between the Exploding Plastic Inevitable and the Electric Circus sort of summed up what had happened with Pop culture as it moved from the primitive period into Early Slick. It was like the difference between a clubhouse under the back porch steps and a country club. The year before we'd had to pioneer a media show out of whatever we could improvise from whatever we had lying around—tinfoil and movie projectors and phosphorescent tape and mirrored balls. But suddenly, during the '66–'67 year, a whole Pop industry had started and snowballed into mass-manufacturing the light show paraphernalia and blow-your-mind stuff. And a good general example of how much things had changed in such a short time is "Eric's Fuck Room." With us, this was just a small alcove off the side of the dance floor where we'd thrown a couple of funky old mattresses in case people wanted to "lounge," but it'd ended up being just a place where Eric hijacked girls to for sex during the E.P.I. shows; now, under the new Electric Circus management, it was transformed into the "Meditation Room," with carpeted platforms and Astroturf and a health food bar.

• • •

In the early summer, we all went out to Philip Johnson's Glass House in New Canaan, Connecticut, for a Merce Cunningham Dance Company benefit sponsored by the de Menil Foundation of Houston. A young kid from Texas named Fred Hughes was helping with the arrangements for the foundation and when he overheard someone wondering what rock group to get, he informed them, "There is only one rock group—the Velvet Underground." He'd seen the Velvets at the Dom the year before when he was in town on one of his trips between Houston and Paris, where he was working at the Iolas Gallery. When he saw Nico at the Dom, he couldn't believe it was the actual girl from *La Dolce Vita* who he'd fallen in love with on screen—I mean, there she was in the flesh standing right in front of him on St. Mark's Place.

Fred had grown up in Houston where the great art patrons John and Dominique de Menil and their five children, George, Philippa, François, Adelaide, and Christophe, lived in a great house designed by Philip Johnson. Fred was only in his early twenties then, but all through his teens he'd been working for them on their art projects and acquisitions. Even before he left Texas for France, he'd bought one of my paintings for himself, and he'd arranged for some of our movies to be screened down in Houston. Later he met Henry Geldzahler at the Venice Biennale, and the next time Fred was in New York, Henry brought him over to the Factory.

In those mod, flower-power days, Fred was conspicuous—one of the only young people around who insisted on Savile Row suits. Everyone always stared at him because he was so perfectly tailored—like something out of another era. When he came by that first day, he was wearing a flared, double-vent dark blue suit,

blue shirt, and light blue bow tie. He and Henry rode up in the elevator with Ondine, who Henry eloquently introduced as "the greatest actor in underground cinema today," and Ondine smiled a very charming smile: "I'm *so* glad you said that, because most people confuse me with being a vulgar pig." The three of them came in as we were screening a sequence titled "Allen Apple" from what would eventually be ****, our twenty-five-hour movie. Henry took me aside and briefed me that Fred worked for the de Menils, which of course was a magic name—they were so interested in art. But Fred, in any case, was a cute kid—young and such a dandy.

The first thing Fred did was tell me very earnestly that he loved my work and that my movies were beautiful, and I reacted my usual way—modest noises came out of my mouth, the sounds you make when you're embarrassed but saying thank you. I told him we were having dinner in the Village and invited him to come along. Fred laughed and said that just coming down to the Factory on 47th Street was a big deal because it was the farthest downtown he'd ever been, so the Village struck him as really an expedition. Just then the movie reel ended and the lights went on, and as Fred turned to look around the loft, there on the big red couch was a black guy fucking a white guy. I hadn't noticed before, so I guess they'd started during that last reel.

Fred did come to dinner with us, and then he started coming down to the Factory almost every day. He'd spend mornings and afternoons at the de Menil Foundation, having meetings with people like Nelson Rockefeller and Alfred Barr of the Museum of Modern Art, and then straight from that he'd come down to the Factory to sweep floors. For some reason, most of the people who came to work at the Factory were drawn at first to sweep-

ing floors—Paul had done it for months, too, before getting involved with other things. I guess it was a natural thing to do, with so much mess around and so many people there making more. Fred got more and more outrageously elegant—black jackets with braiding on them, shirts with bow ties to match. One day he arrived in a big Tom Mix hat. (He eventually gave it to me and I was photographed a lot in it on the *Lonesome Cowboys* set.) But the really funny thing was that a lot of days he wouldn't want to go all the way home to change before meeting his society friends for dinner at places like "21," so there he'd be with a broom in his hand sweeping the floors in his dinner jacket.

When Fred came on the scene in '67, I really wasn't painting at all, but shortly after that I started to work on the large electric chairs for my big retrospective in Sweden the next year. Fred got involved right away with both art and moviemaking—he arranged a commission for me from the de Menils to film a sunset for something to do with a bombed church in Texas that they were restoring. I filmed so many sunsets for that project, but I never got one that satisfied me. However, it was with the leftover money from that commission that we eventually made *Lonesome Cowboys* at the end of the year and the beginning of '68.

At the time of the Merce Cunningham benefit at Philip Johnson's, we didn't know Fred that well yet, which I especially remember because when there wasn't room for all of us to go in the limousines from the de Menil house on 73rd Street off Park where all the people who'd paid a thousand dollars a ticket were having drinks beforehand, Philippa de Menil and Fred were formal enough with us to insist that Paul and Gerard take their places in the cars. (They wound up taking the train out to New Canaan and hitching from the station to the Glass House.)

• • •

In those days the picnic lunches from the Brasserie with the red-and-white-checked napkins were the big rage. The people out at Philip's, who'd all paid a hundred dollars a ticket, got those box lunches for their money—plus a dose of the Velvet Underground and a dance concert by the Cunningham dancers to a John Cage score for viola, gong, radio, and the door-slams, windshield-wipes, and engine-turnovers of three cars. Jasper Johns was there, and I heard him say that in the fall he was moving downtown to Houston Street into a huge building that had been a bank, and that Susan Sontag was going to take over his Riverside Drive apartment.

I couldn't wait to look through Philip's underground art museum. Gerard was carrying his whip that day because he was dancing onstage with the Velvets, Paul was in an eighteenth-century jacket and a lace shirt, I was wearing blue jeans and a leather jacket, and Fred was in a collegiate outfit—a Shetland pullover sweater or something. The four of us looked like extras in different movies as we wandered through the museum together. We were the only ones there at that point, and Paul started giving one of his oral essays on modern art which everyone at the Factory knew almost by heart—Fred was the only one who hadn't been exposed to it yet. In any case, Paul always had a few new put-downs to throw in:

"Modern art is nothing but atrocious *graphics*," he said, stopping in front of a very good abstract painting. "The days of true art are over and I'm afraid they have been for quite some time. Now, if these atrocities were *good* graphics, people would recognize them as such; but they can't, because they're ugly and garish and banal. There *is* no art anymore; there's just bad graphic design, which people are trying desperately to imbue

with some meaning. I mean, if you want to see real abstract de-
signs, you can go up to Harlem and stare at old linoleum! All
modern art is, is graphics and slabs being overanalyzed by a
bunch of morons."

Fred was gaping; he'd obviously never heard anyone talk that
way, let alone someone who worked for an artist. In front of the
artist, yet. And one of my Self-Portraits was hanging nearby. Fred
looked like he wanted to disagree, but he didn't say anything—
he just stared, amazed, while Paul continued:

"Unless you paint a picture of a man, a woman, a cat, a dog,
or a tree, you're not making art," Paul said. "You go into a gallery
today and you look at some drippings and you ask one of those
pretentious gallery people, 'What is this? Is it a candle? Is it a
post?' and instead, they tell you the artist's *name*. 'It's a Pollock.'
They tell you the artist's name! So *what*! All it comes down to
is people looking at price tags in galleries and buying whatever
bad graphics they can afford.

"It's like reading architecture criticism." Paul lowered his
voice a little since, after all, we were in a famous architect's house.
"You read all those words in all those pathetic magazines—
about the windowpanes and doors that're on these modern glass
slabs. The buildings are practically nothing, so they go and in-
vent language to make them sound like something."

The great thing about Paul was that however ridiculous his
arguments were, you couldn't help being entertained by them.
He could be telling you that *you* were a moron and you prob-
ably wouldn't mind—in fact, usually you'd be laughing—be-
cause he'd find some outrageous way to make his case.

"Let's go find the Velvet Underwear," Paul suggested, and we
went back outside. It was dark now, but the lights from inside
the Glass House were shining out on the trees and grass, and

there were picnic baskets scattered all around. The Velvets were already starting to play, and Gerard rushed to join them. I was reflecting that most people thought the Factory was a place where everybody had the same attitudes about everything; the truth was, we were all odds-and-ends misfits, somehow misfitting together.

Fred got caught up in the scene completely. He moved from the beautiful de Menil house where he'd been staying into the Henry Hudson Hotel way over on West 57th, where a lot of our people were living then. He chucked his glamorous, privileged setup for a bare-essentials West Side hotel room—he was fascinated with the kind of seedy glamour he was seeing at the Factory and wanted a heavier dose. The first night he ever went to Max's—or, rather, tried to—he was wearing his big ten-gallon Tom Mix hat and Mickey blocked him at the door and told him, "We don't know you." Fred confided to me later that he was so crushed when that happened that he just said, "Oh, okay," and left and went uptown on the rebound to exclusive El Morocco. (And nothing makes you feel dumber in an embarrassing situation than being in a funny hat.)

People say that you always want the things you can't have, that "the grass is greener" and all that, but in the mid-sixties I never, never, never felt that way for a single minute. I was so happy doing what I was doing, with the people I was doing it all with. Certainly, at other times in my life I'd wanted lots of things I didn't have and been envious of other people for having them. But right then I felt like I was finally the right type in the right place at the right time. It was all luck and it was all fabulous. Whatever I didn't have that I wanted, I felt that it was just a

matter of any day now. I had no anxieties about anything—
everything just seemed to be coming to us.

The Montreal Expo had opened in May on the banks of the St.
Lawrence River with six of my Self-Portraits up there at the U.S.
Pavilion, and I flew up to Canada with John de Menil and Fred
in Mr. de Menil's jet to see them.

The American pavilion was Buckminster Fuller's big geo-
desic dome, with its aluminum shades catching the sun, and an
Apollo space capsule and a long free-span escalator. Those were
things like you'd expect to find at an international exposition.
What was unusual was that the rest of the American show was
almost completely Pop—it was called Creative America. I re-
member thinking as I looked around it that there weren't two
separate societies in the United States anymore—one official
and heavy and "meaningful" and the other frivolous and Pop.
People used to pretend that the millions of rock-and-roll 45's the
kids bought every year somehow didn't count, but that what an
economist at Harvard or some other place like that said, did. So
this U.S. exhibit was like an official acknowledgment that people
would rather see media celebrities than anything else.

In the way of art there were works by Rauschenberg and
Stella and Poons and Zox and Motherwell and D'Arcangelo and
Dine and Rosenquist and Johns and Oldenburg. But a lot of the
show was pop culture itself—movies and blow-ups of stars, and
props and folk art and American Indian art and Elvis Presley's
guitar and Joan Baez's guitar. And these things weren't just *part*
of the exhibit; they *were* the exhibit—Pop America *was* America,
completely.

The old idea used to be that intellectuals didn't know what
was going on in the other society—popular culture. Those

scenes in early rock-and-roll movies were so dated now, where the old fogies would hear rock and roll for the first time and start tapping their feet and say, "That's catchy. What did you say you called it? 'Rock and . . . *roll*?'" When Thomas Hoving, the director of the Metropolitan, talked about an exhibit there that included three busts of ancient Egyptian princesses, he referred to them offhandedly as "The Supremes." Everybody was part of the same culture now. Pop references let people know that *they* were what was happening, that they didn't have to *read* a book to be part of culture—all they had to do was *buy* it (or a record or a TV set or a movie ticket).

Paul thought the Factory should be more under control, more like a regular office. He wanted it to become a real moviemaking-moneymaking business enterprise, and he never could see the point of having all the young kids and old kids hanging around all the time for no particular reason. He wanted to phase out the drop-in, lounging habits of the past few years. This was inevitable, really—we'd gotten to know so many people all over town that our small circle had expanded to hundreds and hundreds, and we just couldn't have the all-day-all-night "open house" anymore, it had gotten too crazy.

Paul turned out to be a good office manager. He was the one who'd talk to business people, read *Variety*, and look around for good-looking or funny (ideally, both) kids to be in our movies. He'd dream up theories to throw out to the interviewers—for instance, he had a whole presentation about how similar our organization was to the old MGM star system. "We only believe in stars, and our kids are actually very similar to the Walt Disney kids, except of course that they're *modern* children, so naturally they take drugs and have sex."

• • •

Most things Paul told the newspapers looked outrageous in print. At first, it was only a comment here and there, but by the end of the next year, interviews about us were full of his quotable spiels. The early Factory style had come out of Pop Art, where you didn't talk, you just did outrageous things, and when you spoke to the press, it was with "gestures," which was more artistic. But now that style was all played out—everyone was ready for some articulation, and Paul was nothing if not articulate.

To make the Factory into more of the "business office" he had in mind, Paul put partitions up around one-third of the floor space, dividing the loft into little cubicles. The intention was to let people know that the Factory was now a place where actual business was conducted—typewriter/paper clip/manila envelope/filing cabinet business. It didn't exactly work out the way he'd envisioned it, though: people started using the cubicles for sex.

Meanwhile, we were becoming the target for some very aggressive attacks on drugs and homosexuality. If the attacks were done in a clever, funny way, I enjoyed reading them as much as anybody. But if someone in the press put us down, without humor, on "moral grounds," I would think, "Why are they attacking *us*? Why aren't they out there attacking, say, Broadway musicals, where there are probably more fags in any one production than there are at the whole Factory? Why aren't they attacking dancers and fashion designers and interior decorators? Why *us*? when all I have to do is turn on my TV to see hundreds of actors who are so gay you can't believe your eyes and nobody bothers *them*. Why *us*, when you could meet your favorite matinee idols from Hollywood who gave out interviews all the time on what their

dream girls were like—and they'd all have their *boyfriends* with them?"

Naturally, the Factory had fags; we were in the entertainment business and—That's Entertainment! Naturally, the Factory had more gays than, say, Congress, but it probably wasn't even as gay as your favorite TV police show. The Factory was a place where you could let your "problems" show and nobody would hate you for it. And if you worked your problems up into entertaining routines, people would like you even more for being strong enough to say you were different and actually have fun with it. What I mean is, there was no hypocrisy at the Factory, and I think the reason we were attacked so much and so vehemently was because we refused to play along and be hypocritical and covert. That really incensed a lot of people who wanted the old stereotypes to stay around. I often wondered, "Don't the people who play those image games care about all the miserable people in the world who just can't fit into stock roles?"

When kids we knew would have nervous breakdowns or commit suicide, people would go, "See? See? Look what you did to them! They were fine until they met *you*!" Well, all I can say to that is, if a person was "fine" when they met us, then they stayed fine, and if they had bad problems—sometimes nothing and no one could fix them up. I mean, there's always been an awful lot of people out there on the streets talking to themselves. It wasn't like someone was issuing me newborn babies with good chemicals and letting me raise them.

And there were a lot of sexually straight people around the Factory, too, anyway. The gay thing was what was flamboyant, so it got attention, but there were a lot of guys hanging around because of all the beautiful girls.

Of course, people said the Factory was degenerate just because "anything went" there, but I think that was really a very good thing. As one straight kid said to me, "It's nice not to be *trapped* into something, even if that's what you are." For example, if a man sees two guys having sex, he finds out one of two things: either he's turned on or he's turned off—so then he knows where he stands in life. I think people should see absolutely *everything* and then decide for themselves—not let other people decide for them. Whatever else it did, the Factory definitely helped a lot of people decide.

This was the summer I met Candy Darling.

Most people would probably think of the following year, '68, as the time we were getting involved with the drag queens who were around downtown, because it wasn't until then that they first cropped up in our movies, when Paul used Jackie Curtis and Candy in *Flesh*. Of course we'd had Mario Montez in a few of our early films, but since Mario only dressed up as a woman for performances—out in the world, he would never be in drag— he was more like a show business transvestite than the social-sexual phenomenon the true drags were.

As late as '67 drag queens still weren't accepted in the mainstream freak circles. They were still hanging around where they'd always hung around—on the fringes, around the big cities, usually in crummy little hotels, sticking to their own circles—outcasts with bad teeth and body odor and cheap makeup and creepy clothes. But then, just like drugs had come into the average person's life, sexual blurs did, too, and people began identifying a little more with drag queens, seeing them more as "sexual radicals" than as depressing losers.

In the sixties, average types started having sex-identity problems, and some people saw a lot of their own questions about themselves being acted out by the drag queens. So then, naturally, people seemed to sort of want them around—almost as if it made them feel better because then they could say to themselves, "I may not know exactly what I am, but at least I know I'm not a drag queen." That's how in '68, after so many years of being repelled by them, people started accepting drag queens—even courting them, inviting them everywhere. With the new attitude of mind-before-matter / where-your-head-is-at / do-your-own-thing, the drags had the Thing of Things going for them. I mean, it *was* quite a thing, it took up all of their time. "Does she tuck?" the other queens would ask Jackie about Candy, and Jackie would say something oblique like "Listen, even Garbo has to rearrange her jewels."

Candy herself referred to his penis as "my flaw." There was always that question of what to call the drags—"him" or "her" or a little bit of both. You usually just did it intuitively. Jackie I always called "him" since I'd known him before he went into drag, and Candy Darling and Holly Woodlawn were "her" because they were already in it when I met up with them.

But if in '68 the drag queens were incorporated into the fun of the general freak scene, in '67 they were still pretty "queer." One hot August afternoon during that Love Summer of '67, Fred and I were out walking around the West Village on our way to pick up some pants I was having made up at the Leather Man. There were lots of flower children tripping and lots of tourists watching them trip. Eighth Street was a total carnival. Every store had purple trip books and psychedelic posters and plastic flowers and beads and incense and candles, and there were Spin-Art places

where you squeezed paint onto a spinning wheel and made your own Op Art painting (which the kids loved to do on acid), and pizza parlors and ice cream stands—just like an amusement park.

Walking just ahead of us was a boy about nineteen or twenty with wispy Beatle bangs, and next to him was a tall, sensational blonde drag queen in very high heels and a sundress that she made sure had one strap falling onto her upper arm. The two of them were laughing, and as we turned onto Greenwich Avenue, where the hustlers leaned against the wall, we saw the blonde throw her head back and say loud, for all the cruising fags to hear, "Oh, just look at all these Green Witches." Then the boy happened to turn around. He recognized me and asked for my autograph on the paper bag he had from the English clothes boutique Countdown. I asked him what was in the bag.

"Satin shorts for the tap-dancing in my new play, *Glamour, Glory, and Gold.* It opens in September; I'll send you an invitation. My name's Jackie Curtis."

I was taking a closer look at the blonde. She was much more attractive from a distance—up close, I could see that she had real problems with her teeth, but she was still the most striking queen around. Jackie introduced the blonde as "Hope Slattery," which was the name Candy was using in those days—her real name was Jimmy Slattery and she was from Massapequa, Long Island.

At some point much later on, after I'd gotten to know both of them very well, Jackie told me how he and Candy had gotten together:

"I met her in practically the same spot that we met you— right by Sutter's ice cream parlor—and I told her, 'There's something, uh, different about you.' And she said, 'I draw attention

because I'm like women on the screen.' And I looked at her and thought, 'Now, *please*. Just *who* is this one like on the *screen*? . . .' Because, Andy, she was a mess. Before she started taking care of herself a little, she looked like the maid in *Dinner at Eight*. Her teeth . . . Her teeth . . ." Jackie shook his head in a let's-not-think-about-her-teeth gesture. "To be truthful, she looked more like the fists of Señor Wences than anything else—a blonde wig on a fist with lipstick and two button eyes. . . . Señor Wences? On *The Ed Sullivan Show*? Anyway, we went into Sutter's and bought a Napoleon. She bit into it and her one good tooth fell out. We stood there staring at it in the palm of her hand, laughing hysterically and going, 'Oh, my God, oh, my God. . . .' I thought to myself, 'This woman is incredible.' I walked her back to where she was staying—the Hotel Seventeen on 17th Street between Third Avenue and Stuyvesant Park, a quiet street with little buildings and lots of window boxes and trees. I was so naive, I didn't recognize all the classic signs that she was dodging her bill there—even when I saw that they were holding her stuff down in the lobby. When she saw that, she turned right around on her high heels and ran across the street. When I caught up with her, she was peering into some guy's ground-floor windows. A dog came out to the bars, and she was going, 'Isn't that dog pret-ty? Pret-ty dog, pret-ty dog. . . .' And I thought to myself, 'She's trying to convince that *dog* that she's a real woman!' Meanwhile she didn't know how to get her stuff back—she'd crawled out of her window and she was ashamed. They knew her scene, and she really was scared.

"Candy touched me so much because I saw myself in her—I was so up-in-the-air myself. I wrote *Glamour, Glory, and Gold* right away and put her in it that fall."

When you hear a person say they're from New York City, you expect them to be really hip and all that. So when Jackie talked about himself as being "naive," it was hard to believe, because after all, he'd grown up on Second Avenue and 10th Street—the upper Lower East Side—living with his grandmother, Slugger Ann, who owned a bar there.

I said to him, "Come *on,* Jackie, how can you talk about 'naive' when you grew up in the East Village?"

"Yeah, well," he said, giving me a look, "that's not exactly Greenwich Village, you know."

I saw his point. For a kid, the West Village street scene was a lot farther away than just the few blocks in physical distance.

Jackie and Candy hung around together for the rest of the summer, and Slugger Ann even gave Candy a job as a barmaid.

"My grandmother," Jackie said, "did not know that Candy was no genetic female. And she certainly did not know Candy would come to work in a slip! But having her there did draw in some new customers—a few fairies from the West Village who couldn't believe she really had a job."

Getting a job in a bar was a dream come true for Candy. She wanted to be the kind of woman you'd find in a diner on Tenth Avenue "slinging hash"—that was maybe her favorite fantasy. Either that or a female whore that men slapped around and treated like dirt. Or even a lesbian—she liked that, too. Anything but a man.

Candy didn't want to be a perfect woman—that would be too simple, and besides it would give her away. What she wanted was to be a woman with all the little problems that a woman has to deal with—runs in her stocking, runny mascara, men that

left her. She would even ask to borrow Tampaxes, explaining that she had a terrible emergency. It was as if the more real she could make the little problems, the less real the big one—her cock—would be.

Eric once told me that he'd known Candy from way back in '64. "I used to see her and Rona walking around Bleecker Street. They rode in on the train together from Massapequa and they'd pretend to be girl friends—lesbians." Rona was another Max's girl. "Candy was going to this German doctor on 79th and Fifth that we all went to," he said. "It was like a dating agency there—everybody knew everybody. Candy was just starting to sprout little rosebuds underneath her blouse from the hormones he was giving her."

The Beatles' *Sgt. Pepper* music was the main strain you heard all through the summer; you'd hear it playing absolutely everywhere. And the *Sgt. Pepper* jacket was the general uniform for the boys at this point—the high-collar military jacket with red epaulets and piping that they wore with stovepipe pants—nobody was wearing bell-bottoms anymore. As for hair, lots of the boys had theirs Keith Richard–style—spiky and all different lengths.

Edie was still around town, living at the Chelsea, but she rarely came by the Factory anymore. One time right after Edie had been there, Susan Pile opened up her pocketbook to take out a phenobarbital and found her pill vial empty—except for an I.O.U. that Edie had stuck in it.

On August 4 the designer Betsey Johnson, who was now engaged to John Cale, had a party for "The Return of Leo" at her

place on West Broadway. There was dancing—lots of the Rascals ("Groovin'") and Aretha Franklin ("Respect") and the Jefferson Airplane ("Somebody to Love"). Every time the Doors' "Light My Fire" went on—which it did a lot, the long version—Gerard's expression went sour. He'd never gotten over the fact that Jim Morrison had copied his leather look, never mind that he'd made it a pop hit: the more famous Jim Morrison got, the more cheated Gerard felt.

Jim had just been in town playing the Scene and he was supposed to be in our movie, *I, a Man.* That summer Nico, who we were always trying to get to do a feature-length movie with us, finally said, "All right. I'll do a movie for you, but it has to be with Jim." She had a big crush on him then. When she asked him, he said sure; he said he knew all about underground movies, that he'd been a film student and all that. But then Nico showed up with a Hollywood actor named Tom Baker instead. "Jim's manager told him he can't do it," she said, "but this is a good friend of Jim's from L.A. and he wants to," and we thought why not.

We'd finished shooting *I, a Man* a few days before the party at Betsey's and it was scheduled to go into the Hudson Theater very shortly (our last movie to play there was *My Hustler*). *I, a Man* was a series of scenes of this guy, Tom, seeing six different women in one day in New York, having sex with some, talking with some, fighting with some. Maybe it was hearing about our having so many girls in a movie for a change that gave Viva the idea that she'd like to be in our next one, because she cornered me at Betsey's party and asked me if she could be.

This was only the third time I'd ever had a conversation with Viva. She'd come over and introduced herself to me at some art opening around '63, when she was living with a photographer

and trying to become a fashion illustrator. I don't remember what we talked about then—art, maybe (she knew a lot of artists). Louis Waldon, an easygoing actor we knew, had run into her for the first time down in the Village around '60, and he once told me about that:

"I met Viva in Joe's Dinette on West 4th Street. She had scabs all over her head. She'd just gotten out of a mental institution for a nervous breakdown and she was picking at the scabs and trying not to. She asked me what I did," Louis said, "and I told her, 'I'm an actor.' She looked me over and said, 'You're a what? You don't look like an actor.' I said, 'Well, I am.' She said, 'No, I don't think you *are*.' At that time she was painting. She'd been a model in Paris, but she just couldn't make it there, so she went home to upstate New York and her parents put her in a mental institution."

I was surprised to hear that Viva had actually had a nervous breakdown—all I'd ever heard her talk about was that she was *about* to.

"When did she recover?" I asked him.

Louis gave me a look and said, "Listen, has she *ever*?"

"Oh, but she was never that bad, was she?" I said.

"No, that's the whole thing with Viva—she's never *that bad*. She's bad enough to drive you nuts and sane enough to keep it up. . . ." Louis and Viva fought constantly (they were an even match) and yet they really liked each other a lot.

But the night of Betsey's party I didn't know much more about her than what I was seeing right in front of me. She had a face that was so striking you had the choice of whether to call her beautiful or ugly. I happened to love the way she looked, and I was impressed with all the references she kept dropping to literature and politics. She talked constantly, and she had the most

tiresome voice I'd ever heard—it was incredible to me that one woman's voice could convey so much tedium. She told me that she'd just done a nude scene in a movie Chuck Wein was film-ing, *Ciao, Manhattan,* and she asked me if I was planning to do a new movie soon. I told her that we were shooting another one the following day, and I gave her the address so she could show up if she wanted to.

I knew that we were probably going to have more trouble with the censors soon—at least if our movies kept getting attention—and I guess I must have known in the back of my mind that it would be a smart idea to have at least one really articulate per-former in each movie. The legal definition of "obscenity" had that "without redeeming social value" phrase in it, and it occurred to me that if you found someone who could look beautiful, take off her clothes, step into a bathtub, and talk as intellectually as Viva did ("You know, Churchill spent six hours a day in his tub"), you'd have a better chance with the censors than if you had a giggly teen-ager saying, "Let me feel your cock." It was all just silly legal strat-egy, though, because to me they were all great, all just people being their real selves on camera and I liked them all the same.

Viva told me that night at the Leo party that she was madly in love with John Chamberlain, the sculptor, but that he was in love with Ultra Violet. She asked me what I knew about Ultra, what her secret was, that so many men were crazy about her, and I said I didn't know anything at all about her. Then I asked her what *she* knew about her.

"Absolutely nothing," Viva said. "Where does she get her money?"

I didn't know that, either, then, but because that was usu-ally the first thing people wanted to know about Ultra—after

all, she dressed expensively and had that big Lincoln and lived in that Fifth Avenue penthouse—I wasn't surprised at Viva's question. Later on, however, as I got to know her better, I found that this was the first thing Viva wanted to know about *every-body*: "Where do they get their money?"

If this was the third time I'd had a conversation with her, the second time had been in '65 when she came by the Factory to ask me for money. She'd done it with all the nonchalance of somebody asking for their paycheck—except that I didn't even know her! What she essentially said was "I need twenty dollars, and you can afford it." I noticed she had the habit of very ele- gantly scratching her cunt on the outside of her dress as she talked to you. I gave her the meaningless line you always say when you don't want to give a handout—"I don't have any money." Now at this Leo party—she was a Leo, too—was the first time since then that I was seeing her, and I asked her what had made her come by that day to panhandle.

"Well," she said, "Gerard was always asking me to come to the Factory and I always told him no, no, no, but then I saw the prices your paintings were getting so the next time he asked me, I went over with him."

"But how did you know Gerard?" I asked.

"Oh, just from around the Chelsea. My sister and I had a room there and we were short sixteen dollars for the rent one month and Gerard came in and tried to make me and I said, 'Get out of here, Gerard—everybody knows you're a big fag!' and he got very upset and started screaming, 'Where did you hear that? Where did you hear that?' and I told him that every- body said he was your boyfriend and he went crazy—'I am not! I am not!'—so I told him in that case to try my sister, and of course she turned him down, too, so then when I went over to

the Factory with him to see you, you turned me down for the money, so that was that."

The next day Viva arrived at the apartment where we were film-ing *Loves of Ondine* (which was originally part of **** but which we eventually released as a separate feature). The first thing she did was open her blouse and show us her breasts: over each nipple she'd pasted a round adhesive bandage, and so we filmed her telling Ondine that if he wanted to see her naked, he'd have to pay for every article of clothing she removed, including the two adhesives.

We all loved Viva; we'd never seen anything like her, and from then on, it was just taken for granted that she'd be in what-ever movie we did. She was funny, stylish, and photogenic—and she gave great interviews. She even wrote reviews of our movies for a local publication called *Downtown,* using the by-line of Susan Hoffmann (her real name), giving herself, naturally, total raves: "Viva! is a hilarious combo of Greta Garbo, Myrna Loy, and Carole Lombard. . . . she combines the elegance of the Thir-ties with the catty candor . . . of the Sixties. . . ." We took blurbs from Viva's rave reviews of herself and ran them in newspaper ads for our movies. Why not? Everything she said was true.

And if a good way to get around the censors was to confuse them, then Viva was perfect for the times, because when she took her clothes off, there was always the question of whether her bony body was a turn-*on* or -*off*—the "prurience" was really in question there.

When *Chelsea Girls* opened at the Presidio Theater in L.A. in late August '67, Paul, Ultra, Ondine, Billy, and I flew to Cali-fornia for personal appearances. Nico was already out there; she'd

been at the Castle all summer with Jim Morrison, but she'd gone off with Brian Jones to the Monterey Festival. (Edie stayed at the Castle a little while that summer, too. She had come cross-country in a Volkswagen station wagon—someone else drove—after being very out of it, taking lots of drugs those last days in New York.)

We were sort of in two groups. Ondine, Billy, and a girl they called Orion the Witch of Bleecker Street—an A-head friend of theirs from New York who'd just moved out to San Francisco—formed one group. They went around terrorizing the flower people and saying every minute how they couldn't stand the West Coast another second. I walked into their rooms once when they had all just taken belladonna, and I watched a friend of Ondine's, naked except for polka-dot socks, drop a marble tabletop on his foot and not feel it. Ondine said, "There *is* no hallucinogen other than belladonna. It is a visual poison." I'd heard that from a few people—that acid was nothing compared to belladonna.

The rest of us just went wandering around the city, getting the feel of the place at the end of the big Love Summer. There were bad vibrations from the San Francisco hippies toward anything that was above a sort of psychedelic poverty level—anything that looked like it cost money was part of the Establishment—and so when we drove around town for a day or two in a Cadillac limousine that the movie theater rented for us, it was like we were waving a red flag; the flower children in the street would turn and glare at us, very contemptuous. That didn't bother us; we thought it was funny, and Paul, of course, was having a ball—he even figured out a way to antagonize the Haight Ashbury types a little more: he'd have our driver pull over beside

groups of kids in beads and flowers, then he'd roll down the limousine window and ask them, "Say, where's the nearest Salvation Army? We want to buy ourselves some hippie clothes."

As we drove through the different sections of town, we were all talking about the Black Panthers. (In between "Negro" and "black," the term "Afro-American" had come up, but it had never caught on the way "black" had—it was like trying to make people call Sixth Avenue "Avenue of the Americas.") The Black Panthers got a lot of attention walking around San Francisco with their guns showing, and nobody could stop them because evidently it wasn't against the law to carry guns openly, just to conceal them. But since nobody much had ever really taken advantage of the technicality before, the sight of those guns was a shocker, especially in the flower-power make-love-not-war city.

It had been a whole year since we were out there at the Fillmore with the Velvets. So many kids were still tripping, but the scene was clearly losing its momentum, and in another month journalists would be writing about what a complete mess Haight Ashbury had become—garbage and scummy soda stains on the sidewalks and the Day-Glo signs that had looked so great when they were new getting all horrible and dirty. October would be the month of the funeral procession through the streets for "Hippie, devoted son of Mass Media," staged by all the original hippies who'd been really involved with organizing alternate community living and who now resented all the free-style young kids who'd come in during the summer who they called "irresponsible" hippies. There was a sense that autumn that the whole hippie thing had been ruined the summer before—made too big and commercial.

•••

As we walked around, I realized that in San Francisco the Vietnam war seemed so much more real than it did in New York—if you stood by the bay, you could actually see ships leaving for Southeast Asia.

The girls in California were probably prettier in a standard sense than the New York girls—blonder and in better health, I guess; but I still preferred the way the girls in New York looked—stranger and more neurotic (a girl always looked more beautiful and fragile when she was about to have a nervous breakdown).

Most of the places around the area that had opened as "free" stores or service centers were starting to close down or go into debt. A lot of the hippies were leaving for communes all up and down the California coast and in western Colorado and New Mexico. In New York, the Diggers were only just about to open a free store ("Free Stew and Coffee") on East 10th Street, right near where Paul lived, and Country Joe & the Fish had just played on the same street, in Tompkins Square Park, at a "smoke-in" where Frosty Meyers, the New York artist, had his laser going all around the sky.

Everybody in San Francisco seemed upset about all the amphetamine that was around that summer—especially the love children, who were embarrassed that so many people were taking it, because speed made you aggressive, it was everything that flower power was supposed to be against. But there really was every kind of drug you could imagine floating around out there.

 We ran into a kid we knew from New York, Gary, walking along the street. He had short hair now and was wearing a sports jacket—he looked very square. But the accordion case he

was carrying turned out to be full of marijuana. We ducked into one of the lesbian strip joints where girls simulated sex things with other girls and there was a dancer who took people from the audience and whipped them. Gary lifted his jacket away from his back pocket and showed us one of those intercom beepers, which he used for communication with some sort of Drug Central. He'd been totally drug-free when we knew him back in New York—he was going to the School of Visual Arts. I asked him how he got involved in the dope business, and he said that for the couple of months before he left New York he was spending most of his time at school in the bathroom smoking joints that one of his teachers was always giving him. Then he and a friend of his went out to San Francisco where the friend knew some people. They rode over the Golden Gate Bridge out to this split-level house in Marin County. There was a Ferrari parked outside, and inside there was a few rock-and-roll bands' worth of equipment, and when you pressed a button, light shows went on all over the ceiling and beds started revolving. There were color TV's in all the bedrooms and all the bathrooms and the kitchen, and stereo sets in every broom closet.

"I went, 'Gee, this is class!'" Gary said. "They told me, '*Class?* Man, we're *poor.* We had a bad week, we only took in ten thousand.' And in the morning when we went down to the kitchen, the lady of the house was looking into the refrigerator at all these grains and vitamins and fruit juices and drugs. First thing, she took out a vial of long needle crystals and said, 'What do you want to do today?' I said, 'Pot would be fine.' But she's holding the crystals and saying, 'I'm going to take some of this. Would you like some?' So I took some—and I thought I'd never be a human being again in my life . . ."

The stripper was whipping somebody at the next table. I said to Gary, "We heard you were hustling out here."

He looked surprised and then very embarrassed. "Yeah, well . . ." I'd only said it to tease him, but now I could tell that I'd really hit on something.

"Just a little bit when I first got out here," he said defensively, "a few guys rubbing up against you, jerking themselves off, blowing you—but listen, I myself have never blown anybody."

We left the strip joint, said good-bye to Gary, and started walking again. Some sounds from a band rehearsing came out of a building we passed.

"Oh, God, the music in this city is so incredibly bad," Paul started up again. "Just think about it: San Francisco has not managed to produce even one individual of any musical distinction whatsoever! Not a Dylan, not a Lennon, not a Brian Wilson, not a Mick Jagger—*nobody.* Not even a Phil Spector! Just some nothing groups and some nothing music. They delude themselves that music is a *group* thing—the way they think everything is. . . ." Just then, the band got louder. "Really, listen to that," he said. "Nothing but tired imitations of bad imitations of white imitations of Negro blues bands. The Beach Boys were the most wonderful group in America because they accepted life in California for the mindless glory it is, without apologizing for it or being embarrassed about it—just go to the beach, get a girl friend, get a suntan, *period.* And that was the most sophisticated approach you could have—musical instead of message-y. Of course, their greatest song, 'God Only Knows,' was never the hit it should have been here in America." He shook his head. "I just don't know. . . ." The music got more and more frenzied. "Oh, *God*!" Paul screamed, covering his ears. "Fortunately, they've

never come up with a melody, so none of this has to stick in your brain to torment you."

On that trip we did some lectures at colleges and shot some footage for *Bike Boy,* but we never did come off cheerful enough to satisfy the San Francisco people—if you didn't smile a lot out there, they got hostile toward you.

Late one afternoon in September, Paul and I went over to the Hudson Theater to check out what kind of audience *I, a Man* was pulling in. We'd be opening *Bike Boy* there in a couple of weeks, and we wanted to see if the audience was laughing or jerking off or taking notes or what, so we'd know whether it was the comedy, the sex, or the art they liked.

We walked into the Hudson and sat down on a couple of scruffy-looking seats. There were a few college-type kids sitting together down front, and some raincoat people, alone, scattered here and there. It was the scene where Tom Baker is trying to turn on one of the girls and he says, "Why don't you relax?" and she tells him, "I don't know you well enough," and then he asks her, "Does it turn you on that I'm sitting here naked?" and she tells him, "Well, if there was *music* I'd be turned on . . ."

We didn't stay too long—just long enough to see that the kids thought it was hilarious. On our way out, the box office guy told us that during lunch hour was when business was the best.

The more we hung around Max's, the more young kids we got to know. There were three tiny little girl beauties who were always there who'd been running around together for years—Geraldine Smith, Andrea Feldman, and Patti D'Arbanville. Patti

had grown up in the Village. Her parents still lived across from the Café Figaro, and that's where the girls would hang out till it closed for the night, and then go over to Patti's house to sleep. One night that fall at Max's, when everybody in the back room was totally silent, drawing in their trip books—with the exception of an outrageous queen who was doing a sort of interpretive dance on top of a table to the Supremes singing "Reflections"— I coaxed Geraldine to tell me about her background.

"I went to three Catholic schools in Brooklyn, and they all threw me out; then I went to Washington Irving High," she said, nodding her head in the direction of 16th Street and Irving Place, just a few blocks away. "And what about Andrea?" I asked her. "Andrea, she went to this progressive school for theatrical-like kids that cost a lot of money called Quintano's—it was the kind of school you could go to just when you felt like it. It was right near [the discotheque] Ondine."

I couldn't imagine any of these girls sitting in classes or working at a job. Maybe a couple of days a year, but that was all. So I didn't understand how they always had the best clothes and went everywhere in cabs. That night I came right out and asked Geraldine where they got their money from. She pointed across the room at a girl who looked about their age. "Andrea and I live with Roberta," she said, "on Park and 31st."

"And where does Roberta get her money from?" I asked her.

"Her husband is very rich."

I took another look at Roberta while Geraldine went on: "She had Donyale Luna living there with her, and now she has me and Andrea, and her husband supports us all." Donyale Luna was one of the first big high-fashion black models and she was gorgeous.

"How old is Roberta?" I asked Geraldine.

"Thirty-three—I swear to God! But you can't tell because she's so tiny."

Geraldine said that she thought they were all going to get kicked out soon because Donyale was making about five hundred dollars' worth of calls to Europe every month and Roberta's husband was getting mad about the phone bill.

"And Donyale has this crazy boyfriend who came in last night and smashed her over the head with a beer bottle"—Geraldine laughed—"right after she was giving us this big lecture about how disgraceful it was that we were smoking pot and taking LSD."

"But who buys your clothes?" I asked her, looking over the designer mini-dress she was wearing and the beautiful leather boots.

"We go shopping on Andrea's charge cards—her mother's, I mean. And I don't know. . . . I can always get people to buy me clothes . . ."

One of the first times Geraldine came into Manhattan from Brooklyn, she said, was when the Beatles were in town and the whole city was going nuts, with girls yelling and screaming on the TV news and Beatles songs blaring twenty-four hours a day on the radio.

"I was walking down Bleecker Street with a couple of my girl friends," Geraldine told me, "and this beautiful blonde girl came running over to us and said, 'Do you want to meet the Beatles?' I thought she was crazy. There was a guy waiting for her in a car, and I thought they were trying to rape us away or something. But they convinced us to trust them and we rode uptown with them to the Warwick Hotel where there were hundreds of girls all lined up in front screaming, like, very insane. We waited downstairs with a man who had some kind of newspaper pass for

about an hour. I kept saying, 'This is crazy, this is a joke—my mother wants me home to Brooklyn by eleven,' but then we got taken up in a little elevator and the door to a suite opens and there's the Beatles having a party! Another girl who was there, I realized later, was Linda Eastman, but I didn't know her then— I was just out of Brooklyn, all I knew was the Beatles.

"We played spin the bottle with them and all these other games like that, and we watched TV till like five in the morning, and then we passed out. Sometime during the night somebody took a big American flag and draped it over the three of us like a blanket."

She trailed off as if that were the end of the story, but I wasn't going to let her get away with that.

"Oh, come on, Geraldine!" I insisted. "You must have made it with them. Admit it! Come on, I won't tell."

"Nooooo! I swear!" She giggled. "The guy who picked us up in the car said to me, 'Why don't you go in with Paul?' and I said no, because at that time I was a virgin, we were very innocent. And the guy got real mad because I guess he was supposed to pick up girls that would do something. . . . In the morning we got woken up by screams from outside—we went over to the window and looked down and the street was all girls having fits.

"When I got back to Brooklyn, my mother said, 'I thought you were dead. Where were you?' That was like the first time I'd ever stayed out all night, so she was real mad. She was sitting there with one of her girl friends and I told her, 'Ma, you're not gonna believe this, but I was with the Beatles.' She looked at her girl friend, like, 'She's crazy—she thinks she was with the Beatles.'"

"So who are you making it with now?" I asked her.

Geraldine giggled and pointed across the room to a handsome blond guy who was new in the crowd then. "I'm having

an affair with Joe Dallesandro, actually. He's asked me to marry him."

I'd heard that Joe was already married, to the daughter of the woman his father was living with, or something.

"But Joe's already married, isn't he?"

"Yeah," she said with a wave of her hand, "but you know with him, that doesn't matter. . . ." Then her expression turned serious. "He's very much in love with me," she said. Then in one split second the seriousness turned into a fit of hysterical laughing.

We'd met Joe Dallesandro when he wandered by mistake into the apartment in the Village where we were shooting a reel for *Loves of Ondine*—he was on his way to visit somebody in another apartment in the building. But when we saw the reel with him in it developed, he turned out to have a screen look and a hot-cold personality that Paul got very excited about.

Paul was always studying faces—how to light them, how to photograph them. He'd walk by with a picture of Jackie Kennedy, murmuring, "Did you ever see a photographer's dream like this face—look how wide apart the eyes are." He used to study Eric and tell me, "Eric has one of the few perfectly symmetrical faces I've ever seen." But something he admired even more than a person with a perfect face was a person with a flaw who knew how to play it down: "Elvis," he pointed out to me once, holding a still from *Loving You,* "has absolutely no chin—that's why he's so intelligent to wear these high collars that stand up."

Paul seemed to see Joe as another Brando or James Dean— a person with the kind of screen magic that'd appeal to both men and women. When I saw Paul one day looking Joe's face over critically, holding his hair back so he could pick out his "bad

side," I could tell that Paul was really interested in making movies with him.

Of course, Paul wasn't doing any of the photography on our movies yet—I was still doing it all. But the next year when I was in the hospital, he made *Flesh* by himself, and Joe was the star. Eventually, he became Paul's main star. ("Don't try to act, Joe—just stand there," I heard Paul yell at him during the shooting of *Trash*. "Stop the Method moping—just talk. And whatever you do, don't smile unless you *don't mean it!*")

So Joe was just starting to be around now, and he was in Max's that night, across from Jim Morrison, who'd come in with a pretty new girl. At another table was Billy Sullivan and Matty— two Brooklyn kids—talking to Amy Goodman—her father owned Marvel Comics—and Matty was telling them that people shouldn't have houses anymore, that they should just have "rest depots." And right beyond them was Jimi Hendrix with one of those beautiful black girls—Devon or Pat Hartley or Emeretta, I can't remember which one, they were all friends. At about three in the morning, Andrea came tearing into the back room in a velvet miniskirt up to her crotch and a big-brimmed velvet hat. She climbed up onto the big round table where we were sitting, ripped her blouse open, and screamed, "It's *Show Time!* And everything's coming up *roses!* Marilyn's gone *five years, so love me while you can, I've got a heart of gold!*"

This was her basic routine. Some nights she'd get too crazy and get into fights, and Mickey would throw her out for a few weeks. But if all she did was stand on the table, rip open her blouse, and sing a couple of numbers, that was fine. Usually, she'd also grab her tits and tell everyone, "I'm a real woman— look at these grapefruits! I'm gonna be *on top tonight!*" Geral-

dine would always egg her on, screaming, "More! Take more off! More! More!" Then Andrea would go find some guy and tease him till he got fairly interested—and then freak out if he even so much as touched her. Patti was over in the corner, and I heard her telling a boy named Robin, a "security guard" at Tiger Morse's boutique where there'd been a lot of shoplifting ("At least *half* the stock leaves without saying good-bye," Tiger once told me), "I don't believe in wearing clothes, *anyway*, so why should I *pay* for them?"

As I said, I tried to imagine these kids at school or work. I tried really hard, but I couldn't—I couldn't imagine them anywhere but right there in Max's back room.

When Taylor Mead left New York in '64 to go live in Europe, he was a little disappointed in my filmmaking style; he felt I wasn't being sensitive enough to actors' performances. I remember how annoyed he was once when I filmed a reel of Jack Kerouac, Allen Ginsberg, Gregory Corso, and him on the couch at the Factory—that I did it from the side and you couldn't really see who was who—and then on top of that, we lost the reel. He thought that was just too irresponsible, and I heard he was calling me "incompetent."

Taylor had planned to stay in Europe until the Vietnam war was over, but already in '67 he was beginning to get tired of France, and when he saw *Chelsea Girls* screened at the Cinemathèque in Paris, he called me right up at the Factory.

"I've been in *La Dolce Vita* land too long, Andy," he said. "*Chelsea Girls* is the real thing. I'm coming home."

He came immediately, and the very day he got back here we filmed him with Brigid and Nico and a former child actor named Patrick Tilden Close (who'd played the boy Elliot Roosevelt in

Sunrise at Campobello with Ralph Bellamy and Greer Garson) in a segment titled *Imitation of Christ* for the twenty-five-hour movie.

Taylor couldn't wait to tell me what had happened at the Paris screening of *Chelsea Girls* to make him come straight home.

"Half the French audience walked out," he said. "I was sitting next to the man who was supposed to be the most far-out person in Paris, and even he got up and left! That whole supposedly sophisticated audience was spooked. That's when I decided that the United States has the worst *and* the best."

It was a typical scene at the Factory: Fred was over in a corner looking at some of Billy Name's photographs that were going to go into the Swedish catalog for my art show in Stockholm the following February; Gerard was reading a letter from a friend in London about Brian Epstein's death from an overdose; Susan Pile was sitting in front of her typewriter looking over the first issue of *Cheetah* magazine (the one with the nude Mama Cass centerfold on the bed of daisies); the radio was playing "Funky Broadway"; Paul was on the phone to a theater manager, telling him we'd have a new movie ready soon called *Nude Restaurant,* and clipping reviews of *I, a Man* and *Bike Boy* out of a stack of newspapers in front of him (Paul was obsessive about cutting articles and mentions out of the papers and pasting them into scrapbooks—his first job had been with an insurance company, cutting out clauses from one policy and pasting them into others so they could be photocopied, and he said that cutting and pasting was something he still liked to do); and I was busy signing some of the posters that I'd done that year for the Fifth New York Film Festival at Lincoln Center's Philharmonic Hall. We were all just finishing up and getting ready to go out to a movie—Fred was reading out a list of what was playing around

town: *Point Blank!, Privilege, Games, To Sir with Love, A Man for All Seasons, A Man and a Woman, Bonnie and Clyde, Ulysses, In the Heat of the Night. . . .*"

As he got to *Thoroughly Modern Millie,* the grate to the elevator opened and a guy came in with a gun.

Just like the time that woman came in and shot a hole through my Marilyns, again it just didn't seem real to me. The guy made us all sit together on the couch: me, Taylor, Paul, Gerard, Patrick, Fred, Billy, Nico, Susan. It seemed to me like he was auditioning for one of our movies—I mean, subconsciously I thought he had to be joking. He started screaming that some guy who owed him five hundred dollars had told him to come to the Factory to collect it from us. Then he pointed the gun at Paul's head and pulled the trigger—and nothing happened. ("See," I thought, "he really *is* joking.") Then he pointed it to the ceiling and pulled it again, and this time it went off. The shot seemed to surprise him, too—he got all confused and handed the gun to Patrick—and Patrick, like a good nonviolent flower child, said, "I don't want it, man," and handed it back to him. Then the guy took a woman's plastic rain bonnet out of his pocket and put it on my head. "Expressway to Your Heart" was coming out of the radio. Everybody just sat there, too scared to say anything, except for Paul, who told the guy that the police would be coming any second now because of the shot. But the guy said he had to get his five hundred before he would leave—and now he was demanding movie equipment and a "hostage," too.

Suddenly Taylor jumped up onto his back. (Later Taylor said, "It felt like jumping a steel statue, he was so strong.")

As Taylor was hanging on his back, the guy started to open up a folding knife. Taylor slid off him, grabbed the rainhat from my head, ran to the window with it over his fist, and broke the

glass, screaming to the YMCA across the way, "Help! Help! Police!"

The guy ran down the stairs as fast as he could—he didn't wait for the elevator. We looked out the window and saw him get into the passenger side of a big car with its trunk open, and then it drove away.

Taylor said that he'd jumped the guy because he'd been so embarrassed for me, to see me looking so silly, sitting there in a woman's rain bonnet.

We went to see Jackie Curtis's play, *Glamour, Glory, and Gold,* at Bastiano's Cellar Studio on Waverly Place in the Village, and later on that night we were at Salvation on Sheridan Square when Jackie walked in with Candy Darling and two men I didn't know. Jackie came over and sat down at the table where I was talking to three of the Stones—Brian, Keith, and Mick.

Salvation had a sunken dance floor and colored lights, but no live band, just records (a good place for dancing, though— the music was incredibly loud). It had opened in the summer of '67 where a place called the Downtown used to be. Bradley Pierce and Jerry Schatzberg and some other people were backing it, but Bradley was the one who actually ran it, deciding who to let in and who to keep out and who to throw out. He was like a father figure to the little groupies, and you could always count on seeing him over in a corner joking with them and sort of taking care of them—like a popular teacher in high school. The Salvation didn't last that long, but it was great while it did: it gave you someplace to go right before Max's. It was an easy money place for the owners, too—just records and drinks. Minimal—perfect for right then.

Jackie and Candy were obviously trying to dump the two creeps they'd come in with. Candy went straight to the dance floor, and Brian looked over at her and said to me, "Who's that guy?" Right away he knew.

Jackie told me they'd just been at Max's. "Tonight was only my second time there, and Candy's first, and they put us *up-stairs*," he said. In the days before there was dancing there, upstairs was definitely not the place to be at Max's—everybody was either downstairs at the bar or in the back room. *No*body went upstairs.

"Our escorts," Jackie said sarcastically, nodding toward the two guys, "thought it was just wonderful up there—they did not even *suspect* we were in Siberia. Candy and I were so embarrassed, we rushed to the ladies' room and stayed there. She just kept putting more and more makeup on, and saying, 'I'm not sitting *there*.'"

"Who are they?" I asked.

"Well, the tall one has been writing checks all week, and let's put it this way—he's got a lot of friends at Chase Manhattan, only none of them has ever heard of him. . . . Oh, well," Jackie sighed, "it was nice while it lasted. We just found out. And the short one is a great fan of Judy Garland's who thinks he has a lot in common with Candy, when all it really is, is their genitals, and he can't resist informing everybody, 'She's a man.'"

I noticed that Jackie was starting to do more femme things than when I'd first met him on the street that summer—he'd probably picked them up from being so close to Candy. "Why aren't you in drag, too?" I came right out and asked him.

"I'm too scared. My family lives around here, you know. People know me."

Candy came over to Jackie and whispered meaningfully, "Hope is here."

"Who's Hope?" I asked Jackie after Candy had gone back to the dance floor.

"Hope Stansbury. Over there with the long black hair and the pale, pale skin," Jackie said, pointing to a girl in a nice-looking forties suit. "Candy moved in with her for a few months behind the Caffe Cino so she could study her, although Candy will never admit that—she gets mad when I even tell people where she got the name 'Hope' . . ."

"But she's not using the 'Hope' anymore."

"Right," Jackie said, handing me the cast list from the play where the billing was clearly "Candy Darling."

There was one very interesting thing about seeing *Glamour, Glory, and Gold* that night—I mean, besides Jackie having written it and Candy being in it. All ten of the male roles were played by Robert De Niro—it was his stage debut. Years later, after he got famous, Jackie explained to me how he happened to be in it.

"He came over to the director's apartment where Candy, Holly Woodlawn, and I were sitting around, and you would have thought he was crazy—*we* did. 'I gotta be in the play! I gotta be in the play! Please! I'll do anything!' he kept pleading. I said to him, 'Ten roles?' He said, 'Yes! And I'll do the posters, too—my mother has a printing press.' I said, 'My grandmother has a bar, how do you do.' He was fabulous in the play—the *Voice* gave him a rave."

One afternoon when we were screening *Imitation of Christ*, a nice-looking guy named Paul Solomon from *The Merv Griffin Show* came by "hunting for talent." Brigid immediately got a

crush on him and he immediately got a crush on Viva and Nico. And that's how Merv got into his period of having quite a few "underground freaks" on his show. Ultra Violet had already been on a few times, and the people over there had liked her a lot— she was articulate, so I guess they thought that on the whole she was a pretty reasonable freak—and she paved the way for the other girls.

Viva was also pretty good on television. But the two TV talk show disasters from our group were Brigid and Nico. When Nico was on, she played a little number on her little portable organ, which was fine, but then when Merv tried to talk to her afterward, she just sat there, saying absolutely nothing. He got so exasperated that right on the air he sent for somebody in production to come out onstage and explain to him exactly who this girl was and why she'd been booked on the show. This was *after* he'd crawled under his chair. That was Nico.

And then there was Brigid. Brigid in those days was incredibly hostile. (After playing the Duchess in *Chelsea Girls,* she actually stayed in that character for a couple of years.) They'd asked me to go on *The Merv Griffin Show,* and I said no, like I always did to television. So I offered them Brigid instead, and I talked her into going on, I even promised to escort her to the studio and be right there in the audience for support.

I went to pick her up at the George Washington Hotel on 23rd and Lexington where she was living. She was in a pink corduroy jacket and jeans and shiny black patent leather shoes, and she had little ribbon bows in her hair. It was raining hard outside, and she was afraid she was going to get her hair all wet, and she was moaning, "Oh, why did I ever say yes. . . ." I called a cab to take us over to the taping at the Little Theater on West 44th Street, but when we passed Howard Johnson's on Broadway she

tried to bolt, pleading, "Let's just split and have a malted." (Brigid wasn't too fat then, just sort of chubby with a beautiful baby face, and she never passed up a chance to eat if she could. She used to tell me stories about when she was little and her mother would bribe her to lose weight—fifteen dollars for every pound she lost—and how she'd just stuff socks under the doctor's scale in her bedroom to lower the reading—and how Nora the house-keeper would find oatmeal bowls under her bed—minus the oat-meal—and how later on when she was married, she'd go out to dinner with friends and then go right home and have another dinner with her husband.) I told her we could go to Howard Johnson's *after* the show.

Backstage in the makeup room at the Little Theater, Dr. Joyce Brothers, another guest on the show that day, was being made up. They told Brigid that the makeup man would do her next, but being Brigid and being hostile, she told them very haughtily, "No," as if to say that everybody *else* might be so plas-tic as to need makeup, but that *she* was *real* and didn't need it! (But I noticed her slip out a Blush-on compact and dust herself when she thought no one was looking.) Then Bill Cosby and Vincent Price walked by, and I left Brigid alone and went down into the audience.

When Brigid came out onstage, Merv tried to open the con-versation up with a little mention of Ultra—probably thinking that the underground was one big happy family, or else that su-perstars would be smart enough to at least *pretend* that it was when they were on television, the way Hollywood people always did ("I had a lot of fun making the picture"). Instead, Brigid put Ultra down—way down. And Merv began to get nervous that Brigid wasn't going to be so nice. He was right. Her attitude to-ward him was like he was a stranger annoying her in a bus

depot—she was really giving him hostile looks there, and once she even threw a pure amphetamine glare straight into the camera. Merv tried everything pleasant he could think of, but still she wouldn't change. The only good thing that happened was when he looked over her outfit and asked, "Who's your designer?" and Brigid stood up and announced, "You can always tell by the little gold button: Levi Strauss." Then Merv, a little encouraged, asked her what she did all day every day since she'd said she didn't work, and Brigid told him the truth: "I dye every day. I go from beige to another color. I take beige jeans and I dye them in my bathtub."

The second the show was finished, Brigid marched off the stage down into the audience to get me. She asked me how she'd done, and when I told her the truth, "Horrible," she didn't believe me! I asked her how many pokes of amphetamine she'd had before going on and she wouldn't answer me. We went over to the Factory and watched the show with everybody there, and even seeing it, she was still so high she didn't realize how bad she was. (She had absolutely no regrets about it at all until years later when she got off speed and finally got embarrassed.)

The day after the show, fifty pairs of large beige corduroy jeans arrived at the Factory addressed to her—courtesy of Levi Strauss & Co. for the plug she'd given them on the air.

In October I got into trouble over some college lectures that the big lecture bureau I was signed up with had booked me to do out west. I always took a group of superstars with me to the colleges where I had "speaking engagements" because I was too shy and scared to talk myself—the superstars would do all the talking and answer all the questions from the audience and I would just be sitting quietly up there onstage like a good mystique. I

brought along people like Viva and Paul and Brigid and Ultra and Allen Midgette, a great-looking dancer we'd used in a few movies, and the colleges always seemed to be satisfied, even though it wasn't exactly a "lecture" we were giving—it was more like a talk show with a dummied-up host.

One night in Max's, I was sitting between Paul and Allen—we were all supposed to be leaving the next day to give a few lectures out west, and I suddenly just didn't feel like going, I had a lot of work to do. After I'd been complaining about it for a while, Allen suggested, "Well, why don't I just go as you?" The few moments after he said that were like one of those classic movie scenes where everybody hears a dumb idea that they then slowly realize maybe isn't so dumb. We all looked at each other and thought, "Why not?" Allen was so good-looking that they might even enjoy him more. All he'd have to do was keep quiet the way I did and let Paul do all the talking. And we'd been playing switch-the-superstar at parties and openings around New York for years, telling people that Viva was Ultra and Edie was me and I was Gerard—sometimes people would get mixed up all by themselves between people like Tom Baker (*I, a Man*) and Joe Spencer (*Bike Boy*) and we just wouldn't bother to correct them, it was too much fun to let them go on getting it all wrong—it seemed like a joke to us. So these antistar identity games were something we were doing anyway, as a matter of course.

The next day, Paul and Allen with his hair sprayed silver flew out to Utah and Oregon and a couple of other places to give the lectures, and when they came back, they said that it had all gone really well.

It wasn't until about four months later that somebody at one of the colleges happened to see a picture of me in the *Voice* and compared it to the one he'd taken of Allen on the podium and

we had to give them their money back. When the local news-paper out west called me for a statement, what could I say ex-cept, "It seemed like a good idea at the time." But the whole situation got even more absurd. Like, once I was on the phone with an official from one of the other colleges on that tour, telling him how really sorry I was when suddenly he turned para-noid and said:

"How can I even be sure this is really you on the phone *now*?"

After a pause while I gave that some thought, I had to admit, "I don't know."

We went back to the colleges that wanted us to redo the lec-tures, but some of the places didn't want us anymore—one col-lege said, "We've had all we can take of that guy."

But I still thought that Allen made a much better Andy Warhol than I did—he had high, high cheekbones and a full mouth and sharp, arched eyebrows, and he was a raving beauty and fifteen/twenty years younger. Like I always wanted Tab Hunter to play me in a story of my life—people would be so much happier imagining that I was as handsome as Allen and Tab were. I mean, the real Bonnie and Clyde sure didn't look like Faye and Warren. Who wants the truth? That's what show business is for—to prove that it's not what you are that counts, it's what they *think* you are.

I should have learned my lesson from that experience, though—that the days of no-fault put-ons were over, that now that we were signing things like contracts, like with the lecture bureau, what we thought of as a joke was what some people could call "fraud." So all of a sudden we had to start acting more grown-up.

(But later on—in '69, yet—I made another big put-on *faux pas* when I told a West Coast magazine something outrageous

like "I don't even do my own paintings—Brigid Polk does them for me," which wasn't true, I just thought I was being funny. Joyce Haber picked it up for her syndicated newspaper column and from there it got into the national magazines, and then, worst of all, the German press started calling about my "statement" because collectors over there who had so much of my art were panicking that they might have Polks instead of Warhols, etc., etc. So I had to make a public retraction. Fred screamed at me for days because he was so tired of taking transatlantic calls and telling people who'd invested hundreds of thousands of dollars in my work that ha-ha, I'd only been kidding. At that point I think I finally learned once and for all that the wrong flip remark in the press can cause just as many problems as a broken contract.)

The hippie musical *Hair* opened downtown at the New York Shakespeare Festival in November, and also that month the first issue of *Rolling Stone* magazine from San Francisco—aimed at sort of college-oriented rock and rollers—turned up on newsstands and in the head shops. (Another—even more intellectual—rock magazine, *Crawdaddy,* had been publishing out of Boston since the beginning of the year.) Both *Hair* and *Rolling Stone* hit the right mixture of counterculture and slick commercialism to cash in big on the new youth market.

Hair spread the idea that the big new youth cult had happened thanks to the Piscean Age finishing and the Aquarian Age coming in—and it certainly did look like the kids were taking over. There were so many new business markets to explore, so many new types of people needing magazines and movies and music to identify with. By now all the smart business people had figured out that kids weren't really growing up anymore, that

they were staying part of the youth market. And a lot of the
smart people figuring that out were the kids themselves—now
that they were staying young longer, when they graduated from
college they could become executive groupies if they wanted to.

In the middle of November, the Play-House of the Ridiculous
production of *Conquest of the Universe* opened at the Bouwerie
Lane Theater downtown. It was like a big social event in the un-
derground because a lot of people from our movies and from the
Max's crowd were in it—people like Taylor Mead, Ondine,
Ultra Violet, Claude Purvis, Beverly Grant, Mary Woronov,
Lynn Reyner, Frankie Francine.

Hair and *Conquest* had been in rehearsal downtown at the
same time. *Conquest* had a short, modestly successful run and
then closed. *Hair,* of course, turned out to be a huge commer-
cial hit, moving uptown after a few months to the Biltmore The-
ater on Broadway, where it kept on playing for years. It marked
a crucial turning point in the history of the theater, just the way
the following year *Midnight Cowboy* would in film.

Now it was clear that there were two types of people doing
counterculture-type things—the ones who wanted to be com-
mercial and successful and move right up into the mainstream of
society with their stuff, and the ones who wanted to stay where
they were, outside society. The way to be counterculture and have
mass commercial success was to say and do radical things in a
conservative format. Like have a well-choreographed, well-scored,
anti-Establishment "hippie be-in" in a well-ventilated, well-located
theater. Or like McLuhan had done—write a book saying books
were obsolete.

The other people—the ones who didn't care at all about
mass commercial success—did radical things in a radical format,

and if the audience didn't happen to get the content or the form, then that was that.

Hair was very straight, because even though it dealt with a hippie lifestyle, it wasn't a part of it—sure, it may have started out as part of it with people like Jim Rado and Gerome Ragni writing the story and the lyrics and Tom O'Horgan directing, but it was very quickly put into the hands of people who knew how to do the slick things that would make it go over with the masses.

Candy Darling was around much more after *Glamour, Glory, and Gold,* and she and Jackie started coming by Max's a lot—they weren't getting ignored and put upstairs any longer. In November when the Stones' album *Their Satanic Majesties Request* was just out, Candy and I were in the back room at the round table together, and when "In the Citadel" came on the juke box, she said, "Oh, listen. This is the song Mick wrote for me and my girl friend Taffy. Listen to the words!" Taffy was another drag queen around town, but I hadn't met her yet. Candy didn't care one bit about rock and roll—her mind was always back in the thirties and forties and the cinema fifties—so it was really strange to hear her use her Kim Novak voice to talk about rock lyrics. Since I could never understand a thing over those really loud sound systems, I asked her what the words were saying.

"Here it comes now! Listen! 'Candy and Taffy / Hope you both are well / Please come see me / In the Citadel.' Did you *hear* it? We met them in the Hotel Albert." The Albert was a cheap hotel down on 10th Street and Fifth Avenue. "We were on the floor above them and we dangled a bunch of grapes down on a string outside their window. You see, the Citadel is New York and the song is a message to *us*—Taffy and me."

"Then how come you didn't say hello to Mick that night at Salvation?"

"I was too embarrassed," Candy said, "because I can't tell those Stones apart. Which one is Mick?"

The screening we had of **** in December at the Cinemathèque—the one and only time we ever screened all twenty-five consecutive hours of it—brought back all our early days of shooting movies just for the fun and beauty of getting down what was happening with the people we knew. (As one reviewer pointed out, our movies may have looked like home movies, but then our *home* wasn't like anybody else's.) At the time I didn't think of that screening as any kind of milestone, but looking back, I can see that it marked the end of the period when we made movies just to make them.

We sat there in the dark at the Cinemathèque watching reel after reel of footage we'd shot all that year, every place we'd been— San Francisco, Sausalito, Los Angeles, Philadelphia, Boston, East Hampton, and all over New York, of friends like Ondine, Edie, Ingrid, Nico, Tiger, Ultra, Taylor, Andrea, Patrick, Tally Brown, Eric, Susan Bottomly, Ivy Nicholson, Brigid, Gerard, Rene, Allen Midgette, Orion, Katrina, Viva, Joe Dallesandro, Tom Baker, David Croland, the Bananas. Seeing it all together that night somehow made it seem more real to me (I mean, more *un*real, which was actually more real) than it had when it was happening—to see Edie and Ondine huddled together on a windy deserted beach on a gray day, with only the sound of the camera, and their voices getting blown away over the sand dunes while they tried to light their cigarettes. Some people stayed through the entire screening, some drifted in and out, some were asleep out in the lobby, some were asleep in their seats, and some

were like me, they couldn't take their eyes off the screen for a single second. The strange thing was, this was the first time I was seeing it all myself—we'd just come straight to the theater with all the reels. I knew we'd never screen it in this long way again, so it was like life, our lives, flashing in front of us—it would just go by once and we'd never see it again.

The next day the Cinemathèque began showing a two-hour version of the twenty-five-hour movie and that was it—most of the reels went into storage, and from then on we began to think mainly about ideas for feature-length movies that regular theaters would want to show.

1968–1969

At the beginning of the year you could pick up your phone and Dial-A-Poem, and by June, you'd be able to even Dial-A-Demonstration—you called a number and a recording actually told you where the public protests around town were that day. The star of my movie *Sleep,* John Giorno, the stockbroker-turned-poet, was the Dial-A-Poem organizer, and the Architectural League was the sponsor. John told me that it was the porno poems that got the most calls.

Astrology and other occult things like numerology and phrenology and palmistry were getting more popular all the time—I mean, there were suddenly Zodiac signs everywhere.

The new style was violence—hippie love was already old-fashioned. In '68 Martin Luther King, Jr., and Robert Kennedy both got assassinated, the students at Columbia took over the whole campus and fought with the police, kids jammed Chicago for the Democratic National Convention, and I got shot. Altogether, it was a pretty violent year.

One afternoon in January as I walked into the Factory, I heard things crashing in the back, then I saw Susan over in a corner crying. "What's going on?" I asked her. "Who's in the back?"

She blew her nose. "Ondine and Jimmy Smith. They're having a big fight."

Before I met Jimmy Smith, I'd heard lots of stories about him, and they all made the same point, that he was insane—a menace, but a fascinating one.

Jimmy Smith was a legend—he was a speed freak and a "second-story man" who'd steal anything, but he only ripped off people he knew. He did it in such a crazy way, though, that most of them wound up being intrigued with him. One night Brigid called me and said:

"Jimmy Smith just paid a call." (She was living on Madison then, in an apartment over Paraphernalia.)

"What did he take?"

"Well, I haven't finished the inventory yet, but let's just say, 'Anything that was of any importance to me whatsoever at this point in my life.'"

"Why did you let him in?"

"He was banging on my door, that's why! I said, 'Go away, Jimmy!' So he broke the door in. Then he quickly handed me two dozen red roses, a pound of Beluga caviar, and a book of poems—and within two minutes he'd ripped off everything in the place."

"But why didn't you just stop him?"

"Because," she reminded me, "he's violent."

Brigid got involved with Jimmy Smith because occasionally she'd let his girl friend, Debbie Dropout, hide in her apartment. Jimmy and Debbie's whole number was one of those chase-and-hide/"please-don't-beat-me" relationships where she would "escape" to somewhere in the city and he would go around to everybody they knew, looking to re-"capture" her. She would run to, say, Brigid's, and scream, "Brigid, let me in! *Please*. Jimmy's after me!" Brigid would tell her, "No, Debbie, no!" But naturally she'd let her in; it was part of the game. And pretty soon Jimmy would show up and drag her home, where he'd chain her

to a radiator so she couldn't leave him again, and then he'd bring nine or ten jazz bongo players in to jam with him—he'd supply the speed and they'd all drum for two or three days. Debbie would be pleading, "Please, Jimmy, please, I just want to go back to the hotel to get some clothes," and eventually he'd give in and say, "Okay, I'll meet you there in an hour." In an hour he'd go there, and naturally she'd be gone. Or another scenario was that she'd convince him to go out for Chicken Delight or something, and when he'd get back, even though he'd locked her in, she'd be gone—out the window—and the chase would start all over again. That was the basic plot of their game.

Brigid called Debbie Dropout the "Queen of the Hotel Scene" because she'd sit in bed in hotel rooms while at least three girls waited on her hand and foot. No one could figure out what powers she had over them.

Debbie was blonde and pretty. Before she got involved with Jimmy Smith, she'd been going with Paul America. Her mother owned a lot of buildings in the Village, and for a while Debbie lived near Abingdon Square in the West Village in a second-floor apartment that was kind of a crash pad.

Christopher Scott, who was very close to that scene in those days, told me something a few years later that I hadn't been aware of at the time: "Those kids were enthralled with the Factory and the inner 'Warhol world,'" he said, "but they felt very much on the edge of it. They didn't have any first-string contact with it, and so they were in eleventh heaven if they ever got inside the Factory—whenever one of them would get there, they'd live off the *aura* of that for the next few months. The group over at Debbie's apartment even had two cats named Gerard and

Drella. They all used to wait for you at that ice cream place on the corner of West 4th and Charles because they knew that you and Henry [Geldzahler] went there sometimes."

But about Jimmy Smith and the big fist fight going on at the Factory between him and Ondine: when Ondine saw Susan so upset, he gave Jimmy another belt, then ran over to reassure her: "Don't cry, Susan, it's only Jimmy Smith and he's *fabulous!*"

Susan already knew Jimmy, though. He'd walked into the Factory one day and told her, "I'll steal all your money." She thought it was just a line and forgot about it. But later when she was leaving, she discovered every penny gone from her pocketbook.

Ronnie Cutrone and his girl friend knew Jimmy because their place, which was over a Bronco Burger on 22nd Street and Third Avenue, was a real crackerbox and Jimmy used to break in all the time and rob them. "Since we knew it was him," Ronnie said, "we used to just let him in—we had to, because if we didn't, he would've broken in, anyway. He'd do nutty things like walk in and trip over every bucket of paint, every coffee can, every jar of mustard, dump everything in a pile in the middle of the floor, and ask you, 'Isn't it beautiful?' But then, just when you were so fed up with it all, he'd do something incredible like hand Betsy a diamond ring.

"You'd be walking down the street with him, and he'd suddenly duck into an alley, and the next thing you knew, he'd be speeding by in a Pontiac he just stole out of a lot. Then he'd just leave it at a light and walk away from it, with the door wide open and the motor running.

"One day he really freaked out at our place. He shoved me against a wall and said, *'Gimme the shoes!'* I didn't know what he

was talking about. He tore the place apart till he found a pair of miniature brown and white plastic spectator shoes off my father's birthday cake that I'd brought back from Brooklyn . . ."

The afternoon of the fist fight in the Factory was the first time I'd ever looked really closely at Jimmy. He was short, with dark curly hair, and it was hard to picture him terrorizing so many people—I mean, he looked pretty harmless. As he walked over to where I was sitting, he pulled a strip of material out of the pocket of his leather coat: it was a miniskirt, but it was huge, about a size eighteen or twenty. "It's for Brigid," he said, and we all started to laugh, because it was such a strange shape for a miniskirt—a long, long rectangle. Ondine took it to the back to show Billy, and Jimmy forgot about it and left.

Apparently, though, somebody got the Jimmy Smith treatment once too often, because late in '68 he was killed in a fall from the fifth story of a loft building downtown. They say somebody caught him breaking into their apartment and gave him a little push. It must have been somebody who knew him, too, because as everybody knew—"Jimmy only stole from his friends." A lot of people had been in love with Jimmy, but a lot more were so sick of all the things he'd done to them that they were relieved when he died.

After he was dead, Brigid met someone who'd known him all his life who told her that, incredibly, Jimmy Smith was from a wealthy Jewish family on Riverside Drive and that every few months when he was totally exhausted from ripping people off, he'd go back home and for a few days his old nanny would literally put him to bed, tucking him in.

•••

By the beginning of '68 a lot of people who'd been doing speed for years were cutting down—even some of the real diehard A-men were admitting that it had crossed their minds to quit. The Velvets' second album, *White Light/White Heat,* was about to be released that January, and one day Lou walked into the Factory and put an advance copy on the stereo.

With lyrics about amphetamine blasting around us, like, "Watch that speed freak / Watch that speed freak / If you're gonna blow him / Make it every week," Lou told me that he was trying to stop, but that Ondine was making it hard. "I just about told Ondine, 'I'm stopping,' and he showed up at my place with two ounces and said, 'Oh, why don't you have some?'" Lou now had a loft on Seventh Avenue and 28th Street. He was one of the very few actual residents in the fur business district, which was jammed in the daytime and absolutely deserted at night. "I bought a pool table last week at Korvettes on Herald Square," he told me, "and Sterling and I carried it the six blocks to my place and then everybody spent hours trying to position match books under it. This marathon went on for days. When Max's closed, we'd go back and play records with all the amps up: there's only one other person living in a radius of four city blocks. Ironically, he lives on the floor above me. A fat nigger junkie. And when the music was on, he jumped up and down and the ceiling sagged and Ondine got very excited and then we danced in a circle. And then Ondine took the two ounces and emptied it out on the pool table. He was leaving and I vowed, 'I will not take it.' He said, 'Well, in *case* you change your mind.' Can you imagine?"

At the end of January we went out to Arizona to film *Lonesome Cowboys.* It was originally supposed to be a Romeo-Juliet type story called *Ramona and Julian,* but quickly got improvised into

a movie about a one-woman all-fag cowboy town. We had Eric there, and Louis Waldon and Taylor and Frankie Francine and Joe Dallesandro and Julian Burroughs, a kid we'd just met in New York who claimed he was William Burroughs's son, and Tom Hompertz, a nice-looking blond surfer we'd met the previous fall while we were making a lecture appearance in San Diego.

We gave everybody plane tickets to Tucson, but since a strange girl we knew called Vera Cruise happened to be driving out there anyway, we said that if they wanted they could cash in their tickets and keep the money and ride out with her, and that's what Eric did.

Vera always drove around in lots of different cars, very flashy Jaguars and other sports models, and she knew how to rip a whole car apart and assemble it back together. She was Puerto Rican, but her accent was just heavy New York/Brooklyn. Every year she went to Arizona for her health; she was always coughing from what she said was tuberculosis. She was such an odd sight to see—under five feet with short, boyish dark hair and a sickly cough, in a black leather motorcycle jacket that she usually wore over a white nurse's uniform. Incredibly, she could rattle off the medical name for any disease. She said she'd taken premed courses once, and she had a job in a lab or something. (The next year she was arrested for car theft—it turned out she was picking up stolen cars at airports and delivering them. Everybody told me, "Oh, come on, don't play dumb—you knew Vera did that! My God, she even *told* you!" But when a person comes right out and tells you, "I steal cars," the way Vera had, somehow you don't think they're serious.)

When we arrived in Tucson, Vera and Eric—and John Chamberlain, the sculptor, who'd ridden out with them—were already

there. They met us at the airport with a rented touring bus that could hold about eighteen people. We all piled in and Vera started driving, fast and bumpy over the highway.

"She loves to drive, doesn't she?" Eric commented, bracing himself. "It was like this the whole way down here—she's *crazy.*" All of a sudden, she veered the bus off the main road and we were cutting across the desert, right through cactus, under bare stars. As the bus rattled, I kept thinking, "What if it breaks down? No one will ever find us *here.*"

Suddenly there was this thud like something had hit the bus. Vera put on the brakes and got out to see what it was. She came back with a big dead eagle, the symbolic kind you're not supposed to kill.

"He attacked the bus," she said, incredulous. "He flew right at it like he was going to lift it up and take it back to his nest—at *night!*"

We finished the ride with the dead eagle in the bus. Later, Vera put it in a plastic garbage bag—"to stop the decay"—and brought it to a local taxidermist. The taxidermist notified the police, and the police held her till they could confirm that it really had been killed by impact with a moving vehicle and not murdered or anything. But they wouldn't give it back to her.

(Vera informed us that this was not the first time that a bird had gotten killed attacking her—she was once riding the back of a motorcycle with a cast on her forearm when a bird swooped down and smashed its head on the plaster.)

The dude ranch we stayed at in Tucson was run by an old man and his wife who were busy trying to sell it so they could retire into a mobile home and travel the country. They had lots of tro-

phies and mementos and pictures of stars like Dean Martin and John Wayne and stills from an O.K. Corral movie.

Someone insisted that the little movie city we'd rented to shoot in belonged to John Wayne—it was the kind of place that easily could have; a lot of famous westerns and TV shows had been shot there, and tourists paid money to come through and see stunt men crashing saloon chairs over each other "just like in the movies."

It was misty the day we started shooting *Lonesome Cowboys*. The dialogue the boys were coming out with was going along the lines of "You dirty cocksucking motherfucker, what the hell is wrong with you?" and in the middle of this type of thing, we saw that they were bringing a bunch of tourists in, announcing, "You're about to see a movie in production. . . ." Then the group of sightseers marched in to "You fags! You queers! I'll show you who's the real cowboy around here, goddamn it!" They started going nuts, rushing their kids away and everything.

Eventually, the grips, the electricians, and the people who build the sets formed a vigilante committee to run us out of town, just like in a real cowboy movie. We were all standing on the drugstore porch, except for Eric, who was doing his ballet exercises at the hitching post, when a group of them came over and said, "You perverted easterners, go back the hell where you came from."

Viva told them, "Fuck you."

For the rest of that day they monitored every move we made. The sheriff came in a helicopter and stood on top of the water tower with binoculars, watching to see if anybody took their clothes off. Pretty soon we just left, it got to be too much of a hassle to work there.

Louis was outraged: "I mean, what the hell—it's a *real* western, the way the West really *was*." Louis played the oldest member of the gang, who had warm feelings and concern toward all the younger ones. "It's probably the most sensitive western ever made!"

But the professional movie cowboys didn't think so. Or maybe they did.

The night before we were leaving Arizona, nobody could find Eric anywhere. I discovered him myself, alone in an old Mexican adobe chapel in a big empty field with mountains all around.

He didn't hear me walk in, and I stood at the back of the chapel watching him. On the walls were hundreds of pictures of Indian boys—soldiers from around Tucson who'd died in Vietnam—and beside each picture was a little name card and a candle and each soldier's personal jewelry. Eric was standing in front of one of the cards. I went over to him and asked how long he'd been standing there, and he said, "There're so many."

He'd been standing there for hours.

At the end of '67 we'd been notified that the Factory building on East 47th was going to be torn down in a few months, so we had to find a new space.

Paul Morrissey and Fred Hughes were the strongest influences on Factory life at this point, and they had very different ideas about what it should be like. I wasn't sure myself, so I'd make noncommittal little noises and gestures. Paul wanted the new place to have desks and spindles and filing cabinets and a weekly copy of *Variety*—to be a real office centered on film production and distribution. He wanted it to be a place that kids

wouldn't feel like hanging around—and if there was any place kids in the sixties didn't feel like hanging around, it was an office.

But Fred wanted the Factory to stay a place that was a mixture of art and business: "Listen," he said to me, exasperated, "you're an *artist*! What do you want to do? Rent a room with a desk and a sign that says 'Podunk Porno Movies?'"

Fred loved making movies as much as anyone, but he felt that I'd be doing more and more art again, too. I finally agreed with him that it would be a good idea to have lots of room— room for whatever we might decide to get involved with. Besides, if we got a loft, we'd be able to continue screening movies.

Even though I didn't know exactly what I wanted, I did know that I didn't want to confine myself to just movies—I wanted to do everything—and you can't grow horizontally in an office, whereas in a loft space you can. My style was always to spread out, anyway, rather than move up. To me, the ladder of success was much more sideways than vertical.

It was Paul who actually found the perfect loft. It was down at 33 Union Square West, the eleven-story Union Building across Union Square Park from S. Klein's. We took the whole sixth floor with a little balcony that looked out on the park. And Max's was only a block and a half away. Fred pointed out that the Union Building was mentioned in F. Scott Fitzgerald's short story "May Day," and as a matter of fact, the Communist party still had their offices on the eighth floor. And when we went down to check the place out, we rode up in the elevator with Saul Steinberg, who told us that he rented the top floor.

Now that we'd decided on the loft, the next big controversy was over how it was going to be set up inside. Paul and Fred, of course, had different ideas about that, too—from the locks on

the door right up to the lighting fixtures. (Billy wasn't taking any interest at all in the move—he came down once, saw that there was a back area that he could set up in, and left, satisfied. And Gerard was out of the country with one of his rich patronesses who'd taken him traveling somewhere.) But the arguments died down the minute Paul noticed that the woodwork around the windows was painted white and needed stripping. One thing about Paul—if you could get him started stripping woodwork, he'd forget about everything else.

When I look back, I can see that the biggest fights at the Factory were *always* over decorating. In other areas everybody stuck to their own field of interest, everybody was easygoing, but when it came to how the place should *look,* everybody had ideas that they turned out to be willing to really fight for.

Fred was doing so much decorating that he nicknamed himself "Frederick of Union Square."

I left the big open spaces to everybody else to section off however they wanted, and I moved into a small narrow office over on the side where I could clutter up and not get in anybody's way.

Paul would sometimes go over to Union Square in the mornings to strip wood before coming up to 47th Street. One morning when he was down at 33, a young kid delivered a Western Union telegram there, at just about the time Paul was realizing that there were just too many painted wood surfaces for one person to do alone. When he noticed that the messenger was well mannered, he started up a conversation and found out his name was Jed Johnson, that he had just arrived in New York from Sacramento, and that he and his twin brother, Jay, were

living right across the park in a fifth-floor walk-up on 17th Street. Paul hired him to help get the place in shape.

It wasn't till we got back from Arizona that we made the actual move downtown. In the course of it, we lost the big curved couch that was so much a part of the old Factory. We left it on the street for only a few seconds, but somebody scurried out of somewhere and walked off with it. Then Fred realized that a big oak desk painted silver that he liked a lot had gotten left behind and he rushed back uptown for it. He was so determined to take it with him that he roped the thing onto dollies—it was mammoth, about six feet by three—and wheeled it the thirty-plus blocks down Second Avenue, right through the Midtown Tunnel traffic, all by himself. (There was a sanitation workers' strike going on at the time and garbage was flowing out of every alleyway, fifty thousand tons of it, according to the papers.) We were all big furniture freaks, really—we couldn't stand to lose a good piece—but Fred deserved a medal for that feat.

Everyone could sort of sense that the move downtown was more than just a change of place—for one thing, the Silver Period was definitely over, we were into white now. Also, the new Factory was definitely not a place where the old insanity could go on. Even though the "screening room" had couches and a stereo and a TV and was clearly for lounging around, the big desks up front as you came in off the elevator gave people the hint that there was something going on in the way of business, that it wasn't all just hanging around anymore. We spent more time than ever at Max's, since it was so close and since Mickey still gave us credit for art. It was like an answering service for us—say we wanted to get in touch with a certain superstar, we'd

just leave a message at Max's for them to call the Factory or else just put out the word in the back room.

From the time in August '67 when we first shot Viva in *Loves of Ondine,* her hair had been getting fuller and more teased every day until eventually it was a full-blown mane. Viva would vacillate between thinking she was beautiful beyond compare and thinking that certain parts of her face and body were plain ugly. She spent three days with Paul and me in Sweden in February '68 right before the opening of the big retrospective of my work at the Moderna Museet in Stockholm, and she came back desperately wanting a nose job. I thought she'd get over it—I mean, the people in Sweden were so perfect-looking that we *all* felt a little strange about ourselves by the time we left—but no, she carried on about that nose job for months, and finally she asked Billy when would be the perfect astrological time to get it done. He did up a nose job chart for her. Meanwhile we all kept on telling her how really beautiful her nose was, and in the end, she never did go through with it.

But then she started staring at her legs in the mirror and moaning that they were out of proportion to her trunk, which I must admit was true, but so what? Everybody had flaws. More than anything, though, she worried about getting old. She wasn't even thirty yet, but she would study every line that she imagined had come into her face in the last week. She was incredibly obsessed with time passing and running out on her—she said she felt she was already living on borrowed time. Most of the girls around then—except for Brigid, who was the same age as Viva, and Ultra, who was older—were in their teens, so Viva really was a different generation, but that's one of the things that made her more interesting than all those little girls screeching

around Max's. And there was absolutely no popular literature around then to persuade women that experienced and lined could be beautiful, too. They were on their own when they looked in the mirror and saw the lines coming.

Women's issues weren't even being discussed then; there was no large organized women's movement yet—I mean, right up through '69 it was almost impossible for a woman to get a legal abortion in this country. Viva was unusual for those times—a girl who'd look into a camera and complain about cramps from her period, or tell men that they were bad in bed, that maybe *they* might think they were doing great but it wasn't doing a thing for her. Viva was the first girl we'd ever heard talk that way.

I was so fond of Viva then; there was something really sweet about her in spite of all her complaints and put-downs. Just when you least expected it, she would turn very modest and get all unsure about herself—which made her an even more appealing person. She'd worry that this kid or that guy didn't like her, and I'd just tell her, "Don't even think about it—when you're famous, you'll be able to buy him," or, "He's probably a fag, anyway." But Viva always seemed to look to men for final approval. She would *talk* very liberated, but she seemed to expect men to do little things for her—like support her! But I was convinced that she'd work out these problems and make it big in the celebrity world. I thought she had all the qualities—plus the magic—that could make a woman into a true star. A long interview with her by Barbara Goldsmith would be coming out in *New York* magazine in April, and Diane Arbus was doing the pictures for that.

Those months between August, when she was first in our movies, and February, when we moved downtown, Viva and I

were inseparable—we made movies, gave lectures, and did in-
terviews and photography sittings together. She seemed like the
ultimate superstar, the one we'd always been hoping to find: very
intelligent, but also good at saying the most outrageous things
with a straight-on beautiful gaze and that weary voice of hers,
the dreariest, driest voice in the world.

She talked about her family a lot—her parents and her eight
brothers and sisters—and her stories all usually cast her father as
a Roman Catholic fanatic and her mother as a Joseph McCarthy
fanatic who made the kids watch the hearings on television in
their entirety. When Viva graduated from her Catholic high
school, she went on to Marymount, a Catholic college in West-
chester, New York, and from there she went to Paris and lived in
a convent on the Right Bank while she studied art. She would
give us all long speeches about what was wrong with the Catholic
Church—putting down every nun she'd ever known, every priest,
every bishop, right up to the Pope—but she always claimed that
there was one good thing about being brought up strict: when
you finally did go out and do all the things you'd never been al-
lowed to, they thrilled you a lot more. She'd often talk about the
physical fights she had with her father, about how he'd chase her
around the backyard, threatening to kill her. It never occurred to
me that her life might not really have been exactly as she'd de-
scribed it. But then one day, something happened out in front of
33 Union Square that made me wonder, and things were never
really the same between Viva and me after that.

It was the day that a big "family photograph" of the Factory
crowd was being taken for *Eye,* the new pop magazine that the
Hearst Corporation was launching, aimed right at the big youth

market. I went down to the Factory and when I got out of the cab on 16th Street, there was Viva in the pouring rain, pounding at the door to the building and kicking at it, jerking furiously at the handle. She looked up and saw me—her face had a crazed expression. She screamed hysterically that she demanded keys to the Factory, that only the *men* had keys: "I don't get any respect because I'm a woman and you're all a bunch of fags!" And then, before I could duck, her pocketbook knocked me in the head: she'd thrown it at me—I mean, I couldn't believe she'd actually done it. I was stunned for a second. I kicked it back at her feet, I was so mad. "You're crazy, Viva!" I screamed.

It upset me a lot to see Viva lose control. After a scene like that, you can never trust a person in the same way again, because from that point on, you have to look at them with the idea that they might do a repeat and freak out again.

I left Viva outside on the street and went upstairs. When I told Paul what had just happened, he said that he wasn't at all surprised—she'd called him half an hour earlier from a pay phone, screaming, "Listen, you fag bastard! Get down here and let me in." He'd hung up on her.

That incident with Viva really got me wondering about whether the problems with her parents had really started with them—for the first time it was dawning on me that maybe she'd twisted all those stories about her father trying to beat her up; maybe she drove him to it, maybe he went after her only after she'd driven him absolutely crazy—and it also made me wonder about Edie's family. I'd always just accepted Edie's story that her whole childhood was a nightmare, but now I started thinking that you should always hear both sides.

• • •

Nico was staying with Fred during the spring of '68, in the apartment he'd taken on East 16th Street, just a walk across Union Square from the Factory.

Fred doted on eccentrics, and Nico was a true specimen: among other things, she thrived only in the gloom—the gloomier she could make the atmosphere around her, the more radiant she became. And the more peculiarities Nico indulged in, the more fascinated Fred became—to find a woman that beautiful *and* that eccentric was a fantasy come true for him. She liked to lie in the bathtub all night with candles burning around her, composing the songs that would be on her second album, *Marble Index,* and when Fred came home from Max's really late, she'd still be in the water.

Fred was back and forth to Europe a lot. When he arrived back at the apartment one night with all his suitcases, he stumbled into the living room and found that he couldn't switch the lights on. He saw a candle flickering in another room around a corner, and then Nico walked in holding a candelabra.

"Oh, Nico! I'm so sorry!" he said, suddenly realizing that Con Edison must have turned off the electricity. "I just remembered I forgot to pay the light bill, and here you've been in the dark all this time!"

"Nooooo, it's fiiiiine," she said, positively beaming with joy. She'd had the happiest time of her whole life, drifting around there in the dark for a whole month.

In May, Paul, Viva, and I went out west together to talk at a few colleges, and once we were out there, we started filming a surfing movie in La Jolla, California.

La Jolla was one of the most beautiful places I'd ever seen.

We rented a mansion by the sea and a couple of other houses for the people who were going to be in the movie—some of them had flown out with us and the others just met us there.

Everybody was so happy being in La Jolla that the New York problems we usually made our movies about went away—the edge came right off everybody. I mean, it wasn't like our going out, say, to the Hamptons to film, where it was just a day-trip extension of New York City.

We'd lounge around listening to our transistors on the beach, playing songs like "Cowboys to Cowgirls," "A Beautiful Morning," cuts from the Jimi Hendrix *Axis* album. From time to time I'd try to provoke a few fights so I could film them, but everybody was too relaxed even to fight. I guess that's why the whole thing turned out to be more of a memento of a bunch of friends taking a vacation together than a movie. Even Viva's complaints were more mellow than usual.

Back in New York, on June 3, I was at home on the phone all morning, mostly to Fred, getting the gossip. Fred was still at home, too. The night before on 16th Street, coming home from Max's, he'd gotten mugged by three little black kids with knives. Even the hippies down in the East Village had gotten really aggressive lately when they asked you for (*demanded*, really) "change." Attitudes out on the street weren't like the summer before when everybody was acting so enchanted.

"It happened right outside your building?" I said. "Was Nico watching?"

"No," Fred sighed. "When I finally staggered into the apartment, she was in the bathtub as usual with all her clothes on, singing."

Ordinarily, Fred would get up early in the morning and

zombie-zip over to the Factory. With Fred, it didn't matter if he hadn't gone to bed till five of nine—at nine sharp he'd be dashing across Union Square Park to work. Getting to the Factory "office" that early didn't make much sense, since nothing much went on there until after one or two, but that didn't matter to Fred—he wanted to set a good example for himself. He'd sit there with his black coffee, take out his fountain pen, and write elegant-looking memos to himself in those little leather-bound, gilt-edged, fine-papered European datebooks.

But this morning it was eleven o'clock and he was still in bed. He sounded really blue; the muggers took a beautiful wristwatch that he said could never be replaced. He quickly changed the subject (his philosophy was always to "chin up" and forget about things) by telling me that he'd heard at Max's that Susan Bottomly and David Croland were breaking up. Earlier in the year, we'd introduced Susan to Christian Marquand, who'd been a matinée idol in France before becoming a director, and he'd put her in Terry Southern's *Candy*—a little scene where she runs down the street crying, "Candy! You forgot your shoe!" They filmed that part here, but then he flew her to Italy to do something, I forget what, with the Living Theater. She'd just come back from Rome, she'd stayed over there for months.

Fred and I spoke some more on the phone—it was Monday, so we had the whole weekend to rehash—and by the time we were done, the early part of the day had gone by.

I got down to 33 Union Square around four-fifteen. I'd done some errands in the East Fifties and, since I was in the neighborhood, I'd rung the bell of a costume designer friend of mine, Miles White, on East 55th Street, but he wasn't home, so I

headed down to the Factory. As I paid the cab driver, I saw Jed coming down the street with a bag of fluorescent lights from the hardware store. I stood there for a few seconds waiting for him, beside a kid who was leaning against the building, blasting "Shoo Be Do Be Doo Be Doo Da Day" on his radio. Then Valerie Solanis came along and the three of us went into the building together.

I didn't know Valerie very well. She was the founder of an organization she called "S.C.U.M." (for the "Society for Cutting Up Men"). She would talk constantly about the complete elimination of the male sex, saying that the result would be an "out-of-sight, groovy, all-female world."

She once brought a script to the Factory and gave it to me to read—it was called *Up Your Ass*. I looked through it briefly and it was so dirty I suddenly thought she might be working for the police department and that this was some kind of entrapment. In fact, when we'd gone to Cannes with *Chelsea Girls* the year before and I'd given that interview to *Cahiers du Cinéma*, it was Valerie Solanis I was referring to when I said, "People try to trap us sometimes. A girl called up and offered me a film script . . . and I thought the title was so wonderful, and I'm generally so friendly that I invited her to come over with it, but it was so dirty I think she must have been a lady cop . . ."

I had gone on to tell the interviewer that we hadn't seen her since. But then after we got back to New York, she started calling the Factory asking for her script back. I'd left it lying around somewhere, and I couldn't find it—somebody must have thrown it out while we were off in Cannes. When I finally admitted to her that it was lost, she started asking me for money. She was staying at the Chelsea Hotel, she said, and she needed the money

to pay her rent. One afternoon in September when she called, we were in the middle of shooting a sequence for *I, a Man,* so I said why didn't she come over and be in the movie and *earn* twenty-five dollars instead of asking for a handout. She came right over and we filmed her in a short scene on a staircase and she was actually funny and that was that. The main thing was, she only called occasionally after that, with those same man-hating S.C.U.M. speeches, but she didn't bother me so much anymore—by now I'd decided that she wasn't a lady cop after all. I guess enough people must have told me that she'd been around for quite a while and confirmed that she was a bona fide fanatic.

It was a very hot day, and as Jed, Valerie, and I waited for the elevator, I noticed that she was wearing a fleece-lined winter coat and a high turtleneck sweater, and I thought how hot she must be—although, surprisingly, she wasn't even sweating. She was wearing pants, more like trousers (I'd never seen her in a dress), and holding a paper bag and twisting it—bouncing a little on the balls of her feet. Then I saw that there was something even more odd about her that day: when you looked close, she'd put on eye makeup and lipstick.

We got off at the sixth floor and stepped right out into the middle of the studio. Mario Amaya was there, an art critic and teacher who I'd known since the fifties. He was waiting to talk to me about putting on a show somewhere.

Fred was up front at his big desk writing a letter in longhand. Paul was across from him at his matching desk, talking on the phone. Jed had gone to the back to put in the fluorescent lights. I walked over to Paul.

The windows in the front were all open—the doors to the balcony, too—but it was still so hot. They were European-style

windows—two vertical panes in wood frames that opened in and you latched them like shutters. We liked to keep them swinging free, not fastened back by anything, so if there was a breeze they'd move in and out, back and forth. But there was no breeze.

"It's Viva," Paul said, standing up and handing me the phone. I sat down in his chair, and he walked to the back. Viva was telling me that she was uptown at Kenneth's salon where the *Midnight Cowboy* production people were trying to match her hair color to the hair of Gastone Rossilli, the boy she was doing a scene with.

Both Paul's and Fred's desks were actually low metal file cabinets with big ten-foot by five-foot boards across between them—the working surface was glass, so that when you looked down to write something, you could see yourself. I leaned over the desk to see how I looked—talking to her was making me think about my own hair. Viva kept gabbing, about the movie, about how she was going to play an underground filmmaker at a party scene where Jon Voight meets Brenda Vaccaro. I motioned for Fred to pick up and continue the conversation for me, and as I was putting the phone down, I heard a loud exploding noise and whirled around: I saw Valerie pointing a gun at me and I realized she'd just fired it.

I said, "No! No, Valerie! Don't do it!" and she shot at me again. I dropped down to the floor as if I'd been hit—I didn't know if I actually was or not. I tried to crawl under the desk. She moved in closer, fired again, and then I felt horrible, horrible pain, like a cherry bomb exploding inside me.

As I lay there, I watched the blood come through my shirt and I heard more shooting and yelling. (Later—a long time later—they told me that two bullets from a .32-caliber gun had

gone through my stomach, liver, spleen, esophagus, left lung, and right lung.) Then I saw Fred standing over me and I gasped, "I can't breathe." He kneeled down and tried to give me artificial respiration but I told him no, no, that it hurt too much. He got up from the floor and rushed to the phone to call an ambulance and the police.

Then suddenly Billy was leaning over me. He hadn't been there during the shooting, he'd just come in. I looked up and I thought he was laughing, and that made me start to laugh, too, I can't explain why. But it hurt so much, and I told him, "Don't laugh, oh, please don't make me laugh." But he wasn't laughing, it turned out, he was crying.

It was almost a half-hour before the ambulance got there. I just stayed still on the floor, bleeding.

Immediately after I was shot, I learned later, Valerie turned and fired at Mario Amaya, hitting him in the hip. He ran for the back room and slammed the big double doors. Paul had been in the bathroom and hadn't even heard the shots. When he came out, he saw Mario, bleeding, holding the door shut. He went to look through the projection room glass, and saw Valerie on the other side trying to force the door. When it didn't open, she walked over to my little office on the side—it was closed, so she tried turning the knob. It didn't open, either—Jed was holding it shut from the inside, watching the knob going around and around—but she didn't know that, she left it for locked. Then she went to the front again and pointed the gun at Fred, who said, "*Please!* Don't shoot me! Just *leave!*" She seemed confused—undecided whether to shoot him or not—so she went and pushed the button for the elevator. Then she walked back to where he was cornered, down on the floor, and pointed the gun

at him again. Right when it looked like she was about to pull the trigger, the elevator doors opened suddenly and Fred said, "There's the elevator! Just *take* it!"

She did.

When Fred called the ambulance for me, they said that if he wanted them to sound the emergency siren, it would cost fifteen dollars extra. Mario wasn't hurt badly, he was walking around. He actually called for another ambulance for himself.

Of course, I was unaware of all this at the time. I didn't know a thing. I was just on the floor, bleeding. When the ambulance came, they didn't have a stretcher with them, so they put me in a wheelchair. I thought that the pain I'd felt lying on the floor was the worst you could ever feel, but now that I was in a sitting position, I knew it wasn't.

They took me to Columbus Hospital on 19th Street between Second and Third avenues, five or six blocks away. Suddenly there were lots of doctors around me, and I heard things like "Forget it" and ". . . no chance . . ." and then I heard someone saying my name—it was Mario Amaya—telling them that I was famous and that I had money.

I was in surgery for about five hours, with Dr. Giuseppe Rossi and four other great doctors working on me. They brought me back from the dead—literally, because I'm told that at one point I was gone. For days and days afterward, I wasn't sure if I *was* back. I felt dead. I kept thinking, "I'm really dead. This is what it's like to be dead—you think you're alive but you're dead. I just *think* I'm lying here in a hospital."

As I was coming down from my operation, I heard a television going somewhere and the words "Kennedy" and "assassin" and "shot" over and over again. Robert Kennedy had been shot, but what was so weird was that I had no understanding that this

was a *second* Kennedy assassination—I just thought that maybe after you die, they rerun things for you, like President Kennedy's assassination. Some of the nurses were crying, and after a while, I heard things like "the mourners in St. Patrick's." It was all so strange to me, this background of another shooting and a funeral—I couldn't distinguish between life and death yet, anyway, and here was a person being buried on the television right in front of me.

My first visitor was unofficial—Vera Cruise, disguised as a nurse.

I was lying in the bed, trying not to think about the pain that racked my body. I was in intensive care, so there was someone else in the room, a young kid I recognized from around Max's who'd overdosed on some drug, but the doctors and his parents didn't know which one. They'd tried to find out from his wife, they told the doctor, but she was on so many drugs herself that she wouldn't tell them. Sometimes this kid would get delirious and start screaming, and that's when I noticed that there was another drama going on, that when nobody was looking, a certain nurse would come in and she and the boy would hug and kiss. *She* knew what drug he was coming down off of, and when he got too bad she'd get it out of the cupboard and give it to him. I would keep my mind off the pain by watching them.

On one of the first days—I couldn't tell the days from the nights, it was just cycles of pain—I looked up at the face on top of the nurse's uniform beside my bed and there was Vera. Then I understood why they don't let you see people when you're in the hospital—because the slightest emotional thing makes the pain come more.

"Oh, go away, Vera," I moaned. All I could think was that

she'd come to steal drugs out of the cabinet, and I didn't want trouble.

My mother visited me with my two brothers from Pennsylvania and my nephew Paulie, who was studying to be a priest. Paulie stayed on with my mother after the other relatives left, because she didn't speak much English and was sort of batty by then. She couldn't be left alone, certainly, since she had a habit of letting anybody into the house who rang the bell and said they knew me. Any reporter could have gone right up there to talk to her and, if nobody was there to stop her, she'd take them on a complete tour, play my tapes for them, arrange a marriage with me if it was a girl, or with one of my nieces if it was a man—I mean, any embarrassing thing could happen if my mother became a hostess.

When I was shot, Gerard had gone up to my house to get her and bring her over to the hospital, and that first night he and Viva took her home. Then somewhere along the line, I heard that the Duchess had been up at the house, too, visiting my mother, so that was food for some horrible thought.

If you value your privacy, don't ever get shot, because your private life turns into an open house very quickly.

Viva and Brigid were sweet and wrote me long letters together every day on yellow legal pads, telling me what was happening with everybody we knew, and eventually, when I could take phone calls, I learned more details about the shooting and the days right after it.

Brigid said that at four o'clock on Monday when I was getting shot, she was in a cab on her way over to the Factory from Lamston's five-and-dime store where she'd gone to buy her

week's supply of Rit and Tintex (she was still "dyeing every day"), but that then she changed her mind and told the driver to take her home to the George Washington Hotel instead—she'd had a fight with Paul the day before and didn't want to face him— and that's how she missed the shooting.

Viva said that when she was talking to me on the phone from Kenneth's salon and the shot went off, she thought someone must be playing with the bullwhip left over from the Velvet Underground days, because the sound was like a cracking noise, and that when she'd heard me screaming Valerie's name, she'd thought I was saying "Viva!" Even when Fred got on the phone and told her I'd been shot, she still didn't believe it, she said. She had someone at Kenneth's call back to check it, and Jed told them the same thing.

Brigid said that the next night, after watching the news at Viva's uptown, she walked into Max's and the people around the cigarette machine told her, "Bobby Kennedy's been shot." She went on toward the back room and collided with Bob Rauschenberg who was coming down from the upstairs, all sweaty from dancing. "I told him the news about Bobby Kennedy," she said, "and he fell to the floor, sobbing, and said, 'Is *this* the medium?'"

"What was that supposed to mean?" I asked her.

"First you, then Bobby Kennedy," she said. "Guns."

One of the letters from Viva and Brigid said that when Louis Waldon came to the hospital the night of the shooting, all the girls in the waiting room rushed over to tell him he had to go home with Ivy and stay with her because she was saying that the moment I died, she was going to kill herself. Later he told Viva and Brigid, "I spent the whole night with her and those poor children of hers and she kept calling the hospital every ten seconds wanting to know if Andy had died yet so she could jump

right out the window if he had. Finally, at six in the morning, they told her they thought he was going to make it, and I collapsed into bed."

When I was well enough to, I read all the newspaper and magazine articles on the shooting that everyone had saved for me. The papers said that Valerie had been up to the Factory earlier that afternoon and that when she was told I wasn't there, she went outside to wait till I showed up. Around seven o'clock, three hours after she shot me, she turned herself in to a rookie policeman in Times Square. She handed him the gun, the papers said, and then told him, "I am a flower child. The police are looking for me. They want me. He had too much control over my life." The policeman took her to the 13th Precinct house, just two blocks away from the hospital where I was still in surgery. She told the police at the precinct, "I have a lot of very involved reasons. Read my manifesto, and it will tell you what I am." Later on in court, she told the judge, "It's not often I shoot somebody. I didn't do it for nothing." The newspapers also quoted a lot from her S.C.U.M. manifesto.

As I've said, I was the headline of the *New York Daily News*— "ACTRESS SHOOTS ANDY WARHOL"—six years to the day from the June 4, 1962, "129 DIE IN JET" disaster headline that I'd silkscreened for my painting. The picture on the front page of the June 4, 1968, final was of Valerie in custody, holding a copy of the day's early edition in her hand. The caption quoted her correcting, "I'm a writer, not an actress."

I couldn't figure out why, of all the people Valerie must have known, I had to be the one to get shot. I guess it was just being

in the wrong place at the right time. That's what assassination is all about. "If only Miles White had been home when I rang his doorbell," I kept thinking, "maybe she would've gotten tired and left."

Fred filled me in on what had happened with the police.

"They took Jed and me over to the 13th Precinct house," he said. "They questioned us until about nine o'clock that night. They told us we were 'material witnesses,' and I was so naive I didn't realize that that meant they were holding us as suspects!"

"Whaaaaat?" I said.

"Yes—until after they booked Valerie, I guess. They wouldn't tell us anything. I kept demanding to know your condition, and they wouldn't even tell me that." He laughed in an ironic way. "They were probably hoping we'd confess."

"They didn't take Paul or Billy?"

"No, just Jed and me, because we were the only ones who'd actually seen the shooting. Viva came running in later, hysterical, and they questioned her for a while—she just told them what she'd heard over the phone."

"Did the police lock up the Factory—rope it off or something?" I asked him. I had television police show "scene of the crime" images in my mind.

"About eight plainclothes detectives came up, and they were running all over the place, putting tape where the bullets were, saying things like"—Fred laughed—"'Let's take the slugs out of the wall.' They got into everything—opened every drawer, went through, God, I don't know, the stills of *Sleep*, old coffee shop receipts. . . . I kept telling them, 'You know, these things you're looking through have nothing at all to do with what happened.' But of course they kept it up. They were going through color

transparencies of the Flower paintings—*any*thing—throwing photographs and slides around, running around bumping into each other. . . . It was like the Keystone Kops."

I started to laugh, and it hurt. "Oh, please, Fred," I had to tell him, "don't say anything funny." It's strange how when you're alone and you read something funny, you don't laugh, but as soon as somebody else is there, you get the physical reaction.

"And after they'd been poking around for at least two hours— *every* drawer in *every* cabinet was pulled out—I saw a paper bag sitting *right on top* of the desk where you were shot.

"I went over to the bag, and I said to the cop—who was sitting there leafing through Paul's photographs of Joe—'What's *this*?' Then I looked inside and—are you ready?—in this paper bag was another gun, Valerie's address book, and a Kotex pad!"

"Are you serious?" I said. Then I remembered the paper bag she'd been twisting in the elevator. "And you mean it was sitting right on top of the desk all that time and the police never even looked inside it?"

"That's right."

Fred also mentioned that when Valerie began shooting, it was quite a few moments before he realized what was actually happening, and his first thought was "Oh, my God, they're bombing the Communist party." As I said, the Communists had their offices on the eighth floor.

The shooting put a whole new perspective on my memories of all the nutty people I'd spent so much time with. I thought about when the girl came up to the 47th Street Factory and shot through the Marilyn canvases, and about the guy doing Russian roulette there. I thought about all the people I'd seen with guns—even Vera used to carry one. But I'd always thought it

was unreal—or else that it was just a joke. It still seemed unreal, like watching a movie. Only the pain seemed real—everything around it was still a movie.

I realized that it was just timing that nothing terrible had ever happened to any of us before now. Crazy people had always fascinated me because they were so creative—they were incapable of doing things normally. Usually they would never hurt anybody, they were just disturbed themselves; but how would I ever know again which was which?

The fear of getting shot again made me think that I'd never again enjoy talking to somebody whose eyes looked weird. But when I thought about that, I got confused, because it included almost everybody I really enjoyed! I decided that I wouldn't try to plan anything out, that I'd just wait and see what happened when I finally did go out around people again.

While I was in the hospital, Paul gave me reports on the local filming of John Schlesinger's *Midnight Cowboy*. Before I was shot, they'd asked me to play the Underground Filmmaker in the big party scene, and I'd suggested Viva for the part instead. They liked the idea of that. And then John Schlesinger had asked Paul to make an "underground movie" to be shown during the "underground party" scene, so Paul went and filmed Ultra for that. Then the casting agent had asked Paul to round up a lot of people we knew—the kids around Max's—to be day players and extras. I felt like I was missing a big party, lying there in the hospital like that, but everybody kept me up to the minute on what was happening, they were all so excited about being in a Hollywood movie.

• • •

I had the same jealous feeling thinking about *Midnight Cowboy* that I had had when I saw *Hair* and realized that people with money were taking the subject matter of the underground, counterculture life and giving it a good, slick, commercial treatment. What we'd had to offer—originally, I mean—was a new, freer content and a look at real people, and even though our films weren't technically polished, right up through '67 the underground was one of the only places people could hear about forbidden subjects and see realistic scenes of modern life. But now that Hollywood—and Broadway, too—was dealing with those same subjects, things were getting a little confused: before, the choice had been like between black and white, and now it was like between black and gray. I realized that with both Hollywood and the underground making films about male hustlers— even though the two treatments couldn't have been more different—it took away a real drawing card from the underground, because people would rather go see the treatment that *looked* better. It was much less threatening. (People do tend to avoid new realities; they'd rather just add details to the old ones. It's as simple as that.) I kept feeling, "They're moving into our territory." It made me more than ever want to get money from Hollywood to do a beautiful-looking and -sounding movie with our own attitude, so at last we could compete equally. I was so jealous: I thought, "Why didn't they give *us* the money to do, say, *Midnight Cowboy*? We would have done it so *real* for them." I didn't understand then that when they said they wanted real life, they meant real movie life!

"Isn't it amazing?" Paul said on the phone one night while I was still in the hospital. "Hollywood's just gotten around to doing a movie about a 42nd Street male hustler, and we did ours

in '65. And there are all *our* great New York people sitting on *their* set all day—Geraldine, Joe, Ondine, Pat Ast, Taylor, Candy, Jackie, Geri Miller, Patti D'Arbanville—and they never even get around to using them . . ."

"What's Dustin like?" I asked.

"Oh, he's very nice."

"And Jon Voight?"

"He's very nice, too. . . . So's Brenda Vaccaro," he said, absently. "They're all very nice." Then he laughed, remembering Sylvia Miles. "And Sylvia's absolutely indomitable. A force of nature."

I got the feeling that making that little film of Ultra and then just hanging around a movie set watching the production had been pretty frustrating for Paul—he thought he should be out there doing a film himself. After all, he'd done his own films before he came to the Factory.

"Well, you know," I said, "maybe we did our film too early. Maybe now *is* the smart time to do a film about a male hustler. Why don't you do another one—this time it can be in color."

"That's what I was sort of thinking," Paul admitted.

In July, while I was still in the hospital, Paul began filming *Flesh* with Jed as an assistant. They didn't shoot too much film and most of what they shot was actually used. Paul liked long takes.

One afternoon Geraldine Smith rang up my room right after she'd finished shooting her first scene.

"You're in Paul's movie?" I said.

"Yeah. Paul called me up this morning and said, 'Why don't you meet us at Fred's apartment; we're going to shoot some film,' and I thought he meant like a little home movie, and my two girl friends were warning me, '*Don't* be in an Andy Warhol

movie—there'll be a spell on you all your life,' but I went over to Fred's anyway and did it—you know how I love Paul." Geraldine had a big crush on Paul.

"What did you have to do?" I asked her.

"Paul told me Joe was my husband or something, I don't know, and threw me in front of the camera and said to do whatever I was going to do, so I told Joe to go out and hustle so I could pay for my girl friend's abortion."

"Who played your girl friend?"

"Patti."

"Patti D'Arbanville's in the movie? How great! Then what did you do? Did you make it with Joe?"

"Are you crazy? In a movie?"

"You didn't make it with him?"

"Although I must say, he had a hard-on." She giggled.

"Ooo. How exciting. Was it really big and hard? What did you do?"

"I—" She started laughing. "—I tied a bow around it."

"Reeeeally?" I said. "Around his cock? And *then* what did you do?"

"You know me," she said. "I started to laugh."

On July 28 I went home from the hospital. My whole middle was taped. I looked down at my body and I was afraid of it—I was scared to take a shower, especially, because then I would have to take away the bandages, and the scars were all so fresh; they were sort of pretty, though, purplish red and brown.

For the following week and a half I had to stay in bed, and that's how I spent my fortieth birthday on August 6. When I called people up and they heard my voice for the first time since the shooting, sometimes they'd start to cry. I was very moved to

see that people cared about me so much, but I just tried to get everything back to a light gossipy level as quick as possible.

David Croland called one morning and I asked him what had finally happened with him and Susan Bottomly, because she'd come back from Europe the day before I was shot, so I'd never gotten the full story.

"Things were just too crazy between us," he said. He still didn't sound too happy when he talked about it; I could tell he really missed her. "The night she got back," he said, "it was sweltering, and I just knew she was going to say she was leaving me. Then Nico came over to the house to tell us you'd been shot. We just sat there in the heat not knowing what to do—should we go to the hospital? Shouldn't we? Finally Nico said, 'We should siiiiit here on the flooorrrrr and waaaaiiiiit with the candles burrrrrning and praaaaay.' I was so freaked that I thought, 'You know, she's right.' So we lit all the candles and Nico closed the blinds and we sat down on the floor. The place looked like a church. Nico was leaning over back and forth, Susan was completely freaked out from being on a crazy up trip in Rome and then coming back and having this thing happen with you right away, and I was going nuts because I knew Susan was going to leave me and you were in the hospital—we didn't even know if you were going to live or not. Whenever we called the hospital, they said, 'All the lines are jammed for him. All we can tell you is that he is in very critical condition.' So it was goose bumps for hours and hours. The three of us sat there like that all night. Nico finally left. We called the hospital again, and they said you were better. A few hours after that, Susan split for Paris."

Henry Geldzahler's career at the Met had taken a big jump in the spring of '67 when he was named curator of twentieth-

century art, and now as I convalesced, we had a few long leisurely chats, almost like in the old days, and he gave me the inside scoop on some of the dramas that had been going on at the museum. There'd been a confrontation between him and Thomas Hoving, the director of the Met, over the exhibition of a huge Pop painting.

During the summer of '67, Henry told me, he'd gone to Paris to look over a show the French government wanted to send to the Met:

"It was unbelievable what they had in that show," he said. "The finance minister's brother-in-law's dentist was in it, the cousin of the fiancée of the security guard. I went back and told Hoving, 'Under no circumstances can we take that show,' and Hoving said, 'You're absolutely right.' And then, without saying another thing to me about it, he signed the agreement to bring it right over. I gulped, but I didn't say anything."

Then in February of '68 Hoving took Jim Rosenquist's big Pop painting, *F-111,* on loan from Bob Scull, and exhibited it right next to Emanuel Leutze's *Washington Crossing the Delaware.* Hoving's idea, apparently, was to contrast a historical painting from the sixties with an older one, but Henry felt that this was cutting into his own twentieth-century art territory, and he resigned.

"While I was on vacation," he told me, "Bob Scull and Hoving had talked at a dinner party or something and decided that the *F-111* should be shown at the Met. True, it's a fascinating picture—however, *I'm* the curator of twentieth-century art, not Scull and not Hoving. So I handed in my letter of resignation, and about ten days later Hoving called me up and admitted that he'd been calling all over the country to get recommendations for a replacement for me and that everyone just told him how

crazy he was to be looking for one. So I agreed to go back to work, but with the understanding that I was in complete charge of all twentieth-century art."

When I was up and padding around the house, I had all the footage from *Lonesome Cowboys* brought over from the Factory; hours and hours of one-of-a-kind scenes. I worked with just a projector and a splicer, chopping whole blocks of it here and there to cut it down to a standard two-hour running time.

With painting, I didn't have the strength to work with big canvases yet, so I did lots of tiny little Happy Rockefeller paintings that were seven by six inches each while I watched TV. It was a violent summer on the news. I watched the Soviets tank into Czechoslovakia, and then came the Chicago Democratic Convention where the demonstrators and the Chicago police fought in the big park and on the streets.

By September I was back at work.

I had to wear heavy surgical corsets to support my scarred sections, but as glued-together as I felt, I was thrilled to be back at the Factory.

However, every single time I'd hear the elevator in the shaft just about to stop at our floor, I'd get jumpy. I'd wait for the doors to open so I could check who it was. We decided to have an entrance hallway built so we could screen people before we let them into the main area, and in the wall there we put a Dutch door—closed at the bottom, open on top. Of course, these security things were just symbolic—they wouldn't stop anyone who had even a good kicking foot, never mind a gun. Still, the place at

least *looked* like it would be much harder to crack. Anyway, the days when people could just drift in were over.

Everyone around the Factory was more protective of me, too—they could see I still had a lot of fear, so they turned anybody away who was acting at all peculiar. I found myself spending a lot of time in the little office on the side, hiding in there with the door closed, talking to the new typist I'd hired. Before, I'd always loved being with people who looked weird and seemed crazy—I'd thrived on it, really—but now I was terrified that they'd take out a gun and shoot me.

Seeing how I'd changed so much, Paul said, "You know, Andy, you've always encouraged people who operate on . . . uh . . ." He looked for the words. ". . . tenuous mental health to come around here. But it's just trouble, and now *you*," he said, pointing to my chest and stomach, "know that better than anybody."

Paul was right, of course: obviously I should avoid unstable types. But choosing between which kids I would see and which ones I wouldn't went completely against my style. And more than that, what I never came right out and confided to anyone in so many words was this: I was afraid that without the crazy, druggy people around jabbering away and doing their insane things, I would lose my creativity. After all, they'd been my total inspiration since '64, and I didn't know if I could make it without them.

I still had to spend a lot of time in bed. Whenever I did go out anywhere after leaving the Factory for the day, I would slip away very early and go home. Then I could wake up at seven all rested and get right on the phone, calling up everyone to see what had

happened after I'd left the party. This vicarious routine suited me as well as actually being there. I started to really enjoy being home in bed, surrounded by candy, watching TV, talking and taping on the phone.

It was easy for me to suddenly stay away from the crazy scenes I'd loved because, actually, there wasn't too much going on anymore. Things had peaked in the summer of '67, and then begun to wind down. Fall '68 was "Hey Jude" time, and everybody was saying how things were more "mellow."

As for Valerie, as far as we knew she was still in jail. Then on Christmas Eve '68, I answered the phone at the Factory and almost fainted when I heard her voice demanding that I drop all criminal charges against her, pay her twenty thousand dollars for all the manuscripts she'd ever written, put her in more movies, and—she capped the list with every lunatic's biggest dream—get her booked on the Johnny Carson show. If I didn't, she said, she "could always do it again."

My worst nightmare had come true: Valerie was out. A man with a name we didn't recognize had put up ten thousand dollars' bail for her.

Luckily she'd been threatening other people around New York, too, so when she showed up at court downtown for her hearing on January 9, she was arrested again.

Five months later, just about a year after the shooting, I picked up the *Daily News* and the front page read, "WARHOL GUN GAL DRAWS 3 YEARS." The article reported that Valerie could put the time she'd already spent in jail toward the three years, so that meant that the most the sentence was for was two.

Toward the end of '69 I got a letter from Vera Cruise who wrote that she'd just gotten convicted of car theft. She'd been

sent to Matteawan, too, and she was seeing a lot of Valerie. According to Vera, Valerie talked about "getting Andy Warhol" when she got out.

Right after I got Vera's letter, Matteawan released Valerie, saying she was cured. She called the Factory a few times, but then she stopped—she must have found some other interests because I never saw her again, although occasionally people would say they'd seen her on the street someplace, usually in the Village.

By fall of '68 the mini look was finished. The year had started off with crotch-high hemlines, but by spring you saw all different-length skirts on the fashionable people. And with all the new talk about above-the-knee/midcalf/to-the-floor/wherever, women were wearing more pants suits. This was the season of the great debates about which of the best restaurants would let a lady in with pants on—there were big controversies and interviews with all the maître d's.

The Max's kids wore more thrift store clothes. The Pakistani-Indian-international-jet-set-hippie look—all embroidered and brocaded—was big. People spent a lot of time in flea markets and antique and secondhand stores, and that look was also showing up—not only in closets but in their apartments and houses. It was as if everyone suddenly realized that "labor" was becoming a thing of the past, that you'd never be able to get the same kind of details in clothes or furniture or anything else ever again.

The tapes the new typist was busy transcribing for me were all the hours and hours I'd been recording over the phone and in person since the first ones of Ondine and company back in '65.

Those Ondine tapes were collected to make a book, *a,* which Grove Press brought out at the end of '68. We called it a "novel by Andy Warhol" but it was actually just transcriptions of all the Ondine tapes with some of the names changed (for example, Ondine was Ondine, and Rotten was Rotten, but I was "Drella" and Edie was "Taxine").

Billy worked with Grove Press, making sure that the pages in the book matched the way the high-school typist had transcribed them, right down to the last spelling mistake. I wanted to do a "bad book," just the way I'd done "bad movies" and "bad art," because when you do something exactly wrong, you always turn up something.

The reviews for *a* weren't all that good. (My favorite bad review described the book as "a bacchanalian coffee klatsch.") All I wanted was for someone in Hollywood to buy the rights, so Ondine and I could see great-looking actors like Troy Donahue and Tab Hunter playing us. I mentioned this to Lester Persky, who'd just gotten his first big movie-producing credit (*Boom,* the movie Judy Garland had wanted to star in so badly—the one she'd fought with Lester and Tennessee about at the Factory back in '65—had finally come out, starring Elizabeth Taylor). "*Please,* Andy," Lester groaned when I asked if he'd like to buy the movie rights to *a.* "I'm trying to forget where I came from. It's literary *properties* I'm looking for—not atrocities . . ."

At the end of July I took Ondine and Candy up to the round-the-block line for Judy Garland at Frank Campbell's Funeral Home on 81st and Madison. I wanted to tape-record them as they were waiting to go past the casket. I knew all Judy's fans would be there crying and carrying on about how much she'd meant to them. I had it in my head that this would make a great

play—Ondine and Candy in a line stretching across the stage with criers and laughers all over the place, and everybody telling each other what'd brought them there. I knew it would be just the kind of thing Judy herself would have thought was hysterically funny.

But being with Ondine that day was really strange; it was like being with a normal person. He hadn't been coming around the Factory much. He had a steady lover now, he said he was totally off speed, and he was sort of settled down, working as a mailman—actually delivering letters for the U.S. Postal Service in Brooklyn! As we stood on Judy's line, I must have just gaped at him—I couldn't believe that he was the same person who'd babbled and screeched his way through *a* on speed, laughing and stuttering and being outrageous. He was saying chatty, conventional things, like "It's very hot out, isn't it?" and he moved normally—no lurching or lunging or foaming at the mouth.

For weeks I couldn't stop thinking about this new nonpersonality of Ondine's. Talking to him now was like talking to your Aunt Tillie. Sure, it was good he was off drugs (I supposed), and I was glad for him (I supposed), but it was *so boring*: there was no getting around that. The brilliance was all gone.

After Billy finished working on the galleys of *a,* he did something very weird: he went into his darkroom and didn't come out. Nobody saw him during the day anymore. In the mornings we would find take-out containers and yogurt cups in the trash, but we never knew whether he went out himself at night to get food or whether some of his friends brought it in to him.

At first it didn't seem like a big deal, just a phase he was going through, but then when it got to be spring and he still

hadn't come out, everyone started wondering exactly what was going on in there.

The darkroom was right next to the bathroom that we all used—the rooms were actually linked by a high, painted-over transom window in the wall, and sounds passed through easily so that when you were in the john, if Billy was moving around and doing things, you could hear—and naturally he heard all the pissing and shitting and running water and flushing all day. Occasionally he'd let someone who stopped by to see him into the darkroom but mostly he wouldn't even answer their knocks.

Everybody expected me to try to somehow get Billy to come out, but I didn't. So many people said to me, "Don't you think he's waiting for *you* to *ask* him to come out?" But I had no idea what had made him go in, so how could I get him to come out? And even if I could, why should I? I felt it wasn't really right to interfere like that. Billy had always seemed to know exactly what he was doing, and I just didn't want to butt in; he'd come out when he wanted to, I figured—when he was ready to.

By November '69 he'd been in the closet just about a year. New people thought it was all very strange that we had this person living in a darkroom who we never saw. But when a situation develops gradually, no matter how weird that situation is, you get used to it. Occasionally we'd ask him through the door if there was anything he needed. I didn't even know if he was still taking amphetamine. But then one day Lou Reed came by and spent three whole hours in the darkroom with Billy. When he came out, he looked really spooked.

"I should never have given him that book last year," Lou said, shaking his head.

I didn't know what he was talking about.

"The Alice Bailey book," he said. "Actually, I gave him *three* of them."

I'd heard that name before. Ondine used to mention her a lot; she wrote occult books.

"I was reading one of her books," Lou said, "but it was so difficult, I thought, why not have Billy read them and tell me, you know, the interesting parts? The next thing I knew he was in the closet and not coming out. He's shaved his head completely—he said the hairs were growing in, not out—and he's only eating whole-wheat wafers and rice crackers."

"But I thought he goes out at night after we leave and gets stuff from Brownies." Brownies was the health food store around the corner.

"Not anymore," Lou said. "Now he's following the white magic book that shows you how to rebuild your cell structure— you play with the cell centers and eat, like this yogurt. I asked him to tell me how to do it, and he said it could be really dangerous, that he'd only tell me part of it because if I made a mistake and did something wrong, I could end up like him."

"What was the part he told you?"

"It was just, like, a chant—*Ahhhhhmmmmmmmmn.*"

Things kept getting weirder and weirder with Billy. In the john we'd hear talking on the other side of the wall, and for a while we thought another person had moved in there with him. It turned out that both voices were Billy's. But I still felt he should work whatever it was out for himself, and I believed that, somehow, he would.

For me, the most confusing period of the whole sixties was the last sixteen months. I was taping and Polaroiding everything in sight, but I didn't know what to make of it all.

In '69 there were big California earthquake predictions, and Danny Fields went out there and rented a house as close as he could find to whatever fault line it was, because, he told us, "I want to be in a Disaster. I've been seeing movies about them for so long, I really want to know what it feels like." People were so bored that they wanted something big to happen—in the media, in the earth crust, anywhere, anything.

I went down to the Factory compulsively every afternoon and spent four to six hours there, yet I was confused because I wasn't painting there and I wasn't filming there. I would just sit in my tiny office and peek out toward the front at Paul and Fred taking care of business. When harmless-looking friends or friends of friends stopped by, I'd step out and tape and photograph them, and then I'd go back into my office and wait for somebody else to drop by.

Now that I think back on it, I guess it was all the mechanical action that was the big thing for me at the Factory at the end of the sixties. I may have felt confused myself, but the sounds of phones and buzzers and camera shutters and flashbulb pops and the Moviola going and slides clicking through viewers, and most of all, the typewriter and the sounds of voices off the tapes being transcribed—all those things were reassuring to me. I knew that work was going on, even if I didn't have any idea what the work would come to. I'd get jealous whenever I'd hear about other low-budget people suddenly coming into big bucks, getting money from sources that sometimes would even leave them completely alone to do their art. I still felt that our films, full of the strange, funny people we picked up on, were unique, and I couldn't understand why no big studio had come forward to push us forward.

The big question that everyone who came by the Factory was suddenly asking everyone else was, "Do you know anyone who'll transcribe some tapes?"

Everyone, absolutely everyone, was tape-recording everyone else. Machinery had already taken over people's sex lives—dildos and all kinds of vibrators—and now it was taking over their social lives, too, with tape recorders and Polaroids. The running joke between Brigid and me was that all our phone calls started with whoever'd been called by the other saying, "Hello, wait a minute," and running to plug in and hook up. I'd provoke any kind of hysteria I could think of on the phone just to get myself a good tape. Since I wasn't going out much and was home a lot in the mornings and evenings, I put in a lot of time on the phone gossiping and making trouble and getting ideas from people and trying to figure out what was happening—and taping it all.

The trouble was, it took so long to get a tape transcribed, even when you had somebody working at it full-time. In those days even the typists were making their own tapes—as I said, *everybody* was into it.

It's hard to believe, but very few journalists tape-recorded interviews back then. They'd come with their pads and pencils and scribble down key words you said and then go home and do it up from memory. (Of course, when I said "everybody was taping," I meant "everybody we knew." Other people weren't taping at all and, as a matter of fact, when they'd see your recorder they'd get all paranoid: "What's that? . . . Why are you taping? . . . What are you going to use it for?" etc., etc.)

Tapes brought up great possibilities for interviews with all kinds of celebrities, and since we were a long time between movies lately, I began to think about starting a magazine of

nothing but taped interviews. Then John Wilcock dropped by one day and asked me if I would start a newspaper with him. I said yes. John was already publishing a magazine on newsprint called *Other Scenes,* so he had a complete typesetting and printing setup already. Together we brought out the first issue of *Interview* magazine in the fall of '69.

Newspapers and magazines kept sending reporters to do stories on us, and we made sure we always had somebody new around for them to focus on. At the end of the year it was Candy Darling—she confided to them all that she had a "multipicture deal" with us, and she'd dream up titles—*Blond on a Bummer, New Girl in the Village, Beyond the Boys in the Band,* whatever phrase occurred to her that day. (Even if our movies had gotten fewer and farther between, there was no shortage of titles.) We got thousands of dollars' worth of publicity for movies we weren't bothering to make and for superstars we never got around to using on film.

 Flesh had a smash run from October '68 through April '69 at the Garrick Theater on Bleecker. Joe Dallesandro got quite a following around town—the assistant manager at the Garrick, a young kid named George Abagnalo, told us that he noticed the same faces coming back to see the movie again and again. And Candy, too, was a big hit in her one scene where she sits, very ladylike, on a couch with Jackie and reads old movie magazines out loud while Geri the topless go-go dancer gives Joe a blow job.

 Sometime during the run of *Flesh,* Jackie and Candy rented a room together at the Hotel Albert on 10th Street and University Place. By then Jackie was into total drag—complete with

bushy red hennaed hair, dark lipstick, and forties dresses fastened with big brooches, including a favorite one that spelled "Nixon" in marcasite. When people asked him why he'd "gone all the way," Jackie would explain, "It's much easier to be a weird girl than a weird guy."

Jackie as a full-blown woman wasn't that hard to take because he played it like a total comedy; it was his in-between stage that had been so creepy. He'd started taking female hormones sometime in '68, and by that summer, when Paul was filming him and Candy in *Flesh,* he was in that weird part man/part woman stage—but still a long, long way from both. His eyebrows were all plucked and he wore pancake makeup, but it didn't make up for much: the beard was coming through in stubble, and there were welts—tiny red bumps—where you could see he'd been getting electrolysis. (A lot of the drag queens we knew had their body and face hair removed by the students in a midtown electrolysis school—it was cheaper that way.) But the creepiest part of a sex change has nothing to do with appearance—it's *the voice.* In Jackie's case, he did what most men do when they want to sound like a woman—he dropped his voice to a whisper. However, the thing was, whispery voices never made the drag queens sound more femme—they only made them sound more desperate.

Studying the shortcomings of the other drag queens made you realize how special Candy was, how hard she had to work to stay so femme—and how successful she was at it.

Candy suffered a big disappointment in '69. In fact, she never got over it. As soon as the news that a movie of *Myra Breckenridge* was going to be made appeared in the trade papers, Candy began writing letters to the studio and the producers and

whoever else she could think of, telling them that she'd lived the complete life of Myra and that she knew even more about forties movies than Gore Vidal did. It was true.

And they gave the part to Raquel Welch.

Poor Candy wrote begging them to please, please reconsider. She knew that if there was ever going to be a role in Hollywood for a drag queen, this was it. When she didn't hear anything back, something changed with Candy—it wasn't a change you would notice unless you knew her very well (after all, she was always giving some level of a performance). But suddenly she had to face the fact that Hollywood had slammed the door on her. All her life she'd been rejected and rejected by everybody and everything, and all through it she'd held onto the fantasy that even if no place else in the world would take her in, that Hollywood would, because Hollywood was as unreal as she was; Hollywood would surely understand—somehow. So when she didn't get the part of Myra and she saw that Hollywood didn't want her, either, I saw her become bitter.

The big nude theater craze hit in '69. It was only the year before that police had stood by in San Francisco to arrest the Living Theater performers if they so much as *started* taking their clothes off. Then all of a sudden the new thing was for performers to take all their clothes off and dance around completely naked on stage in long-playing well-advertised shows like *Oh! Calcutta!* and *Dionysus in '69.*

During this period I took thousands of Polaroids of genitals. Whenever somebody came up to the Factory, no matter how straight-looking he was, I'd ask him to take his pants off so I could photograph his cock and balls. It was surprising who'd let me and who wouldn't.

Personally, I loved porno and I bought lots of it all the time—the really dirty, exciting stuff. All you had to do was figure out what turned you on, and then just buy the dirty magazines and movie prints that are right for you, the way you'd go for the right pills or the right cans of food. (I was so avid for porno that on my first time out of the house after the shooting I went straight to 42nd Street and checked out the peep shows with Vera Cruise and restocked on dirty magazines.)

I'd always wanted to do a movie that was pure fucking, nothing else, the way *Eat* had been just eating and *Sleep* had been just sleeping. So in October '68 I shot a movie of Viva having sex with Louis Waldon. I called it just *Fuck*.

At first we kept it at the Factory, screening it occasionally for friends. Then, when we opened *Lonesome Cowboys* in May and it began to die pretty quickly, we had to think about what to replace it with, and I wondered if it should be *Fuck*.

I was still confused about what was legal in pornography and what wasn't, but at the end of July, what with all sorts of dirty movies playing around town and dirty magazines like *Screw* on every newsstand, we thought, oh, why not, and put *Fuck* into the Garrick Theater after changing the title to *Blue Movie*. It ran a week before getting seized by the cops. They came all the way down to the Village, sat through Viva's speeches about General MacArthur and the Vietnam war, through Louis calling her tits "dried apricots," and through her story about the police harassing her in the Hamptons for not wearing a bra, etc., etc., etc.— and *then* they seized the print of our movie. Why, I wondered, hadn't they gone over to Eighth Avenue and seized things like *Inside Judy's Box* or *Tina's Tongue*? Were they more "socially redeeming," maybe? It all came down to what they wanted to seize and what they didn't, basically. It was ridiculous.

• • •

Viva wanted to go to Paris in November '68 so I gave her a round-trip ticket. In January I got a letter from her saying, "If you don't send me money, I'll work against you as well as I worked for you." When somebody threatens me, I don't listen to them anymore. Naturally I was disappointed, but with Viva, I was getting used to disappointment. A telegram from her came in February saying essentially the same thing and I deliberately ignored it. Then we heard she'd gone to Los Angeles to star in Agnes Varda's movie *Lions Love.*

The time did seem right for Viva to make it. More and more girls were picking up on her look—the elegant velvet and satin look, the tunic-length blouses over pants, the slouch and the bored gestures, and most of all the hair—the frizzed, full-blown, out-to-there hair.

In March while I was in the hospital for a follow-up operation, another telegram from Viva arrived at the Factory—this time from Las Vegas: it said she'd gotten married. About a week later she returned to New York, with her new husband, a French filmmaker named Michel that she'd met in Europe and taken out to Hollywood with her. I wished her luck in her marriage. As we talked, she was making little asides to the husband, asking his advice on what to do about this check or that photograph. She told me she was writing an autobiographical novel called *Superstar* for Putnam's and that it would also be an exposé of the underground. She added that, as a matter of fact, she was taping this phone conversation of ours for a chapter in it.

At the end of the sixties it looked like Hollywood was finally about to acknowledge our work and give us money to make a big-budget 35-mm movie. (*Flesh,* meanwhile, had opened in

Germany and was a huge success. When Paul and Joe went over there to publicize it, they got mobbed.) Columbia Pictures wanted to do a project with us and they told us to go ahead and put some sort of script or treatment together.

About this time we met a writer named John Hallowell who was living in L.A. doing interviews with movie stars for the *Los Angeles Times.* John was doing a book called *The Truth Game,* a bunch of chapters on different stars but written sort of like a novel with him as the boy reporter main character. He came to see us in New York because he wanted to end the book with a chapter on the Factory crowd. He and Paul hit it off immediately and started collaborating on a screen treatment for us to take out to Hollywood—showing the different areas of life in L.A. It was tailored for a mix of our superstars with some Hollywood stars John said he could line up.

John went back to Hollywood to talk the idea up with the people out there. We'd get excited calls and telegrams from him saying things like "Raquel can't wait," or "Natalie says wonderful," and I'd tease him about all the name-dropping. (Once he astounded me—he actually did put Rita Hayworth on the phone. But somehow we couldn't really talk to each other, maybe because she was shy and I was shy. We mumbled something about art—she told me she'd once done a painting of a gardenia. She was very sweet, but it was sad because she was slurring her words and sounded sort of lost. She said she just knew I'd make her "the most super star of all.")

In May, Columbia flew us out to L.A.

The conferences with the studio seemed to be going fine until one of the executives asked whether the Great Dane in the treatment was absolutely necessary. (This was the routine way they talked budgets down in Hollywood—he was just dutifully

asking questions to sound economy-minded.) When Paul told him oh, yes, the dog *was* essential because one of the girls was "going to have an affair with it," he went into shock. Paul assured him that the sex with the dog would be off-camera, but we could see that the roof had fallen in.

We didn't hear another word from the studio. When we were back in New York, John called to say they had turned the project down for "moral reasons." "Don't you love it?" he sneered. "For 'moral reasons': They're about as moral as Attila the Hun."

That trip to L.A. wasn't a complete waste—we'd seen a real preview of the New Hollywood. Peter Fonda and Dennis Hopper had just finished making *Easy Rider*. We saw a rough cut of it over at Peter's house in one of the canyons. They put the film on the projector and as it started, Peter turned on his stereo and played all the rock songs that went with it—they weren't actually on the print yet. (Afterward Paul teased him, "What a great idea—making a movie about your record collection!") It was exciting to see young kids like Peter and Dennis putting out the new youth image on their own terms. The idea of using rock that way made you think back to certain underground movies, but what made *Easy Rider* so new-looking was the Hollywood style of opening it up, getting it out, and moving it on the road. (And of course, it was Jack Nicholson's first great role.)

I have to admit, though, that at the time I wasn't so sure *Easy Rider* would be a box office hit, that people would accept its loose style. Little did I know that when it opened that coming July it would be the exact image millions of kids were fantasizing—being free and on the road, dealing dope and getting persecuted.

• • •

The superstars from the old Factory days didn't come around to the new Factory much. Some of them said they didn't feel comfortable with the whiteness of the place. When people called up looking for them (magazines doing stories or model agencies with jobs or just old friends of theirs who'd lost touch), we'd try to find out where they were staying and we'd leave messages around town for them. But things had changed.

By the end of '69, after the yes-no-maybes/it's on–it's offs from L.A. had dragged on for a whole year, we were restless to get started on another movie.

Paul was tired of drugs being glamorized, he told me—especially in the movies. He wanted to completely take the romanticism away from drug-taking—shoot a movie about a Lower East Side junkie and just call it *Trash*. It sounded like a good idea to me and I said sure, to go ahead.

The cast was a new, younger, post-Pop group of kids (like Jane Forth, a sixteen-year-old beauty with great shaved eyebrows and Wesson-oiled hair). All the morality and restrictions that the early superstars had rebelled against seemed so far away—as unreal as the Victorian era seems to everybody today. Pop wasn't an issue or an option for this new wave: it was all they'd ever known.

POSTSCRIPT

Some of those kids who were so special to us, who made our sixties scene what it was, died young in the seventies.

Edie stayed out in California, living quietly. She even got married. But she was in and out of hospitals and in 1971 she died of "acute barbital intoxication."

One day little Andrea Feldman left some notes in the apartment where she lived with her family at Fifth Avenue and 12th Street. She said she was "heading for the Big Time" and then jumped out the fourteenth-floor window, clutching a Bible and a crucifix.

They found Eric Emerson one early morning in the middle of Hudson Street. Officially, he was labeled a hit-and-run victim, but we heard rumors that he'd overdosed and just been dumped there—in any case, the bicycle he'd been riding was intact.

Candy Darling never made it to Hollywood. Tennessee starred her in his off-Broadway play *Small Craft Warnings,* and that was the closest she ever came to regular show business. In 1974 she got cancer and lay dying for weeks at Columbus Hospital, just a few blocks from the Factory. Then she had the movie star's funeral she'd always wanted, uptown at Frank Campbell's.

One morning when we got to the Factory, the door to the darkroom at the back where Billy had locked himself in for two years was open and he was gone. The room smelled horrible.

There were literally thousands of cigarette butts in it and
astrology-type charts all over the walls. We had the mess cleared
out and the black walls painted white. A few weeks later we
leased a copying machine and it became the Xerox room. About
a year later someone told us they'd seen him in San Francisco,
but I never saw or heard from him again after the note he'd
tacked to the wall when he left that night. It said:

ANDY — I AM
NOT HERE
ANYMORE BUT
I AM FINE
LOVE, BILLY

INDEX